D1200265

Vivian Maier

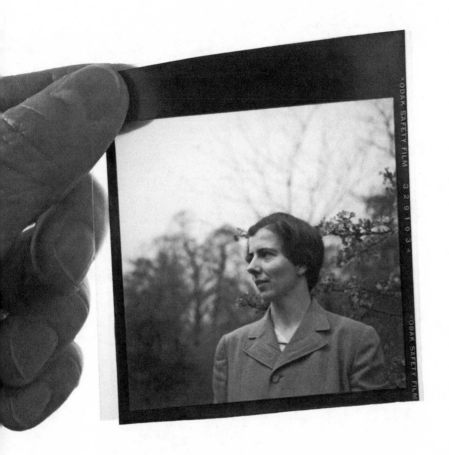

VIVIAN MAIER

A PHOTOGRAPHER'S LIFE AND AFTERLIFE

Pamela Bannos

THE UNIVERSITY OF CHICAGO PRESS + + + CHICAGO AND LONDON

The University of Chicago Press, Chicago 60637
The University of Chicago Press, Ltd., London
© 2017 by Pamela Bannos
All rights reserved. No part of this book may be used or reproduced in any
manner whatsoever without written permission, except in the case of brief
quotations in critical articles and reviews. For more information, contact the
University of Chicago Press, 1427 E. 60th St., Chicago, IL 60637.
Published 2017
Printed in the United States of America

26 25 24 23 22 21 20 19 18 17 1 2 3 4 5

ISBN-13: 978-0-226-47075-7 (cloth)
ISBN-13: 978-0-226-47089-4 (e-book)
DOI: 10.7208/chicago/[9780226470894].001.0001

Library of Congress Cataloging-in-Publication Data
Names: Bannos, Pamela, 1959– author.
Title: Vivian Maier : a photographer's life and afterlife / Pamela Bannos.
Description: Chicago : The University of Chicago Press, 2017. | Includes
 bibliographical references and index.
Identifiers: LCCN 2017022051| ISBN 9780226470757 (cloth : alk. paper) |
 ISBN 9780226470894 (e-book)
Subjects: LCSH: Maier, Vivian, 1926–2009. | Women photographers—United
 States—Biography. | Street photography—United States.
Classification: LCC TR140.M335 B36 2017 | DDC 770.92—dc23 LC record
 available at https://lccn.loc.gov/2017022051

♾ This paper meets the requirements of ANSI/NISO Z39.48–1992
(Permanence of Paper).

FRONTISPIECE: Pamela Bannos holding a color transparency of an image of
Vivian Maier from the Ron Slattery collection. Maier dated the film envelope
"April 22, 1955, Central Park." Original in color.

Contents

Plates follow page 234.

Introduction

There are many ways to get the wrong picture about Vivian Maier. Call her a nanny, as if that was her identity, instead of a photographer. Call her just a Chicagoan or just a Frenchwoman, instead of a born Manhattanite and self-styled European. Call her Vivian, as if you know her well. Call her a mystery or an enigma, as if no one ever knew her, or ever could.

To get the right picture, look at her squarely, as she would look at you: on her own terms, from her own evidence of who she was and what she did. Only then can we begin to see Vivian Maier, woman and photographer, and begin to enter her world.

The story of the Vivian Maier phenomenon has been told so many times that it can now be reduced to a few short phrases:

> Her storage lockers went into arrears.
> A young man named John Maloof bought a box of her negatives.
> He Googled her name and found that she had died a few days earlier.
> He discovered the woman known today as the mysterious nanny street photographer.

But rarely is a story as simple as the filtered-down version that results from multiple retellings. Each link in the chain of the Vivian Maier story branches to reveal a much more complex and nuanced saga. Our current lack of understanding of this woman and her passion for photography stems from oversimplifications of her emergence and packaged versions of the story.

Ethical issues have largely been glossed over in favor of a heroic narrative that benefits the people who have been selling her work. We are told that they have saved Vivian Maier from oblivion and have allowed us to own pieces of her legacy. Many

people believe that Maier would be pleased with the sharing of her work in this way; yet she plainly chose to not share it while she was alive. Some feel that Maier would have destroyed her work if she didn't want it to be found; one writer has even suggested that she had saved it for us.

I have looked carefully at tens of thousands of Vivian Maier's images. I have walked in her footsteps. I have delved the archives in search of everything we might know about Vivian Maier and her work. As I entered the world of her photographs, a different person emerged for me than the one who was shaped for the public imagination. I also learned about Maier's development as a photographer and her life as an independent woman. She cultivated an air of mystery, but she no longer seems like a "mystery woman" to me.

This book is a counterpoint, a counternarrative, and a corrective to the public depiction of Vivian Maier and her work that emerged through five photo books that were published between 2011 and 2014, drawing on two separate collections of Maier's photography, one belonging to John Maloof and the other to Jeffrey Goldstein.[1] Each book was larger than the last. Hundreds of her pictures also appeared in documentaries about her. Altogether, the books and movies reproduced more than a thousand images—possibly illegally. In addition, Vivian Maier's photography has spread across every social network site and countless individual blogs.

In the time since her work first emerged into the public eye, Vivian Maier became big business: Jeffrey Goldstein, who amassed his collection for $100,000, sold $500,000 worth of her work in one year, and John Maloof's film, *Finding Vivian Maier*, has grossed more than $3.5 million.[2] A third collector, Ron Slattery, sued a gallery for $2 million on account of damage to some Maier photographs.[3] Some of Vivian Maier's vintage prints are priced upwards of $12,000 apiece. There have been posters, brochures, postcards, and movie DVDs—not to mention the fortune to be made in licensing fees.

In my research, I found repeated themes that permeate both Vivian Maier's work and the story of its discovery and propaga-

tion. High and low culture intermingle, with profound economic results; Maier's work and her life are defined over and over again by presumptions about and representations of her as a woman; and both in life and work, no one can quite agree on her story, her character, and her value. Even in France, where she spent key parts of her childhood and young adulthood, opposing associations have claimed Maier's legacy. Two men from opposite sides of Maier's mother's family have claimed to be her heir— with profound implications for those who claimed the right to reproduce and profit from her photographs.

Vivian Maier's abundant legacy (more than four tons of stored boxes) was scattered at auction. As a result of the way her photographic work was dispersed and resold, dozens of people now own her possessions and pieces of her work. Since I began studying her fractured archive, I have found and been contacted by individuals who were at the auctions of her possessions and others who subsequently bought her belongings on eBay.

While the rest of the world may be hearing of her story for the first time, in Chicago the story has become familiar. Chicago is where "Viral Vivian" emerged, where the major players in her story reside, and where the press has incessantly reported on the triumphs of her works' exposure, and some locals are now "Vivian Maiered-out." In the summer of 2014, prints from Jeffrey Goldstein's collection were exhibited simultaneously in four separate Chicago-area venues. The abundance of photographs threatened to water down Maier's oeuvre, doing her no favor in its presentation. A local newspaper headlined an article "Vivian Maier: Cottage Industry."[4] A local writer penned his version of the saga and called it "The Vivian Mire."[5]

The scuffles around ownership of Vivian Maier's legacy have diminished her presence, relegating her to the background in her own photographs. In many ways, Vivian Maier's world was established before she was born: she perpetuated the legacy of her mother and grandmother, who were live-in servants, and her mother's illegitimate birth established the first in a line of family secrets. Maier entered the world of photography, which like her took shape in both France and New York and, like

her, has no simple lineage. Vivian Maier's multiple shooting strategies remained constant. Her earliest known photographs reveal a confident and informed photographer—not a "street photographer" or a "suburban nanny photographer." Maier and her photography were all of that and much more.

Vivian Maier's story is a more complex story than a few short phrases can describe. We need to thoroughly understand both it and her if we are to accurately honor her life and legacy.

PART 1

BEGINNINGS AND ENDINGS

The Dispersal of Vivian Maier's Storage Locker Items

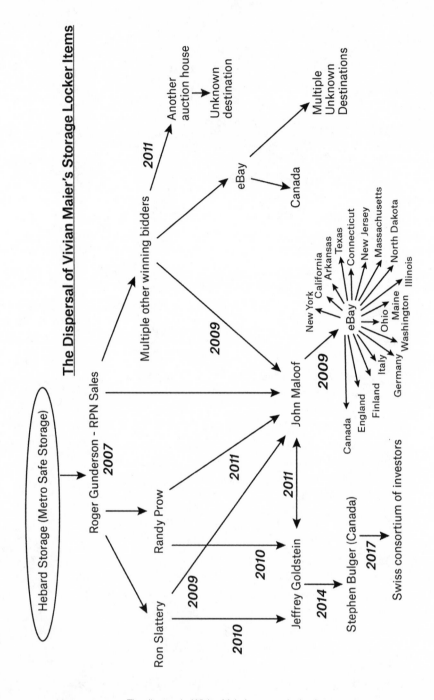

FIGURE 1. The dispersal of Vivian Maier's storage locker items

A Fractured Archive

Eighty-one-year-old Vivian Maier had five storage lockers in a warehouse on Chicago's North Side. But by mid-2007, she had stopped paying the rent.

Within the previous year, the six-story storage facility had changed hands for the first time since it was built eighty-five years earlier. As with Vivian Maier herself, the building's heyday had passed; a no-frills business model had sullied the pristine marble welcoming area with do-it-yourself packaging materials. Only vestiges of the building's former elegance remained. Originally known as Hebard Storage, home to a full-service moving company, the business was now called Metro Self Storage.

Did the change in name confuse Maier and cause her to stop sending payments? Maier likely had not visited the facility lately. The new owners had spent $5 million to acquire the building and nearly a half-million dollars more modernizing it.[1] Had the rental fees increased beyond Maier's means? Three of her units were small at five by five feet, but two were larger, each five by ten feet.[2] By August 2007, a bright yellow "Now Open" banner had been fixed to the building's pale-gray front. A second celebratory banner offered special storage rates at a new telephone number.[3] Did Vivian Maier try to phone the old, now disconnected number? Had she been given a special rate when she moved her possessions in? In the 1970s, she had lived in the same lakeside high-rise building as the daughter of Hebard Storage's founder. The new owners may not have known or cared about the business's history.[4]

Following the company's policy, when Vivian Maier's payment was thirty days past due, an employee affixed a padlock

over each of her units' secured doors and then removed her locks. After opening the doors for a quick look at the lockers' contents, the manager placed two public notices, a week apart, in a local newspaper. By law, the storage company was required to list the renter's name and a brief description of the stored items.

As on the popular television shows *Storage Wars* and *Auction Hunters*, Vivian Maier's possessions attracted a motley assemblage of enterprising bidders hoping to reap profit. Roger Gunderson, owner of RPN Sales & Auction House on Chicago's Northwest Side, had attended many of these events to provide material for his resale business. Typically, he and other fortune hunters would size up contents from a unit's open door: *look, but don't touch*. Storage auction aficionados have different criteria and preferences. Some look for flat or old boxes that may contain important paintings or antiques; others look for easily resalable furniture. Sometimes nothing looks appealing, and a bidder stays on the sideline waiting for the next door to open.

One particular item grabbed Gunderson's attention, propelling him to purchase the contents of all five lockers: an old traveler's steamer trunk covered in stickers, one from Paris. Its romantic aura captured his imagination. There was not much other interest in Vivian Maier's possessions that day. Gunderson took everything in the five units for $260.[5]

Beyond that, Gunderson didn't know what was in Vivian Maier's hundreds of boxes—or what they weighed. When he began loading them into his sixteen-foot truck, able to support nearly two tons of cargo, he didn't expect to jeopardize its suspension. By evening, he had hauled two-and-a-half truckloads of what he described simply as "heavy paper." Gunderson dragged, lugged, and hoisted carton after carton of books and magazines, along with boxes filled with personal items like bills, documents, and correspondence. Contained within some of the dozens of casually stacked cardboard boxes were thousands of photographs of all sizes, perhaps one hundred thousand negatives, countless yellow Kodak boxes of slides and motion picture reels, and more than one thousand rolls of undeveloped film.

+ + +

Everything changed for Vivian Maier in the summer of 1952. The twenty-six-year-old Maier roamed Manhattan's streets and parks, sometimes alone, sometimes with the child she was looking after. When accompanied by the little dark-haired girl, she mostly stayed around the girl's home on Riverside Drive, or they went to Central Park. But when she wandered solo, she traversed far-flung neighborhoods. That July was particularly memorable for its extended heat wave; the temperature stayed above eighty degrees from the twelfth through the twenty-fifth. Vivian Maier had gotten a new camera right before the heat wave struck, one like the professionals used, a Rolleiflex.[6] She now looked like a serious photographer. From Maier's earlier cameras, and her understanding of measuring light value and the relationship between the camera's shutter speed and aperture, the transition was easy; her earliest daytime exposures were spot-on.

+ + +

Roger Gunderson began sorting through Vivian Maier's personal effects. As usual, he "weeded through" the boxes and threw out personal items, such as bills and other documents. "Boxes and boxes of paper" remained, including books, magazines, and Maier's photo-related materials. He thought about discarding Vivian Maier's film negatives, which typically have little or no value.[7]

Gunderson separated and grouped Vivian Maier's items into small lots in what he called "pop flats," traylike cardboard boxes that typically store cans of beer or soda pop. And then he put them up for sale. He included Maier's possessions in four or five auctions, offering eighty to one hundred pop flats of her books, magazines, newspapers, and other paper ephemera per auction. Maier's photographic material was largely offered at the last two auctions, held on October 17 and November 7, 2007.

RPN Sales advertises in a local newspaper, and for the Octo-

ber 17 sale its listing exclaimed, "Oil Paintings, Etchings, Old Photos, Old Stamps, Many BOOKS & 30–40–50s Magazines, News Papers, Some Really Great History Here!" The paragraph-long itemization, which included furniture, along with "Knick Knacks, and What Nots," closed with, "PLUS Many Box Lots of Merchandise. Please Come By and Check it Out!!!"[8]

One man bought all of Vivian Maier's books, paying up to $40 and $60 each for some of the lots. Apparently, he resold them individually on eBay. Another attendee recognized photography books from the early-1970s Time-Life series. Later, a man whom Maier had watched as a boy recalled a rare glimpse of her: "She loved to read. In all these storage bins, there were hundreds and hundreds [of] books. . . . She loved biographies and autobiographies."[9]

Ron Slattery, an RPN Sales regular who attended both of these auctions, thought about skipping the first one because of rain.[10] Others must have felt similarly because the crowd was thin that evening. Slattery, who was about to turn forty-four, belonged to a lively web-based community of vernacular photography buyers and sellers who trafficked in mid-twentieth-century snapshots. A familiar and recognizable figure because of his large stature and long ponytail, Slattery also had a loyal following on his website Big Happy Funhouse, where he posted esoteric photographs and cleverly captioned family snapshots that he'd acquired at flea markets and other secondary sales like RPN's. Slattery bid on and won so much of Maier's materials that evening that he needed to take several trips to his car afterward.

Three weeks later, when it was calm and dry outside, a mass of fidgeting spectators packed the RPN Sales showroom. Gunderson recalled that as a result of word of mouth about the photographic work offered in mid-October, between ninety and 130 bidders and onlookers—a much larger audience than usual—attended the final auction. There, Ron Slattery got nervous when he saw a man he knew: "The second auction—when I walked in the door I saw Randy Prow. We are friends. But . . . we both gave each other that 'Oh no' look. We knew that the price of playing poker just went up. We both collected photos.

We smiled at each other. It was going to be a fun night."[11]

The large crowd and extra bidders resulted in much higher prices than the first auction. Slattery wasn't as aggressive as he might have been had he not already acquired box loads of Maier's early prints and other materials. As the evening progressed, two other individuals dominated the winnings. "[At] that auction, Randy and a local businesswoman bought the lion's share of the material. The prices were 10 times what I paid at the first auction," said Slattery.[12]

A businesswoman paid the most when she purchased a portfolio of Vivian Maier's photographic prints for $500. Ron Slattery ended up paying a total of $250 for all of his purchases, which comprised thousands of vintage prints of various sizes, some black-and-white negatives, color slides, motion picture footage, and more than one thousand rolls of undeveloped film.[13]

Earlier that day, John Maloof, a twenty-six-year-old real estate agent, had visited RPN Sales and placed an absentee bid on the largest box of negatives: "There were several boxes that went with the set. I just went for the biggest one. . . . I won it for I think it was $380."[14] Fairly well known in the Chicago real estate community, the entrepreneurial Maloof also had an eBay business where he sold items that he had bought in bulk.[15] He had a number of other small side projects, including a photo book he was coauthoring about his neighborhood.[16] His life was about to become thoroughly entangled with Vivian Maier's work.

Yet at this moment, it seemed like the story was over. Roger Gunderson's $260 purchase of the five storage lockers had resulted in up to $20,000 in sales.

+ + +

Less than ten miles away, Vivian Maier trudged around the streets of her neighborhood, Rogers Park. She spent her days gazing out at Lake Michigan from her favorite park bench. Throughout her life she had photographed beaches and bodies of water around the world. As a child and as a young woman, she had sailed on grand steamships, and later in life, she had cruised

up the Great Lakes to Canada, had ferried across Lake Michigan, and had toured the Chicago River by boat. She had also climbed mountains and viewed cities from high up on rooftops, always photographing, sometimes with more than one camera, creating an enormous body of work.

Because Vivian Maier's prints and negatives were scattered with the rest of her belongings, it is difficult to chart her progress in her early years as a dedicated photographer. There are photographs from July 1952 with Maier's handwritten notations in one collection that match the negatives in another collector's stash, and a third individual has prints with corresponding negatives from the same month. It is possible that more work from this time is with someone else, or is in the hands of someone who doesn't realize what they own; it is also conceivable that photographs from this month were destroyed or that Maier discarded them, keeping only her best exposures. What is certain is that Vivian Maier knew how to work that sophisticated Rolleiflex camera when she began using it in the early part of July 1952.

There is no evidence that Vivian Maier ever used a digital camera or the Internet, but it is safe to say that her emergence would not have occurred without today's technology. The recognition of her photographic legacy could only have happened the way it did today. What is now known as the "mystery" of Vivian Maier stems from her inclination not to share of herself or her photographic work. That mystery persists, since the auctions have made it impossible to reassemble her archive of books, correspondence, the residual evidence of her travels, and her immense photographic output.

Conflicting and sometimes dubious testimony has characterized what we can document about Vivian Maier's life, and it created a picture of an eccentric "nanny photographer." Maier hid her personal life from those who have stood in to speak for her. And those who bought her possessions have had shifting stories. Combined, we have had tangled accounts rife with mystery. But we can explore her family, her life, and the history of photography to begin to suss out who she was and what her true legacy may be. Maier's entire life was suffused by photography,

even as she worked at the margins of the field. The origins of Vivian Maier's world can be found in the history of photography, French village records, and countless other sources, formal and informal. Just as photographs can be selectively cropped and edited, official testimonies can unintentionally hide—or reveal.

Chapter Two

A New World, a New Art Form

Vivian Maier's ancestors appear twice on France's official 1896 census. Germain Jaussaud, her maternal great-grandfather, had recently acquired some land that, in 1943, seventeen-year-old Vivian Maier would inherit. The census listed the Jaussaud family of five—Germain, his wife, Émilie, and their children, Marie Eugenie, Maria Florentine, and Joseph Marcellin— within the village of Saint-Laurent-du-Cros. But, additionally, at the periphery of the adjacent town of Saint-Julien-en-Champsaur, on a plot of land called Beauregard—"beautiful view"—a separate census record indicates a smaller Jaussaud ensemble: Germain; Émilie; sixteen-year-old Eugenie; and an unrelated farmhand—*domestique*—Nicolas Baille, age seventeen. In fact, Eugenie had just turned fifteen.[1]

The next year, at two o'clock in the morning on May 11, 1897, Eugenie and farmhand Nicolas became the parents of Maria Jaussaud, Vivian Maier's mother.[2] Nicolas was not at the event, nor was he mentioned in the official handwritten record, which states that the father of the baby is unknown. Although considered illegitimate and not a legally recognized member of any family, Maria, by French law, would have her mother's family name.

The world of the Jaussauds was small and provincial. When Germain Jaussaud had been born in 1823, electricity, indoor plumbing, modern transportation, and photography had not yet been invented. Germain was sixteen in the summer of 1839 when Louis Daguerre introduced his daguerreotype photograph to awed crowds in France's capital. But Paris was four hundred miles and a world away from the provincial hamlets in the

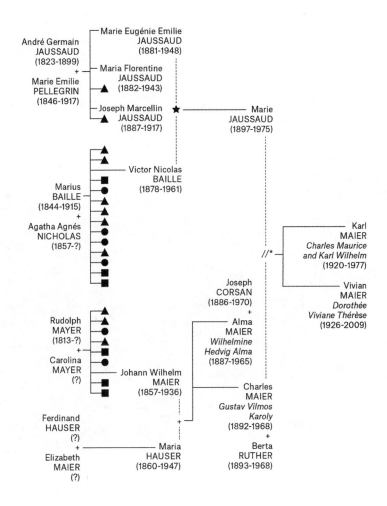

**Vivian Maier's
FAMILY TREE**

FIGURE 2. Vivian Maier's family tree

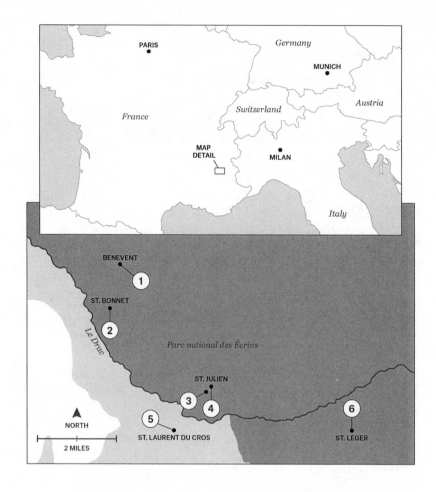

CHAMPSAUR VALLEY Lighter color indicates higher elevation

1. Bénévent-et-Charbillac: Emilie Pellegrin's birthplace (Maier's great-grandmother)
2. Saint-Bonnet-en-Champsaur: Where Maier attended school from 1932-1938
3. Beauregard Estate: Inherited by Maier; Marie Jaussaud's birthplace (Maier's mother)
4. Saint-Julien-en-Champsaur: Town adjacent to the Beauregard Estate
5. Saint-Laurent-du-Cros: Germain Jaussaud's birthplace (Maier's great-grandfather)
6. Saint-Léger-de-Mélèzes: Nicolas Baille's birthplace (Maier's grandfather)

FIGURE 3. Champsaur Valley

Champsaur Valley; the villagers may not have known about the invention of photography until years later. The valley was so remote that when the young Vivian Maier visited there with her mother in 1932 and spoke English, she was perceived as an "extraterrestrial."[3]

For generations, these peasant farmers had remained within their family enclaves or settled in nearby villages. An adventurous few moved to larger towns for the increased opportunities they afforded; others bought nearby farmland. Germain, the sixth of eight children, stayed with his family well into adulthood in Saint-Laurent-du-Cros, where they had lived for generations. But by the time fifty-five-year-old Germain married thirty-one-year-old Émilie Pellegrin, he resided in the larger neighboring town of Saint-Bonnet-en-Champsaur.[4] After their 1878 marriage in Émilie's nearby village of Bénévent-et-Charbillac, the couple settled back in Saint-Laurent-du-Cros. For all of this movement, the various villages were no more than a dozen miles apart. Émilie and Germain had five children—two who died young—before they departed for their newly acquired Beauregard farm.[5]

Germain died in 1899. Émilie told the 1901 census enumerator that her household included her two daughters, her son, and her granddaughter Maria. But fifteen days after the census taker's visit, Eugenie was five hundred miles distant from the Champsaur Valley, boarding a steamship alone to America from Le Havre, on France's northwest coast. Eugenie told the ship's registrar that she was a housekeeper and that her last residence was in Gap, the region's largest town. Whatever the case, Eugenie left France on her daughter Maria's fourth birthday, May 11, 1901.[6] She would never return. More than a decade would pass before her daughter joined her, leaving the remaining family in France.

Today, Eugenie Jaussaud is forgotten in France. No family or village memories remain, and no known photographs can represent this woman whose life changed irreparably when she scandalously gave birth to Vivian Maier's mother as a result of a liaison with farmhand Nicolas Baille.

THE ARRIVAL OF EUGENIE JAUSSAUD
AND EARLY PHOTO PRACTICES

Nine days after leaving France, Eugenie Jaussaud arrived in America. Five weeks after that, Nicolas Baille also sailed to New York City from Le Havre.[7] It may appear as though he was following Eugenie—he had also listed his last residence as Gap—but he soon made his way to Walla Walla, Washington. Eugenie's destination was nearer to New York City: Connecticut, where a man whom she listed as her uncle would receive her.

."Uncle" Cyprien Lagier was not actually a blood relative, but he, too, had come from Saint-Julien.[8] Close in age to Eugenie's mother, Cyprien had left France in 1871 when he was nineteen.[9] Within two years he was married to an American woman and had settled in western Massachusetts.[10] Following the birth of their first child, the couple relocated to the town of Norfolk in Litchfield County, Connecticut, where Cyprien took up farming.[11]

Virginie and Scipion Bertrand, another family from the Champsaur Valley, had also settled in Litchfield County in 1893, with their sons and their twelve-year-old daughter, Jeanne, the same age as Eugenie Jaussaud.[12] Scipion died in 1899, and by the end of 1900, Jeanne had moved out and was boarding in the neighboring town of Torrington.[13] Jeanne Bertrand had decided to be a photographer, and the local photography studio proprietor took her on as his assistant, teaching her how to use a sophisticated camera along with providing instruction in portrait lighting techniques. While demonstrating independence in choosing her own trade, Jeanne Bertrand would soon enough find herself alone in her life's pursuit. Her mother would move to the West Coast, leaving Jeanne and an older brother behind. Her story both foreshadows and shadows aspects of Vivian Maier's.

From the start, women had taken up photography as a trade and art form—in fact, the celebrated decade-long career of Julia Margaret Cameron concluded with her death in 1879. Typical of

many early photographers, male or female, Cameron came from a wealthy background and used the medium whimsically. She photographed her family and friends in historical scenes or as literary characters in a pictorial style that resembled painting. Young Jeanne Bertrand's studio portrait studies had a similar sensibility.

From the beginning, photographers put the medium toward different ends. While pictorial photographers like Cameron traveled in artistic and literary circles and had fine arts aspirations for their work, other practitioners saw the medium as a recording device best employed without embellishment. In 1899, as Jeanne Bertrand learned how to adjust her brass and mahogany studio camera in Connecticut, fellow Frenchman Eugène Atget was using similar equipment to record the streets of Paris. Atget saw the camera as an instrument to record the world with precision and accuracy; although he would be posthumously embraced by the art world's elite, he never aspired to be an artist. These distinctly different uses would continue to permeate the photographic medium and feed debate among its connoisseurs and historians.

At Torrington's Albee Studio, Jeanne Bertrand honed her craft, developed her eye, and experimented with various photo processes. By the summer of 1902, she was famous for her accomplished work. On August 15, the *Torrington Register* reported on her return from a national photography convention; and the following week, the *Boston Globe* ran a feature on Bertrand, detailing her family history and publishing two of her portrait studies along with a self-portrait.[14] The reporter noted Bertrand's femininity and attractiveness as assets to her career and considered her intuition and hard work the mark of a genius. "In the career of this fatherless girl, a foreigner in a strange country, with no friends to give her a start, and with little academic education, there is a certain inspiration for all girls." Eugenie Jaussaud remained in Litchfield County for at least two more years and was likely well aware of the local celebrity photographer, Jeanne Bertrand.[15]

THE ARRIVAL OF THE MAIER FAMILY
AND MODERN PHOTOGRAPHY

Four years after Vivian Maier's maternal grandmother Eug-
enie Jaussaud arrived in America, her father's family left the
German-speaking region of Hungary and journeyed to the port
of Bremen, Germany. On October 10, 1905, Wilhelm and Marie
Maier, along with their seventeen-year-old daughter Alma and
eleven-year-old son Karl, left for New York City in a second-class
cabin on the *Kronprinz Wilhelm*. Wilhelm Maier, soon to be
William, told the ship's registrar that he was a butcher and that
his family had come from the Hungarian town they called Mod-
ern.[16] The Maier family settled in a then-rural section of Queens
called Whitestone, where Wilhelm worked as a farmer.[17]

Exactly a year later, Marie Maier's brother, Julius Hauser,
arrived there from the same Hungarian town. The ship's mani-
fest lists Hauser's sister as Maria v. Mayer, using the abbreviation
for "von," which signified an elevated social rank. Alternate
and phonetic spellings of the family name persisted throughout
Vivian Maier's life, later confusing genealogists. Her paternal
grandfather, Wilhelm, was the only member of his family to
spell his name "Maier"; the rest were known as "Mayer"; but
the Hausers' mother's maiden name was spelled "Maier."[18]

Within five years, the Maier family had moved to the Yor-
kville section of Manhattan, where the seven-unit apartment
building at 220 East Seventy-Sixth Street where they lived held
thirty-six people of all ethnicities. William Maier worked as
a gardener on the grounds of a nearby hospital. His son, now
called Charles, had a job as a salesman at a grocery store, and
his daughter Alma worked as a matron at an orphanage.[19]

At the same time that the Maier family arrived in New York,
a young photographer had begun recording the arrival of immi-
grant Europeans at Ellis Island. Sociologist Lewis Hine had
recently acquired a five-by-seven-plate box camera and, using
a wooden tripod to steady the bulky instrument, he recorded
the surge of hopeful newcomers with compassionate individual
portraits.

Another American photographer was also recording European oceanic travelers, but his intention was different from Hine's. In 1907, Alfred Stieglitz was a first-class passenger aboard the *Wilhelm Kaiser II*—a sister ship of the one that took the Maier family to America—en route back to Bremen from New York. While the steamer was stopped in England, Stieglitz noticed the combination of light and perspective that could lead to a dynamic photograph.

Hugging his four-by-five camera at waist level, he looked down into the viewfinder and exposed one glass plate, making the photograph he would call *The Steerage*, one of the most famous in the history of art photography. In employing the play of sunlight and shadow to create a striking formal composition, Stieglitz had also captured the social dissonance of the most poverty-stricken passengers traveling in the bowels of the great steamship. Stieglitz hadn't always viewed photography in this way. He had been a proponent of the pictorialist movement, working in a style similar to Jeanne Bertrand's. In 1902, in an attempt to promote fine arts photography, Stieglitz founded an invitation-only group that he called the Photo-Secession. The same year that Jeanne Bertrand's pictorial photography was featured in the *Boston Globe*, Stieglitz's movement established a rift that lasts today: elitism versus populism—the selection of what is deemed important by an expert versus the public's preferences.

Five years after Stieglitz established his pictorialist group, *The Steerage* initiated an abrupt philosophical shift. With Stieglitz's realization that a photograph could be expressive solely through its composition and attention to light and form, he pushed the medium toward modernism.

THE ARRIVAL OF MARIA JAUSSAUD
AND THE JOINING OF CULTURES

Like Alfred Stieglitz on his 1907 luxury trip back to Europe, wealthy American citizens rode the increasingly opulent vessels back and forth across the Atlantic—among them the *RMS*

Titanic. On April 20, 1912, five days after the shocking news of the *Titanic* disaster, the *SS France* left Le Havre on its maiden voyage. While not as imposing as the *Titanic*, but larger than any other French ship, the *France*'s interior opulence surpassed the *Titanic*'s. Dubbed the "Versailles of the Atlantic," its rooms mimicked the baroque embellishments of Louis XIV's palace, and the impressive staircase leading to the first-class dining room was copied from an elegant Parisian mansion. The ship had grand parlors, dining rooms, suites, a library, a gymnasium, which included hydrotherapy and a massage room, and a massive marble fireplace, over which hung a portrait of Louis XIV.

It was within a first-class cabin on this lavishly appointed vessel that Vivian Maier's mother, Maria Jaussaud, sailed to America in June 1914, a month before the onset of the First World War.[20] She had just turned seventeen and was traveling as the personal maid to Louise Heckler, a thirty-six-year-old unmarried American businesswoman. The ship's manifest indicated that Jaussaud had been living in Italy, where she had spent her youth in a convent.[21] The two made a striking pair: the stately and fashionable dark-haired Heckler stood over six feet tall in her heels and towered over Jaussaud, who was five feet four with fair hair and gray eyes.[22]

The manifest indicated that Jaussaud was accompanying Heckler to her Fifty-Fourth Street apartment in New York, but Heckler was actually delivering Maria to Eugenie Jaussaud, who had not seen her daughter in thirteen years.[23] Jaussaud worked as the personal cook for Heckler's friend, Fred Lavanburg.[24] By the following year, Eugenie, along with a Danish butler, and Maria, who was working as a seamstress, were all living with Lavanburg on West Sixty-First Street.[25]

Around the same time, a member of the Maier family took a social step upward into a culturally rich downtown enclave. Alma Maier, now twenty-six, had married Joseph Corsan, a Russian Jew who had emigrated from Kiev and was now a successful silk importer. The Corsans lived in the Gramercy Park neighborhood on a stretch of East Nineteenth Street that was home to prominent artists, actors, writers, and assorted cultural elites.[26]

+ + +

Fueled by reports of impending war in Europe, patriotism united the new Americans. In 1912, William Maier's naturalization papers had been finalized, and by law his wife, Marie, and their son, Charles, also had become American citizens.[27] By mid-1917, a military draft was in place and, nearing his twenty-fifth birthday, Charles Maier claimed an exemption as his parents' sole provider; he was working as an engineer for the National Biscuit Company in Manhattan's Chelsea neighborhood.[28]

While the war affected everybody, day-to-day living went on and modes of expression advanced with the dizzying progression of technology. New simpler cameras proliferated throughout the decade. Serious photographers had used glass plate negatives in their bulky cameras that often required a tripod for steadiness. Meanwhile, though the technology for snapshot photography dated to 1888—when George Eastman announced a roll film box camera with the slogan, "You push the button, we do the rest"—it took until around the time of the First World War for it to become more widespread. Eastman commercialized photography by being the first to place advertisements in popular magazines. In 1893, undoubtedly piggybacking on *Life* publisher Charles Dana Gibson's wildly popular Gibson Girl (i.e., a girl embodying the fashionable ideal of the late nineteenth and early twentieth centuries), Eastman introduced the Kodak Girl. She became the era's icon of the kind of photographer Vivian Maier would one day emulate, exuding independence as a camera-toting world traveler. In the first decade of the twentieth century, photography ads presented the Kodak Girl with taglines such as, "Take a Kodak with you," "Vacation Days are Kodak Days," and in extending the brand name from noun to verb, "Kodak as you go."[29]

In 1911, under the image of a freewheeling Kodak Girl whose hair has blown loose as she stands holding a sailboat's rig, cradling her camera in the other hand: "Let Kodak keep a picture record of your every outing. There's a new pleasure in every phase of photography—pleasure in the taking, pleasure in the

finishing, but most of all, pleasure in possessing pictures of the places and people that *you* are interested in" (emphasis in original). A 1912 ad shows a train porter setting down a woman's suitcase covered in travel stickers, similar to the one Vivian Maier would later have. The Kodak Girl stands over the porter clasping her camera, with the copy, "The World is mine—I own a KODAK."

Film developing and printing became part of the photography experience. Called "Kodak Witchery" in ads that showed a Kodak Girl peering at a strip of negatives, darkroom work was presented as the next step in photographing.

This first widespread popular use of photography occurred simultaneously with the discussions around pictorialism and modernism. Pictorialist photography mimicked painting. George Eastman's ads proposed that anyone could be a photographer. Separately, photojournalism, in its infancy stage, was having a conversation of its own. By 1917, Manhattan's city directory listed more than five hundred photographers and photography studios.

INVENTIONS AND STRUGGLES

There is nobody today who can testify as to how the French maid living on the Upper West Side met the Austro-Hungarian engineer residing across Central Park in the German Yorkville neighborhood. Maria Jaussaud was then one of several domestic servants working for the George Seligman family on West Seventy-Fourth Street, and Charles Maier was still living with his parents on East Seventy-Sixth Street.[30] The elegant Saint Jean Baptiste Catholic Church, which Maria attended, was just a block away from the Maier family's apartment.

However they met, on May 11, 1919—Maria's twenty-second birthday—she and Charles were married at Saint Peter's German Lutheran Church at Lexington Avenue and Fifty-Fourth Street, not far from where the Maier family had recently moved.[31] Unlike the eighty-nine other marriages at Saint Peter's witnessed by two friends or family members in 1919, this union

was certified by the pastor's wife and the church janitor. The couple's parents weren't there.

We cannot know why Charles and Maria both lied about their origins, but Maria changed or embellished practically every verifiable life event on the official record of their marriage. The documents state that Charles was born in Vienna, Austria, and Maria was born in Lyon, France. Both locations were far more cosmopolitan than the environs of their youths. Charles correctly stated his birthday, but Maria claimed that she was a year younger and changed her birthdate to the day before the wedding. In addition to giving herself the middle name Margaret, Maria Jaussaud altered her parents' surnames. She changed her father's name from Nicolas Baille to Nicolas Jaussaud, and converted Eugenie Jaussaud's surname to her maternal family name, making her Eugenie Pellegrin. This kind of rewriting, as we will see, was common in the family.

Maria Maier began her married life as an additional member of someone else's household, moving in with her husband and his parents. Two male boarders also shared the flat. However the living quarters were divided up, and whatever sort of privacy may have existed in the crowded household, Maria was soon pregnant with her first child. Not quite ten months after her wedding, on March 3, 1920, Maria Maier gave birth to a baby boy.

On Maria Maier's twenty-third birthday, she stole away from her husband and baptized their son at Saint Jean Baptiste. With her mother as the sponsor, the baby was christened Charles Maurice. But because the boy's parents had not married in the Catholic Church, the attending priest acknowledged him on the official ledger as "filius naturalis," the natural-born son of an invalid marriage.[32] The next month, Charles was baptized again, this time in his father's German church, where he was recognized as Karl William Maier, the name he was to use on legal documents throughout his life.

At the end of the year, Eugenie Jaussaud sent a letter to her sister in France, relaying her daughter's growing travails related to financial difficulties, and more pointedly, to arrange the sale

of her portion of the family's farmland legacy. She mentioned that Maria and Charles were struggling and that she had bought them nearly all their furniture and had given them money. Eugenie also mentioned Nicolas Baille, wondering if he could do anything to help his daughter. Further, she was worried because Maria had fallen recently. Eugenie wrote that she was afraid her daughter was so weak that she might die.[33]

During this period, Maria Maier's mother resided farther uptown in a new Italian Renaissance–style apartment building near the Metropolitan Museum of Art, where she was a live-in cook for the Henry Bell Gayley family.[34] Now nearly forty, Eugenie Jaussaud had spent her adult life as a single woman working for wealthy families. The sacrifice of her own family life had led to more comfortable circumstances than her daughter's foreign and crowded household, but Eugenie's living quarters came at the mercy of her employers.

And indeed, Henry Bell Gayley's death changed his family's needs, and Eugenie Jaussaud moved on to work as the cook for the Charles E. Lord family, twenty-five miles outside of Manhattan in Tarrytown.[35] In 1925, the year that F. Scott Fitzgerald's *The Great Gatsby* detailed posh living in the Hamptons, Eugenie Jaussaud was in equivalent surroundings in the Hudson Valley. Charles Lord's ten-acre property, which included greenhouses and outbuildings for his servants with families, was not far from the John D. Rockefeller estate and near Washington Irving's legendary Sleepy Hollow. The Lords' staff included two chambermaids, a housemaid, and a live-in secretary. A kitchen maid assisted Eugenie, and a waitress served the meals she made.

By this time, Maria Maier's marriage was faltering, and at the expense of her young son. In May 1925, with the help of the State Charity Aids Association, five-year-old Karl was temporarily placed in the Heckscher Foundation's children's home.[36] Later testimony would state, "Karl was born into a home where constant conflict was presented between his parents," and while Karl's paternal grandmother laid partial blame on her daughter-in-law's "laziness," she was much harsher on her son Charles, whom she referred to as "a gambler and drunkard."[37] Later in

1925, the New York Children's Court placed Karl in his grand-parents' custody.

Vivian Maier was conceived while her brother was in the children's home. Charles and Maria Maier were separated through much of the pregnancy, but they reunited at the birth of their daughter. Soon after Vivian's birth, Charles left the picture permanently, and the family scattered irreparably.

+ + +

During the 1920s, cultural worlds merged, innovations accelerated, and all was recorded in moving and still pictures. Cultural developments linked Paris and New York: Josephine Baker danced the Charleston at the Folies Bergère; art maven Gertrude Stein held court on the Left Bank; and Charles Lindbergh completed the first transatlantic flight from New York, arriving in Paris to adoring throngs. Art and literary luminaries whose names we still recognize today mingled in 1920s Paris: writers Ernest Hemingway, James Joyce, and publisher Sylvia Beach; artists Pablo Picasso, Man Ray, and Salvador Dalí; and musicians Aaron Copland and Cole Porter, among many others, were drawn to the mecca of creativity that France became after the war.

In New York, popular culture thrived at Broadway theaters and the new motion picture houses. Charlie Chaplin, Buster Keaton, Mae West, and W. C. Fields left their vaudeville acts and starred in their first motion pictures. In 1927, *The Jazz Singer* introduced sound to cinema, and crowds jammed Times Square at its premiere. The year before, a different sort of spectacle had unfolded as ten thousand mourners converged at the Frank E. Campbell memorial chapel. Front-page headlines had reported the untimely death of thirty-one-year-old romantic film idol Rudolph Valentino, and fans mobbed the chapel as if attending one of his movie premieres. Jostling onlookers were injured in the crush, and hysterical women reportedly fainted. There was talk of suicide attempts. The culture of celebrity had arrived.

Chapter Three

A Family Divided / Photography's Complex History

Vivian Dorothy Maier was born in New York City on February 1, 1926, a cold and rainy Monday. Four weeks later, she was christened Dorothée Viviane Thérèse Maier at Saint Jean Baptiste. Her godparents were noted as Charles Maier Jr. and Victorine Bennetti, a sixty-year-old French domestic who likely knew Maria or Eugenie through work.[1]

Soon after that baptism, Vivian Maier's parents' marriage collapsed amid accusations of abuse and abandonment. She was not christened in her father's Lutheran Church, and during the next few years Maria and her daughter's whereabouts are unclear. In October 1926, when Vivian was eight months old, Maria Maier appealed to the New York Catholic Charities; and then three years later, a week after the stock market crash of 1929, she opened a case at the National Desertion Bureau to track down support from her estranged husband.[2]

By early 1929, Charles Maier's parents had relocated to the Bronx with their nine-year-old grandson; the following year, their granddaughter and daughter-in-law moved into an apartment a mile away. Marie, as she now called herself, and four-year-old Vivian resided with another French woman: Jeanne Bertrand.

The women and young Vivian lived together in a top-floor apartment in a new six-story building that towered over the vast Saint Mary's park and the surrounding neighborhood.[3] It is unknown how the women found each other, but for several

years, Eugenie Jaussaud and Jeanne Bertrand both lived in Litchfield County, Connecticut. Perhaps Eugenie lent a hand in connecting the women.

By the time Marie and Vivian Maier shared forty-nine-year-old Jeanne Bertrand's home, newspapers had stopped reporting on Bertrand's accomplishments. As early as 1903, publications had detailed her "nervous prostration" and progressively troublesome mental health issues.[4] Over the next decade, regional newspapers had carried single-paragraph stories about Bertrand's mental health under such headlines as "In Retreat," "Goes Insane Here," and "In Sanitarium."[5] By her late thirties, Bertrand's illustrious days were behind her. In June 1917, a Massachusetts newspaper reported:

Miss Jeanne Bertrand . . . tried to kill two nieces early yesterday morning at her apartment in the Conley Inn, Torrington. Early yesterday morning the nieces ran to the clerk, their clothing torn almost from their bodies and their hair down their backs.

It was found that Miss Bertrand had gone violently insane. The authorities had difficulty in securing her. She will probably be taken to the Connecticut hospital for the insane at Middletown, where she was an inmate several years ago.[6]

Once heralded as an inspiration for young girls, Bertrand's celebrity made her personal travails seem fair game for public consumption. But her mental disturbances were exacerbated by events that were not reported; two weeks before the episode reported above, Bertrand had given birth to the son of a man who was married and had three children.[7] Either unable to care for the baby or pressured by the morals of the day, she left him with his father's family.

Jeanne Bertrand and Marie Maier were united by their French origins and jarring circumstances related to illegitimacy and abandoned children. They didn't stay together in the Bronx apartment for very long, and it is unclear whether four-year-old Vivian was yet aware of what it meant to be a photographer.

+ + +

While Marie Maier and her daughter were boarding with Jeanne Bertrand, Eugenie Jaussaud had moved on to cook for the Hunt T. Dickinson family at a sprawling estate in Locust Valley within the town of Oyster Bay, on Long Island.[8] In 1909, nine-year-old Hunt Dickinson had inherited the astronomical sum of almost $5 million from a great-uncle—more than $100 million today—and his extreme wealth insulated his family from the privations of the Depression.[9] The Dickinsons had recently reopened their summer estate, returning with the servants from their Park Avenue apartment, located across from the Waldorf-Astoria Hotel that was then under construction.

The Acme Newspicture Agency's roving street photographers frequently captured Mrs. Dickinson as she strolled Park Avenue. While today we think of street photographers as those who snap pictures of unsuspecting subjects, these photographers set up tripods on the sidewalk, bringing the portrait studio outdoors; they would give approaching pedestrians a card with instructions on how to receive their inexpensive portrait. By contrast, Acme's Park Avenue photos of Elizabeth Dickinson were more of a hybrid blend of street photography, celebrity sighting, and city fashion. Capturing New York's aristocracy had as much cachet as photographing a movie star and effectively put a face on the city's elite. In April 1926, a Dickinson street portrait was captioned "Members of the New York Society have started a movement to revive the muff for fashionable wear. Mrs. Hunt T. Dickinson, one of the leaders of the movement, was snapped on Park Ave., NYC, setting the style." A few weeks later, an image of Dickinson in a stylish cloche hat and fur-collared coat promenading directly toward the sidewalk cameraman was simply captioned "Society on the Avenue. Mrs. Hunt Dickinson strolling Park Avenue." Within days of Wall Street's 1929 stock market crash, Dickinson, with an entire fox pelt draped on one shoulder, was caught approaching a photographer; unsmiling, she diverted her eyes from the camera. Like some results of

today's stalking paparazzi, the photographer happened to freeze an unwelcome moment.

While the Dickinsons strolled Park Avenue and lounged in Locust Valley, Marie Maier was struggling. Back in Manhattan in December 1930, Maier appealed to the New York Protestant Episcopal City Mission, and by autumn 1931, she was working as a live-in domestic servant for a family on the Upper East Side.[10] Five-year-old Vivian's whereabouts are unknown at this time, but the Protestant Episcopal City Mission Society ran settlement houses and had other programs that may have helped place her in temporary care.

By early spring 1932, Marie Maier was looking for work again while residing at the Swiss Benevolent Society's women's boarding house. On March 13, she placed an advertisement in the *New York Times* that emphasized her French origin and suggested she had no attachments:

CHAMBERMAID-MAID. French; references.
Call Susquehanna 7-7540. Mlle. Jaussaud.

Unsuccessful, she and Vivian were soon reunited.

In August, Eugenie Jaussaud paid to send Marie back to the Champsaur Valley, along with Vivian. Eighteen years earlier Marie had arrived in New York as a seventeen-year-old, traveling first class on an elegant steamer; she was now returning to the provincial villages of the "old country" with her American daughter. As Marie had been at the mercy of her mother's difficult choices and circumstances, so was six-year-old Vivian Maier. She was to live in France for the next six years.

THE CHAMPSAUR VALLEY IN THE 1930S

Marie and Vivian Maier left New York in 1932 in the depths of the Depression. They could hardly have gone anywhere more different. English-speaking Vivian Maier struck villagers as a visitor from El Dorado, the legendary place of wealth and abundance.[11]

Clearly, Americans—rich or poor—had mythical qualities.

Soon after Marie Maier's arrival in France, she attended to legal matters related to her own childhood. Marie's unacknowledged father, Nicolas Baille, was living within a few miles of Saint-Bonnet-en-Champsaur, where Marie and Vivian were staying. After a decade of shepherding in the American Northwest, fifty-four-year-old Baille now owned and inhabited a plot of land in the hamlet of Les Ricous. Baille had never married, nor was he known to have fathered any other children. Marie had recently turned thirty-five, and while she was now an American citizen through her marriage and had two children of her own, she was still considered illegitimate and thus had no legal family rights in her native country.

Napoleon, who had established France's civil code in 1804, was known to have said, "Society has no interest in the recognition of bastards." The code had not changed much since it was put in place and established family and property as intertwined. The three parts of the Napoleonic Code addressed the family as the country's primary unit, with the husband/father as sole authority. A young woman was considered part of her father's family until she married and then effectively became her husband's possession, as did anything she owned. A single woman, however, was independent and could freely own property.

Marie Maier's maternal family members—all unmarried—each held land in their own names, as they had inherited their Beauregard farmland after their father's death in 1899.[12] Within a month of their father's death, Eugenie, Florentine, and their brother Joseph had split the proceeds of their first sale of some of the land. Subsequently, Eugenie had sold off a small portion a couple of months before her departure for America in 1901. And then, when twenty-nine-year-old Joseph died without a will in 1917, his share of land was distributed equally to his two sisters.[13] At the end of 1920, Eugenie had sold Florentine nearly all her share to help her daughter when she was struggling after Karl's birth. The entire Beauregard farmland was ultimately handed down to Vivian Maier, who would auction it off in separate parcels in 1950.

Since Marie Maier was not a legally recognized member of the Jaussaud family, she was unable to benefit from any of the property sales or claim ownership in any way. However, in 1896, one year before Marie's birth, an amendment to the civil code had allowed for inheritance rights if her father acknowledged paternity.[14]

On August 12, 1932, Nicolas Baille officially acknowledged Marie Maier as his daughter. The thirty-five-year-old ledger in which her birth had been recorded was retrieved, and beneath the name "Maria Jaussaud," a government official transformed Marie's status by scribbling in his own name, her father's name, that day's date, and a simple notation that she was now Maria Baille.

A struggle with naming and validation permeates the Jaussaud women's legal documents as they hid the shame of illegitimacy. Marie's doctored marriage license renamed her father "Jaussaud" and gave Eugenie the name "Pellegrin." And the year before Marie returned to France, Eugenie had created new names, places, and meticulous dates to authenticate her "widowed" status on her naturalization papers. On her petition for American citizenship, Eugenie invented her husband as François Jaussaud and said that he was born in the fictitious town of Saint-Barnard in 1871; she stated they were married in Saint-Julien on March 9, 1896, and that he had died there on August 20, 1900. Eugenie's certificate of arrival at Ellis Island— dated May 20, 1901—matched her petition's date, which was the only traceable fact; she also correctly listed Marie's birth as May 11, 1897; both items seamlessly fit the fabricated biography.

A year after Marie became recognized as part of the Baille family, she was photographed with her daughter. The photo is among the earliest known images of Vivian Maier and one of only two potential likenesses of Marie.[15] In the August 1933 picture, neither mother nor daughter—with matching short-cropped bob haircuts—smiles for the camera.[16] Seated in front of a stone farmhouse, Marie, partially hidden behind Vivian, is further obscured by her wide-brim straw cloche that casts her face in shadow. She holds a dark-haired baby whose atten-

tion is diverted by the wilted leafy stalks that young Vivian presents for the camera. With a slightly mournful expression, the seven-year-old clutches the droopy bouquet and gazes toward the camera lens as her wind-mussed hair wisps across her face.

In each of the three extant photographs from this day, Vivian Maier is wearing a short-sleeve flower-patterned cotton dress that hangs loose to her knees and is embellished with lace trim at the sleeves and collar. The second photograph shows the seven-year-old seated in profile studying a small white flower at her lap.[17] Her hair is still disheveled. Someone in a dark dress, visible from the shoulders down, dangles the baby into the picture frame, positioning him to view the flower.

In the third photograph, Vivian's hair has been smoothed, and the white flower holds it in place at her left ear.[18] Standing on stone-paved ground at an open-shuttered and iron-barred window, she shares the picture's frame with a stern-looking woman whose fashionable dark satin dress indicates that she is the one who dangled the baby in the previous photo. An awkward double portrait, the two subjects face forward from opposite sides of the window. The woman, in white high-heeled shoes, glares at the camera from the window's left side, her arm wrapped around one of the vertical iron bars. Young Vivian stands at the window's right side, her left arm jutted straight out, holding the open shutter; with her chin down, she gives a goofy grin. Perhaps she felt peculiar with her hair held in place with the white flower; her stance and expression make her seem uncomfortable or embarrassed.

Someone kept the photographs from this roll of film, and they have been revisited and shared decades apart in vastly different circumstances. In August 1959, after touring East Asia, Vivian Maier passed through the Champsaur Valley and while visiting, photographed an assortment of these 1933 snapshots arranged on someone's dining table.[19] A pitcher of water and a plate of unfinished food sit behind ten small prints that have been set down in two rows. In another frame from Maier's 1959 negatives, the twenty-six-year-old snapshots are visible on the table

in an open box as three seated men and a standing woman in a soiled apron smile for Maier's camera.[20]

In 2013, the three photos were put on display in an art gallery four hundred miles away in Paris. Together with a 1930s-era box camera and a 1960s self-portrait, the gallery presented the three vintage prints accompanied by a sign that stated, "Courtesy Association Vivian Maier et le Champsaur."[21]

THE EARLY 1930S IN AMERICA AND
THE RETURN TO THE STATES

Far from the Champsaur Valley, the New York photography world was zooming ahead. Even in the Depression, the medium thrived. A 1931 *New York Times* article observed: "Photography is the machine-age art par excellence. The moving picture and the snap-shot mark the tempo of our time. The mass production implicit in the photographic process is economically modern.... 'The well-dressed' room in the year 1931 is decorated with plates by Moholy-Nagy, Strand and Atget. They harmonize with the aluminum furniture, for one thing; and they express the state of mind that substitutes the shingle for the pompadour, the vitamin for the viand, gin for Burgundy and Ernest Hemingway for Henry James."[22]

Laszlo Moholy-Nagy, Paul Strand, and Eugène Atget epitomized new currents in photography. The first two were innovators who worked deliberately at developing new approaches. Atget, however, was a product of others' visions, as elaborated below, but like Vivian Maier, his posthumous emergence pegged his work in a way that he may not have considered. Other similarities in rescue and representation also characterize both Maier's and Atget's afterlives.

The American photographer Berenice Abbott had seen Eugène Atget's photographs for the first time while in Paris and subsequently met and photographed the seventy-year-old photographer shortly before his death in 1927. She returned to the United States in 1929, after nearly a decade's stay in Paris, with an archive of Atget's life's work in the form of more than

one thousand heavy glass plate negatives and eight thousand prints.[23] New York's modernists celebrated Atget's photographs of old Paris architecture, interiors, gardens, and street scenes for their flat, descriptive quality. Under the headline "Fame Comes to Photographer after His Death," an Associated Press article exclaimed, "France is hailing a man who may turn out to be one of the world's first master-photographers. Critics say that Eugène Atget, photographer of Parisian subjects, was a forerunner of most that is good and nearly all that is new in modern photographic art."[24]

While Atget intended his work to exist strictly as documentation, its direct and unaffected approach aligned with modernist ideals. The very photographs that Atget had created during the previous decades, which had been considered old-fashioned and out of step, soon began influencing a new wave of photographers.

The 1930s also introduced new trends in photography, and by the end of the decade, three artistic forms had emerged across America: the West had precision landscapes by Edward Weston and Ansel Adams; Chicago had the New Bauhaus aesthetic movement with Moholy-Nagy's Institute of Design; and New York had the developing social documentary approach through the New School for Social Research and a group called the Photo League. Simultaneous to the pursuit of the medium as a serious art form, wire services and mass-production technologies introduced picture and movie magazines, including *Life*, *Look*, *Pic*, *Click*, *Photoplay*, and *Silver Screen*.

+ + +

Meanwhile, young Vivian Maier remained out of the picture, even to the rest of her family in New York. On January 29, 1936, Maier's paternal grandfather died, and the next day his obituary appeared in the *New York Times*:

von Maier—Wilhelm, on Jan. 29, 1936, at Lenox Hill Hospital, dearly beloved husband of Marie von Maier, devoted father of Mrs. Alma C. Corsan and Charles von Maier, and grandfather of Charles von Maier Jr. Funeral private.

The family had reclaimed the ennobling preposition "von," and its patriarch's name had reverted to Wilhelm. More meaningfully, it had eliminated Vivian Maier from the family. In the next day's newspaper, the family's young French family member suddenly appeared, but absorbed, in a way, into the German family:

von Maier—Wilhelm, on Jan. 29, 1936, at Lenox Hill Hospital, dearly beloved husband of Marie von Maier, devoted father of Mrs. Alma C. Corsan and Charles von Maier, and grandfather of Charles von Maier Jr. and Dorothea Vivian von Maier. Funeral private.

As Dorothea Vivian von Maier, ten-year-old Vivian was nearly invisible.

On the occasion of William's funeral, the Saint Peter's Lutheran Church record further embellishes the Maier surname, identifying him as Johann Wilhelm Edler von Maier, with "Edler" (the lowest rank of nobility in Austria-Hungary and Germany) signifying still greater status. Vivian Maier, however, has vanished again: the book notes Wilhelm Maier's remaining family as his wife, one son, one daughter, and one grandchild.

Eugenie Jaussaud, who had subsidized Marie and Vivian's stay in France, sending $50 per month for their support, may have been responsible for the addition of her granddaughter's name to William Maier's death notice.[25] She and William's widow, who preferred the name Marie von Maier—and was twenty years older than Jaussaud—formed a kinship and emerge as responsible, yet weary forces. The formidable pair of grandmothers, who apparently saw each other often, made a striking picture: von Maier was described as "small and of frail stature" and as a "sincere and truthful little woman, who really has [grandson Karl's] interests at heart," while Jaussaud, who gave von Maier money to help with Karl's care, stood five-foot-five and weighed more than two hundred pounds.[26] Marie von Maier opened a savings account in Karl's name and took out a twenty-year endowment insurance policy for $1,000 in his name,

for which Jaussaud would assume payments if von Maier were unable to make them.[27]

Karl Maier's difficulties became more pronounced as he entered his teenage years, and his father and paternal grandmother each blamed the other for his conduct: Charles accused his mother of spoiling his son; and Marie said that Karl was "very childish" and was "greatly influenced" by his father, whom she also characterized as a drunk, a gambler, and a liar. On May 17, 1934, after Charles Maier had effectively accomplished a "poor man's divorce" by abandoning his children and his first wife, he married forty-year-old Berta Ruther.[28] Ruther soon left for a three-month visit to Europe, and days later, fourteen-year-old Karl ran away.[29] He was found by police two days afterward in Pennsylvania. In December 1934, he was removed from his eighth-grade class to a probation school "for being truant, disorderly, impudent and disobedient" and, on graduation, was transferred to Bronx Vocational High School, where a hearing on his truancy resulted in his being required to pursue part-time study with a mandatory attendance officer escort. And then, in May 1935, Karl ran away again, winding up in Texas before he returned home more than two months later, after pleading with both grandmothers and his father to send him money.[30]

Karl Maier's mental health and his behavior in response to the various family shifts took a more extreme turn at the death of his grandfather in early 1936: a March arrest for tampering with U.S. Mail and forging a check led to a three-year sentence at the New York State Vocational Institution, an upstate reformatory generally known as Coxsackie for the town in which it was located.[31] Although Karl was an impressive six foot two, the sixteen-year-old was among the youngest inmates at the year-old facility. He had recently taken up the guitar and was interested in music as a career, but the institution provided no music program. Charles urged officials to place his son in carpentry training. Karl's entry documents there include a statement that further demonstrates Vivian Maier's divide from her immediate family: "Has a sister living with mother in France, she is about 10 years old. Does not know her name" (plate 3).[32]

As the Maier family drama played out in New York, Vivian and Marie Maier remained isolated in the alpine villages of southeast France. Vivian attended school in Saint-Bonnet-en-Champsaur, and in May 1934 she received the Catholic sacrament of confirmation from the region's bishop.[33] Early in 1934, Maria Florentine, Vivian's great-aunt, had drawn up a will that bequeathed the entire family legacy—more than 170 acres of land—to eight-year-old Vivian.

When news of Karl's incarceration reached Marie Maier, she, apparently at a loss for information, penned a letter to President Franklin D. Roosevelt. It ended up in the hands of the Post Office Inspector in Charge in New York City, who forwarded her request for information to the postmaster at Coxsackie.[34] It is unknown if the institution responded to the query, but eight months later, at the end of March 1937, "Marie Maier neé Jaussaud" wrote to Coxsackie, supplying her address in the tiny village of Bénévent-et-Charbillac on the outskirts of Saint-Bonnet-en-Champsaur.[35]

In August 1937, after more than a year of incarceration, Karl Maier was let out on parole and sent to live with his father. But his freedom lasted only a month; "due to his uncooperative attitude toward parole, and his unsatisfactory behavior," Karl was transitionally sent to the Tombs prison in Manhattan.[36] A flurry of activity followed, and after the probation officer interviewed an assortment of individuals that included a musician friend's mother and all of his family members, including his Aunt Alma Maier Corsan, he was sent back to Coxsackie. Alma Corsan's upwardly mobile marriage had separated her from her family, but her connections included an assistant district attorney, who stepped in as a friend to try to help prevent Karl's return to the reformatory. Only Eugenie Jaussaud felt that Karl should be returned to Coxsackie "for more education." The parole officer noted in his report, "The others, however, being unwilling to comprehend the parolee's short-comings, implored PO to release the parolee for purely sentimental reasons."[37]

Eugenie Jaussaud was ensconced in luxurious surroundings during Karl's incarceration. She had sent him postcards from

Palm Beach, Florida, where she was the cook for Margaret Emerson, the widow of Alfred Gwynne Vanderbilt, who died in the sinking of the *Lusitania*. Before Karl was released on parole, Jaussaud wrote: "My Boy Charlie, I receive letter from Grandma Maier. She is well hope you be out soon be good boy I wishe you she Beautiful florida. I receive lettre from Vivian she is do well in school. Mother is well hope you soon be alrigt. . . . My love to you Mrs. Jaussaud."[38]

After Karl returned to Coxsackie, Jaussaud sent a letter that began, "My Dear boy Carl, I am very sorry not able to help you," and she noted: "Mother is vell Vivian I receive lettre from here yesterday. Vivian prays God every day in you nam."[39] The family members were strikingly separated by geography, language, culture, gender, age, and economic and psychological limitations.[40]

Midway through 1938 Marie Maier prepared to return to the States; Vivian Maier was then twelve and by that summer she would have completed France's compulsory education sequence. She had learned to read and write French through a sixth-grade level and had studied the history of the country that she was about to leave. She was now returning to the States as a French girl, having spent half her lifetime in the Champsaur Valley.

Vivian Maier and her mother returned to New York on the ocean liner SS *Normandie*, which must have been spectacular for the twelve-year-old.[41] Art deco sleek, the vessel was the largest and fastest of all passenger ships. The elegant steamer with its abundance of first-class suites was well known as a luxury liner, and several celebrities were aboard during the five-day journey. Garnering the most attention was Darryl Zanuck, the prolific movie producer. His last film, *Little Miss Broadway* starring ten-year-old Shirley Temple, opened nationwide while the ship was at sea, and his next release—*Alexander's Ragtime Band*—would premiere in New York within the week. Benny Goodman, the famous jazz clarinetist, was also aboard. Singer and actor Eddie Cantor was on the cruise, as was Eddie Rickenbacker, the First World War's most decorated flying ace.

But while the celebrity travelers supplied newspaper filler,

another *Normandie* passenger made big news. A gathering of headlines reveals the story and shows one type of article that Vivian Maier later collected within mounds of newspapers and scrapbooks: "Professor Jumps Off Normandie after Attempt to Choke His Wife"; "Believed Drowned: Missing Professor Beats and Chokes Wife, Disappears at Sea"; "Chokes Wife, Leaps Off the Normandie: Duncan, Colgate Professor, Vanishes after Quarrel as Ship Nears New York."[42] Some of the newspapers showed a photograph of Duncan's bandaged wife leaving the ship. Tabloid photojournalism was approaching its heyday.

Exactly two months after Marie and Vivian Maier's departure for New York, the photographer Lisette Model left from the same port on the *Normandie*'s sister ship, the SS *Ile de France*. Model, who like Vivian Maier had an Austrian father and a French mother, had made her name in 1935, when the French Communist picture magazine *Regards* had published and snidely captioned her bold and unflattering portraits of wealthy French Riviera vacationers. In 1941, *PM Weekly*, a New York leftist photo and news magazine, republished the series under the title "Why France Fell," reflecting that country's travails, but changing the context of Model's photos. By the early 1940s, *PM* was publishing aggressive and deliberately sensational pictures by a press photographer named Weegee.[43]

When twelve-year-old Vivian Maier arrived in New York in the summer of 1938, high and low photo cultures were also entering new phases. While tabloid and pinup photography geared up for a rash of new magazines, the Museum of Modern Art was launching its first one-person photography exhibition. A government-sponsored project had Walker Evans crisscrossing the country, documenting its places and people. The exhibition *American Photographs by Walker Evans*, along with its accompanying book, acknowledged the parallel between Evans's work and Eugène Atget's.

Demonstrating the popularity of the medium by the end of the 1930s, and the influence of photographers like Evans, the *New York Times* encouraged everyone's participation. Under the headline, "SIDEWALK PHOTOGRAPHS—Many Opportunities

for Excellent Camera Pictures in the City Streets," the reporter suggested ways of photographing that mirror contemporary street photographer strategies: "Men at work washing windows, mothers tending to their children, reflections, imposing 'canyon' scenes along the avenues, sidewalk salesmen—all are subjects for the camera lens."

Vivian Maier was a French-speaking outsider, invisible and unrecognized even among her own family members, and those traits may have helped her develop skills as an unobtrusive street photographer. But on her return to New York at age twelve, she was more immediately at the mercy of her precarious family situation.

THE FAMILY IN NEW YORK

In the SS *Normandie* register, Marie Maier listed the Saint Paul Hotel on the Upper West Side as their destination. A *New York Times* advertisement presents its own descriptive details:

> 60TH, 44 WEST—ST. PAUL HOTEL.
> No frills—just homey. Double, private
> Bath, $2.50; weekly, $9.; suites, $14.[44]

The Maiers' return to the raucous streets of New York in August 1938 may have seemed jarring after their summer in bucolic Champsaur Valley. The Saint Paul Hotel, a block from Columbus Circle and upper Broadway, faced Saint Paul Catholic Church, with its twin ten-story granite towers. The Ninth Avenue elevated train screeched by the hotel's third-floor windows as it came to a halt alongside the building at the Fifty-Ninth Street station.

If Vivian Maier was allowed to explore the neighborhood on her own, she could have walked east from the hotel directly into the southwestern entrance of Central Park, Manhattan's green valley, where she would eventually spend many days photographing. On her way she would cross Broadway, and at her right she would see cars and trucks circling a giant statue of Christo-

pher Columbus at the top of a seventy-foot column. Beyond the column, curved buildings displayed billboard advertisements for automobiles and cigarettes, and at the far side, a giant neon sign shilled Schenley's Golden Wedding Rye Whiskey. In February, six months before the Maiers' arrival, Berenice Abbott had composed photos from behind that same immense whiskey sign, lining up the structure's skeleton frame parallel with the Columbus column, overlaying the ad's cursive lettering onto the grid of distant buildings.

Marie Maier and her daughter stayed at the Saint Paul Hotel for two weeks; three days after her arrival, Marie phoned Karl's parole officer, Joseph Pinto, and told him that she would be moving to an apartment on the Upper East Side and was willing to have Karl move in with her. Despite the fact that she didn't have a job and her own mother was supporting her, Maier said that she would do all she could to help her son find work. Her young daughter did not figure seriously in the conversation.[45]

Marie was bringing more drama to an already-fraught situation. She wrote to Karl, complaining about the parole officer's visit to her home: "I must tell you the day after that animal was here I took violently sick—vomited all over. I was nearly dying. I was going to call for the Dr. I am still weak—my end will surely come soon if I have to have dealings with people to upset me like that."[46]

Eugenie Jaussaud may have arranged for her daughter and granddaughter's new three-room apartment through her network of work acquaintances; numerous domestic servants resided in the forty-five apartments at 421 East Sixty-Fourth Street. Located nearly at the East River, the tan brick building connects with twelve others in a block-long complex. All together, the buildings contain around one thousand apartments, creating somewhat of a village within the city. Several of the thirteen buildings' combined population easily equaled that of an entire French village.

The whole family participated in claiming, suggesting, or pleading over where they thought Karl Maier should or should not reside and offered aid through connections, including

Marie's early employer, George Seligman, and a Mr. Lindenberger, whom Eugenie knew. Eugenie and Marie had an attorney draw up a document that implored that Karl be released to Marie, with Eugenie's financial support. But Karl tried his own connections, writing a long letter to his musician friend, Eugene Fabian, asking if Fabian's mother could take him in, saying, "I don't want to have anything to do with my people no more the more I've listened to them the more trouble I've gotten into."[47] A note in the Coxsackie files that recommended Karl's parole stated, "No definite plan has been proposed to date. Reports received indicate that there is constant conflict between the members of the inmate's family, and they have been unable to offer a feasible plan."[48]

On October 13, 1938, Karl moved in with his mother and young sister. Karl was required to submit monthly reports on his efforts to find employment and details on how much income he had drawn and saved and to account for how he spent his evenings. He sometimes succeeded in finding work as a guitarist in bands at local drinking venues, but mostly he remained unemployed and spent his evenings at home, at his grandmother's house, or at the movies. In the middle of November, Marie Maier complained to officials at Coxsackie about her son's laziness and frame of mind, blaming the institution for beating him and putting him into confinement: "What I want you to know is that if he is unable to earn his own living through mental deficiency this Institution which is a bad place will be held responsible and will have to pay for this. This boy went through so much that it sounds like a war atrocity and not a thing of humanity."[49] A terse written exchange ensued.

The official updates on Karl Maier's case include acknowledgments of the unsettling home environment and illustrate the prevailing expectations of the time. Parole officer Pinto reported, "He does not pay much attention to his mother for he feels that she is 'crazy.' She does not do anything for him in the way of cooking or laundry and he claims that he has to do it all himself."[50] In the middle of December, he further reported: "It is apparent that the parolee is sincerely and earnestly devoted

to his music and is contented to spend all of his time playing his guitar. His maternal grandmother bought him a guitar which is said to be valued at about $100 and she is also paying for his music lessons. There is little if any love or devotion between the parolee and his mother. Parolee resides at home in the capacity of a boarder and not as a member of the family. Parolee's mother acts very indifferently towards him and in view of her temperament and disposition the parolee avoids her as much as possible."[51] The subsequent report stated, "The relationship between he and his mother has become so strained that the parolee has placed a lock on his door."[52]

Family tension continued into 1939 as Karl and Vivian, now nineteen and thirteen, respectively, dealt with the tight living arrangement. Marie complained in a letter to Pinto that "Charles Maier or Karl as you call him—is making us disturbances in the house all the time."[53] Paranoid, she ranted: "I have heard that his Father has other children and that my son sees him and they have all this plotted against me."[54] Charles and Berta Maier in fact had no children of their own. Marie did not follow up on Pinto's request for a phone conversation. Four weeks later, Karl Maier's court supervision expired, and he went off on his own.

In the following spring, Marie Maier still lived on East Sixty-Fourth Street, but it's unclear if Vivian remained with her. Inexplicably, Marie told a census worker that her husband Charles and their twelve-year-old son, Charles Jr., also lived at the address with her and fourteen-year-old Vivian. Further, she erroneously stated that her husband worked as a steam engineer at an apartment house and she also invented his work history and yearly salary. (Charles and Berta lived in Queens, and he had worked at the Borden Milk Plant for at least four years.) Marie Maier was listed as unemployed; it's possible that Eugenie Jaussaud was still supporting her daughter and granddaughter with monthly stipends.

Eugenie Jaussaud—once again, in striking contrast to her daughter's family situation—was still cushioned in secondhand prosperity. After a decade on estates in Long Island, she was

back in Westchester County, nearly forty miles from Manhattan, working on the Charles Dana Gibson family estate, Ensign Farm, in Mount Kisco.[55] This was horse country, and steeplechases coursed over the fence that ran alongside the ten-bedroom house. As in other situations, Jaussaud told her employer that she was a widow.

PHOTOGRAPHY IN THE 1940S

Marie and Vivian Maier's 1938 return to America coincided with a surge in all forms of photography, and as with most other developments in the high and low cultural world, everything seemed to be happening in New York City. Many photographers of the 1930s through the 1950s were also filmmakers, and experimental filmmaking techniques emerged alongside conversations around modernist art. The Museum of Modern Art established a film department in 1935, five years before it recognized photography with the same distinction.

In 1930, a group called the Workers Film and Photo League had formed in New York as an offshoot of a communist German organization. Both groups used photographs and early documentary and experimental film techniques to record subjects that they believed the mainstream press censored or neglected. The American group eventually split up over politics, and in 1936 the Photo League emerged as its own entity.

Similar to the way Works Progress Administration and Farm Security Administration photographers were making iconic images of farmers and the American dustbowl's bleak landscape, members of the New York Photo League portrayed urban ethnic and black communities on the Lower East Side and in Harlem. Photo League leaders championed photography that combined formal considerations with compassionate representation, and discussions were known for critical appraisals of effective photography.

In the mid-1930s, when highbrow photography enthusiasts had not yet broadened their vision to appreciate a Photo League exhibition called *Murder Is My Business* by Weegee,

the Museum of Modern Art was rushing to assemble its first extensive photography show, a centenary exhibition that effectively established today's canon. In less than a year, art historian Beaumont Newhall put together the most comprehensive photo exhibition ever offered in America. Simply titled *Exhibition of Photography: 1839–1937*, the show was a blockbuster, with eight hundred items filling all four floors of the museum. In addition to converting one gallery into a camera obscura—a room-size demonstration of how a lens projects an image inside a camera—the museum showed vintage cameras dating to the beginning of the medium. Exhibition prints comprised what the museum considered "fine examples of photography," while the press release listed other uses of the medium, including scientific applications, press photography, and motion pictures. The exhibition's catalog was hastily assembled but became a significant history book, supplying generations of photo history students with Newhall's point of view and historical choices and showing the significance of initial presentation in conditioning popular understanding.[56]

A month after the exhibition closed, a new magazine—*Popular Photography*—was launched for a broader audience. The magazine's inaugural cover remains eye-catching for its garish color scheme. In an inset picture, against an emerald-green background, a broadly smiling nude woman standing in the tub of a magenta-tiled bathroom cups one breast with a towel. A sidebar lists the magazine's sections: "Photo Kinks," "Candid Shots," "Home Movies," "Common Errors," "Tricks Exposed," "Photo Markets," "Exposure Charts," and "Color Photography." With its combination of nude women, technical articles and camera ads, *Popular Photography* catered to a new wave of mostly male photographers and camera club members.

Camera clubs promoting pictorialist and purely aesthetic techniques were still active in the 1940s, but this new group of photographers co-opted and tweaked earlier clubs' offerings. Encouraged by magazines like *Flirt*, *Eyeful*, *Wink*, and *Titter*, packs of camera-wielding voyeurs gathered in studios and outdoor locations, capturing peepshows through their viewfind-

ers. Beyond pinup photography, camera enthusiasts could aspire to make picture stories for *Life* and *Look*, two magazines that helped popularize photojournalism in the late 1930s. The magazines stood out even on vibrantly chaotic newsstands, and their picture stories educated and entertained.

After the war, French photographers formed Group XV, the kernel of what became known as "humanist" documentary photography. Astute compositions that celebrated Parisian culture, family, and relationships romanticized the "city of lovers." International publications and exhibitions heralded the Paris photographs of André Kertész, Robert Doisneau, Izis (Israëlis Bidermanas), and Willy Ronis, among others. Then, in 1947, Henri Cartier-Bresson, along with three other photographers, created Magnum Photos, an independent photojournalist agency. Cartier-Bresson had established his own approach, which transcended documentary photography via special attention to timing and visual juxtapositions. Based in Paris and New York, the Magnum photographers emerged with the advent of miniature cameras that could shoot 35 mm film. In the 1940s, camera options dramatically increased, with devices designed for every level of enthusiast.

In 1938, the *New York Times* had inaugurated a weekly camera and photo column on a page that eventually became packed with camera store ads, photography news, and technical and aesthetic advice for enthusiasts. A 1947 article, "New York's Streets: Making Picture Stories of the City's Avenues," promoted a higher level of snapshot photography and gave practical suggestions that foreshadowed Vivian Maier's early New York photography strategies, which were to emerge in just five years: "Some sort of general orientation should be adopted to avoid aimless wandering, but many pictures will depend on chance and proper lighting. The best approach is the leisurely one, with no set program to reach anywhere at a particular time. The hurried photographer is a harassed one who misses some of the best pictures in his effort to take in everything. It is more important to get the flavor of a street than to record its details. People usually provide such material better than buildings."[57]

Street photography had arrived for everyone who wished to stroll parks and avenues with a camera. The range of available equipment included simple Brownie box cameras; traveling vest-pocket folding varieties; sophisticated large-format press cameras; and the new subminiature models that took 35 mm film. Within the range of cameras small to large and simple to sophisticated, the medium-format German Rolleiflex camera was introduced to American consumers in the 1930s as a precision instrument capable of the sharpest possible images on a two-and-a-quarter-inch square negative. By the late 1940s, the Rolleiflex had become the camera of choice by photographers whose style Vivian Maier was soon to emulate.

THE DISSOLUTION OF VIVIAN MAIER'S FAMILY

Maier's teenage years coincided with the Second World War. She was fourteen when Germany invaded and occupied France in 1940, and two months after the sneak attack on Pearl Harbor, the U.S. Navy struck back at Japanese forces on her sixteenth birthday, February 1, 1942. By August 1945, when *Life*'s Alfred Eisenstaedt photographed a sailor kissing a nurse in Times Square in celebration of V-J Day, Maier's teenage years were nearly over. Within months of the official Japanese surrender, she turned twenty.

Maier was also permanently separated from her mother and most of her family in this time. By early 1943, she was living with a married couple that fostered children in Jackson Heights, Queens.[58] John and Berthe Lindenberger were acquaintances of Eugenie Jaussaud. John had worked as a chauffeur and a car mechanic. He died in January, but Vivian Maier stayed on with the widow.[59]

In 1943, American teenagers were typically attending high school or contributing to the war effort by working in munitions plants, planting victory gardens, or participating in scrap drives. And teen girls were about to become the focus of a magazine called *Seventeen* that highlighted fashion, along with ideas and trends related to the transition to adulthood. For her part,

seventeen-year-old Vivian, who had shuttled between countries and families, was never quite part of any dominant culture.

While living with Berthe Lindenberger, Vivian Maier began working in a factory that manufactured baby dolls.[60] The Madame Alexander Doll Factory, which was already famous in the early 1940s for its lifelike dolls with innovative features like rooted hair and eyes that closed, was a picturesque train ride from her Jackson Heights home. With the destination of East Twenty-Fourth Street by Gramercy Park, the elevated train ran west through Queens, passed along the Queensboro Bridge over Welfare Island, and then rumbled thirty-five blocks down Third Avenue. Maier was becoming familiar with a route through Manhattan that she would soon record with photographs.

While Vivian Maier embraced her independence, working at a place that foreshadowed her avocation as a nanny with a particular draw toward babies, her mother removed to an apartment on West 102nd Street. Marie Maier was working at the Hotel Dorset on Fifty-Fourth Street near Fifth Avenue, and she would soon revert to her maiden name.[61] In ongoing efforts to find work, she moved from place to place, either residing in her employer's home or living alone. On August 22, 1948, she placed a no-frills "Situation Wanted" ad in the *New York Times* from the West Eighty-Eighth Street home of her employer:

CHAMBERMAID —waitress, city, country;
references. Marie Jaussaud, TR 4–8565.

Marie Jaussaud was still on West Eighty-Eighth Street two months later when she was called to her mother's employer's home at 960 Park Avenue. Sixty-seven-year-old Eugenie Jaussaud had suffered a heart attack and died on the morning of October 19.[62] Her cooking skills had consistently led to work within opulent surroundings during the age when battalions of servants formed communities of workers. Jaussaud was obviously beloved by her final employer, who listed her obituary in the *New York Times* and arranged her funeral at the famous Frank E. Campbell Funeral Chapel, where a hysterical crowd had once gathered

to mourn the death of Rudolph Valentino.[63] A requiem mass for Eugenie Jaussaud was held at Saint Jean Baptiste Catholic Church. Jaussaud had lived in New York her entire adult life, supporting her troubled American family, never returning to the France.

+ + +

In March 1950, Vivian Maier prepared for a trip to France, in part to claim and sell the family's Beauregard estate, by signing her new U.S. passport.[64] Using a fountain pen in the way that she was taught as a child, and in neat and slightly backhand French cursive, she wrote, "Vivian D Maier." As required, she also penned her signature across the top of her photographic portrait, validating her earliest known adult likeness. She stated that her occupation was "machine operator."

Twenty-four-year-old Maier didn't resemble typical American women of her age. Throughout the 1940s, women wore their hair shoulder length à la Lauren Bacall, who was a year and a half older than Maier and already a star. Maier was the same age as Marilyn Monroe and Princess Elizabeth, who had both established their signature looks and shorter hairstyles by 1950. Vivian Maier wore her nearly waist-length hair parted on the side, held in place with a headband, and pulled back into a bun. In her passport photograph she appears as a cleanly scrubbed schoolgirl with a plump face and a grin.

Within days of receiving her new passport, she was on the SS *de Grasse* heading back to the French Alps of her youth.[65] On April 12, she exchanged dollars for francs at a bank in Saint-Bonnet, the town where she had spent her school days.

The earliest known Vivian Maier photographs materialize after her arrival in France in the spring of 1950. In her time abroad, she took more than three thousand pictures. The negatives were made on eight-exposure rolls, amounting to an excess of four hundred rolls of film. She returned to New York with this mass of negatives and snapshot-sized prints, most of which survive today—spread out, now, among the various holders of her archive.[66]

THE EMERGENCE OF VIVIAN MAIER

Chapter Four

Young Photographer /
Final Days

After Vivian Maier's possessions were purchased from her storage lockers—then picked through, divided, and re-auctioned—the winning bidders scattered with their prizes. Some, like Ron Slattery, continued to buy more items at other venues. Slattery's habits sound a bit like Maier's own: "I was buying photographs like a maniac. I was just buying boxes and boxes and boxes of photos. It got kind of bad; it was almost kind of a hoarding situation."[1] But this was not because he had seen something extraordinary in Maier's work. "I just kind of looked and said, 'Oh, neat-o, photos,' . . . At the time I was buying so many photographs that I was putting them into boxes and putting them into storage, much the same way Vivian did."[2]

The local businesswoman who paid $500 for a portfolio of Maier's photographs is said to have bought them to decorate her office. Unlike most other auction attendees, she didn't intend to resell what she had purchased.

Another woman, Kathy Gillespie, had been at the RPN auctions with her son, Will, looking for items for their eBay resale business.[3] At one of them, Gillespie noticed Maier's book collection and recognized a stack from the 1970s Time-Life Library of Photography series. Several large leather portfolios stuffed with black-and-white photographs also caught her eye. She was barely able to contain her excitement while leafing through them, and her son had to remind her not to bring attention to herself. As in any competitive setting, it paid to be discreet. Twenty-three-year-old Will Gillespie was more interested in the shoeboxes filled with black-and-white negatives than he was in the books

of prints, and they lightly argued over which to bid for. Kathy Gillespie questioned her son's interest in the negatives because they didn't usually deal in items like those, but he was insistent. They had been buying a lot of material lately and were now on a tight budget, so they agreed to keep their total purchases to around $300. When his bidding on the negatives reached their agreed limit, Kathy signaled to him to stop. For whatever reason, there was less interest from others in the portfolios; by the end of the evening, she and Will owned all four spiral-bound leather books containing around 150 eleven-by-fourteen-inch Vivian Maier photographs. The 1950s-era exhibition-quality black-and-white prints cost them $297.

Kathy Gillespie thought a photojournalist had taken the pictures: "The majority of the photos were NYC street, some architectural and foreign travel, many dirty poor children and children crying, bag ladies, skid row bums and a series of vineyard or orchard looking shots with a woman writing taken in an almost clandestine way."[4] Gillespie decided that she didn't want to sell the photographs at that time, and she and her son kept the portfolios intact.

Gillespie considered mounting an exhibition of the work, but none of the prints was marked in any way: no signatures, notes, or dates helped identify who shot the photographs or assembled the portfolios. The minor clues that they detected weren't helpful except to indicate that someone once cared about these long-ago moments: "There were a few photos that looked more personal in nature and also some leaves, like pressed fall leaves, in one of the sleeves."[5] Later, Gillespie pulled out one of the photographs that she thought looked like a portrait of a young Susan Sontag and which she now thinks may be a portrait of Vivian Maier. Gillespie says that the print has since become lost within her own storage lockers.

After the 2007 auctions, Randy Prow, who reportedly paid a total of $1,100 for multiple boxes of Maier's photographs, negatives, color slides, motion picture reels, and hundreds of rolls of undeveloped film, put them aside and eventually moved out of the Chicago area.[6] Of all the buyers, Prow was the most con-

nected to the world of photography, having worked in photo studios; and like Ron Slattery, he collected vintage snapshots. But he wasn't gone for good.

The twenty-six-year-old real estate agent, John Maloof, has said that he placed an absentee bid on a box of negatives, hoping he would find images of his Chicago neighborhood for the book he was coauthoring; he, too, was a high-volume eBay seller. Maloof would soon dabble in printing from Maier's black-and-white negatives, offering them up on eBay; within a few months of the RPN Sales auction, he was selling prints.[7]

One of Roger Gunderson's employees at RPN—another prolific eBayer—successfully bid on some of Vivian Maier's locker contents. Within weeks, amid a sea of music CD listings on eBay, a strikingly different one emerged: "BOX OF 8MM KODACHROME MOVIE FILM- (HOME MOVIES)." The successful bidder purchased the lot for $29.99 and posted positive feedback on January 6, 2008: "Thanks so much! The films are great! Lots of old Chicago footage!"[8]

Another super-eBayer who attended the auctions was also soon offering items that stood out amid his other listings: motion picture reels of Chicago subjects. This eBayer also offered paper items with direct links to Maier's life story—among them, a Santa Fe Chief train ticket and meal stubs from a train Maier rode in 1959.[9] The RPN employee and the other eBayer also each sold single issues—July 1944 and May 1945—of an obscure political and photo-themed magazine called *See*.

One buyer was Hugo Cantin, a collector of 8 mm motion picture films. In February 2008 he had purchased a total of sixty reels from these two eBayers. The yellow Kodak boxes are covered in Maier's unmistakable penciled script and detail the films' contents, which, according to Cantin, include "lots of footage of kids playing outside, school playground, ice skating, Halloween . . . many beach scenes . . . art fair, amusement park . . . kids birthday parties . . . some urban shots; train/car window travelling, street scenes . . . some poetic shots; the sea and waves, falling leaves."[10]

Neither of the sellers can recall details about their abundant

listings from that time that might further illuminate any con-
nection to Vivian Maier's life. But collectively they also sold
more than a thousand black-and-white negatives and box-lots of
35 mm slides, scattering what was likely Maier's work.

At the time of the sales, Vivian Maier, unaware of her expand-
ing presence, had another year to live.

1950: THE EMERGENCE OF VIVIAN MAIER

In one of the earliest known adult portraits of Vivian Maier,
she looks confident, towering over a gathering of women and
children in a French village in spring 1950.[11]

Twenty-four years old, Vivian Maier stands between two
women with four young children clustered in a toy car at their
feet; everyone except Maier and one small child—who twists
back and stares up at the tall foreign woman—squints toward
the camera in the high-noon light. The sunlight creates shadows
on her cheekbones that highlight Maier's mature demeanor as
she smiles pleasantly, her eyes open and relaxed despite the glare.
While the two young mothers, one white and one black, each
casually rest a hand on a child before them—and the children
writhe tightly together—Maier stands with her arms down at
her sides, maintaining a narrow gap from the others. Two black
toddlers squirm at the foot of the woman who is presumably
their mother, and two white children are positioned at the foot
of the white woman who appears nearly as a child herself. In
another photograph from this same rural setting of dirt roads
and ramshackle stone houses, a seated pipe-smoking black man
poses with his arms around the shoulders of two children, one
black and one white.[12] Maier seems welcome and at ease in this
small, diverse community.

Vivian Maier had walked from Les Barraques, a tiny ham-
let next to the even smaller Les Allards—merely a cluster of
farmhouses—where she photographed and posed with the
locals. Though only two blocks long, Les Barraques was well-
traveled because the narrow road running through it was a
segment of the Route Napoleon—the national highway that

had opened with international fanfare in 1932 during the same month that Maier arrived here with her mother at age six. Just yards away, one of the famous eagle-topped pedestals identified the route and marked the road's historical significance as part of Napoleon's two-hundred-mile journey back from exile.

It was well known that "ragged people" and gypsies lived in Les Allards because of its location near the highway, and the ease of access to points beyond the valley. From both hamlets, the picturesque village of Saint-Bonnet-en-Champsaur could be seen lower in the verdant valley, a cluster of square buildings surrounding a tall-spired church. A low bridge spans the River Drac, which separates nearby Saint-Bonnet from its satellite communities and runs eighty miles through the valley, north to Grenoble.

Vivian Maier doesn't look as out of place among the village women as she may have in New York with her calf-length skirts and buttoned-up shirts, but she is the only woman whose hair is long and tied back. On an earlier camera roll, Maier photographed a family at their farm in Bénévent-et-Charbillac, the hometown of her great-grandmother Émilie Pellegrin, and where she stayed part of the time with her mother in the mid-1930s.[13] Vivian Maier spent a bright spring day with the family whose daughter appears to be around Maier's age; other than their hairstyles, the villagers look similar in their loafers and long skirts. But later, in the summer, a woman who looked like a French Marilyn Monroe joined Vivian Maier for a day in Saint-Bonnet. This woman, in her platinum hairdo and stylish heels, shows that the region was indeed connected to the world's wider trends and styles. She gamely posed for Maier's camera solo, standing among some children, and sitting with a small group in a doorway.[14]

As Vivian Maier traveled through the region, she gathered small groups for her camera: children, families, workingmen, and combinations of two or three men, women, and children. Always facing her subjects toward the bright sun, she consistently achieved the groups' ease and cooperation, even as they often squinted back at her, sometimes shielding their eyes.

Everyone faces Maier and her camera agreeably; they smile, they sometimes appear coy, and often there is laughter. Vivian Maier managed to get fidgety boys to pose in a straight line with their arms at their sides, young girls to appear amenable and unself-conscious, and entire families with awkward teenagers to go along with the picture-taking activity. In one photograph, perhaps taken at Easter time, a group of children surround a cart filled with dead lambs; they smile, laugh, and some salute the camera, again shielding their eyes from the sun.[15] There's no way to know her strategy for achieving this level of cooperation.

From the time of her arrival in France, Vivian Maier relentlessly recorded people and her environment, but she was not photographing in a way that shows an affiliation with the philosophy of New York's Photo League or the French social documentarians. Nor was she utilizing modernist strategies or working like a magazine photographer for *Look* or *Life*. Helen Levitt's candid photographs of New York children in the 1940s show them playing in the street; Maier's are most often posed like obedient schoolchildren. Henri Cartier-Bresson waited for the "decisive moment" when a passing figure would activate his formally balanced composition; Maier's camera framing during this period does not consider movement. And all of the photographers who promoted modernist notions of originality and "the shock of the new" had little effect on Vivian Maier's earliest known work.

Rather, she seems to be unique—or simply old-fashioned—in her appearance and photographic inclinations. Black-and-white alpine views were not unusual along the historic Route Napoleon, but back in New York City, glossy color chrome postcards of the Statue of Liberty, Times Square, and the Manhattan skyline were already common. And while other amateur photographers were experimenting with new equipment and materials—like 35 mm cameras and Kodachrome slide film—or were roaming sidewalks to find compelling subject matter and to create dynamic compositions, Vivian Maier was following the trail of a woman who had bicycled through this region when Maier lived here as a young girl. As Marguerite Joubert had photographed

the Champsaur Valley, creating mass quantities of photos and printing them as postcards, so would, in a more limited way, Vivian Maier.[16]

The vast majority of Maier's thousands of photographs from this time portray landscape views. Presented side by side, some of Joubert's and Maier's photographs appear as if made by the same person standing on the same spot. Each woman framed valley scenes with overhanging tree branches, captured a similar modeling of light and shadow on the same mountain ranges, and documented distant villages from equivalent elevated perches. It seems logical that Vivian Maier would have known of and been influenced by Joubert's work in the region. In later correspondence with Saint-Bonnet camera shop operator and postcard publisher Amédée Simon, Maier acknowledged that she considered her landscape views as postcards, and indeed Simon printed postcards from her negatives.

Out of context, a few of those photographs might seem like tourist snapshots. But the massive quantity and obvious quality of the black-and-white negatives demonstrate otherwise. Experimentation is apparent in many images: one example shows how using lens filtering in different ways from frame to frame darkens the clear sky; in another, the deep focus resulting from a closed-down lens aperture emphasizes boulders in the foreground while a snaking stream pulls attention to a distant mountain.[17] Other types of subject matter also show a range of technical approaches: looking as if shot with a close-up attachment, a ground-level perspective of a chicken amid a clutch of baby chicks shows the effect of an open aperture, creating a sharp foreground offset by an out-of-focus background.[18] There is also a picture of a herd of sheep running alongside a bus, which Maier leans out of to capture the blurred movement.[19] Her versatile camerawork reveals technical proficiency and visual curiosity. Maier's images, produced on large 2¼ × 3¼–inch negatives, show impressive detail and nuance. Still, throughout, she appears to be at work making picture-postcards.

Given that she hardly stopped long enough to fully experience any one place, Vivian Maier's photographing may have

been designed to document her travels—or provide proof of her worldliness. Nearly three decades later, Susan Sontag wrote: "A way of certifying experience, taking photographs is also a way of refusing it—by limiting experience to a search for the photogenic, by converting experience into an image, a souvenir. Travel becomes a strategy for accumulating photographs. The very activity of taking pictures is soothing, and assuages general feelings of disorientation that are likely to be exacerbated by travel. Most tourists feel compelled to put the camera between themselves and whatever is remarkable that they encounter."[20]

+ + +

Any student of photography would immediately recognize Vivian Maier's various camera adjustments. She was likely using a vest-pocket-style folding camera and may have traveled with more than one. Long popular among travelers like the globe-trotting Kodak girls, folders could be manually focused and mechanically adjusted, including with the use of add-on filters and a lens hood, all of which are evidenced in Maier's photographs.

The quality and range of Vivian Maier's photography from this one-year period has been widely misunderstood and mischaracterized. John Maloof established the "Official Website of Vivian Maier" before these negatives emerged from someone else's collection. As of this writing, the website states, "Sometime in 1949, while still in France, Vivian began toying with her first photos. Her camera was a modest Kodak Brownie box camera, an amateur camera with only one shutter speed, no focus control, and no aperture dial. The viewer screen is tiny, and for the controlled landscape or portrait artist, it would arguably impose a wedge in between Vivian and her intentions due to its inaccuracy. Her intentions were at the mercy of this feeble machine."[21]

Maloof has assumed that a 1914 box camera that he acquired with some of Maier's belongings is the source of all of her photography before 1952.[22] Images from that camera, a Brownie

Rainbow Hawkeye No. 2, would look nothing like Maier's photographs from this period. Hardly a feeble machine, the camera she did use smoothed her later switch to the square format of the Rolleiflex that she was to prefer in the following decades.

This misinformation has led to skewed perceptions and the spread of inaccuracies—the least of them being that Maier did not arrive in France until April 1950. This portrayal has been a disservice to Maier and is at odds with a more careful reading of her early works. This depiction of Maier has been reinforced in the picture books of her work, one of which declares: "Like many other novice photographers at the time, Maier used an old-fashioned box camera. . . . It had no focus and minimal adjustments for shutter speed and depth of field, so its range was limited. To compensate, young Maier kept it simple."[23] The erroneous initial presentation of Maier's work created unnecessary mystery and set the table for further mythmaking.[24] Was she a mysterious nanny? Or was she a photographer savant? Focusing on these questions pulls away from what we should be looking at: what Vivian Maier actually did.

Vivian Maier returned to her mother's region as the heir to the Beauregard farmland. While the preparations were being made for the land's eventual auction, she traveled the valley and the Haute-Alpes region, visiting with relatives she had last seen half her lifetime ago. She traveled by bus, by bicycle, and on foot along country roads, photographing other travelers and shepherds with their flocks. On the back of a picture of an elderly man with a walking stick, wearing a beat-up felt hat, she wrote, "Sur le chemin de St. Leger" (On the way to St. Leger).[25]

Maier occasionally noted the date and location in pencil on the back of her snapshot-sized prints.[26] Sometimes her notation is vague—"Spring 1950"—but in other instances she was exact: "St. Andre, Basses Alpes January 21st 1951 Sun." Maier's negatives, initially on eight-picture rolls, were cut into individual frames, breaking their continuity. The jumble of solitary images could seem hopelessly repetitive, with generic mountain ranges and distant clusters of tiny houses settled around similar church steeples. But by matching negatives to notated

prints, and then ordering and mapping the images, gradually the craggy Haute-Alpes separate from the smooth and hilly Basses-Alpes, and increasingly, the mountains' silhouettes become familiar. Changing seasons become apparent and visual strategies emerge.

Vivian Maier spent time in Saint-Bonnet, photographing the narrow streets, arches, and market, framing shots with the town's distinctive church steeple as a focal point. She photographed Amédée Simon's camera shop at the Place du Chevreuil, by the fountain that Marguerite Joubert represented as a postcard in the 1920s.[27] Maier took several portraits of Simon, including one of him standing at a window display highlighting Lumière-brand black-and-white film and paper.[28] Unlike Times Square camera stores' overloaded window displays of brash, shiny flash reflectors and Kodak's glossy color posters, Simon's shop window—shaded by a striped awning—presented a few cardboard advertisements and some black-and-white Alpine landscapes, all tastefully presented on curtain-backed glass shelves.

She let others use her camera, too, and sometimes they took pictures of her with it. In Saint-Laurent-du-Cros, Maier posed with her great-uncle, Jean Jaussaud.[29] In the more than a dozen portraits, Vivian Maier often looks apprehensive or seems in mid-expression, as if she is directing the making of the picture. But in a couple of instances she is playful and relaxed. In an uncharacteristic lighthearted portrayal, Maier's hair hangs loose past her shoulders as she sits in short sleeves and a skirt.[30] With one hand, she lifts a melon-sized rock as she regards the camera with a comically impassive expression. In another set of pictures, Maier and an acquaintance, Nelly Richebois, take turns photographing each other bending down to touch the trickle of a stream.[31]

Richebois lived with her family on land adjacent to that of Vivian Maier's grandfather Nicolas Baille, in Les Ricous, and they were with him one bright sunny day. Richebois may have been behind the camera for the single image of Baille with his granddaughter; the picture of the two is slightly out of focus.[32] Baille leans awkwardly on his cane, while his granddaughter,

with her sleeves rolled up, sits casually alongside him, with a concerned expression (plate 5). Richebois recalled Baille as a nearly destitute man whom village children mocked for his eccentricities, such as digging pointless holes on his property.[33] At the doorway to his house, he had dug a deep trench designed to foil intruders. Some villagers suggested that he had been hit on the head with a hammer while returning from America.

Vivian Maier was somewhat of an object of suspicion herself. She was always carrying her camera, and she became well known throughout the valley. Because of her constant photographing, though, some people thought that she was a spy. A policeman once questioned Maier extensively about her activity.

During her time in the Champsaur Valley, Maier visited families to whom she may have been distantly related, sometimes photographing them posing with props. Members of a family in Pont-du-Fossé alternate standing amid tall flowers, cradling roses as they smile for the camera; an older man holds a long iris stalk, comically deadpanning his pose, looking like Buster Keaton.[34] In Saint-Léger-les-Mélèzes, a brother and sister take turns sitting in a chair in front of their family's old stone farmhouse, holding open a book of nineteenth-century studio portraits.[35] Vivian Maier photographed adults and children posing with dogs, kittens, lambs, piglets, and, in a subject she was drawn to throughout her life, babies in their mother's arms. She also began her lifelong photographic exploration of cemeteries.

Maier photographed graveyards in the Champsaur Valley and across Europe. In some of the pictures she visualizes tombstones as elements in the Alpine landscape, framing them to align their forms with distant mountains.[36] Sometimes she seems to be documenting gravestones that identify personally meaningful people or family names or ones similar to her own, like "Meyer."

Maier also recorded cemetery activities and made several portraits of gravediggers, singly and in groups. In one picture, three men stand facing her with upright shovels, posing pleasantly in front of an open grave (plate 8). They were reinterring her Aunt Maria Florentine from the common burial area to a single plot.[37]

Then she photographed the grave's new concrete slab.[38] Maier also recorded parades of mourners and graveside funerals. One Saint-Bonnet photograph depicts a long trail of walkers from a distance, showing them offset by the town square against the ubiquitous mountain backdrop. This series continues inside the cemetery where she photographed the huddled mourners from a slight distance. In one frame, a girl is glaring over her shoulder at Vivian Maier and her camera.[39]

In another Saint-Bonnet funeral procession, Maier captures the approaching group, following their progress in several shots from the church to the graveyard. One picture stands out for its timing and poignancy: a robed altar boy has turned back, sneaking a look at the four young girls cloaked in ankle-length white veils, who carry a toddler-size casket. On the back of one of the prints from this set, Vivian Maier wrote, "March 16th 1951 Fri. funeral of Ollivier's daughter, thirty months old."[40] Maier had already established the lifelong theme of documenting other families' rites and celebrations. And as her year's stay was nearing its close, she was photographing in a way that foreshadows her mature work, using the street as a theater to record people or activities.

Vivian Maier remained in the Champsaur Valley during most of her time abroad, sometimes staying in the bigger town of Gap with an older couple, Joséphine Jaussaud Lafont and her husband, Bruno. Joséphine, a distant relative, worked as a nanny, and during Maier's visits she was watching a sister and brother.[41] Maier photographed Joséphine often, sometimes with Bruno, but mostly posing with or tending to the children. Maier also posed groups of neighborhood children for many portraits—in one instance, with each child holding a flower in his or her mouth.[42] She also repeatedly photographed from the window of her room, once capturing Joséphine in a sequence walking toward the house, holding a baguette in one hand and the hand of a child in the other.[43]

Portraits of elderly women permeate Maier's entire body of photography. In these French photos, in addition to Joséphine Lafont and strangers in markets and on narrow streets, Maier

photographed a pair of widows in Les Allards. These women, dressed entirely in black—one wore a black bonnet from an earlier era—pose agreeably on their farmland. The sequencing of images indicates, through farming activities and the condition of the fields, that Maier frequently visited these congenial women in black.[44]

In June, Vivian Maier did leave the valley region and headed southwest to Provence, where she toured Avignon and spent time in the medieval towns of Tarascon and Beaucaire, which are separated by the Rhône River. More than sixty photographs depict the two towns' ancient fortresses from every angle. During one day in Tarascon, Maier met a physically malformed, dwarflike woman who was accompanied by a small child. The three appear to have spent a good portion of the day together. The woman poses with the boy in various places, including on the bridge spanning the Rhône. In what seems to be the day's final photograph, the woman and the boy look up at Maier, whose distant vantage point suggests that she's aboard a departing train.[45]

Later in the summer, Vivian Maier took a bus tour north along the Route Napoleon and visited the huge equestrian statue of Napoleon at the edge of Lac de Laffrey. She photographed the gardens and grounds of the Château de Vizille with picture-postcard precision. In several photos of the palace—from across a vast lawn so she could fit in the entire structure—she experimented with framing using a variety of dangling pine branches and bracketed her exposures of the bright cumulus-swathed sky to ensure printable negatives.[46]

At the end of July, Vivian Maier was back in the valley, busy recording hay-harvesting activity. Conical bundles dot the broad landscape, a farmer with a sickle pantomimes his work, horses pull carts with billowing loads, children play and pose in front of a mountainous pile, and in one picture, a farmer and his horse do their work before a house-sized mound. On separate occasions, one of the Les Allards widows and Nelly Richebois each pose for Maier in waist-deep dry grass.[47]

On one bright August day, Maier stopped by the Beaure-

gard farmhouse. She had photographed the ancient three-story stone dwelling before, and images of it appear in her negatives throughout the changing seasons. This was where sixteen-year-old Nicolas Baille had joined the household, and this was the house where her mother had been born in 1897. A large and still-growing family now occupied the home. On this day, Vivian Maier gathered and photographed the parents with eight of their children. Maier made one group portrait by arranging the family as a three-tiered cluster organized by height—with the youngest boy-girl pairs holding hands in the front row—and then after lining them up shoulder to shoulder, filling the farmyard, she backed up to frame the entire house along with the dramatically cloudy sky and a distant mountain range.[48] The children and their father appear miniature and nearly featureless, a tiny phrase in the symphonic organization of the photograph.

Her travels continued—and, indeed, they went longer than she had originally intended. She had planned to go for only four months, but she stayed on, ultimately for a full year.[49] By the end of August, she had stayed at the hilly Saint-Véran, wandered the narrow streets of Briançon, explored the crumbling ruins of Sisteron, and perched on the rim of the great dam at the Lac de Chambon. Along the way, her camera work became more brazen and she expanded her approaches to portraiture. She leaned out of her tour bus window to capture a truck and another bus that were stuck at a tight mountain curve.[50] In Saint-Véran she made a poignantly discordant portrait of a boy posed arms akimbo in front of an overloaded donkey as a humpbacked woman sat in profile on a nearby porch (plate 7). The whole time, she was making impressive postcard landscapes.

In September, Maier was back in Gap with the Lafonts, attending the town's events. In addition to the Tour de France, which each summer ends one segment and begins another at Gap, the town sees another cycling race, the Tour de Gap, at the opening of its autumn festival. The shots that remain from Vivian Maier's coverage of the race show views of the approaching cyclists from six separate vantage points. In one sequence Maier

pivoted from right to left following the bicyclists around a bend, then backed up to get a shot of a row of spectators sharply focused against the blurred speeding racers. In the street shots that also depict spectators, nobody else is photographing the action; in a couple of photos, people turn back to look at Maier, who appears to be standing within the street course.[51]

Other late summer festival activity in Gap included a traveling carnival with rides and sideshow-type acts, including a black boxer dressed in white satin trunks. In several photographs, shot from the side of the makeshift stage, Maier's emphasis is more on the onlookers than the main attraction.[52] Similarly, she wandered to the edge of the carnival setup and met an itinerant family at their caravan wagon. The resulting group photograph reads as a lineup of stereotypical Hollywood-type carnival characters: in mismatched-patterned clothing, the eleven men, women, and children are all standing or positioned facing forward, unsmiling but intently cooperative, with their clothes and hair fluttering in the breeze.[53]

Vivian Maier attended a speech by Maurice Thorez, the country's leading Communist politician. On the back of one of the resulting small prints Maier wrote, "Sept. 19, 1950 Sun Gap, Place Verdun Torez speaking." She shot an entire roll of film—eight frames—of the event, both from her seat and from behind the stage or at the periphery—more distant views that establish the scale of the gathering. The last image in the series shows the empty, disheveled chairs and offers a clear view of the stage area with its banners, flags, and slogans.[54]

In the week leading up to the sale of the Beauregard farmland, Vivian Maier left France for an excursion to Switzerland. She crossed the border on September 29, heading for Neuchâtel— possibly not a random touristic destination, as her New York landlady Berthe Lindenberger was from that city.[55] She arrived there on the first day of the city's grape harvest festival, and on October 1 she was among the spectators at the annual parade on the city's aptly named Beaux-Arts Street. Amid the fancy building facades, the sidewalk crowd and others who leaned out of windows two and three stories above were awed by a proces-

sion of colorful flower-decorated floats, soldiers in regalia on horseback, and waving, costumed characters. After the spectacle ended and the clear sunlight shone directly up the confetti-covered street, she crossed the road to frame the brightly lit faces of the departing crowd amid the empty bleachers.[56]

Maier then traveled south to Geneva and stayed at a chalet near the foot of Mont Blanc. She photographed the great snow-capped peak in a series of images that show the stepped layers of mountains foregrounded in a picturesque fog.[57] A portrait of Maier taken in Geneva shows her in a tailored blazer and skirt, nylons, and laced oxford shoes, as if she is attending a business meeting.[58] Maier stands alone at a curb, arms at her sides, her shiny dark leather purse in one hand, looking directly and seriously into the camera lens. Over the course of this year, she cut her hair twice, first shortening her nearly waist-length hair to just below shoulder level.[59] Yet the style still lagged behind fashions for women her age. Also partway through this year, Vivian Maier started donning a beret, a look that she embraced throughout her life—one that announces *Frenchness* and perhaps a cosmopolitan flair, but also a guise that would later seem eccentric.

Vivian Maier returned to France and began the process of cutting her ties to that country, dissolving her great-grandfather's legacy.[60] On October 7, 1950, she met with Saint-Bonnet's official notary to settle the prices and initiate the offering of the various lots of her family's 173 acres—thirteen various-sized lots with different potential uses.[61] The parcels sold over two days of auctions, leaving her a windfall $5,300, or more than $50,000 today. On November 9, the day the transactions were recorded at the mortgage office at Gap, Vivian Maier's notations on the backs of her photographs show that she was out photographing the surrounding landscape, and then the alleys and gravestones at the Gap cemetery. During those days, she was also busy photographing animal farming activities. Maier's photographs show a pig farm and pigs in wooden crates at the Saint-Bonnet market; cows at pasture and at the Saint-Bonnet market; and, in more than forty instances, sheep being herded to the lower valley for the winter.[62]

In one two-photo sequence showing a shepherd funneling dozens of sheep through the narrow alleys of Saint-Bonnet, Maier photographed the shepherd from behind, guiding the mass with his crook. In the first photo, his face in profile is lit by the sunlight at his left as he steps into the shade of the narrow street. For the second shot, which shows the group a few steps farther along, Maier either ran back to get a wider shot or switched cameras for a lens with a wider angle of view. At some point on her return to the United States, she made a five-by-seven enlarged print of the first shot. It is among many enlargements that still exist from her year abroad.[63]

Maier stuck around the Champsaur Valley through late fall and winter. At the end of November she ventured along a mountain ridge to nearby La Chapelle-en-Valgaudémar, where she photographed waterfalls and people she met, including a toothless elderly man standing with a walking stick and hooded cape, mirroring the distinctive profile of Mont Olan behind him. In her five-by-seven-inch enlarged print of this scene, she cropped the man's legs from the full view, resulting in a mountain-like abstraction of his form. Additionally, in the darkroom, she dodged—selectively lightened—his face to accent his gaping expression in the print.[64]

The snow-covered valley kept Vivian Maier busy through December and into January. Skiers, sledders, and a sleigh-riding family appear among the winter landscape shots that duplicate views from other seasons.[65] And then, in the middle of January, she packed up and headed south for the Riviera. On the five-day journey to the palm-tree-lined boulevards of Nice, Maier stopped at Saint-André-les-Alpes and then paused through the smooth, hilly landscape by the Lac de Castillon, where she photographed reflections of mountain ranges and other mirroring effects of the lake's surface.[66] In more than forty images, Maier experimented with exposures, filters, and framing; one set laid out left to right demonstrates her camera pivots, all together depicting a sweeping panorama.[67] After a brief stop in the mountain town of Entrevaux and a visit to its medieval fortress, Maier arrived in balmy Nice.[68] On the evening of January 25, she walked down

to the pebbly beach and, in a sequence of shots, photographed the sun setting over the Mediterranean Sea.[69]

Vivian Maier turned twenty-five during her time in the Riviera, and on one sunny day she posed for a picture, appearing tan and relaxed in a light-colored, seersucker dress, while sitting on the ledge that frames Nice's boardwalk.[70] This ledge lines the famous Promenade des Anglais, where photographer Lisette Model had made her oft-appropriated portraits of wealthy vacationers in the 1930s. In one portrait of a deeply tanned gambler slumped in a chair, his half-closed eyes on the camera, Model's subject's character reads as feline and cunning. Model's negatives from the series show her camerawork as deliberately approaching the vacationers and framing two or three shots as they idle on wicker chairs.

Although Vivian Maier's photography would soon parallel Lisette Model's approaches in very specific ways, it doesn't appear that she was yet influenced by Model's work. The ubiquitous wicker chairs of the promenade do show up in a Maier photograph from late January 1950, but only as a background to young children feeding pigeons.[71]

Vivian Maier made two daytrips during her time in Nice. A couple of days after her arrival, she spent an afternoon across the border in Genoa, Italy.[72] She rode the scenic route along the Riviera coastline and spent most of the day at the Cimitero Monumentale di Staglieno, famous for its realistic funerary sculpture.[73] Maier made another daytrip to visit the picturesque fifteenth-century French hillside village of Saorge.[74] She shot more than a dozen frames on the winding approach to the steep cluster of houses. Not many photographs survive from Vivian Maier's week in Nice, but those that do include posed shots of children on a sidewalk near the train station and an elderly woman in a fancy hat—adding to her burgeoning collection of photos on that theme.[75] Other soon-to-be familiar subjects also emerged during Vivian Maier's quick stays in Nice and then Marseille, including a person slumped and asleep in a public place and her earliest known documentation of a motion picture crew. She made two prints—a snapshot-sized one and a five-by-

seven—from a negative showing men packing up theatrical lights on a sidewalk at an art nouveau–embellished storefront. Nice and the local Victorine Studios—known as the "Little Hollywood of the Côte d'Azur"—was internationally famous for its film production. Maier followed two of the men from the set, framing them as they walked out of the sidewalk scene. This early paparazzi type of photography stands out at this point in her work.[76]

Maier also revealed her propensity to gravitate toward action and work like a photojournalist. Her sidewalk photographs of Marseille show her walking route. In a two-frame sequence, she spotted and framed a man with a young girl and their dog crossing the street in a heavily pedestrian area. She photographed a woman calling a man a thief, stepping off the curb toward him as a police officer and another man hold out his arms.[77]

Arriving at the next stop of her winter excursion, Vivian Maier crossed Spain's Portbou checkpoint into Barcelona, where she spent a couple of days photographing the city's sights.[78] One picture stands out: from a vantage point behind a cluster of folding chairs in the wide span of the Plaça de Catalunya, Maier stood behind of a gathering of people within the shade of the grassy perimeter.[79] The image shows her perspective as a witness to others' activities; seen another way, it is one of the early views that position Maier as a spy.

This partially intrusive, clandestine quality is apparent in a sequence she shot in Granada, too. There, she followed an all-male funeral procession through the streets. As in other cases, in one picture a man has turned and appears to glare at Maier. It also appears as if one of the mourners left the procession and was caught midstride approaching the camera.[80]

Not all her work in Spain—whether in Granada, Córdoba, Seville, Toledo, or Madrid—was so fraught. She photographed from the Alhambra, sometimes incorporating the Moorish-style window openings into her compositions. In addition to getting fourteen children of various ages to pose in one long line at Córdoba's Great Mosque, she got a shot of a couple of teenagers in a shoving match at Seville's Cathedral.[81]

Vivian Maier left Seville for Madrid in high style, on a DC-3 airplane. Not surprisingly, she photographed every stage of the journey, including the runway, aerial perspectives of the landscape, a view of the sky framed along with the plane's wing, and ground crew activity at Madrid.[82] Within hours of her arrival, Maier was strolling the city's wide boulevards. Less than two weeks after arriving in Barcelona, she headed to Paris by train.[83]

Vivian Maier didn't stay long in Paris either, but compared with her speedy tour of six Spanish towns in twelve days, her week there must have seemed leisurely. She spent one of those days away at the Palace of Versailles, where, unlike in her earlier postcard views of the Château de Vizille, she incorporated fellow tourists in her pictures and was more sensitive to the play of light in her framing.[84] Few negatives and prints are known to exist from her days in Paris. Those that do show human activity, with typical landmarks serving only as backdrops.

The Paris photo scene was strong at this time. Five years had passed since the formation of Group XV and the development of the "humanist" documentary style popularized by Henri Cartier-Bresson. And there were also depictions of romantic Parisians as represented by Robert Doisneau, André Kertész, Willy Ronis, Izis, and earlier by Brassaï, whose book *Paris de Nuit* (*Paris by Night*) was first published in 1933. American photographers were also working in Paris in 1951: Paul Strand, Elliott Erwitt, Todd Webb, and Ruth Orkin all depicted this dreamy city in the course of the year.

Maier's Paris street photos do not show the formal precision or developed vision of those photographers. Her images are more in line with her previous approaches and show a gradual shift of focus from scenery to action. When a spectacular event was progress, however, she operated as a bold photojournalist. After a traffic accident left an automobile on its side in the middle of an intersection, Maier circled the car, depicting, alternately, its top and exposed undercarriage.[85]

At the end of February, with only six weeks left until her return to New York, Vivian Maier was back in the Champsaur Valley, photographing its wintry landscape as if she had never

left.[86] But she also sought out local activities and took many individual portraits, including one of the cemetery custodian standing at the open gate of the Saint-Bonnet graveyard.[87] She also framed an additional twenty-five elevated views of Gap.[88]

In her final photographs from the Champsaur Valley, Vivian Maier took up a strategy and theme that would become characteristic. During a market day, when the town was loaded with villagers, she took two photographs of a poorly dressed woman struggling with an overstuffed sack; in the second image the woman poses for Maier with her sack on her shoulder, a classic character study.[89] Maier also spotted a "ragged man," perhaps homeless. She photographed him seated on a stoop from a slight distance then took three more pictures from separate angles, as if studying him.[90] Maier photographed this man on more than one occasion and appears to have made his acquaintance. In a waist-up portrait that she would later emulate in New York's Bowery and Chicago's skid row, he looks directly into her camera's lens—held at waist level—resulting in a disarming direct gaze down at us, the viewers.[91]

These three thousand skillful photographs from 1950–51—not naive snapshots made with an ancient cardboard box camera—introduce Maier as the incessant picture taker that she would remain for decades. From the temporal gaps in the prints and negatives, it is possible that more than a thousand images have not yet surfaced in her fractured archive, the entirety of which—at least six thousand prints and negatives—twenty-five-year-old Vivian Maier carried across the ocean and kept until she put them into storage decades later.

2008: VIVIAN MAIER'S PHOTOGRAPHS DEBUT ON THE INTERNET

Eighty-two-year-old Vivian Maier would sit for hours on her favorite park bench on the Lake Michigan shore. A series of grassy tracts and narrow beaches lined Chicago's northeastern edge just yards from where she lived. Maier's apartment on Sheridan Road in the Rogers Park neighborhood faced north as

the street curved east to the lake, that short segment marking the city's northern boundary. Behind the condo development across the street from her building, a nineteenth-century cemetery spanned 120 acres, lining the lakeshore and adjoining the suburb of Evanston.

Unlike other ritzy lakeshore neighborhoods, Rogers Park has long been primarily a transient community of blue-collar workers, college kids, ethnic families, and people on the margins. An abundance of multiunit apartment buildings helps account for the density and variety of the neighborhood's inhabitants. In recent years, Sheridan Road has become lined with low-rise elder-care facilities. It's not unusual to pass parked ambulances with ominous revolving and flashing red lights on this mile-long stretch.

Vivian Maier had lived alone in Rogers Park for around a decade, but it was only around 2004 that she moved into a first-floor apartment on Sheridan Road. During this time, she sat on the park bench so often and for such extended stretches that some of her neighbors thought she was a vagrant. One local resident didn't even realize they were neighbors: "We knew her as a homeless woman (we weren't aware that she had an apartment because she spent so much time in the park) who seemed, in many ways, neglected by the world."[92]

Maier became a familiar figure distinctive for, among other reasons, the desire to be left alone. A young woman who referred to Maier as "the French lady" said, "She was here a lot, sitting on the bench, but I don't think anybody really talked to her. There are a lot of eccentric people around here, and I just thought she was one of them. You knew to just leave her alone."[93]

A resident who lived alongside the park echoed the other observers. "She would sit for hours on the bench at the entrance to Rogers Beach Park on the lake reading books or papers and in all kinds of weather. . . . I was struck that she was sitting in a very public place, yet didn't wish to talk to people. . . . My heart went out to her as I thought of my mother and all the old women you see in the city, alone and making their way by themselves."[94]

Yet she wasn't entirely aloof. Patrick Kennedy, who has lived

across the street from Rogers Beach Park for decades, shared the bench with her on occasion, though it was a long time before they had any sustained communication. Kennedy liked her sense of humor and thought that she was smart. He knew nothing about Maier's background, and she didn't divulge any stories of her past; in retrospect, Kennedy doesn't think she told him her name.[95]

Kennedy did learn that Vivian Maier had lived in this part of Rogers Park only for a few years and that a young French Canadian woman had helped Maier move from a building a few blocks away to her apartment by the lake. Kennedy once introduced Maier to a French-speaking renter in his building whom she slowly warmed to.

From the back of his own apartment, Kennedy could see that Vivian Maier had a routine where she would circle "her block" by walking through the alley from her apartment at its north end and then east to Eastlake Terrace and Rogers Beach Park. During Maier's treks through the alley, she would lean into garbage cans looking for magazines and newspapers and bring them to the park bench. In any season she was always wearing the same outfit: a hat, a long coat, men's shoes, and thick nylon stockings, seemingly from the 1940s or 1950s.

By the time Patrick Kennedy's path crossed with Maier's, she had shed her camera—long the most meaningful element in her complete look—and was largely regarded as a cheerless curiosity. And by spring 2008, the dispersal of Maier's storage locker possessions had been going on for several months. As her belongings were separated from her, others acquired them for myriad reasons—including nostalgia for a past not their own.

+ + +

In 1997, around the time Vivian Maier moved to Rogers Park, eBay was established as a virtual flea market.[96] In the late 1990s, old photographs filled perhaps a dozen pages of eBay listings; ten years later a keyword search of "1950s snapshot" would lead to thousands of items. Trading in mid-twentieth-century vernacular photography is a recent phenomenon boosted by the acces-

sibility that eBay abets. Snapshot photos are generally small—less than five-by-seven-inches—and printed by a drugstore or photo lab. They are typically casual pictures made by amateur photographers, though it is possible to compare some formal and conceptual elements with those of established photographers. Yet it can be hard to assess their quality: digitization imparts a kind of democratic sheen; when a large number of images are all the same thumbnail size on a computer screen, a casual snapshot can look very much like an image from a master.

Hobbyists can now assemble snapshot collections based on locations, formal techniques, visual themes, or other more esoteric subjects. There are collectors who seek snapshots of people pushing lawn mowers, shaking hands, or eating watermelon. One well-known collection consists of people whose eyes are closed or hidden.[97] Ron Slattery collects snapshots that depict plastic-covered sofas and, also, those that show people in perplexing situations. Removed from their original context, the pictures invite interpretations.

In 2004, Slattery established a website for his favorite snapshots. He named it Big Happy Funhouse and first introduced photos under the heading "Accidental art. Found photographs. Via Chicago." Within a year, he had put more than nine hundred photos online and was profiled in the *New York Times*. While the Internet was making seemingly anonymous photographs more accessible, the writer opined, "there is something disquieting to see photos that were never meant to be public."[98]

The earliest eBay snapshot sellers and collectors are a tight group who mutually helped establish a market for a new genre of art collecting. And they further extended the web presence of anonymous found snapshots: soon after Slattery debuted Big Happy Funhouse, collectors Nicholas Osborn and John Foster initiated their websites Square America and Accidental Mysteries, respectively.[99]

Collections of anonymous photographs became quickly popular. Ten days before Vivian Maier's prints and negatives were first auctioned, an exhibition opened at the National Gallery of Art in Washington, DC, called *The Art of the American Snapshot*.

The show comprised Robert E. Jackson's collection of snapshots, itself compiled from the holdings of more than a dozen snapshot collectors across the country. Afterward, 138 snapshots became part of the museum's collection, canonizing the anonymous snap shooters and establishing those images' artistic value.[100]

It was into this milieu, in early 2008, that Vivian Maier's work was introduced to the public. She was living alone in her apartment near Lake Michigan, while John Maloof first posted her photographs on eBay, presenting them as anonymous imagery and offering them as prints from the digital scans he had made from her negatives.

Maloof had logged more than three thousand transactions since he established his eBay account five years earlier. He sold designer jeans and handbags, as well as movie theater coupons, cookie jars, antique-style brass items, and other tchotchkes that he had apparently acquired in bulk. He described his offerings as "an eclectic array of items ranging from antique reproduction home hardware to collectible figurines and from home and garden items to fashion accessories."[101] In February 2008, Maloof began adding copies of Vivian Maier's "old" and "vintage" photographs to his listings, pricing his prints at between $7.99 and $9.99. (The term "vintage" usually means printed by the photographer or under her direction.) Maloof identified each photograph by an all-capital-letter short description:

NEW YORK STRIP-RAMA VAUDEVILLE OLD PHOTO STRANGE

VINTAGE 50'S OLD NEW YORK PHOTO OF L-TRAIN/MOVIE

NEW YORK JOES RESTAURANT OLD PHOTO PRINT

VINTAGE 50S NEW YORK CHOP SUEY PICTURE PHOTO PRINT

NEW YORK QUEENSBOROUGH 59TH STREET BRIDGE

PHOTO[102]

Maloof eventually sold copies of more than one hundred separate images representing Maier's wanderings through New York, Chicago, San Francisco, and Canada. A couple of the images yielded more than a dozen sales each. Altogether, he sold more than 270 digital reproductions.[103]

In June 2008, Charlotte Jones purchased one of John Maloof's photo reproductions for $9.99. Described as "VINTAGE NEW YORK SHIP LADY BUGGY OLD PHOTO PRINT," the digital print, on borderless eight-by-ten-inch paper, cropped the top off of Maier's square negative as she had framed it in her camera's viewfinder. In the 1950s photograph, a woman standing near the edge of a dock leans over a baby buggy as an ocean liner looms behind her in New York's harbor.[104] Bent at the waist, the woman looks over her shoulder toward Vivian Maier and her camera.

Jones said: "I found it interesting because it's like a still from a film—it makes you think. It makes you want to make up a story about it or find out the story behind it—a desolate dock. She looks either furtive or simply looking up at the photographer. Is there even a baby in the pram? Or is she a mother or nanny simply taking the child somewhere new? I was a nanny in NYC so I related. There is a sense of loneliness about it."[105]

Charlotte Jones, a former New York nanny, bought the photo of someone she thought might have been a nanny, not realizing there was a woman behind the camera who had also worked as a nanny.

1951: NEW YORK NANNY

On April 16, 1951, Vivian Maier made her way once again to Le Havre and boarded the SS *de Grasse* to head back to New York.[106] This was the final leg in a journey that closed a chapter of her family's history.

During her ten days at sea, Maier continued photographing. She shot more than ten rolls of film, maintaining the pace she had established during her time abroad. In addition to documenting the French harbor and the ship's guiding tugboat, Maier recorded parts of the vessel and the crew performing their duties. She perched on an upper deck, coming face to face with a young mariner clinging to a post, and in another view stood level with a dangling lifeboat, photographing a deckhand as he secured its cover and ropes.[107] In a couple of short sequences, she aimed her camera toward the horizon, depicting sunlight

glistening over the water.[108] She repeatedly captured a distant steamship en route to Europe.[109]

On the *de Grasse*'s upper deck, Maier recorded fellow travelers as they lounged on recliners, played shuffleboard, and stood at the rails. On the main deck, she made portraits of bundled-up babies, a small group of kids, and women with children.[110] In a small set of photos, she separately captured a woman, a man, and a mother and baby napping in the sun, closing in on them even tighter than Lisette Model had on her deeply tanned Nice gambler.[111] Maier had to have been standing within four feet of the sleeping figures to achieve her tightly framed portraits.

The *de Grasse* made news on its arrival in America on account of two Brooklyn high school boys who had snuck aboard the ship when it had last left New York.[112] They were detained while the *de Grasse* was en route to France and stayed on the ship until its return to New York. In a set of three photographs, Vivian Maier portrayed two rumpled high schoolers standing by the steamship's railing. In a close-up view and a couple of head-to-toe double portraits, they stand with stoic expressions and gaze into the distance.[113]

Judging from the number of people she photographed, Maier must have become a familiar figure during the voyage. She befriended an elderly woman in old-fashioned black ankle boots who posed for her in various places. In one shot, someone photographed Vivian Maier alongside the woman as they faced the camera holding paddles by a ping-pong table.[114] Maier also appears alone in several photos standing in a long coat and wearing or holding a beret.[115] Looking self-assured, and with a sophisticated air, Maier regards the camera with a serious expression or a slight smile. In one portrait, her wavy shoulder-length hair flutters in the breeze as she stands leaning an elbow on the rail (plate 9). She is wearing her traveling suit with nylons and loafers, a far cry from the bobby-soxer who left America a year ago.

During Vivian Maier's time away, American photo culture most notably changed with the increased use of cameras and the prevalence of color photography. In the month after her depar-

ture in 1950, Kodak had initiated what became a decades-long presentation of the world's largest and most viewed color photographs. At eighteen feet high and sixty feet long, the backlit "Coloramas" illuminated the east balcony of Grand Central Terminal's elegant main concourse, dazzling more than a half-million people each day. Edward Steichen of the Museum of Modern Art (MoMA) sent a telegram to Kodak: "EVERYONE IN GRAND CENTRAL AGOG AND SMILING. ALL JUST FEELING GOOD."[116]

In the summer of 1947, Steichen had become the director of MoMA's photography division. Steichen had continued to evolve with new technologies and cultural changes. During the Second World War, he curated a patriotic-themed photo show for the museum called *The Road to Victory* and directed *The Fighting Lady*, a Technicolor documentary film about an aircraft carrier, which won an Academy Award. Steichen's ideas about photography's mass appeal would dominate MoMA and New York's conceptions of photography for many years. During Vivian Maier's time away, Steichen had led a panel discussion at the museum titled "What Is Modern Photography?" featuring ten "top ranking photographers" and a range of practitioners.[117] The program was transmitted overseas by the Voice of America. There was no consensus on what "modern" meant in relation to photography; several of the ten refused to acknowledge the term, and most suggested that a photographer's approach was simply personal expression. Lisette Model stated, "I want to prove nothing with my pictures. The photographs I take prove something to me. What counts is sincerity, realism and truth. The art of the split second is my means of exploring."[118]

At the end of the summer of 1950, a Kodak marketing research study found that about twenty-six million families—half of America's households—used cameras. Of those, about 90 percent owned box cameras or the type of folding camera that Maier likely used in Europe.[119] The study was reported in the *New York Times'* Sunday photography feature, which presented technical advice and advances, notices of camera club contests and exhibitions, and other relevant news and articles. More than

a dozen camera and store advertisements shared the page's eight columns. New York camera culture was booming.

Three days after Vivian Maier returned to New York, the *New York Times* Sunday Magazine ran a two-page feature, "Photographers Unlimited," accompanied by a collage of eleven pictures depicting photographers of every level using cameras on the streets and in parks: "The outcropping of amateur photographers these spring days suggests that the time is rapidly approaching when there will be more Americans than not taking pictures with Brownies, Leicas, Rolleiflexes, and Graflexes. At latest count there were more than 30,000,000 camera-users across the nation."[120] Still, the relentlessness of Maier's photographic activity would have likely set her apart from all but the busiest professional.

+ + +

In the summer of 1951, Vivian Maier was in Southampton, Long Island, within a wealthy community similar to those in which her grandmother had once worked. A portrait from this time shows Maier with short and styled hair, seated in a garden between two young girls.[121] The sophisticated traveler has transformed into a babysitter in a domestic uniform: a loose-fitting belted shirtdress with nylons and white slip-on shoes. In dozens of instances over the summer, Maier photographed the sisters separately and together at various locations including at the beach, in the pool at the Southampton Beach Club, and amid various flower gardens.[122] When she wasn't watching the girls, Maier wandered along Gin Lane photographing the landscape and places of interest, including Lake Agawam, Saint Andrew's Dune Church, and beach and ocean views.[123] She made posed portraits of people from different social strata: a shirtless field worker, women in aprons, businessmen in summer suits, and elegant women in crisp white dresses and broad-brimmed straw hats.[124] It's possible that the sisters were along during these strolls; they appear amid film shot inside the Old Southampton Cemetery. On the back of one of the prints, she penciled, "Dimanche le 16 Septembre 1951 Premier Cimetier

de Southampton." Sometimes the notations on Vivian Maier's prints are in English, but most often they are in phonetic French; in some instances, French lettering appears over erased English notes: she erased "March 16th 1951 (fri)" and replaced it with "Vendredi 16 Mars 1951."[125] Maier may have been cultivating a French persona, but her formal command of the language was limited because her French schooling had ended at age twelve. Among other misspellings, in every instance of her writing the French word for the month of July, she spelled it as "Julliet" instead of "Juillet."

Maier did not confine her exploration of Southampton to its posh summer beach community. She also ventured to the nearby Shinnecock Indian Reservation and photographed impover-ished Afro–Native American children.[126] In one of the images, French lettering, perhaps hers, appears scribbled into the dirt.[127] The Shinnecock children—who, in the course of three rolls of film, pose alone, in groups, and in pairs—are mostly barefoot and wearing rumpled, dirty, or threadbare clothing. Sometimes they smile slightly, but mostly they appear expressionless. Maier was kneeling or seated on the ground as she shot the photos; standing children peer down at the camera, and in one instance, the camera is at eye level with three children tussling on the grass.[128] One boy, wearing a sweatshirt that says "Camp Red Fox," smiles broadly toward Maier while lying on his back.[129]

A sad-looking girl appears in several pictures, and in one of the solo pictures, her right foot obscures part of several words drawn in the dirt.[130] The fragments appear as, "le ren . . . Rose." The image, together with the one of the boy in the Camp Red Fox shirt, brings to mind the famous novella, *The Little Prince*, by Antoine de Saint-Exupéry. The fable, first published in 1943 and by 1951 a best-seller, contains a passage about a fox and a rose—in its original French, "le renard et la rose." Perhaps Viv-ian Maier knew the story and was relaying a lesson the fox told the prince: "It is only with the heart that one can see rightly; what is essential is invisible to the eye."[131]

2008: THE LAST DAYS IN ROGERS PARK

The summer and autumn months of 2008 marked the end of Vivian Maier's lifelong independence. Even though Maier had mostly lived in other families' homes, she always fought to maintain her own space and the right to freely wander alone or with her camera.

But just as Vivian Maier's independent life was ending, her photography was brightening the lives of faraway admirers. John Maloof was delighting eBay purchasers with prints from her negatives. And while Maier sat anonymously in Rogers Beach Park, her name appeared alongside her photographs on Ron Slattery's Big Happy Funhouse website.

On July 22, 2008, Slattery posted six color images scanned from 35 mm slides he had acquired at the October 2007 auctions. Adding them to a long scrolling page of other photos, Slattery wrote, "The last six slides are from a street photographer named Vivian Maier. I don't know much about her. From the images, I can tell she mostly shot in New York and Chicago 1950s and 60s. I bought a ton of her stuff at a small auction. Part of what I got are 1200 rolls of her undeveloped film. They sit in boxes next to my desk. Everyday, I look at those boxes and wonder what kind of goodies are inside. . . ."[132]

Five of the six color photos depicted men wearing fedoras, including a close-up portrait of a black man gazing out of the frame; a reflected silhouette of a man with a cigar; and a man, head tilted back, drinking from a pint bottle of whiskey. There was also a windy-day frame shot from inside a bus that included a man holding his hat's brim amid a small crowd of pedestrians before a movie house marquee that announced *Dracula Has Risen from the Grave*. The remaining image shows three people sitting on a lawn with an ambulance parked in the foreground. While the images were all Maier's, the selections reflected Ron Slattery's tastes.[133]

A few months earlier, Slattery—who also owned many sleeves of black-and-white negatives from the auction—had brought ten rolls of Vivian Maier's undeveloped black-and-white

film to a Chicago photo lab for processing. The developing and the contact sheets cost Slattery $200, nearly what he had spent on his entire cache of Maier's items.[134]

The randomly chosen film spools contained negatives that were shot between 1969 and 1974, plus one set from 1964. Three of the rolls consisted of pictures of newspapers—some stacked on magazine stands, some spread out across a wood floor, and others open on a lawn (plate 28). One roll contained details of clumps of snow on bare branches and shadow patterns; another presented unsteady shots of flyers on a bulletin board; a separate contact sheet showed overexposed and blurry views of what appeared to be a restaurant where a political gathering was in progress. Other subjects included an evening adult education class and an author at a signing in a small bookstore. One roll showed individual frames, each shot in a different location.

Some frames are entirely overexposed, with one contact sheet presenting only three readable frames: a view from a commuter train of the distant Chicago skyline, an image of the Wrigley Building clock tower, and a marquee of the Blackstone Theater presenting *Waltz of the Toreadors*. All together, the group portrayed a confusing mishmash of subject matter and a variety of uneven exposures. While some frames did stand out aesthetically or for historic value, these were images that Vivian Maier never considered beyond her framing of them in her camera; she had accumulated the latent images as part of a habit she'd been practicing by that time for more than twenty-five years.

In subsequent months, Ron Slattery put up more slides and added some 1950s black-and-white pictures he had scanned from Maier's vintage prints. By early winter of 2008, Slattery had posted more than a dozen images.

+ + +

On November 25, 2008, the Tuesday before Thanksgiving, Vivian Maier got up from her favorite park bench, and then fell. It was around four o'clock in the afternoon—within a half hour of sunset—during an unusually cold month. Maier hit her head

on the concrete sidewalk. Paramedics were on the scene by the time Patrick Kennedy's sister noticed the activity from her first-floor window. She called her brother, who crossed the street as Maier was being loaded onto a stretcher and saw her trying to persuade the paramedics not to take her. Maier turned to him with an expression beseeching him to help release her. He didn't think there was anything he could do, and the paramedics told him they needed to take her to a hospital. It was the last time he saw her.[135]

During the remaining five months of Maier's life, activity related to her photography and recognition intensified. Shoppers on eBay continued to buy John Maloof's reproductions of her work, and Maloof established a separate presence on the photo-sharing website Flickr where, like Slattery, he identified Maier by name. On January 1, 2009, in his first post, Maloof put up a photograph of two women casually sitting facing each other on the railing of Chicago's Michigan Avenue Bridge. Like the prints he sold on eBay, the image was cropped to an eight-by-ten ratio from its original square negative. Maloof titled and captioned the photograph, casually referring to Maier by her first name: "1950s—Vivian Maier. This is my favorite picture of vintage Chicago. I have tons of vintage negatives from Chicago in the 50s and 60s from Vivian and this one really inspires me as a street photographer. The original negative scan has way more detail, as you can imagine."[136]

Two days later, Maloof posted an image of his own, titled, "Dark alley 2009—Homage to Vivian Maier," and then he posted, titled, and captioned another Maier photograph that had inspired it: "Dark alley original 1950s—Vivian Maier. This is made from the original negative from the 50's. I tried to grab the same shot as the photographer did then."[137]

Both "dark alley" photographs were rendered as tightly cropped vertical black-and-white images. Maloof's was shot with a Sony A100, a once-expensive digital camera. Unlike Vivian Maier's Rolleiflex from fifty years earlier—a twelve-exposure film camera that lacked a light meter—Maloof's camera gave instant feedback and could record hundreds of images. Later,

Maloof would say he was teaching himself photography by looking at Maier's negatives; more remarkably, he asserted that Maier herself was instructing him: "Throughout that time, I'd compare my work to Vivian's and think, 'Wow, this isn't good for me.' She was teaching me photography."[138]

During January 2009, while John Maloof delved deeper into Vivian Maier's negatives and Ron Slattery posted eight more images from her vintage prints and slides, they were conversing with each other. Slattery had known Maloof for ten years. He was a friend of Maloof's older brother, and they both frequented local flea markets. Aware of Maloof's interest in Maier's negatives, Slattery agreed to give one thousand rolls of his undeveloped Vivian Maier film to Maloof for a token dollar per roll. It would have cost Slattery tens of thousands of dollars to continue developing the film.

John Maloof learned how to develop film and began processing Maier's undeveloped rolls himself.[139] Within a few months, he began offering single frames of Vivian Maier's negatives on a separate eBay account, and a new group of photo enthusiasts embraced the opportunity to acquire her negatives.[140]

1951: SHOOTING STRATEGIES AND THE STATE OF THE ART

As the summer of 1951 changed to fall, the seasonal Southampton families returned to Manhattan, and their summer help found other work. Vivian Maier's photographs from that autumn establish that she was in Manhattan and illustrate her ongoing practice of seeking out portrait subjects. A September series of people on park benches at the East River Esplanade reveals one of her shooting strategies and demonstrates a benefit of using a camera that does not shield the photographer's face.

The bench-lined promenade provided stationary subjects and allowed Maier to approach individuals as they sat facing the water. The narrow green provided a convenient portrait studio as she moved along the pathway and homed in on people. Her subjects—distinguished older men, smiling elderly women, a

boy with his dog, and a girl with her doll—appear at ease, and their positions in relation to her waist-level lens give the impression of eye-to-eye encounters.[141] Conspicuously absent from these photographs—which her penciled notations indicate were shot on two Sundays—are young men and women close to Maier's own age.

Vivian Maier's waist-level periscope-style viewfinder also made it easier for her to photograph another subject that permeates her life's work: people asleep in public places. These motionless individuals presented Maier with the opportunity to capture subjects at even closer ranges. The push-pull fascination of intimate scrutiny, mixed with the danger of being discovered, carries through in images of men sleeping on the benches. Unshaven and attired in torn and threadbare clothing, they are stereotypical 1950s' "bums."[142] Vivian Maier had photographed the same type of "ragged" man at the Saint-Bonnet market, but these sleeping men were not aware of her presence.

Inquisitiveness—and even voyeurism—is the basis of on-the-street photography. The tradition of photographing New York's less fortunate dates back to Lewis Hine and the earliest documentarians who worked for social change. Maier's photographs read less like vehicles for social change than up-close studies of unwitting subjects. What comes through clearly, however, is Maier's boldness as a twenty-five-year-old female photographer.

In some of her long series of "sleeping man" photographs, Maier comes progressively closer, as if telescoping in on the figure. But her lens doesn't zoom, and visualizing her steps toward the sleeper makes the images feel even more daring. In two pictures in the East River Esplanade series, Maier photographed a man lying on his back. He first appears from the waist up in a view that indicates she had been hovering over him; the other image, shot even closer from a different angle, shows that either she returned or the man stirred because his head is now turned and his fedora covers his face.[143]

Vivian Maier's remaining 1951 photographs cover outings and events and continue established threads. But one grouping from this period stands out as uncharacteristic within her

entire oeuvre. In this series, which reads as a planned portrait session, Maier photographed three dark-haired Italian sisters—Serafina, Beatrice, and Anna Randazzo—in a variety of pairings and poses on the roof of their apartment building. The resulting portrayals are awkward and unflattering.

The Randazzo sisters had lived in a five-story walkup on East Sixty-Third Street their whole lives, just yards away from the massive Sixty-Fourth Street apartment complex where Maier had lived with her mother. The eldest, Serafina, and Maier were born within weeks of each other.[144]

Maier posed the young women in different places—or perhaps the sisters chose their own poses—and the results appear as a combination of glamour shots and typically arranged family pictures. Popular photo magazines and camera club "cheesecake" photographs of stereotypically feminine women had clearly influenced the women's affectations. As a group or in pairs, they took more traditional stances, but individually the sisters mostly struck "girly" poses and sometimes gazed dramatically out of the frame. In one photo, the middle sister put one hand on her hip while she ran her fingers through her hair and smiled down toward the lens.[145] The majority of the individual portraits are of Serafina, who mostly grimaces and appears inelegant in her forced poses.

The rooftop was not much of a studio for glamour shots. The chimneys, tar-spattered parapet, a television antenna, and a stairway-access bulkhead consistently overpower the compositions, making the portrait session seem strange and a bit silly. Also, Maier's habit of facing her subjects toward the sun encouraged squinting, while the glaring overhead light hardened the women's features and created deep shadows that often blocked out their eyes. The series suggests that Vivian Maier's photo talents did not include deliberately flattering or conventionally provocative female portraiture. Or perhaps more experienced and agreeable models would have helped.

Several of the rooftop photos included views of neighboring buildings with glimpses of fire escapes and hanging laundry. At some point during or after the sisters' session, Maier wandered

around the roof and photographed a locked cage full of homing pigeons, a popular feature of certain New York rooftops of the time; she also recorded a panorama of the western skyline.[146] The latter two pictures, much more indicative of Maier's work, excel as lasting images for their evocation of a specific time and place.

Within a couple of weeks, Maier was photographing from an even taller building across the East River in Long Island City, establishing an ongoing choice of vantage point that harked back to the French Alps. Maier's top-of-the-world perspective makes Queens and the scene across the river appear like the postcard views from her year abroad. Her soaring panoramas depict rare landscape views of 1951 Manhattan and Queens.

The twelve-story Chatham and Phenix Bank Building was the largest structure in Queens when it opened in 1928. At the base of the Queensboro Bridge, the building anchored Queens Plaza, then being hailed as a center with potential to rival Times Square. By the time Vivian Maier frequented this crossroads, it hadn't achieved that lofty goal but had become a major transportation hub.

What really distinguished Queens Plaza, though, was its extravagant proliferation of signs. Billboards populated the major thoroughfares into it. Nearby factories had crowned themselves with gigantic lettered and illustrative signs. As early as the 1910s, the Packard automobile plant boasted that its lit-up twenty-foot-tall sign could be seen for miles, and in 1914, a cookie company had topped off its new factory with a six-hundred-foot-long wraparound sign using four thousand light bulbs.[147] Neon technology had recently extended to animated graphics that danced on a massive network of metal supports.

The Chatham and Phenix Bank Building had joined in the activity in 1946. Spanning the width of the block-long building, a spectacular multipart blinking series of lettering heralded the Lockheed Constellation airplane. Towering over Maier's head, words flashed on and off in sequence, surrounding a constant image of an airplane in flight: "Fly, Fly, Fly, Lockheed, Constellation, West Coast, Chicago, Latin America, Europe."[148]

When the building opened, its offices were filled with law-
yers, architects, and other professionals. By 1950, tenants also
included offices of various government agencies and a half-dozen
private employment agencies.[149] It's hard to say what brought
Vivian Maier to the building, but obviously someone gave her
access to the roof. She photographed from that vantage point
repeatedly over several years.[150]

It's also not clear what connections led to Maier's next job,
but she ended up caring for the children of a jet-setting family
that took her along on their travels related to the sugar industry.
The first stop was sunny Cuba. Camagüey, three hundred miles
from Havana, had an international airport and a thriving sugar
cane industry. In addition to photographs of a young blond girl
posing in the crook of a tree—its back marked "Mr. and Mrs.
McNulty's daughter"—Vivian Maier documented the spindly
stacks of the Francisco Sugar Company's refinery and drifted
from the complex to photograph a group of natives much as she
had arranged schoolchildren in the Champsaur Valley.[151] The
Cuba photographs cover the same themes as the French village
pictures in the way Maier approaches the landscape and portrays
the locals individually and in orchestrated clusters.

The American entourage continued on to Amancio—another
sugar town near Cuba's southern coast—where Maier gravitated
toward the local primary school and arranged sixty-five children
for a group shot.[152] The entire student body agreeably focuses
on Maier and her camera. Another group portrait appears like
an ethnographic study: a racially mixed, orderly mass of chil-
dren and adults stand between dilapidated thatched-roof dwell-
ings.[153] Maier's ability to organize and achieve cooperation in
such a mingling of individuals is a testament to her ease and
comfort in a broad range of environments.

After ten days in Cuba, Vivian Maier went with the family
to Savannah, Georgia. She documented Broughton Street, with
its festively draped lights, then backed up to widen her view to
include the chimney stacks of the Imperial Sugar Company.[154]
All of Maier's travel photographs through the end of 1951, with
their balanced compositions and posed portraits, do not resemble

the street photography for which she initially became known, but they clearly demonstrate her ongoing documentation of her surroundings.

Vivian Maier's photographs reveal her footsteps; they demonstrate her evolving strategies and disclose her access to places and milieus. Traveling with a wealthy family provides license, and operating a camera gives activity a sense of purpose. Privileged access was extended to Maier's employers' children, the real point of her contact with other worlds. At the end of November, she achieved a first-class spot among a tight throng of children along the balcony of the Hotel Astor in Times Square. She was there to watch the Macy's Thanksgiving Day Parade, and the elevated and front-row position gave her the best view of the spectacular event. Frontal views of enormous balloon characters fill the frame and dwarf the background. The giant toy soldier, Mighty Mouse, and a rotund clown glide past at eye level.[155] Maier shot at least three rolls of film during the parade, and her sequence of the event is a thorough historical document. But her last shot stands out as a lasting exclamation mark and attests to her extraordinary power as a photographer.

The famous Thanksgiving procession climaxes with the arrival of Santa Claus, who ushers in the Christmas season. As Santa's float wheeled by the Hotel Astor, and as the sleigh and reindeer filled her viewfinder, the man in the red suit who was the focus of everybody's attention turned and looked directly up at Vivian Maier. The photo's framing includes hundreds of people packing the sidewalk on the other side of Broadway, all of whom appear to be laughing and smiling for her camera.[156] This is Maier's most spectacular group portrait and illustrates her awe-inspiring confidence.

+ + +

In this same week, *Life* magazine was announcing the ten major winners of its "Contest for Young Photographers."[157] Its awards of first prizes of $3,000 and $2,000 for two divisions—"Picture Story" and "Individual Picture"—were part of a total

of $15,000. Three of the ten winners were women—and one was pictured on the magazine's cover with her 35 mm camera held to her eye—showing their visibility in the field and providing role models for young girls. The magazine reported that the best photographers "were interested, primarily, in the emotions and experiences of people, and these they recorded with clear-eyed honesty and perception."[158] Several of the winners' names and photographs remain familiar today—for instance, Elliott Erwitt, Robert Frank, and Ruth Orkin.[159]

Also at the same time, the Museum of Modern Art was having a Christmas sale of photographers' prints. Mounted photographs by Edward Weston, Lisette Model, Berenice Abbott, Aaron Siskind, Ansel Adams, and others were offered for prices between $10 and $25 each. In reporting on the sale, the *New York Times* stated, "The Museum of Modern Art's pioneering in this field for the benefit of photographers could set a significant pattern. The time may yet come when photographic art in its best form may have a ready market through art galleries to private collectors. And perhaps some day great photographs accompanied by canceled negatives may command—and deserve—prices commensurate with the artistry that goes into them."[160]

Chapter Five

New York Street
Photographer / Viral Vivian

John Maloof began selling Vivian Maier's negatives on eBay in
early spring 2009. Maier had been hospitalized since her fall late
in 2008, and unbeknownst to him was twenty miles away in a
north suburban nursing home.[1] Individual frames that he had
cut from the processed film were first offered for a minimum
of $4.99, and a small crowd of eBayers quickly recognized some-
thing special. While Maloof was selling dozens of negatives,
Vivian Maier's health was rapidly declining. She died on April
21, just as a disparate group of strangers began celebrating her
photographic work.

Englishman Philip Boulton, a photographer and graphic
designer, first noticed Maier's negatives as he was routinely
perusing eBay.[2] Maloof's headings "VINTAGE CHICAGO STREET
SCENE CARS PHOTO NEGATIVE" and "VINTAGE 60s FINE ART
OLD YOUNG GIRL PHOTO NEGATIVE" led Boulton to Vivian
Maier's meticulous compositions, shadow play, and other now rec-
ognizable signature features of her street photographs. Certain
images made him laugh and others were captivating for their
attention to light. Boulton collects anonymous images, tweaking
and collaging them into his own products. He buys what catches
his eye and ends up mostly filing away his favorite images,
leaving them untouched. After minor bidding wars, Boulton
won his first two Maier negatives at the end of March 2009.
Both were identically described: "VINTAGE 60s CHICAGO PHOTO
NEGATIVE LOOP STREET SCENE." He paid $26.00 for each of
the 2¼-inch square pieces of film, plus shipping to England.

Philip Boulton eventually acquired twenty-six negatives, and

his collection is a fairly accurate representation of what became Vivian Maier's entire oeuvre. He has signature themes: a sleeping man; legs; women with unusual hair or wearing hats, shot on the sidewalk at close range; people from behind; projected shadows; and leaves on the ground. A missing subject is a small child or a baby in someone's arms, but Boulton wasn't drawn to that theme. Such photos appear in other eBayers' collections, as do variations of her self-portraits.

When shipping negatives, John Maloof would often throw in images that he seemed to find less compelling. Boulton bid on a negative of an unshaven disheveled man in a dirty white suit; he received two negatives, which together show how Maier interacted with the man (plate 21). In the first picture, as she and her subject are approaching each other, the man looks suspicious of her. In the second, more conventional street portrait, he has warmed and there is an agreeable rapport.

In Helsinki, Finland, eBayer Kimmo Koistinen, a journalist, was also bidding on Vivian Maier's work. Koistinen summed up his favorite acquisition: "Among this writer's most valued, most important photographic findings ever, are several taken by Vivian Maier in mid sixties. Perhaps the most fascinating one has three separate features in it: an old bag lady searching routinely through the trash bin; a somewhat younger heckler trying to irritate or get attention and then the final touch; old, beaten up Checker taxi cab looming in the background, like a silent witness for all the grimness and unkindness of the big city."[3] This image, listed as "VINTAGE CHICAGO STREET HOBO LADY OLD PHOTO NEGATIVE," sold for $8.99. Nobody else put an offer on it.

In some of John Maloof's listings of Vivian Maier's negatives, he mentioned that he was selling negatives from old film that he was developing; according to some accounts, he named Maier as the photographer, and he also offered eBayers the opportunity to purchase the remaining rolls of undeveloped film in bulk.[4] His entrepreneurial production and sales of Maier's film and negatives was logical, and it found an eager audience.

Twenty-four-year-old Benjamin Wickerham was an eBayer

living in upstate New York who had recently finished an undergraduate degree in digital art and art history at the Pratt Institute. Four years younger than Maloof but versed in the world of photography, Wickerham first encountered Vivian Maier's negatives in April 2009:

I was working with the Jenny Holzer Studio when I began purchasing photographs, snapshots, and negatives that caught my eye. When I first stumbled across the Maier negatives, I knew instantly that they were special and quickly purchased several that caught my attention. I remember that the listing mentioned they were purchased at auction and that there were hundreds or thousands of developed and undeveloped rolls of film. They were offered for sale as a lot, and I quickly inquired. I was offered the lot for approximately $3000 and I contemplated the purchase for some time before deciding it was not realistic financially at the time. This may seem silly to say, but it is one of the biggest regrets of my life.[5]

Another eBay negative purchaser also remembers a $3,000 offer for Maloof's entire lot of negatives but recalls the details differently.[6] The series of events on eBay in spring 2009 is a bit foggy today. And memory plays tricks.

Some buyers remember Vivian Maier's name as part of the listings' description, but others don't. At least three bargained with Maloof to purchase the bulk of negatives, but not all agree on who initiated the negotiation, and it's not clear whether he was selling negatives or what was left of the still-unprocessed film. One person relayed that a friend was trying to raise $15,000 to buy the entire collection of negatives and rolls of film; but before they could raise the funds, the works were taken off the table.[7]

In addition to Boulton and Koistinen, a woman in Canada purchased eBay negatives; their three collections account for around seventy-five individual frames.[8] In the United States, Vivian Maier negatives were sold to people in at least a dozen states, from New Jersey to Washington. All in all, Maloof sold around two hundred individual negative frames before he stopped listing them on eBay.

One of the American buyers was Allan Sekula, a prominent artist and theorist, best known for his photographic projects and critical writing. For more than three decades, Sekula taught at the California Institute of the Arts and other universities, and his photographic works are in more than thirty international museum collections. With his early essays, including 1975's "On the Invention of Photographic Meaning" and 1986's "The Body and the Archive," Sekula helped educate generations of art and photography students.[9] He had now stepped into Vivian Maier's world, and his presence slowly started the wheel of her recognition turning.

After Sekula bought a couple of negatives, he and Maloof began corresponding. On April 16, 2009, Maloof offered the undeveloped film from which he said the eBay offerings were derived. Maloof explained that he had already processed two hundred rolls and more than 750 remained undeveloped. After estimating one in ten images as salable on eBay, he suggested those individual items added up to a potential gross of $10,000. Maloof said that he had earlier offered the entire lot to another buyer at a higher price, but that he was now willing to part with everything for $2,500 because the burden of selling was starting to encroach on his real estate practice.

Allan Sekula responded by saying that he didn't intend to sell negatives on eBay or anywhere else and that he would just as soon continue to buy a few at a time from him at the auctions; he was just interested in Chicago photography from the 1940s through the 1970s. He did offer to try to get Maloof some publicity to help him sell his negatives, adding, "The problem of course is that the work gets dispersed."[10] Sekula was thinking about the negatives as part of Maier's larger body of work, her entire archive.

By this point, Sekula had already begun researching Vivian Maier by Googling her name, which led him to Ron Slattery's Big Happy Funhouse. He mentioned to Maloof that he found a reference to Maier as a "New York street photographer" and asked if Maloof had acquired any proof sheets or prints at the auction, implying that those might reveal more about Maier's

methods. He also inquired whether there were any dates or notations on the rolls of film. Sekula was trying to contextualize Maier's work within the medium's history and saw her activities as steps in a traditional photographer's process.

Speculating about Maier's hundreds of rolls of unprocessed film, Sekula suggested to Maloof on April 20, "She must have hated the darkroom, and simply let her unprocessed film accumulate: it's a weird short-circuit in a typical photographer's working process."[11] In contrast to everybody who was thinking of Vivian Maier's pictures as compelling anonymous snapshots, Allan Sekula approached her negatives with curiosity about the photographer. This first acknowledgment and consideration of the woman behind the camera occurred the day before Vivian Maier died, as Sekula discovered just days later.

On the day that Vivian Maier's obituary was published in the *Chicago Tribune*, Allan Sekula sent an e-mail to Ron Slattery, inquiring about his collection of Maier materials, possibly for purchase: "Can you give some more idea of what you have by Vivian Maier. Format, condition, price, jpegs."[12] Slattery responded four days later by offering to direct Sekula to another individual who had acquired the bulk of negatives at auction: Randy Prow, who had acquired considerably more material than Maloof at the second auction of Maier's storage locker items. Slattery had already tried to buy Prow's negatives, but Prow was asking more than he thought was fair. Slattery told Sekula, "Right now he thinks they're gold bars."[13]

In his follow-up e-mail, Sekula sought to confirm that Maloof's undeveloped film was definitely Maier's: "Was undeveloped film attributed to Viviane [*sic*] Maier sold at the auction[?]"[14] Slattery replied that it was and said that he had bought many unprocessed rolls that he subsequently sold to someone who was developing them and offering the negatives on eBay. Without mentioning Maloof by name, Slattery offered to get Sekula the undeveloped rolls that Maloof had already pitched to him.

Allan Sekula's e-mail exchange with Ron Slattery occurred just as he discovered Vivian Maier's obituary. The following

weekend, Sekula came to Chicago for an art history conference. Operating on a hunch, he seized the opportunity to continue his detective work.

Sekula's wife, Sally Stein, also a noted writer and photo historian, had published extensively on twentieth-century American photography and was then working on a set of essays about the photographer Dorothea Lange—though she did not share Sekula's passion for Maier. In an e-mail to Stein, Sekula detailed his Chicago weekend, beginning with his gut feeling: "Crazy Day May 2: figured out that the old hands—of which there are several—at Central Camera (since 1899) would know Vivian Maier and indeed they did and I have a video interview to prove it."[15]

Sekula had presumed—correctly—that Vivian Maier frequented downtown's century-old Central Camera photo supply shop. His sleuthing had brought him to the doorstep of Vivian Maier's sanctum. The shop was celebrated as "Chicago's Most Complete Photographic Store" and its oldest. The building's 1930s-era green-and-yellow sign remained intact, its red neon stripes flickering underneath the Wabash Street elevated train tracks. Inside, the long narrow shop presented a corridor of glass cases and counters loaded with new and old cameras of all types, along with a plethora of film, paper, and darkroom supplies.

The camera store had been owned by the Flesch family for three generations and had maintained the same dedicated employees for decades. Unlike her Rogers Park neighbors who knew nothing about the nameless eccentric in their midst, Maier had from time to time in the past shared select personal information—and her passion—with these fellow camera and photography enthusiasts, who remembered her well but hadn't known about her death until Sekula told them of it. These old-timers recalled Vivian Maier from as far back as the 1970s. They knew her name from the envelopes that they sent off for developing her film, and she had been a steady customer. She was tall, wore hats and big coats, and always carried a Rolleiflex. As Sekula told Stein, they said that "she baby sat for a living, which explains the various children in her photos. She always

overdressed, which sounds like the habit of a refugee, wearing all her clothes at once. She was a tough customer, it turns out, but did indeed love going to the movies, as long as they weren't American. Did not have a lot of money to make prints or even develop film, or perhaps preferred sitting in the dark theater to standing in the dark room over stinky trays of fixer."[16]

The countermen also remarked that Maier was very particular about the work they did for her. However, they didn't specifically recall Maier's photographs; everyone who came into the store was a photographer on some level, and she seldom shared her work. Vivian Maier mostly stood out because of the way she looked, her personality, and her consistent presence over the years. Still, they hadn't seen Maier for quite some time.

However—and however inadvertently—the Central Camera men initiated two tropes about Maier: either Maier invented the stories that she told people about herself or others presumed things about her. As a result, Allan Sekula left Central Camera believing that Vivian Maier came to the United States as a Jewish refugee of wartime France.

Sekula's was the first interpretation and articulated impression of Vivian Maier's photography process and persona, and it set the groundwork for attempts to understand Maier through what she saved, how she looked, and what she chose to share of herself.

VIVIAN MAIER'S AWAKENING

The city seen from the Queensboro Bridge is always the city seen for the first time, in its first wild promise of all the mystery and the beauty in the world.

F. SCOTT FITZGERALD, THE GREAT GATSBY

The Great Gatsby's New York reverberates throughout Vivian Maier's photographs, even thirty years later. The Queensboro Bridge was Maier's artery between Manhattan and Queens; and in early 1952, New York was a reprieve from her latest babysitting job, thirty miles away in Brookville, Long Island. Maier's

pictures from this time show a toddler and family members, the interior of their grand home, and the estate's wooded surroundings but also periodic excursions to Manhattan.[17] As she trolleyed across the Queensboro Bridge, she'd pause midway to photograph the East River from the stop at Welfare Island (now Roosevelt Island), also recording city views and elements of the bridge itself.

The early 1950s were a vibrant time in photography and camera culture, and New York City was the epicenter of activity. The availability of many types of cameras encouraged every level of expertise, and magazines and newspapers inspired a burgeoning generation of documentarians. The *New York Times'* weekly photo page featured spectacular ads that made camera shops thrilling destinations. Taking up as much column space as movie house listings, the businesses played at outsizing one another: Willoughby's was the "World's Largest Camera Store," while Peerless Camera boasted "The Largest Display of Cameras in the World!" Shops that couldn't compete with quantity developed enticing cost-centered taglines, including Abe Cohen's Exchange, "The House of Photographic Values"; Penn Camera, "Famous for Fairness"; and Olden, "Cameras at Impossible Prices." With a more affable approach, Minifilm Camera Exchange claimed to be "Where Customers Become Friends." More than twenty camera stores worked to make photographers out of all New Yorkers.

Recreationally, there were camera clubs that encouraged a pictorial sensibility and emphasized experimental techniques, while others focused on outings with hired female models. In addition, New York was vibrant with higher-minded discourse and learning opportunities. In particular, the Museum of Modern Art presented ongoing photo shows and programming, and the New School for Social Research offered classes and public exhibitions. With the help of faculty member Berenice Abbott, the New School mounted an enormous exhibition of Eugène Atget's Paris street photographs—made easier by Abbott's ownership of thousands of Atget's prints and negatives.

In its coverage of the exhibition, the *New York Times* com-

mented that the French photographer seemed to like and record "nearly everything" that he saw, and acknowledged Atget's importance to contemporary photographers: "Today he is recognized as a forerunner of the documentary movement, despite the fact that his pictures were never the commentaries on society that documentary photographs later became, but only personal notes on the beauty he saw in the world around him."[18] The article also credited Berenice Abbott with rescuing the master's glass negatives and noted that Abbott had made many of the prints in the show.

Another New School faculty member, Lisette Model, was also featured in the *New York Times*. In an op-ed, Model put forward her idea that photography was a method of pure recording through sensitive seeing: "To make an experimental picture is the easiest thing in the world. But try to put life into a subject, and a strong organization of elements, and see how difficult it is. As for composition, this is not a separate entity, but grows out of the content of the picture."[19]

The museum also mounted an exhibition that further aligned with Vivian Maier's background and evolving photographic inclinations: *Five French Photographers*. On the morning of January 24, 1952, on her way to the museum, Maier photographed the Queensboro Bridge from the Manhattan side.[20] Standing nearly underneath its hulking mass at Fifty-Ninth Street and Sutton Place, her photo shows the bridge's delicate ironwork reaching over the river. Maier also aimed upward and framed a looming twenty-five-story-tall steam chimney stack, echoing her sugar refinery photos from a few months earlier. Completing the set, two separate views from under the bridge show the sidewalk descent toward her old East Sixty-Fourth Street neighborhood.[21] It was still morning when she arrived at the museum.

Maier recognized a famous artist near the museum's doorway. The surrealist painter Salvador Dalí was giving a young woman his autograph. Maier stayed back on the sidewalk outside the curved stainless steel canopy, and hiding slightly behind a wall, she quickly framed a slightly tilted shot.[22] Then she

ventured underneath the canopy for a second shot.[23] This time, the flamboyant Spanish artist appeared to be flirting with the autograph seeker. Dalí crossed a leg and dashingly leaned on his cane while the young woman hugged a stack of papers and laughed coyly. Neither of them seemed to be aware of Vivian Maier's presence, ten feet away.

When Dalí left the entryway, Maier ensnared him against a railing.[24] Unlike her street portraits of agreeable subjects, and in contrast to Dalí's reaction to his last female encounter, he does not smile or appear relaxed. Maier captured the usually outrageous painter, famous for his dramatic flair, as uncharacteristically diffident and restrained. He looks warily down at the camera, almost grimacing from the direct sunlight. From the camera's low vantage point, Dalí towers like a chimney and looks like a glowering businessman; his comically upturned mustache is the only visible trace of his colorful persona. The portrait stands out for its contrast to both subjects' best spontaneous and expressive works.

Inside the museum, *Five French Photographers* was a celebration of spontaneity. Through the work of Brassaï, Henri Cartier-Bresson, Robert Doisneau, Willy Ronis, and Izis, New Yorkers saw new ways of framing everyday activities. The *New York Times* hailed the show for its freshness and emphasized that the men were simply utilizing, "ordinary material available to anyone who is willing to take a good look at his world."[25] The Frenchmen photographed in an unaffected way, recording their encounters through expert framing with a sensitivity to people and their surroundings. The exhibition presented unframed photographs—printed to the edges of the paper—directly on the museum walls.[26] In addition to the selective in-camera framing, the photos were further cropped in their presentation, emphasizing ultimate control through the printing process.

Vivian Maier's French background is evident throughout her photographic oeuvre. For example, soon after seeing the MoMA exhibition, she took a picture in Bryant Park that she later marked: "Mercredi le 13 Fevrier 1952, west 42nd St. N.Y. two French women who were looking for Lane Bryant."[27] The

wide-angle shot of the seated women in their tasteful gloves and hats also depicts a third, unacknowledged individual: further along the park bench, a man eating a sandwich averts his eyes and looks slightly annoyed to be part of the picture. Maier clearly intended to include him; the bench was her centered subject.

In early spring, Maier returned to East Sixty-Fourth Street, where she repeatedly photographed her old apartment building as a backdrop to casually posed neighbors, and she returned to the East River Esplanade.[28] She photographed bundled-up children at a small park at East Seventy-Eight Street and found older men huddled around a makeshift bocce court on the barren open ground at East Forty-Ninth Street, adjacent to the new United Nations complex.[29] On a blustery Sunday, Maier hung out as the only female spectator. Edging her way courtside, she took a couple shots of the action, and then, after waiting out the match, she made several individual portraits.[30] She would return to this desolate spot often during the construction of the United Nations complex.[31]

Vivian Maier's photos during this time illustrate her free-floating independence. She explored Central Park, expanding her sleeping man repertoire by circling splayed-out dozers— eventually including women and babies—on grassy fields, and she strolled Fifth Avenue, photographing friendly carriage men by their horses at Fifty-Ninth Street. On one jaunt, she spotted a famous actress in conversation with some fans, but Maier did not pursue her further after photographing from a distance. She penciled on the back of the print, "Beatrice Lilly [sic] english comedienne."[32]

A notable shot reveals Vivian Maier's movements and shows an affinity with the French photographers who portrayed Parisian lovers on the street. But, unlike their pictures' split-second timing or amusing juxtapositions, Maier's photo, taken at the south fringe of Central Park, reiterates her stalking technique. It appears that Maier crept up a hill behind a couple embracing on a park bench. She framed them between some narrow trees with the elegant Plaza Hotel as the backdrop. The resulting

photograph shows the woman turning backward and smiling toward the camera.[33] It's hard to tell if she is acknowledging Vivian Maier's presence with derision or if they had a friendly exchange, but the picture clearly illustrates the effect of the photographer as an outsider. Maier's ongoing bond was apparently with her camera, through which she connected to the world.

Vivian Maier now had a new babysitting job that kept her in Manhattan, and she was, in 1952, slowly making New York's streets her own. The Upper West Side was her new base, and the children along Riverside Drive became new subjects. As the city warmed, benches filled and Riverside Park became a playground. Along with babies and toddlers in buggies and strollers, older children clustered and invented games, as parents and nannies sat nearby. Dozens of Maier's photographs portray this community and setting along the Hudson River.

Maier's new charge was a rambunctious dark-haired girl. Around six years old and missing her two front teeth, she often dressed in Western wear, complete with boots and a gun with belted holster. The girl nearly always wore a Band-Aid across her knee or shin, and she usually seemed game to pose for Maier's camera. She mostly played around boys and appears with a small group of them on bicycles, hers with well-worn training wheels.[34] Other photographs show sets of girls with baby dolls.

The dark-haired girl, who looked of mixed-Asian descent, lived with a Caucasian couple who seemed old enough to be her grandparents. Their elegantly appointed flat, on one of the top floors at 340 Riverside Drive, overlooked Riverside Park at 106th Street. Vivian Maier photographed the living room and took advantage of its elevated vantage point to make a series of panoramas of the Hudson River, including one where she leaned out of the window for a north view that included the side of the building; she also managed to get onto the roof to record Manhattan from her top-of-the-world perspective.[35]

Through June and into July, in the guise of babysitting outings, the dark-haired girl accompanied Vivian Maier on photography excursions. On these jaunts, which included trips through Central Park and to Liberty Island, the girl wore freshly ironed

cotton dresses. In Central Park, Maier photographed the girl sitting tableside next to an older man playing chess, and then, recognizing the position with the best light, she interrupted the match by alternatingly posing the man and his opponent from the same seat.[36] On Liberty Island, the girl appears as a solitary distant figure amid the landscaping.[37] The two seemed an amicable and adventurous pair.

In early summer, Vivian Maier took the girl to New Jersey's Palisades Amusement Park, where she played in a wave pool that lapped at a narrow sandy shore of manufactured beach. Maier photographed the girl at the water's edge, and then she turned and captured an image of a couple lying like lovers on the sand (plate 10).[38] The framing of the picture makes it seem as though Maier is in the midst of a large and densely crowded beach. A man reading a comic book and a metal garbage can flank the couple, resulting in a jarring juxtaposition of public and private.

Within the next couple of weeks, Vivian Maier's photography changed dramatically, marking the next chapter of her life as a photographer. In the middle of July, as New York was entering a historic heat wave, her negative frames suddenly became square-shaped. She had begun using a Rolleiflex camera, a sophisticated and expensive German device that was well known as a journalist's or magazine photographer's camera. Although the Rolleiflex was clunky and hung like a brick on a neck strap, wearing one made a photographer look professional.

Four of the five French photographers in the MoMA exhibition used a Rolleiflex. (Henri Cartier-Bresson preferred the quickness of the smaller 35 mm Leica.) For Maier, the new square format meant that she could shoot three more negative frames; her folding camera allowed only eight pictures on the same 120-format film. It is unknown how Vivian Maier was able to afford this camera that retailed for more than $200 (around $1,800 today); she likely tapped into her inheritance. Some of her earliest Rolleiflex pictures were shot within the Riverside Drive apartment's living room. Dressed in shorts, her heat-wilted employers sat obligingly for Maier's new camera.[39]

This was not the only change at this time, for she seems to have accessed a darkroom in a facility that also offered a photography course. The summer of 1952 marked Maier's birth as a serious street photographer.

2009: VIVIAN MAIER PHOTO BLOG

Allan Sekula did not tell John Maloof about his Vivian Maier research and his visit to Central Camera. Since his suggestion on April 20 that Maloof not disperse Maier's work, six eBayers— including Sekula—amassed another couple dozen negatives from his archive. And in May and June, fifty more negatives arrived at the scattered addresses of budding Vivian Maier collectors.

In the middle of all this activity, John Maloof established a Blogspot site that presented Maier's work, much as Ron Slattery had done nearly a year earlier.[40] On May 18, under the heading "Vivian Maier—Her Discovered Work," Maloof posted five images. Cropped from her square negatives to the same shape as the rectangular prints he had been selling, his assortment did not represent Maier's impeccable framing and quick eye. However, the work did show four ongoing subjects: women in hats; an urban landscape from an elevated vantage point; people watching an event; and someone seen from behind. Even random selections of Maier's work showed her consistent thematic threads.

Allan Sekula bought his last Vivian Maier negative on May 30, but he continued his research and the consideration of her work within a broader context. On June 6, Sekula e-mailed Maloof, saying that he'd stumbled onto his new photo blog—which by then was displaying thirty-eight images—and remarked that he had read Maier's obituary and also discovered some details about her life. Sekula asked if Maloof still had those negatives. He again nudged Maloof: "I would love to see some sort of exhibition of her work, but this would require institutional support. Of course, the fact that her negatives are being dispersed to private buyers does not help on that count, although I understand

absolutely that you need to realize a return on your considerable and careful effort."[41] Sekula was considering showing prints from his Maier eBay negatives as part of an upcoming Chicago exhibit of his own, "as a supplement on the unknown history of Chicago street photography," offering that it would "help draw attention to her work."[42]

Maloof asked Sekula what he'd learned about Maier's life, lamenting that he had been unable to uncover anything about her himself. Maloof agreed that the dispersal of Maier's negatives was not ideal and said that he was discontinuing the eBay sales. He conceded that he hadn't realized how good Maier's photography was and mentioned that he, too, was considering an exhibition of her works.

Sekula told Maloof what he had been told by the Central Camera men and said that he was glad the eBay sales had stopped. He added that he would let friends who had a gallery in France know about the new website, and signed off, "I hope you can answer me yes that you still have the negatives of the pictures posted on your blog."[43]

In the next few days, John Maloof came to recognize that Allan Sekula was an important figure in the world of photography. He then wrote Sekula to ask his opinion on publishing a book of Maier's photographs, based on the quality of the images on the new website. Sekula replied that he thought a book would be appropriate, but that editors would be concerned that Maier never saw the photos, "except at the moment she made the exposure," adding, "it will take a photo publisher with an unusual interest in the mystery of her work."[44] Sekula had misunderstood that Maloof was referring to the 1950s New York work he was posting, not the previously undeveloped film from the 1960s and 1970s in Chicago from the eBay listings, but the mystery of her work was a key point for consideration.

During the time that John Maloof was selling Vivian Maier's negatives and digital prints from her negatives, he was also learning about photography. After he first introduced Maier's name and photographs on Flickr on New Year's Day 2009, he bought an old Rolleiflex camera like the one he had seen Maier

holding in her self-portraits. He had taken classes at a local junior college and built a darkroom in his attic. By the time he started listing the negatives for sale, he had already developed two hundred rolls of Maier's film. But it was only after processing the first hundred rolls that he realized he should be compensating for issues related to forty-year-old film emulsion.[45]

He began posting his own work and hers on Blogspot.[46] Both sites on Blogspot presented black-and-white images on a solid black background, and together, under the titles *Vivian Maier—a Photographer Discovered* and *John Maloof, Chicago Street Photography*, Maloof established his new venture into the world of photography.[47] The imagery on Maloof's personal website did show evidence of Maier's influence: his twelve photographs posted between June and August 2009 included a seated mother with a sleeping child, people from behind, and a group sitting on a park bench. He soon abandoned the Blogspot account and replaced his real estate website (johnmaloof.com) with his new photo blog, "John Maloof, Chicago Street Photography."[48]

By September, 115 Vivian Maier images—including one of the Riverside Drive dark-haired girl eating a hot dog on Long Island's Jones Beach—populated Maloof's Vivian Maier website. Sekula didn't end up including Maier's photographs in his exhibition, which would have formally introduced her works within an esteemed art venue. Sekula had been thinking of representing her as part of an unexplored history of Chicago photography, and the context might have made her a historical footnote. But Maloof was thinking of other, broader outlets for her work. During August, Maloof had resumed selling digital prints of Maier's negatives, and then, all of his Vivian Maier eBay activity stopped.

Altogether, around two hundred negatives and 265 digital prints—from more than a hundred negatives—were dispersed through Maloof's eBay sales from March 2008 through August 2009, grossing around $5,000. Relative to his initial investment of $380, the eBay sales had been profitable.

One of his earliest item descriptions points to a photograph that represents a significant chapter in Vivian Maier's life as a

young New York street photographer: "VINTAGE 50'S OLD NEW YORK PHOTO OF L-TRAIN/MOVIE." Several copies were sold, including one in August 2008, during Maier's last hot Rogers Park summer.

SUMMER OF 1952 AND A NEW IDENTITY

In the summer of 1952, Vivian Maier took her new Rolleiflex camera onto the steaming sidewalks of New York and ended up on Third Avenue, above which elevated train tracks extended for miles. At the southern end of the line, below Cooper Square into the Lower East Side, Third Avenue was called the Bowery, which also gave its name to a neighborhood famous for its bums and flophouses. A decade earlier, Lisette Model and tabloid journalist Weegee had photographed the drunken revelry at the cabaret in Sammy's on the Bowery. And in the 1930s, Berenice Abbott had extensively documented Third Avenue as part of her project, "Changing New York."

Third Avenue's dappled light and street activity had always drawn photographers; its storefronts ran a colorful gamut of high to low in culture and goods. In 1951, a *New York Times* reporter had called it "a street of contrasts—the city's curio shop," adding, "antiques worth hundreds of thousands of dollars are sold next door to junk, fruits and vegetables. The people are as different from one another as is the eighteenth century from the twentieth."[49] In Midtown, the swanky Le Café Chambord sat amid junk shops whose wares spilled out through their recessed doorways. Further north, establishments were a bit more prosaic: at Fifty-Ninth Street, a restaurant called Joe's sat alongside a pawnshop and a hardware store. Across the street, a second-floor Chinese eatery simply announced "Chop Suey," as its patrons ate at windows within yards of the elevated train platform. Vivian Maier frequented this corner on Third Avenue, where a walk east on Fifty-Ninth Street led directly to the Queensboro Bridge; and she was there on August 1, when the street was nearly shut down during the filming of a Hollywood movie.[50]

Twentieth Century Fox had rented the pawn shop at 983 Third Avenue to shoot a scene for *Taxi*, starring Dan Dailey, and the crew had parked a fleet of trucks and limousines under the train tracks. On this Saturday morning, Maier climbed to the Fifty-Ninth Street train platform, perched on a spot overlooking the sidewalk, and composed a landscape picture. As she had adjusted to her Rolleiflex, Maier's self-assuredness was becoming more pronounced and the camera's square framing had resulted in more measured compositions. Flanked by the old storefronts and dark train tracks, and balanced by the clear open sky, her raised vantage point revealed the pavement as a slice clear to the horizon. Slightly shifting the framing— pointing downward or toward the right to favor the spectators who focused their attention at the same point—Maier made several exposures.[51] The standout photograph equally features the urban landscape—crowned by the spire of the distant Chrysler Building—and the summer crowd, united in fascination.[52] Moving along the train platform she continued shooting the sidewalk scene from her omniscient perspective.[53]

Vivian Maier may have gravitated toward the movie production—she labeled the negatives' glassine envelope simply, "Dan Dailey"—but she may have also already been at that location for her own business. While a pawn shop fronted 983 Third Avenue at ground level, upstairs, Robert Cottrol's Studio 983 offered darkroom and studio access from morning through midnight, seven days a week.[54] Cottrol—a New York University–educated black man living in Queens—had also recently begun teaching informal eight-week courses at the studio, where students used the darkroom.[55] A magazine and newspaper journalist whose photographs would later appear in *Time*, *Life*, *Newsweek*, and *Ebony* magazines, Cottrol's Studio 983 was only a temporary venture for him; but judging by Maier's photographs from that summer forward, Cottrol's space may have been a more lasting and influential stopover for Vivian Maier.

Maier had already photographed at the doorway of 983 Third Avenue, making a series of portraits of a seated older man that are among the earliest known darkroom prints by her own hand;

and one photograph that she shot during the production of *Taxi* places her squarely at the building's entrance.[56] A photo in the series shows Maier's arrival on the sidewalk from the 983 doorway: a mass of spectators—or film extras—face her in an arc, leaving a broad swath of open pavement between them; along the building's front, a man seated in a director's chair turns from his newspaper toward Maier, who is standing behind some movie lights on stands.[57] For a second shot, she advanced to the middle of the sidewalk, where, from the center of the emptied sidewalk, she photographed the entire amused crowd, including two uniformed police officers (plate 12).

Vivian Maier proceeded to make the sidewalk her own and continued documenting various aspects of the location setup, recording the film crew's activities from the street, between the parked trucks, and from various angles on the sidewalk. At some point the lead actors sat in director's chairs reading over the script. By that time, Maier must have been a familiar presence; she made several photographs of Dan Dailey and his costar, Constance Smith.[58] A handsome young man, apparently a stunt double dressed in the same checked shirt and khaki pants as Dailey, stood amiably for a couple portraits. All together she shot a more than two-dozen photographs that remain today as snapshot-sized prints.[59]

The Rolleiflex gave Vivian Maier still further command of her medium. And the perceived legitimacy of a photojournalist's camera may have given her a boost to venture beyond her familiar territory; other than forays to Liberty Island through Battery Park, none of Maier's known photos through the summer of 1952 place her anywhere south of Forty-Second Street. But on a sunny summer morning, Maier rode the Third Avenue El into the Bowery. Perhaps she was there for a class assignment or maybe it was her own idea; disembarking at the Houston Street platform, she shot a photograph from under its canopy, a studied composition of buildings enhanced by the geometry of the square viewfinder.[60]

The series of portraits that Vivian Maier made in the Bowery look like assignment pictures; the subjects—all individual

men—appear uniformly framed at a conversational distance of within four feet. They gaze down into Maier's waist-level lens, presenting dignified figures in contrast to their shabby clothing and unshaven appearances.[61] Seated men in doorways and along park stoops seem more casual with the lens at their eye level. None of the men looks up at Maier's face; rather, their focus is on the device on which she also fixes her attention.

Maier prowled the Bowery looking for portrait subjects; she went along Houston to Elizabeth Street, up Bowery past Sammy's saloon, then by the Holy Name Mission to Second Street and southeast to Chrystie Street's Sara Delano Roosevelt Park.[62] She entered a fenced area and photographed a black man against a handball court wall, its vertical stripe offsetting his arms akimbo and unevenly buttoned shirt.[63] On her journey, she found countless men passed out in drunken stupors or sleeping soundly on sidewalks, on benches, and in doorways.[64] Boldly approaching each, she sometimes framed as near as her lens could focus, performing like an anthropologist in a daring game.

Some pairs of Vivian Maier's sleeping men photographs show evidence that she returned to the scene: shadows shift or subjects change positions. But one two-picture set from the Bowery goes further than time-lapse study and demonstrates either that she had help or that her audacity was even more outrageous than before. A close-up side view of a filthy young man asleep in a pushcart is followed by a shot from a separate angle, in which the cart has been turned and set down ninety degrees counterclockwise; although not roused, the man has slid down the angled surface and turned his head to reveal a dirty bandage over his right eye.[65] The second position provided a direct view into the boxlike enclosure, and together with the first, revealed the process of setting up a well-lit shot.

Throughout the summer, in addition to exploring the seedier parts of the city, Maier took advantage of the area's beaches and recreational spots. In a rarity among her pictures, which typically give the impression that she's alone, Maier appears together with her friend Emilie Haugmard at Staten Island's South Beach. The short and stout gray-haired woman had long

worked as a governess.[66] She was French-born, and she and Maier had both lived in the East Sixty-Fourth Street apartment complex in 1940, where Haugmard still lived.[67] The two women alternated photographing each other by the water. In a delightful double portrait, they stand in bathing suits smiling side by side, creating a study in contrasting ages and body types and of friendship (plate 11).

Maier left a trail of photographs that show her summer activities; her negatives also reveal experimentation and extensions of her photographic repertoire that included quick-timed shots and a heightened awareness of her surroundings. She caught an acrobatic man doing a split jump in midair, his perfectly extended legs lining up with Central Park's distant horizon (plate 13).[68] She explored details of the Queensboro Bridge, making a series of abstractions that show networks of crisscrossing girders flattened against the sweeping sky.[69] And in a combination of pathos and formal sensibility, she devoted a half-dozen negatives to alternative framings of a crushed bloodied pigeon on a crosswalk stripe. One of the pictures shows Maier's shadow merged with the dappled shade overlaying onto the dead bird—an early and perhaps inadvertent example of portraying herself as part of her photographic world.[70]

In autumn, before she photographed another Macy's Thanksgiving Day Parade—this time from an upper window across Sixty-Third Street from the Ethical Culture School at Central Park West—Maier was at the United Nations complex exploring the architectural details within the new General Assembly building.[71] She also managed to ascend onto the penthouse terrace of Tudor City's Prospect Tower across the street. From that twenty-two-story perspective, Maier captured a look at the United Nations Plaza that also included a view of the East River, the Queensboro Bridge, and Long Island City's skyline. While on the terrace, among its strewn chaise longues, Maier composed frames that show the roof's medieval-style terra cotta features lined up against the futuristic facades of the Chrysler Building and other modern office buildings (plate 14).[72]

In fewer than three years, Vivian Maier had shot in excess

of six thousand photographs, including more than seventy rolls of film she wound through her Rolleiflex camera from mid-July 1952 through her twenty-seventh birthday in February 1953.

READING VIVIAN MAIER INTO THE HISTORY OF PHOTOGRAPHY

While John Maloof was teaching himself photography by looking through Vivian Maier's negatives, he was also learning about the history of photography by repeatedly watching a six-part BBC program called *The Genius of Photography*.[73] Loosely chronological, each hour-long episode covered a theme that had resonance with Vivian Maier's work (though the series featured only four female photographers).

Joel Meyerowitz, a well-known New York street photographer, led off the first episode authoritatively: "Photography is about the frame you put around the image; what comes in or what is cut off, and yet the story doesn't end, it's told beyond the frame through a kind of intuition." Near the end of the first episode, a contemporary gallery owner expounded upon the virtues of a 1950s-era photograph that had "turned up in a shoebox at a flea market."[74] The case of French photographer Jacques-Henri Lartigue, whose childhood works had lain undiscovered for five decades, was also discussed: "Fifty years after these pictures were taken, Lartigue was discovered by the photographic establishment and re-packaged as a kind of primitive precursor of cutting edge photographers like Garry Winogrand, who achieved by design what the child genius had discovered by instinct. In fact, Lartigue's photographs are a testament to the rich culture of amateurism which nurtured his precocious talent."[75]

In the second episode, Meyerowitz introduced Eugène Atget: "Our Mozart. The single greatest artist of photography who stands head and shoulders above everybody else."[76] Since his death in 1927, Atget's work had been celebrated in its own right but also through Berenice Abbott's portrayals of him. A French curator presented Abbott's portraits of Atget, saying of one, "I think that she liked it because in a way he looked like an old

man, and for me, that's part of the myth that she has built a little bit; that Atget was an old, poor photographer, selling his pictures for nothing."[77]

Meyerowitz opened the third episode by describing Henri Cartier-Bresson's "decisive moment" and the theme of "right place, right time" that established the documentary qualities of photojournalism and mass media. The fourth episode presented Robert Frank's seminal 1958 road-trip book, *The Americans*, in which Beat poet Jack Kerouac described Frank as photographing "with the agility, mystery, genius, sadness, and strange secrecy of a shadow."[78] During his yearlong cross-country project, Frank shot seven hundred rolls of film.

Such inadvertent evocations of Vivian Maier, her photography, and her stomping grounds are peppered throughout the series. Robert Adams talked about street photography as "an excuse to be in the world"; Colin Westerbeck mentioned the need to be "absolutely fearless"; and then Joel Meyerowitz conjured Vivian Maier's New York in saying, "Fifth Avenue is an addiction. Once you get the drift of it and feel the energy of it, it makes you want to go back again and again. Because it's where life seems to be."[79] New York's main street was evoked as a "happy hunting ground" and the epicenter of modern street photography, where Lee Friedlander, Diane Arbus, and Garry Winogrand spent fruitful days in the 1960s.

In the same way that Jacques-Henri Lartigue's childhood photo albums were overlooked for fifty years, and Eugène Atget needed to be recontextualized to have his importance recognized, Vivian Maier and her work could be resurrected and woven into the history of photography. From one perspective, John Maloof might be to Vivian Maier what Berenice Abbott was to Eugène Atget.

The final episode introduced one more story of discovery, again involving French players and decades-old work. But this was a cautionary tale. Seydou Keïta became famous after his early but anonymous photography had been recognized as special. Keïta was still alive in 1991 when a Parisian curator tracked him down in Mali. The curator returned to Paris with more

than nine hundred of Keïta's seven thousand studio portrait negatives that, forty years earlier, Keïta had loaded into a tin and buried in his backyard. By the time Keïta's photography premiered at New York's blue-chip Gagosian Gallery five years later, gigantic new prints—as large as four by five feet—from the vintage five-by-seven-inch negatives were being offered at $16,000 each. A crowd of two thousand mobbed the opening reception to fete the elderly photographer.

Seydou Keïta's story made him famous, and his high-priced work sold quickly, but a legal struggle ensued. Beginning with Keïta's own mistrust of the handling of prints from his negatives while he was still alive, the fight continued after his 2001 death, with arguments between two men who claimed to own and control hundreds of his negatives. In 2007, the production and sales of Seydou Keïta's photographs were at a standstill. A French copyright attorney stated that the legal battle could go on "for years and years and years."[80]

American copyright law was established to protect creative works (individuals' intellectual property) from exploitation by unauthorized reproduction. Its concept was written into the U.S. Constitution. Continually revised since the original Copyright Act of 1790—to modify duration of protection, extend expression from writing to other creative forms, join with other countries, and adapt to new technologies—intellectual property law generates considerable confusion.[81] An 1865 amendment extended copyright protection to photographs and negatives. In 1909, President Theodore Roosevelt said of copyright laws, "They are imperfect in definition, confused and inconsistent in expression; they omit provision for many articles which, under modern reproductive processes, are entitled to protection; they impose hardships upon the copyright proprietor which are not essential to the fair protection of the public; they are difficult for the courts to interpret and impossible for the Copyright Office to administer with satisfaction to the public." Copyright is enforced through the challenge of its infringement.

VIVIAN MAIER'S NEW TECHNIQUES

The casual amateur does not worry about producing art, although experts are sure that, scattered in the nation's family albums, there are enough undiscovered masterpieces to fill the National Gallery.
"AMATEUR PHOTOGRAPHER: EVERY MAN HIS OWN ARTIST,"
TIME, NOVEMBER 3, 1953

By the end of 1952, Vivian Maier had acquired a flash attachment for her Rolleiflex and was practicing new techniques by snapping interior portraits in her old East Sixty-Fourth Street complex. She moved through the apartments posing residents, and the flashbulb bursts revealed every detail of their modest rooms. Pictures show contrasting flower-patterned carpets, curtains, and upholstery, alongside walls whose grime was made more visible by the flash. A teenage girl presented a French-costumed doll; an elderly woman in a black, knit shawl stood cradling a rosary; and a young couple clutching a screaming baby sat against a wall under a local drugstore's calendar. These were Maier's peers, a separate demographic from her employers and the subjects she encountered on the streets. She fit in here comfortably among the ethnic families and working-class residents who welcomed her into their homes.[82]

Vivian Maier's photo prowess escalated as she reached her twenty-eighth year. Her ease with the Rolleiflex and the confidence it instilled in her, combined with a Manhattan babysitting job that promoted outdoor activity and enough free time to wander independently, contributed to a striking period of artistic growth. Maier's pictorial compositions became more deliberate, with the symmetry of the square format assisting in ordering lines and forms. She returned to the Chatham and Phenix Bank Building rooftop, this time framing a network of upright and diagonal metal supports to outline a distant factory with a sign that merrily announced "Sunshine Biscuits," and then from the reverse perspective, she framed the bank building's ornamental parapet to mimic the distant Manhattan skyline.[83]

Maier's evolving approaches were less inclined toward

catching split-second "decisive moments" than in homing in on nuanced interactions and recording events or people that caught her eye. Sometimes she positioned herself in anticipation of action. Maier hovered at the sidewalk entrance of the Fifty-Seventh Street Magistrates Court and Jail, where a nine-picture sequence begins with a curbside view of a prisoner transport van.[84] The next frame from the same location shows a different truck with a disheveled man disembarking from its back door, and then in the subsequent three frames, two officers help that man assist a bedraggled older detainee with crutches out of the paddy wagon.

Maier came in closer for the third shot, which shows a police officer and the younger man steadying the old man. Moving with the action, she scurried across the sidewalk to get the three-some from another perspective and then circled back, capturing them from behind as they approached the jailhouse door. The men had advanced merely two more steps when Maier deftly grabbed a wide shot from yards away. This last frame includes a variety of onlookers—an older businessman, a teenage boy, and a white-gloved woman in a fancy hat. Maier bypassed this shot when she made a tightly cropped five-by-seven-inch print of the original threesome as they began their walk from the truck to the curb. The composition that appeared in her square viewfinder was often cropped down to make her intended subject the central focus of the photo.[85]

It's hard to tell if Maier's intention with the last image in this sequence was to juxtapose the gaping spectators with the heartrending crutches scene, or if she had backed away to capture a portrait of the woman in the fancy hat. Women in hats often excited her interest. The subsequent two-frame sequence begins with a rear view of pedestrians that includes a woman with an umbrella and an elaborate old-fashioned hat. The next frame shows that Maier apparently ran through the street to get in front of the woman; the shot reveals her as a relic from an earlier era. This urgent portrait, taken on East Fifty-Ninth Street and Lexington Avenue, was followed by a cloud study six blocks south along Third Avenue, and then, after a walk

northwest, the next frame depicts a horse and carriage by the Plaza Hotel. Vivian Maier's quest for subjects made her into a probing street detective.

Maier's new approaches also became more personal and symbolic: in a Liberty Island photograph, her shadow extends into the frame next to an open purse arranged to reveal a *Time* magazine cover featuring a French coin alongside a portrait of the French prime minister. The picture is an openly interpretive layered mix of France, America, New York, and the French-American photographer's likeness.[86] This early shadow self-portrait led to other pictures where Maier incorporated her likeness into a scene or in which she was the main subject. A striking self-portrait shows her on Fifth Avenue in a smart business suit; her hair is cropped short and the entire androgynous presentation is stunning in contrast to her earlier, more feminine, persona.[87] A deep vertical shadow evocatively obscures half of Maier's face, illuminating one eye as it stares back at itself.

Just as photographs do, mirrors introduce questions of truth and illusion. The Rolleiflex viewing lens optically reverses images, and the dark interior of the viewing hood can make the backlit projection appear as a virtual world. Peering simultaneously downward and outward gives the photographer a sensation of being removed from the scene; for an observer, the photographer's target is not always clear. The boxy camera can be turned sideways, giving a false impression to onlookers as a picture is taken from an angle different than the photographer's stance; for the camera operator, handling the device can give concurrent feelings of secretiveness and omnipotence.

Just as photographs do, mirrors flatten space. Vivian Maier was inclined to lurk with her camera in recessed doorways, and in 1950s New York some were lined with mirrors. In a confusing split-framed depiction of Fifth Avenue from a deep-set shop entrance, Maier recorded the street view along with its mirrored rear-view perspective, effectively recording two images swapped from her own viewpoint. In the forward scene, a blond woman in a patterned headscarf glanced directly at Maier, who recorded her in mid-stride. It might be that the woman was the

subject of the tricky streetscape; the second photo reveals the first one's illusionistic strategy: after the blond woman passed, Maier turned in the opposite direction and shot another picture, this time including her own reflection in the photograph. The blond woman had stopped to look in a store window, and the camera's perspective creates an illusion that she is looking directly at Vivian Maier. Maier's own reflection on the opposite wall repeats to infinity.[88]

In another example of clandestinely utilizing mirrors in conjunction with the Rolleiflex's right-angle viewfinder, Maier was able to surreptitiously photograph an intimate restaurant exchange. The restaurant's mirrored ceiling allowed Maier to hold her camera horizontally while looking straight ahead from another table, recording the ceiling's view of the adjacent table. Presented upside down, the resulting image shows an aerial perspective of a man and woman holding hands across a table. Complicating any interpretation, the man appears to be wearing a wedding band, though in reality the ring is on his right hand.[89]

Motion picture filmmakers also make use of illusions and convincing ploys to transport an audience. And as we have seen, Vivian Maier gravitated toward spectacles and events, including filming locations. In 1953, Maier was at Columbus Circle for the filming of the new Judy Holliday movie *It Should Happen to You*. Magazine and freelance photographer and filmmaker Ruth Orkin was also there, and her candid on-set portrait of Holliday shows a mass of onlookers gathered behind a rope divider.[90] Vivian Maier may have wanted to photograph the film's famous lead actress, too, but lacked the credentials. Instead, as a street photographer drawn to spectacle—and women in hats—she found Judy Holliday's identically costumed stunt double seated curbside in a Jaguar convertible. On a break, the woman had tilted back her broad-brimmed hat and pulled its veil down under her chin. She was about to light the cigarette that dangled from the corner of her mouth when Maier stepped within five feet of her. With the Rolleiflex at the woman's eye level, the photo captured her looking at the lens, appearing mildly annoyed at the intrusion.[91]

Other photos from 1953 also show Vivian Maier's strategies and shooting locations, even though the context may not be clear. A photograph can be misleading; it isolates an instant in time that a wider-angle view or a representation of what immediately occurred beforehand or afterward might clarify. Maier portrayed a man and woman modeling in a Central Park horse carriage. Two shots show the couple in an identical pose; but in one picture they're alone, while the other frame includes carriage drivers. Similarly indicating a posed setup, the couple is dressed for summer while in the background, trees are bare and the carriage men are wearing wool topcoats. If Maier wasn't orchestrating her own fashion shoot, it's conceivable, as indicated in her pictures of an earlier photo shoot at the same location, that she was documenting another photographer's setup.[92]

Photographed scenes that are missing context stand out for their mystery. A thin man seen from behind appears not to be wearing pants as he walks along the sidewalk; a passing businessman sees a view of him unavailable from the photographer's perspective. A separate frame shows that the man's pants were rolled up to the top of his thighs; he's holding a paper bag and appears inebriated as he is led away by a police officer. Maier tracked the man for more than a block to get the second shot, which revealed the scenario. The first frame, on its own, encourages multiple readings.[93]

During this year when Vivian Maier found her innovative photographic voice, she continued babysitting for the dark-haired girl, and they shared activities for more than a year. Looking like coconspirators in a double self-portrait, they stand side by side at a sidewalk mirror on Broadway at Eighty-Sixth Street. Sometimes another child accompanied them, and her photographs show that Maier also watched other children from the same neighborhood; on special days, she had two or more in tow, joining in her urban adventures.[94]

In the summer of 1953, Vivian Maier joined the dark-haired girl on a family vacation in Vancouver, Canada. She went sightseeing with the family, photographing the Capilano Suspension Bridge and the totem poles in Stanley Park; she brought her

flash equipment along and used it to make an interior group shot of the relatives. While touring the Grouse Mountain funicular, Maier handed off her camera to someone to make her portrait: she appears as a small figure alone in the distance, standing dashingly in a long white coat with arms akimbo. Maier also took off on her own, photographing beach activities and the English Bay at all hours.[95]

As before, Vivian Maier ventured away from the upscale and touristy zones, seeking out the local populace. In Vancouver she found a rural Aboriginal village where she made group portraits of a family on the porch of their clapboard house (plate 15). First, they posed standing in a group; then Maier pulled back to include the ramshackle house, and they settled into a more casual seated arrangement. The picture of the six children and their mother looks like a Depression-era documentary photograph used to encourage social change. Unlike Maier's increasingly innovative street photography, these group portraits—one of which she enlarged—could have been contenders for Edward Steichen's *Family of Man* exhibition, which was in development at the Museum of Modern Art at that time.[96]

Described as the museum's most ambitious photo project ever, Edward Steichen's show was to include "penetrating photographs that portray the basic and universal elements in human relations, as revealed by the particular, and demonstrate the role that can be played by the art of photography in communication of man to man."[97] Steichen scoured Europe for images, while his assistant pored over *Life* magazine's archive of three million pictures. By January 1954, the selection had been narrowed down to ten thousand photographs.[98]

OCTOBER 2009—VIRAL VIVIAN: WHAT DO I DO WITH THIS STUFF?

As John Maloof selected Vivian Maier's works for the website he had created in her name, his edited version of her life's work emerged. By the end of September 2009, Maloof had put 120 Vivian Maier photographs online. A week later, using a new

strategy with a different Internet outlet, everything changed.

On Friday night, October 9, 2009, John Maloof approached a Flickr group called Hardcore Street Photography and posted an announcement, along with a series of questions that did not divulge his previous conversations with Allan Sekula about exhibiting and publishing Maier's work:

I purchased a giant lot of negatives from a small auction house here in Chicago. It is the work of Vivian Maier, a French born photographer who recently past [sic] away in April of 2009 in Chicago, where she resided. I opened a blogspot blog with her work here; http://vivianmaier.blogspot.com.

I have a ton of her work (about 30–40,000 negatives) which ranges in dates from the 1950's-1970's. I guess my question is, what do I do with this stuff? Check out the blog. Is this type of work worthy of exhibitions, a book? Or do bodies of work like this come up often?

Any direction would be great.[99]

Although Maloof had been actively posting Maier's photographs for five months, his blog lacked an attentive audience. But this Flickr forum, which boasted some thirty-seven thousand members, was different. Self-described as "a group dedicated to candid situations that momentarily reveal themselves amidst the mundane hustle and bustle of everyday life," Hardcore Street Photography had a clear affinity for work like what Maloof had already put online.[100] A substantial response was all but guaranteed.

Ron Slattery and John Maloof were exchanging phone calls and e-mails during the period before Maloof approached the Flickr group.[101] The conversations circled around questions regarding post wording, the look of the Blogspot site, and other subjects related to Vivian Maier and her photography. Maloof was good at querying sources with more experience than he had to get help that otherwise was beyond his expertise, as in his exchanges with Sekula.

The Hardcore Street Photography group had an editorial board, which established a new discussion thread around

Maloof's question. If Vivian Maier's work didn't hold up on its own, a different discussion—or worse, silence—may have ensued. Maloof's five months of posting her images showed his dedication and reinforced the powerful attraction of Maier's story. His question now landed within a vocal community of "Flickrites," an influential and well-informed group that was more than happy to share their impressions and advice.

The post's first response, offered by a user known as ph [K], was simply, "!!!" The next reply, by locaburg, asked Maloof if he had contacted galleries or curators, commenting that the Chicago work could be of local historical value. Maloof responded to locaburg that he had applied for an exhibition at the Chicago Cultural Center on Michigan Avenue—a former public library building that Maier photographed—and had approached a Chicago commercial photography gallery. The gallerist responded that Maier's was "strong work . . . above average for the time period," but told Maloof that since he had only negatives, there wasn't much a gallery could do for him. The commercial value would be in original prints.

Next, WAXY weighed in, suggesting Maloof approach the Chicago History Museum or the Art Institute of Chicago, or perhaps he could donate the work to the Native American Heritage Association. WAXY posted Vivian Maier's obituary and the link that he found with a quick online search:

Vivian Maier, proud native of France and Chicago resident for the last 50 years died peacefully on Monday. Second mother to John, Lane and Matthew. A free and kindred spirit who magically touched the lives of all who knew her. Always ready to give her advice, opinion or a helping hand. Movie critic and photographer extraordinaire. A truly special person who will be sorely missed but whose long and wonderful life we all celebrate and will always remember. Memorial donations can be given to the Native American Heritage Association, P.O. Box 512, Rapid City, SD 57709.[102]

Maloof replied that he was very familiar with the obituary and stated that the *Chicago Tribune* had given him "dead ends on the people who placed the ad" and provided him with "an

address that doesn't exist and a phone number that is discon-
nected." He relayed that he had tried but couldn't find any fur-
ther information about Maier but then mentioned Allan Sekula:
"I was contacted by a photographer named Alan [*sic*] Sekula.
He dug up info on her and found that she was a Jewish refugee
from wartime France. She was a 'keep your distance from me'
type of person and had strong opinions for women's rights. She
was a loner and poor."

John Maloof disclosed that he owned a thousand rolls of Mai-
er's undeveloped film and had already successfully processed
four hundred rolls. Addressing WAXY's question, he stated that
he wasn't interested in donating the work if it would be stored
but not exhibited; then, in a garbled bit of photo history, he
added, "although I believe much of Atget's work was found after
his death in the form of glass negatives."

Over the next day, Maloof's post generated more suggestions
and overwhelmingly positive responses to the photographs. Like
the eBay buyers who were wowed by Maier's negatives, this
audience recognized the value of the imagery. Several people
thanked Maloof for saving the work; Mud Gecko asserted that
the negatives were, "Too good to be shut away in a historical
museum archive for another 50 years." Another group member
offered, "I certainly hope you make some progress with this;
it should be a show or two and a book, at the least. Great stuff,
great find. Thanks for saving it."

One user had several questions: "Do you know does this rep-
resent the majority of her life's work? Or are there other nega-
tives out there somewhere? What does a lot like that in the after
death auction market go for anyways? I'm assuming you didn't
get an IP assignment with the lot." Maloof addressed these
with confidence, though his statement about the percentage of
Maier's work he had purchased would soon prove to be false:
"The work I have is probably all of the work she did during that
period. Whether or not she had more before or after is another
question. I know that I have about 80–90% of the work that sold
at the auction. I'm not sure what an IP assignment is so, don't
think I got one of those. Not sure what market value is."

The abbreviation "IP" stands for Intellectual Property, and an IP assignment is a claim to the copyright of published material. The next commenter, Therrr, posted a link to a document that defined intellectual property rights and brought an ominous note to the conversation: "I may be wrong, but I believe that without an ip assignment the copyright remains with the heirs to whoever (her, I assume) owned the negatives at the time that the film was exposed. For 50 years after her death." Therrr offered, "I would suggest you not spend too much of your own money on developing the film until you sort that out. Maybe you could re-sell the negatives and make a profit on them now that you have a better idea of the quality of the images? The images would still find an audience."

Another group member, notgnihsaw, interjected to ask, "why not upload them under CC [Creative Commons] to flickr? . . . Essentially, distribute them in an open manner to the largest audience possible." Creative Commons licensing was developed as an "information age" response to established copyright practice.

The next day—Sunday, two days after his initial post—Maloof answered these challenging posts:

@Therr: I seriously don't think she had heirs. One of her obituary's [*sic*] said that she was a "second mother to" . . . (so and so). I looked them up and they are not related. I assume it was the children she was the nanny to for many years, who also most likely put up the obituary. If there were any heirs, you would think they would have claimed some of her estate. Instead, her entire property was auctioned off, to my knowledge. This is what I learned talking to the owners of the auction house. I looked into the legal rights on these and it's vague if there are no heirs.

I did start selling her negatives on eBay. I sold about 200 of them. They sold for a lot. One in particular sold for $80! That's when I stopped and realized there's something here that should stay together.

In response, Therrr emphatically agreed that the negatives should stay together, adding, "I just thought maybe you could sell the whole body of work to some organization with the money

and influence to put it together—or figure out how to get it recognized as orphaned. I'd think you might be able to make a tidy bit of money." So-called orphaned visual property can be reproduced if an exhaustive search fails to turn up anyone who can rightfully claim the copyright, but the copyright could be challenged if an heir did emerge.

Maloof also answered more questions from Hardcore Street Photography members: he explained that Maier's negatives had been in sleeves, but they weren't organized within their shoeboxes; he explained that "each sleeve may have a couple of words in French describing the location and the date"; he further offered that there were some "small prints with no description on them"; and he concluded, "I have done a bunch of research. Most lead to dead-ends. I have a few more leads but I really am afraid there may not be much info on her."

Group members offered more advice, and then Paul Russell99 submitted: "I'm sure the whole story about how you came across them + quality of images + historical document aspects add up to it being interesting enough to become newsworthy, and then more information about her, offers of help from curators, etc. might follow on from there." The idea caught John Maloof's attention, and he responded, "What type of news medium do you think I should approach?" Paul Russell99 replied, "oh, I don't know, I was just saying that it will probably find you if you do a bit of internet promotion." Another member chimed in, "I'd get in touch with local radio, newspapers, tv whatever . . . try and get the community involved and make it real. . . . I just think the internet makes things a little too distant at times."

Earlier in the thread, WAXY was captivated by the bits of Maier's biography that Maloof had offered, exclaiming, "This story is so amazing and I love reading the details"; Maloof responded in kind: "The mystery is what keeps me going on her. If I knew all about her, I don't think I'd be as interested." Now, two days later, group member kinoglass began opining about Maier, her process, and her absence from this display of her work:

Interesting that Vivian Maier did not see her work, she would shoot and store the negs. What was she planning to do, I wonder.

Looking at the images deprived of any other details raises many questions, while most are distinctively shot in Chicago some are likely to have been shot in NYC. Then, when, in what year, as time defines almost everything.

There is no question the artist and his/her work are bonded together, not just by the clicking of the shutter, but by time, location, age, context and personal history. Other wise the meaning of art is nearly destroyed reduced to a meaningless image suspended in time, keeping you guessing.

We can't hardly define Vivian Maier by looking only at her work, work she never saw!

Kinoglass had conflated Maier's vintage negatives with her undeveloped film, a misunderstanding that was to confuse the story and at times make it too complex for a simple summary. Maloof clarified that the thirty to forty thousand negatives included twelve thousand frames from a thousand rolls of undeveloped film; also, he had "a handful of about 100 small prints." Kinoglass replied somewhat incredulously, even suggesting that "Vivian Maier" might be a hoax.

Maloof responded to kinoglass by adding to the intrigue, introducing what some would soon see as the most astonishing coincidence in the whole incredible scenario:

Kinoglass: The only way I found her name was because it was written with pencil on a photo-lab envelope. I decided to "Google" her name about a year after I purchased these only to find her obituary placed the day before my search. She passed only a couple of days before my Google search. How wierd? [sic]

I thought about meeting her in person prior but, the auction house had stated she was ill so, I didn't want to bother her. Soooo many questions would have been answered if I had. It eats at me from time to time.

Enthralled, group member ndiginiz replied, "Wow, the story behind this gets better and better!"

Perhaps John Maloof was getting caught up in the attention

over his "discovery" of Vivian Maier's photography. It was a good story. But Maloof had posted Maier's name on his own Flickr page months before her death, her name was on many of her materials, and the Sekula correspondence clearly indicated a lot of Googling had already occurred by the time Maier's obituary appeared.

Maloof had acquired an attentive audience and he began giving updates. Soon news of his initial post began garnering the attention of independent bloggers and other photo-interest websites. On Monday, under the tagline "Lost, and Found," a blogger shared news of the developing phenomenon: "This story seems so scripted it could almost be a fairy tale. A photographer spends her life in obscurity shooting the streets of Chicago, dies with 1000 rolls of film still unprocessed, and is discovered later to be a visual savant."[103]

By Wednesday, more Flickr users had expressed their delight in Maier's photography, and thanked Maloof for posting the images. Maloof asked the group members for more advice: "@ everyone: Do you think I should open her blog site up for comments? Currently, you cannot comment." Amyb68 responded—"@johnmaloof—yes, definitely!"—nearly simultaneously with Dr Karanka's announcement: "This seems to be spreading in the blogosphere quite nicely." Funkaoshi answered both posts: "Maybe open the site up for comments, but keep them moderated. Blog comments are such a magnet for spam. (And stupidness I suppose.) I posted this over on MetaFilter. And Kottke.org seems to have found your site as well. It's a cool story."

Maloof's story continued to spread and as he received more advice on sharing the images, with curdiogenes interjecting, "Getting some traction on the interwebs," and copied links to Rangefinder Forum and Burn Magazine, both of which mentioned the Flickr thread. bryanF added, "Yeah, I would sit and wait now. If Kottke has picked it up, it'll snowball from there. Perhaps try contacting the LENS. This seems to be something they might gravitate to, and if it hits the NY Times, well, then I say, you're almost certainly going have people knocking at your door."

Paul Russell99 asked Maloof if there was a way that he could put the story together in a more cohesive way than the "snippets" that he added to the Flickr post: "Journalists like to have stuff to cut and paste, ahem, I mean text to work with." Maloof responded that he had just updated the website, adding, "I hope I didn't leave anything important out."

VIVIAN MAIER, NEW YORK STREET PHOTOGRAPHER

In January 1954, thousands of amateur photographers learned that they could be contenders for *The Family of Man* exhibition. Even though Edward Steichen and his assistant had already assembled ten thousand photographs, they aimed to "comb every possible source throughout the world and thus assure the most comprehensive coverage."[104] Every photographer seemed equally qualified for inclusion: "Anyone, anywhere, who has anything to say photographically to illustrate the project's theme—to portray 'the universal elements and emotions and the oneness of human beings throughout the world'—is asked to respond to the search for appropriate pictures."[105]

Vivian Maier certainly had photographs that fit the show's criteria, but as she developed new technical skills, her most recent work veered in new directions; in the last few months, her street work had extended to nighttime photography. On Christmas Eve, 1953, Maier was out on the sidewalk on the Upper East Side when a brawl brought two bloodied men curbside. Working like Weegee, Maier was ready with a flashbulb loaded in her Rolleiflex. She captured a police officer and a cigar-chomping gent hauling a half-conscious man across the street. The flash caused the scene to appear as if Maier had directed a spotlight on the men, and the effect fairly compared with results from the best press photographers. And then, like an experienced photojournalist, Maier followed the action: she popped out the hot bulb and twisted in a new one; then, standing within feet the curb, she lit up the night again as she shot the two bloodied men slumped against a dark sedan. The set of images reads like classic film noir.[106]

In another instance, Maier mounted her camera, this time without her flash, on a tripod at the edge of Columbus Circle. It had recently rained, and along with a large puddle that mirrored a neon-lit billboard, the slick pavement and glistening lights created an ethereal tableau. Light trails lingered as cars ghosted through the minutes-long exposure, enhancing the otherworldly effect of the late night street. Most striking is the lit-up billboard featuring a clock that places Maier on this corner at a specific time—from 11:15 through 11:18 P.M.—and invites speculation about why the now-twenty-eight-year-old woman was out at that hour with her camera. Although it's impossible to tell if she was alone or with a companion, the desolate streetscape—made to seem more so by the long exposure, which eliminated traces of potential passersby—creates the sense that Maier was the only one at the scene.[107]

The night as an alternating place of wonder and vice was another theme in Vivian Maier's inventory of subjects. People remained her primary focus, particularly older women, babies, and mothers with children; certainly she could have put some work together for Edward Steichen's consideration. But *The Family of Man* exhibition required applicants to submit photographs, and Maier was no longer making her own small prints. Notations on envelopes and the back of some photographs indicate that someone else had been processing Maier's film and making prints from her negatives during the past year. In one example—penciled on the back of a chemically stained print of a man reading a newspaper—a tally of five rolls of film, one enlargement, and six small prints amounted to $5.85, and it took three payments to clear the balance.[108]

Among Maier's photographs from this period, portraits of two older white-haired women stand out for their surrounding contexts and details. They were both photographers: one posed seated at a desk surrounded by framed wedding portraits and also stood by her large wooden view camera; the other woman held narrow glassine envelopes filled with strips of Maier's processed film. That woman stood next to a table loaded with printing and darkroom paraphernalia, including a negative holder

and a box of photo paper. Clothespins dangled on an overhead line that was likely used to hang drying negatives.[109]

Vivian Maier does not seem to have been affiliated with any camera club; membership would have connected her with a community and perhaps access to darkroom facilities. Maier struggled with some aspects of her photography. In this time, she came up with a far-fetched but enterprising idea to get satisfactory prints made from her negatives, reaching out to Amédée Simon, the proprietor of Saint-Bonnet's camera shop. Simon had once enlarged her work into postcards for her. Maier told him that she currently had a friend who was developing her film, but she was not satisfied with the quality of the woman's printing. She then proposed to send her negatives to Simon in France so he could print enlargements for her at a reasonable price. She mentioned that she didn't like glossy photos and suggested a semigloss stock, like the "good paper" he had used for her landscape postcards.

She noted that she had "stacks of good shots" that she had made with her "German machine Rolleiflex." She referred to "struggling" with her earlier camera, describing it as a "dear old box" that had given her "so much pleasure." Acknowledging her creative development, Maier added, "I have made many experiments since my return to the United States, photographs taken at night, etc. and if I say so myself, they're not bad." It is not clear what, if anything, came of this idea.[110]

Vivian Maier was apparently no longer babysitting the dark-haired girl—who donned a beret in the final outdoor pictures. Although during this time various children appear in pictures within apartments and in outdoor scenarios, other photos suggested Maier was creating work samples for job opportunities, or she may have actually been employed as a photographer. She devoted an entire roll of film to an unremarkable restaurant interior, and the envelope containing the negatives indicates two enlargements were produced from the batch.[111] Separately, a series depicting a gray-haired woman modeling a hearing aid included an over-the-shoulder view that showed her smiling into an ornate mirror while the camera revealed the device tucked behind her

ear.[112] A tabletop still life presented a bowl, a wooden spoon, eggs, butter, a cookbook, and a neatly handwritten recipe for a chocolate soufflé. Both of these had characteristics of advertising.[113]

Maier used her camera's flash attachment or a single light source to shoot the domestic scenes, but her subjects would have been better served with other techniques. Harsh shadows punctuate forms, and as with the outdoor night flash, open space beyond the bulb's reach recedes to black. The soufflé setup appears as if it's on a small stage in a darkened theater. A sunny window would have provided a more pleasant kitchen environment and natural effect. A series of otherwise cheery birthday party portraits also suffers from the limitations of an on-camera flash as the portrayal of each child in a festive handmade paper hat is offset by an ominous black void. If Maier had utilized several lights, directing them into walls or the ceiling, or employed other diffusing flash techniques, she would have softened the flashbulb's stark effect.[114]

Some interior shots from this period appear to emulate a picture magazine story: a series shows two boys—one in a toy Native American ceremonial headdress—crawling around a miniature service station. These and other photographs of children from 1954 suggest that Maier continued photographing and babysitting simultaneously. By autumn, her pictures show that she had an ongoing commitment with a new family in an immense apartment complex called Stuyvesant Town and Peter Cooper Village.[115]

Together, Stuyvesant Town and Peter Cooper Village formed their own city within the city. Privately developed after the Second World War with returning veterans in mind, the eighty-acre high-rise campus extends from Fourteenth Street to Twenty-Third Street and from First Avenue to Avenue C at the East River. When opened in the late 1940s, the 110 buildings, averaging thirteen stories each, established a unique environment designed specifically for middle-class families. Around twenty-five thousand people occupied the eleven thousand apartments, and with the traditional family as the intended focus, children's playgrounds dotted the vast settlement.

From Vivian Maier's perspective, the fenced-in concrete playgrounds provided a convenient photo zone, where she could document kids in Halloween costumes, crying toddlers in their mother's arms, and clusters of boys and girls at play. Maier also photographed around the complex, including views of children pressed against windows, a worker on a ladder pruning a tree, and a boy being scolded by his mother.[116] And on the curb at First Avenue just beyond the complex, she caught a boy urinating openly as his mother watched; the boy turned toward the camera as his stream arced to the street.[117] But the most documented subjects during this period were three young sisters and the family who employed Maier during the autumn and winter months. Maier appears in one shot, smiling pleasantly while seated with the two older girls inside one of the playgrounds.[118]

Framed photographs lined the family's apartment walls, and above the couch a set of images depicted South and East Asian subjects, including a view of the Taj Mahal and a portrait of a Chinese man with a flowing white beard. Maier seems to have had an easy rapport with the girls' father, who may have shot the photographs that were exhibited in the apartment. He printed small pictures in the bathroom; Maier documented him seated at the edge of the bathtub with a darkroom tray on his lap, leafing with tongs through a stack of small prints.[119]

From mid-autumn through winter, when Vivian Maier photographed the sisters—who, like the dark-haired girl, also soon sported berets—around their complex, at the Central Park Zoo, and on a rural excursion, she maintained her incessant street photography practice. In the middle of what seemed to be an especially vigorous period—with captures that included a drunk being loaded into a taxi and a police officer in the middle of a sidewalk confrontation—Maier somehow got hit in the face and ended up with a black eye. Soon afterward, she handed off her camera to have someone make her portrait: she slightly raised her eyebrows and gazed out of the frame, presenting her shiner like a badge of honor.[120]

In 1954, as Maier traversed Manhattan from the upper Nineties down past Union Square—photographing touristy spots like

the top of the Empire State Building, Times Square, the Staten Island Ferry, the Statue of Liberty, Central Park, and along upper Fifth Avenue—she also continued to seek out spectacles. On September 30, the *New York Herald Tribune* announced: "Ava Gardner will make a personal appearance at 3pm today in the lobby of the Capitol Theater where her latest film, *The Barefoot Contessa*, is playing. Miss Gardner will distribute autographed photos."[121]

Vivian Maier showed up in the Capitol Theatre lobby ready to photograph. With a flash attached to her Rolleiflex, she approached Ava Gardner, who was giving autographs, and made an exposure. It doesn't seem a planned or a posed picture, rather, it looks like Maier got as close as she could to the seated actress and popped off a shot. An errant shoulder and arm appears along the picture's right edge, and in the shadows beyond the stretch of the flash, a man gazes steely-eyed in Maier's direction.[122]

At some point during that same warm autumn day, Vivian Maier also managed to confront Lena Horne somewhere on the streets. Maier achieved a lovely portrait of the smiling singer who directed her attention above the camera's lens, eye to eye with the photographer.[123] In the strained political climate of the time, Lena Horne, known for her stand on racial equality, had been accused of being a Communist. Such accusations roiled the photography community as well, leading to the demise of the New York Photo League.

A dark paranoia suffused the 1950s with suspicion, which became evident in the mass media. *Confidential* magazine had its own team of detectives and slogans like "uncensored and off the record" and "tells the facts and names the names." The tabloid's exposés provided a secret agent–like thrill; everyone was working undercover when they carried *Confidential*. As the fastest growing magazine of the time, its popularity led to similarly lurid rags with names like *Hush-Hush* and *On the Q.T.*

In August 1954, Alfred Hitchcock premiered *Rear Window*, featuring James Stewart as a wheelchair-bound New York photojournalist who spends his time peeping into his neighbors' windows, closely watching their goings-on from the aperture of

his own courtyard window. Stewart's character's voyeurism also implicated the movie's viewing audience; together they sank into the suspenseful plot generated by the ambiguity of the view through neighbors' windows, their silent cropped scenes open to misinterpretation, just like a photograph.

On November 26, 1954, Maier was aiming her Rolleiflex at a somber throng gathered for the funeral of one of the original members of the Communist Party of America. Israel Amter was a well-known local figure: he had run for various public offices, including governor and mayor. His funeral, at the Gramercy Memorial Chapel on Second Avenue at Ninth Street, was also near Stuyvesant Town. Deep rows of men in fedoras and women in patterned scarves lined the sidewalks, and several Amter associates gave public eulogies. Former East Village resident Allen Ginsberg, would mention Amter in his poem "America," adding, "Everybody must have been a spy."[124]

Vivian Maier perched alongside a boy on a storefront ledge with a privileged view over the top of the standing crowd—just as she had squeezed into her position on the Astor Hotel balcony on Thanksgiving Day. In two images shot in quick succession, everyone appears solemn; nobody else wields a camera. A sea of tightly packed mourners peer off frame, but several faces turn unsmiling toward Maier; a few glare warily, and one woman— her movement slightly blurred—appears as if she may approach the camera. Characteristically, Maier's position situated her as an outsider looking in. As nearly always, her motivations were unclear, but evident was her steadfastness to photograph everything around her.[125]

In a year that started with photographs of a new painting exhibition at the Metropolitan Museum of Art—juxtaposed with museumgoers' gestures and postures—and ran the gamut to drunken street scenes and rural family outings, Vivian Maier maintained a frenetic pace that exceeded her ability to print all of what she witnessed.[126] It's unknown whether Maier submitted work to Edward Steichen for *The Family of Man* exhibition. What's undeniable, though, is the existence of dozens of postcard-sized prints that were made from Maier's 1953 and

1954 negatives, including shots of subjects that fairly portrayed the exhibition's quest for the visualization of "universal elements and emotions and the oneness of human beings throughout the world."

THE REINVENTION OF VIVIAN MAIER

Chapter Six

Mysterious Nanny Photographer

John Maloof promoted Vivian Maier and her photography in the same informal manner as he had approached the Flickr community and other websites where casual communication was the norm. Calling Maier "Vivian" gave the impression that Maloof was her peer. Maloof's voice stood in for Maier's, making him a kind of surrogate for her, and their audience grew simultaneously. However, the early descriptions of Maier's life and photographic output that Maloof helped spread were inaccurate and incomplete, giving rise to ever-changing and increasingly embellished stories that created a myth: a mysterious French nanny who was also, secretly, a photographer.

Seven days after John Maloof introduced Vivian Maier to the Hardcore Street Photography group, the initial rush had faded, but some users were ready to go deeper. Blake Andrews—the first to link the story back to his own blog—wrote, "Now that the dust has begun to settle from last week's Vivian Maier maelstrom (with posts [linked] here, here, here, here, here, here, and here, not to mention, here), it's time to dig a little deeper. [Another blogger] Bryan Formhals poses the natural next question, 'How many other Vivian Maiers are still out there undiscovered?'"[1] Andrews opened his short essay with a Jacques-Henri Lartigue photograph and listed other examples of resurrected photography while also acknowledging earlier promoters of underappreciated artists. But those photographers, mostly unrecognized outside their high-culture context, did not enjoy the benefit of the Internet, which reached beyond the art

community. That Maier was a woman further set her apart in this male-dominated realm.

As the Maier/Maloof story continued to spread, Googling Maier's name now led to growing chatter stemming from the Flickr conversation. But that story did skid slightly off track when someone contradicted the impression that Maloof alone "discovered" Maier's work by linking to Ron Slattery's Big Happy Funhouse post from July 2008. The revelation fed the mystery while also expanding the story. Flickr user mort* posted three color Maier images from Slattery's website, offering, "I just stumbled on this via a Google search. Looks like another collector has some colour slides from her." Another group member added, "The plot thickens . . ."

John Maloof responded frankly to mort*'s discovery: "I know this guy. He was at the same auction. I bought the negatives and he got the rolls of film. I purchased the rolls and prints off of him after the auction. I knew someone would stumble upon those old posts and have some questions in a matter of time. Thank you for the lead." A couple group members visited Big Happy Funhouse and made some comments. Maloof then reclaimed the thread by linking to an update on his website of Maier's photography. He had met with the brothers who had written Vivian Maier's obituary and was sharing what he'd learned. Under the heading "Unfolding the Vivian Maier mystery . . . ," John Maloof disclosed new biographical details while emphasizing that even though these men had been under Maier's tutelage for their entire childhoods, she was an enigma to them, too. Maloof relayed that Vivian Maier was not Jewish but Catholic, that she came to America from France in the early 1930s and worked in a New York sweatshop, and that "she learned English by going to theaters." Most important, "she was constantly taking pictures, which she didn't show anyone." [2] This new life story was just as romantic as the one the Central Camera countermen had relayed to Allan Sekula—and it was still inaccurate.

Maloof ended his short post by saying, "I have many very interesting and peculiar facts about Vivian but, I'll wait to share them in the book." The first clear portrait of Vivian Maier

accompanied the text: her face in profile, reflected in a hand mirror.[3] By portraying Maier as peculiar, and withholding further clarification, Maloof built mystery into his post. The story wasn't unfolding as the heading promised; rather, he had crafted a teaser for a book. Vivian Maier's photography generated page views, appreciative comments, and post sharing, but simultaneously promising and suppressing peculiar details of an exotic life sounded more like the strategy of a spy novel or a movie.

The previous day, Maloof had approached another network at ExpertLaw.com, asking, "When Do I Own the Rights to Reproduce Photographs[?]":

I purchased a body of work from a photographer's estate. . . . I did some digging on the rights and found that from 1963 and earlier, if the photographer did not file a copyright registration renewal after the first term, then they are in the public domain. Is this true? What about the images from 1964–1976?

Any help would be great.[4]

Maloof had secured copyright in his name for a book on real estate after he acquired Maier's negatives in 2007, so he'd recently been through the official process to protect his own interests, but this was unfamiliar territory. The Internet's open-sharing culture—where he had already published more than one hundred Vivian Maier photographs—had blurred some lines, and infractions were nearly impossible to police. Copyright law was a bit clearer for print publication, but it could be difficult to interpret in special cases. The fair use doctrine was relevant here, too, as it allows for the educational and nonprofit use of imagery. Experts were needed, and Maloof sought them here.

The next day, LawResearcherMissy responded by citing from chapter 3 of the U.S. copyright law: unpublished or unregistered works created before 1978 were protected for the life of the creator plus seventy years. Maloof replied that the "author has died and she has no known heirs," though there was an "executor of her estate"; he wondered if that person would own the copy-

right. LawResearcherMissy responded, "The estate owns the copyright. You'd have to go through the executor to see about transferring the copyright."

Maloof did not follow up for ten days. He was fielding inquiries and international offers to exhibit Maier's photography, and he was posting a new Maier photograph nearly every day. The selection of images spread over decades and included a 1950s view of New York window-shoppers from within a recessed doorway; a 1960s elevated panorama of the Chicago skyline from beyond the Chicago River; an abstract skyward perspective that included New York's Chrysler Building; and an early-1970s Evanston, Illinois, street corner setup of a young motorcyclist waiting for an elderly woman with an aluminum walker to cross.[5]

Back on the Hardcore Street Photography thread, a user with the handle RT Smokes brought up the question of copyright again: "Whoever auctioned the lot probably doesn't realise it's a potential gold mine, but if this project results in a book/exhibition etc, the inheritor of the copyright (and there almost certainly is one) will probably want a hefty payoff." John Maloof replied, "I hammered out the copyright law for this work and tracked down the executor of her estate." He explained that they were working together and planned to donate "a portion of the book profits to a charity in honor of Vivian."

John Maloof returned to ExpertLaw with new questions: "If the executor of the estate grants me rights, what happens if an heir pops up? Does the copyright revert back to them?" KeyWestDan responded that the executor would know if there were heirs and confidently answered, "This is NOT an issue in the least." LawResearcherMissy weighed in again, too: "Should this hypothetical mystery heir show up, the copyrights would need to have been specifically left to him in the will for him to have any claim. Elsewise, one assumes that the will instructs the executor to liquidate the estate." But Vivian Maier had not left a will.

On November 1, Maloof followed up with what he said was his last question, warning that it was "trickier": "If there are any

outstanding debts that the author had before they died (which there likely were), will I be liable if I am profiting from the authors work even if I owned the work before the author died and I am given permission to publish and profit from the work by the executors? Or would the executor of the estate be liable since they authorized the release of the copyright to me? Or is this a non-issue?"[6] KeyWestDan closed the thread by insisting: "It is a non-issue. There is simply no available tort or claim against you, especially if the estate gives you a release and transfer of copyrights." Moreover, he said, with unwarranted confidence: "Nobody has any legal claim on the copyright, period, except for you as the owner of the photographs. Any liability is strictly on the part of the executor, but again, there is none. This is all a non-issue."

That same day, the British newspaper the *Independent* ran the first story that announced Vivian Maier to a general audience. With its tabloid title "Little Miss Big Shot: Fifties America Exposed—by a French Nanny," the article characterized the story as "one man's mission to rediscover Vivian Maier: nanny, eccentric and 'photographer extraordinaire.'"[7] The article presented Maier as a mystery and credited Maloof for the little information that we had about her. His "chance discovery" had now wrought "publishing offers, invitations to exhibit Maier's work all over the world, and the hope, from some, that a new star of mid-century American photography had been unearthed." Referring to Maloof's collection as an "intact but uncatalogued archive," the article—accompanied by a slideshow of forty-five photographs from Maloof's website—implied that he owned Maier's complete life's work.

The article introduced more curious anecdotes, including the sad information that Maier "had no family that anyone knew of, never, so it's said, taking a single personal call at the house she worked in for a decade." It closed with a series of musings: "Why did this intensely private person pursue her rich, revealing photography? Certainly not for public show believes Maloof, who says there only a few, small prints in the archive. Who was Vivian Maier? Perhaps more biographical tidbits will

emerge over the next few years—but there is surely only one place where we might find the answer: in the dark room."

Maier's negatives do reveal tidbits about her life, but at this point John Maloof's small portion of her output only generated questions, and his choice of images to share led to new interpretations of her life. Within the first couple of weeks of the Flickr discussions, Vivian Maier's story spread to a photo blog based in Spain. After noticing that countless scenes were from Chicago, a blogger there added a new spin to story, "También existen unos cuantos de Nueva York por lo que se piensa que estuvo una temporada viviendo en esa ciudad" (There are also a few pictures of New York and it is thought that she spent a short time living in that city).[8]

1955: LEAVING NEW YORK

Vivian Maier was born in Manhattan, and other than the six years she spent with her mother in France during her youth and the year she spent there as a young adult, she had lived in New York her entire life. But in the middle of 1955—during the period in which New York would spearhead the genre that became known as street photography—she was to leave the city, never to return beyond short visits. It's not clear why. Since her year abroad, Maier's photography activity and experimentation accelerated but may not have been lucrative enough to replace her babysitting jobs. There is no evidence that the pictures resulted in publication or professional jobs. And although the families that employed her may have had meaningful connections, they knew her as their babysitter with a camera.

The Family of Man exhibition opened at the end of January and closed on Mother's Day, May 8. Numbers dominated the show's recap: more than 270,000 visitors saw 503 pictures by 273 photographers from 68 countries. An average of 2,600 visitors per day roamed the theatrical maze of images that turned out to be more Edward Steichen's vision than those of the individual photographers, whose names and titles were not part of their pictures' display. The museum handled the printing. No frames

interrupted the images, all of which were variously cropped and presented borderless. Each room had a theme, and with photos suspended on poles, curved along custom walls, hung on the ceiling, and as larger than life-sized murals, the effect was, appropriately enough, like a virtual walk through an issue of *Life*.

Throughout *The Family of Man*'s run, Vivian Maier remained at work at Stuyvesant Town. Nearby, a unique new exhibition venue, Helen Gee's Limelight Coffee House and Photography Gallery, aimed to highlight individual photographers while offering their prints for sale. Presenting photographic prints as collectible artworks was nearly unprecedented, and their price tags hardly compared to other art works. In the month preceding the opening of *The Family of Man*, the Limelight presented a who's who of masters that Steichen had shown at MoMA, including Berenice Abbott, Ansel Adams, Brassaï, Harry Callahan, Imogene Cunningham, Robert Doisneau, Robert Frank, Izis, Lisette Model, W. Eugene Smith, Paul Strand, Edward Weston, and Minor White. Prints were affordable by nearly any standard—$10 each for Cunningham and White; for a Frank, $25, an Abbott, $35, a Weston $50; and for an original photograph by master printer Adams, between $25 and $60—yet few sold.

Vivian Maier seems to have been less interested in selling or showing photographs than in taking them. Even though Maier mounted at least one photo in a way that was typical for camera club salons—an eight-by-ten-inch print mounted on an eleven-by-fourteen-inch mat—there are no marks on the back of the board that would indicate she submitted it for display. The print, one of her early flash pictures, depicts a smiling child with a runny nose wearing a construction-paper hat.[9]

By spring, Vivian Maier's camera work broadened to include color photography. Medium format positive film for the Rolleiflex was slow, and sharp pictures were easy only in bright sunlight or with still or slow-moving subjects.[10] Maier was shooting Kodak's Ektachrome, and although it was less vibrant than their Kodachrome, it was easier to get developed, as it was designed for home darkrooms or local labs.

On April 22, Vivian Maier loaded her Rollei with Ekta-chrome and headed to Central Park where, along the reser-voir, the cherry blossom trees were in full bloom. It is easy to speculate that Maier is alone on her jaunts; but that day she handed off her camera to appear in one of the most casual of her existing portraits. Just as she had directed her recent subjects, Maier gazes out of frame toward the diffused sunlight. She wears a tailored suit and a slight grin; a pink cherry blossom cluster behind her adds a vital accent. The rest of the film strip reveals the pull of color: vibrant flowering trees offset buildings, a Central Park vendor sells flags and banners, and red jackets become vivid targets. She dropped off her film for processing nearby, at Fifty-Seventh Street's Modern Camera Center. Due to Ektachrome's unstable dyes and the passage of time, these images are now awash in magentas and purples.[11]

In early May, taking color play a step further by experiment-ing with studio-style lighting, Maier marked one lab envelope, "First time with cue light."[12] In two rolls of film, a woman near Maier's age poses playfully and theatrically in what must have been a riot of color and pattern, but today reads as a subdued blue/purple. With a paisley cloth backdrop, the dark Mediterranean-looking woman wrapped in a red-trimmed diamond-patterned scarf gazes off at various angles. In another scene that emulates the interior of a gypsy caravan tent, she lays on a flowery pillow draped in the diamond scarf offset by a dappled swag back-drop, revealing only her face and arms. In other pictures, the woman wears a pale chiffon dress, has an armload of balloons, and cradles a bright red rose while modeling matching crimson lipstick. Unlike the harsh, focused beam of a camera flash, the studio setup portrays the woman in a soft wash of light. In one candid shot, she appears with a giggling boy. Other black-and-white photos of this woman show that she lived in Stuyvesant Town, where Maier was spending her last months in New York.[13]

In this period, the Eighth Annual Loyalty Day Parade—staged in opposition to the perceived Communist appropriation of May Day—sent crowds to Fifth Avenue. Maier embraced the opportunity. At the procession's starting point, she found an

entourage of dignitaries outfitting Mayor Robert Wagner with a commemorative sash. Maier stepped up and photographed the activity. She eventually made an enlargement of a shot that included a shiny parade convertible with "Little Miss V.F.W. Loyalty," according to her sash, wearing a decorative tiara.[14]

The first couple weeks of May were notable for the closing of *The Family of Man* and talk surrounding the shutting down of the Third Avenue El. The iron network had extended nearly the entire length of the city, and Maier memorialized herself jointly with it in a poignant self-portrait. Standing on the Fifty-Third Street platform with the sun low at her back, she framed a tight street corner showing the platform's canopy projecting onto a brick facade. Her distinctively hunched silhouette stands centered between shadows of the decorative roofing and a shepherd's crook light pole, a cinematic rendering of the twenty-nine-year-old New Yorker melded into Manhattan's distinctive, ever-changing landscape.[15] The last elevated train ran through Manhattan on May 14, about the time that Vivian Maier was organizing to leave the city and the vestiges of her own family behind.

Within the next few weeks, whether on her own or traveling as a babysitter with another family, Maier was en route to Quebec City. Still using color film, she recorded the activities of a Native Canadian powwow. Homing in on the colorful regalia, she moved through the small crowd, hung out by a log fence, and approached tribe members for individual portraits. Bleachers filled with tourist families lined the periphery of the dance arena, and with a jarring dissonance, two ten-foot-tall Canadian flags formed the tribal dance backdrop. And then, as usual, Maier wandered away, into the environs of the indigenous residents and rounded up small groups for portraits.[16]

While in Quebec City, Maier used two cameras or traded between Ektachrome and black-and-white film, shooting color views from upper windows and brilliant stained glass from within a dark church; in black-and-white she did street photography. Merging her Rolleiflex skills with earlier styles she had tried in France, she explored this seventeenth-century settle-

ment that was already established when the Palace of Versailles was still a hunting lodge. Quebec City was a unique hybrid of France and North America; the ancient winding streets of the old walled city looked and felt like Europe even though the American border was less than 150 miles away.

Maier soon left Quebec City and made her way west, riding the Canadian Pacific Railway down to Toronto and through Ontario, past Thunder Bay and Winnipeg, into southern Manitoba, and then across Saskatchewan, past Calgary to the Canadian Rocky Mountains and the Continental Divide. Along the way, Maier shot Ektachrome transparencies that read as colorized versions of her 1950 French postcard views.[17]

By the middle of June, Vivian Maier had arrived in Los Angeles, which may have been her destination all along—perhaps fueled by her interest in cinema. In an early example of the way Maier kept her records, she photographed a letter she was about to send to New York. The already-folded note lay open on a dirty linoleum tile floor:

Los Angeles, Cal.
June 29th 1955

Dear Sir:

Please send me in care of the Los Angeles First National Bank the Balance of my account no. 505 425, all except twenty-five dollars, as soon as the interest is due. I am enclosing my pass book, kindly send it back with my funds to the Los Angeles Bank. Thank you.

Sincerely yours,
Vivian Maier[18]

2010: VIVIAN MAIER EMERGES

John Maloof's Vivian Maier website received more than a thousand visits during the week after he introduced Maier's work to Hardcore Street Photography.[19] Maloof was busy during the subsequent weeks, posting Maier's images and working behind

the scenes. Among the pictures he released were ones of a dog wearing a bonnet at the Fifth Avenue Easter Parade; a matron on a park bench at Riverside Park; tourists on a New York ferry; and a boy being scolded by his mother at Stuyvesant Town. Two months later, Maloof returned to the Flickr group to report that he had obtained what he believed was "the remainder of Vivian's work." His tally included a hundred thousand black-and-white negatives and approximately twenty to thirty thousand 35 mm color slides, encompassing the years from 1952 through the mid-1990s. He also stated that he'd acquired an additional two thousand rolls of undeveloped film, most of which were color slides.

Maloof had been tracking down bidders from the 2007 storage locker auctions, buying their winnings to add to his cache. But the confident claim that he had the remainder of her work echoed his similar assertion eighty thousand negatives and just two months prior. Two years had passed; it was certainly possible that an unknown mass of photographica was unaccounted for. One collector he did not track down, for example, was Kathy Gillespie, who still had Maier's portfolios containing 150 eleven-by-fourteen-inch prints.[20]

In March 2010, a shopping mall in Denmark mounted the first exhibition of Vivian Maier's photography.[21] Maier's 1950s' photographs set the look for the Danish outlet's spring fashion features.[22] Maier's pictures were up for only around three weeks, but the exhibit marked the point where her work began to emerge into popular culture.

Throughout this time, people were contacting Maloof for interviews, and through these exchanges, the story was spun further. In the introduction to an interview at the end of March, details of Maloof's discovery story were further embellished: "After spending seven months reviewing the photographic material in his possession, he found written, almost illegibly on one of the sleeves of film, the name Vivian Maier."[23] This interview characterized Maloof as a street photographer. Maloof suggested that perhaps Maier didn't always have access to a darkroom, but he offered, "when color film became readily available in the 70's, she jumped right in."[24] Maloof was appar-

ently unaware that Vivian Maier had shot color extensively beginning in the mid-1950s.

The exchange ended with Maloof's ominous acknowledgment of how close the world had come to never learning of Vivian Maier: "Not to sound gloomy for aspiring photographers but, I was only a hair away from never touching these again. I had purchased the remainder of the boxes from people who also did not realize the caliber of work they had in their possession. I'm afraid that if I wasn't working on my book at the time these may have never been exposed, but who knows."[25]

At the end of April, Maloof checked back in to Flickr to make two short announcements: he would be publishing a Vivian Maier book in the first half of 2011; and he had started production on a documentary film about Maier.

During this period, Maloof had taken Maier's work to a local art appraisal firm.[26] In the first week of May, a representative of the firm initiated a weekly series of short online articles about Vivian Maier's photography, connecting her to famous photographers of earlier eras while emphasizing the story's suspenseful angle: "Details of her private life are as mysterious as tightly wound, spooled film negatives."[27] In exalting the photographs, the writer suggested that Maier had intended for the work to be public: "Under the broad umbrella of 'street photography,' we find Maier personally standing with her Rolleiflex camera—her pathos, wit, boldness, and love affair with strict black and white rainbows of the mid century [sic] all exposed for us."

In the second essay, the appraiser posted two dozen Vivian Maier photographs, conveying the firm's high estimation of them: "Maier's photographs are masterful, poetic, and feel already like classics; it's as if a seminal book, for half a century lost, has returned to its proper place on the shelf alongside its rightful companions."[28] And then, just as real estate appraisers' reports show comparable homes as part of value assessments, seven Maier photographs were laid out in parallel to artists— including Henri Cartier-Bresson, Brassaï, Walker Evans, and Robert Frank—who were characterized as her "accomplices."

The third essay gave a short history of street photography

and presented some contemporary work. The series concluded with a John Maloof interview that also included four of his photographs. The questions, like many future queries, assumed Maloof was the authority on Maier. The writer additionally portrayed Maier's discovery as Maloof's destiny, further entwining them:

> "Do you believe it was your fate to find the photographs of Vivian Maier?"
>
> "How has finding the Vivian Maier collection changed your life?"
>
> "Do you think her aspirations lay only in the process of taking the photographs, rather than producing them?"
>
> "Where and who do you think she would fix her attention upon if she were taking photographs in this era?"
>
> "What is her moving film like? Did she see herself as a documentarian?"
>
> "What do you think Vivian would think about all of the recent attention given to her work?"
>
> "Do you think you would have been friends?"[29]

Maloof replied to the questions, downplaying the idea of fate but recognizing that finding the work had changed him: "I'm now a street photographer in charge of Maier's legacy." He didn't claim to know what Vivian Maier was thinking, but he hedged about her background: "There have been some very important discoveries in her history that reveal interesting insight to her possible spark into photography. Unfortunately, because we are working on the documentary film, I am not allowed to spoil the mystery." He ended with a winking emoticon.

Speculation about Maier's background and personality was taking on a life of its own. A Vivian Maier Wikipedia page was established in November 2009, based on information culled from John Maloof's website, the *Independent* article, and a Spanish website that mostly copied from Maloof's site. Another website, billed as "the web's largest LGBTQ group blog," built off of Maloof's recent characterizations to make new inferences about Maier.[30] A contributor there cited the Wikipedia quote: "She was a Socialist, a Feminist, a movie critic, and a tell-it-like-it-is type of person. . . . She wore a men's jacket, men's shoes and a

large hat most of the time."[31] The short piece was filed under "Entertainment, Gay Icons and History."

John Maloof continued to slightly embellish his story in the media. In a hybrid radio/audio piece with the Kitchen Sisters, Maloof said, "Well, I knew it was a woman because you see her in the images. And I had a kind of moment where I thought, I want to see if this person is still alive. Later that week, I'm like, let me just Google to see if this person is even anybody. . . . The only thing that was on the search was an obituary. I mean, but there was nothing about this person being a photographer, a journalist, an artist. Absolutely nothing."[32]

In the course of 2010, as Vivian Maier's story spread through different permutations, John Maloof continued to seek out experts and approach major institutions: he spoke with Joel Meyerowitz, and he submitted Maier's work to the photo curators at the Museum of Modern Art.[33] But more importantly from the perspective of her growing fame—and his own—he pursued other routes that would ultimately catapult Maier further into the mainstream and popular culture.

On November 11, Maloof returned to his Vivian Maier website with an update on his work.[34] He listed a fall 2011 release date for the book, news of work on a feature-length documentary, and an announcement that Maier's first U.S. exhibition would open in January at the Chicago Cultural Center. After a few more details about his growing collection, Maloof signed off by thanking everyone for their support, offering that he had "a lot of weight" on his shoulders, and said that he hoped he was "doing the right thing for Vivian Maier's legacy." And he promised, "I'll update the blog with more info as things progress."[35]

1955: CALIFORNIA

Vivian Maier established her Los Angeles bank account in the middle of June with a deposit of $99.42.[36] She made two withdrawals, leaving only $1.42 before depositing small weekly sums that may indicate she had found work. In the middle of July, Maier's New York bank transferred $1,825 to her Los Angeles

account, and throughout the summer she maintained a balance in excess of $2,000 (more than $17,000 today).

Within Maier's first two weeks in Los Angeles, she wandered Hollywood Boulevard and checked out Grauman's Chinese Theatre, where Hollywood stars pushed their hands and feet into wet concrete. Giant letters spelling *The Seven Year Itch* loomed on a marquee over the courtyard entrance and now-classic images of Marilyn Monroe announced her new movie. The famous scene of the sidewalk grate whooshing Monroe's flowing white dress was filmed in New York during the week that Maier tracked Ava Gardner and Lena Horne.

Vivian Maier spent some time watching other tourists in the courtyard. She photographed a woman stepping into Jeanette MacDonald's footprints while a bystander watched from the adjacent prints of MacDonald's dance partner, Maurice Chevalier. A group of teenagers in matching chiffon dresses organized themselves for a photographer wearing a Chinese coolie hat; his tripod sign announced, "See your photo made in one minute." Maier caught a good shot of the one-minute Polaroid photographer entering the courtyard and raising his eyebrows in a look of annoyance toward a woman of Maier's age who held a sophisticated Exacta 35 mm camera—the same model that James Stewart's character used in Alfred Hitchcock's 1954 *Rear Window*.[37]

On the same day, Vivian Maier was also two miles away on Sunset Boulevard at another movie house. The Sunset Theater was into its second week of an international film festival, and the bill featured two French films: the ten-year-old classic, *Les enfants du paradis* (Children of paradise), and the 1946 comedy, *Les gueux au paradis* (Hoboes of paradise). Maier made a close-up portrait of a stylish woman at the theater's entrance.[38]

If Maier was looking for recognizable figures, she found one off the Hollywood tour bus route, at the Brentwood Country Mart, a small farm-themed shopping center: Richard Widmark.[39] The actor's latest movie, *A Prize of Gold*, was showing throughout Los Angeles, and he had been recently featured on a popular television program.

In the months before Maier left New York for Los Angeles, the American TV audience had followed Lucy and Ricky Ricardo as they made the same coast-to-coast transition, leaving their gritty neighborhood on New York's East Side for glittery Hollywood. Throughout spring and summer 1955, the television audience had followed Lucy Ricardo's star-struck escapades: she stepped into Joan Crawford's footprints at Grauman's Theatre where she stole John Wayne's concrete patch, and multiple episodes portrayed zany encounters with movie stars that included Cornel Wilde, Van Johnson, and Rock Hudson. In a notable madcap installment featuring a Hollywood bus tour, Lucy Ricardo ended up inside Richard Widmark's Brentwood home. Vivian Maier had landed at the epicenter of America's celebrity obsession.

Maier was staying downtown at the Southland Hotel, conveniently located two blocks from Henry's camera store—a shop that boasted "New York Prices"—and three blocks from her bank.[40] The area resembled New York and her summer photographs show familiar tactics. She found women in fancy hats on park benches, recorded a sidewalk scuffle, and gravitated toward human anomalies, like a pedestrian with a hunchback and an elderly woman on crutches pushing her own wheelchair. Maier walked up and down Seventh Street, stopping to photograph near the corners of Hope Place, Grand Avenue, and Hill Street; and she traveled along Broadway and lingered at Pershing Square.[41]

At the beginning of July, Vivian Maier began nannying a blond blue-eyed toddler who became the subject of dozens of photographs, shot on Ektachrome. The girl and her Siamese cat appear in a variety of poses with multicolored props; one shot shows the cat perched with a bowl of food on a miniature table covered with the Sunday comics. Maier separately captured a vividly saturated cluster of bougainvillea draped over a white wall. In the black-and-white shots, the California sunlight gleams. As the rough-and-tumble dark-haired girl from Riverside Drive embodied New York, the blond toddler exuded California's golden luster: she lounged in the grass, presented

translucent leaves, and sat suspended in dappled shadows on a playground swing. Inside, sunlight streamed through the windows. Maier didn't always have success with the girl's poses: a picture of the toddler inside an old wooden barrel shows her screaming to be lifted out, and other times she's visibly cranky; full-time modeling was a lot to ask of a two-year-old.[42]

At some point in mid-1955, Vivian Maier purchased her second Rolleiflex camera, which she began showing off in mirrored self-portraits.[43] Subsequent photos show her earlier Rolleiflex and may indicate that she shot with both models. The new, slightly heavier camera had a function that locked together the shutter speed and aperture dials, making picture effects easier without altering exposures, a mechanical breakthrough in this age before in-camera light meters.

Vivian Maier's photos indicate that she was in and out of Anaheim throughout July and August, and she also photographed out bus windows during rides from downtown Los Angeles.[44] And although no Maier photographs have surfaced of the area's main attraction, Disneyland, "the happiest place on earth" opened with immense fanfare in the middle of that summer.

Despite the promise of happiness and a land filled with children and celebrities, Vivian Maier left Los Angeles. Pictures of the blond toddler halted at the end of August, as did Maier's weekly savings deposits, suggesting the termination of the nannying job. A series of September bank withdrawals correspond to images of nearby Pasadena, where in addition to general street photography, Maier shadowed a wedding at the First United Methodist Church. She documented the empty church interior and the crowd of attendees from across the street, and she made a happy portrait of the bride and groom through their departing car's window. The photos also included shots over the shoulders of the couple's official photographers with their large press cameras.[45]

At the end of September, Maier ventured south to San Diego and then crossed the border into Tijuana, Mexico. She later enlarged a Mexican street shot of a small group congregated by a Coca-Cola cart. But the trip was merely an excursion; within a week she was back on the streets of Pasadena.[46]

Maier's banking ledger shows activity on par with her high-volume photographing; twice a week she withdrew $40 or $50. The daily room rate at downtown hotels was around $5 per day, so Maier's withdrawals suggest more extravagant essentials, such as camera equipment, photo supplies, and film and processing costs. For whatever reason, on Friday, October 14, Maier withdrew $225 and abandoned Southern California. She left $1,445 behind at the Security-First National Bank of Los Angeles, where it would remain for more than three years.[47]

Maier headed north to San Francisco, where she found work as a nanny for a young boy who was part of a large extended family. Her numerous five-by-seven-inch enlarged prints from this period include images of the boy alone and as part of a group with his relatives. Other photos show the city streets from high up within the Nob Hill neighborhood. More like alpine vistas than urban street shots, Maier vertically cropped two views—along Pine Street, at Taylor and Mason Streets—in such a way that the roads appear as plunging canyons.[48]

The San Francisco prints present a hybrid of street and landscape photography with an eye for action and compositional nuance. A densely graphic image shot across Market Street includes the domed city hall, a passing streetcar, the crisscrossing of overhead wires, and billboards advertising the impending city elections; but it seems the camera's main focus was a sailor on the concrete traffic island tending to his four-by-five camera on its tall wooden tripod.[49]

In early November, Maier accompanied the boy and a team of his relatives to Golden Gate Park, where she framed a shot that included four adults and six children engaged with all levels of the playground's twenty-foot-tall spiral slide, oblivious to the camera. The evenly spaced group photo reads like a "family at the park" magazine pictorial. The day's outing also extended to the seaside amusement park, Playland-at-the-Beach, where Maier made a portrait of the boy and his mother in the funhouse's distorting mirror.[50]

Among the final photographs from Vivian Maier's time in California is a set recording the family's Thanksgiving dinner.

As she circled the narrow room's long table that seated more than eighteen, family members passed plates and put forks to their mouths, not acknowledging Vivian Maier or her camera's blazing flash.[51]

2010: EMERGING PIECES OF THE ARCHIVE

The legend of the "mystery nanny photographer" was spreading far and fast. In January 2010, John Maloof established Vivian Maier's Facebook page, where he posted Italian and Argentine articles about her, followed by news of the Denmark exhibition and an upcoming show in Norway. He also linked back to his Vivian Maier website, where, by spring, viewers could scroll through two hundred images out of the hundred thousand negatives he had. The work—all black-and-white square format—spanned from early 1950s' New York street photographs through late 1960s' shots of Chicago area streets and beaches. Nearly half the pictures represented Maier's earliest Rolleiflex work, completed during her last three years in New York.

Although Vivian Maier's oeuvre also included landscapes, portraiture, color work, journalistic reportage, and ethnographic studies, Maloof's choices brought to mind modernist photographers like Lisette Model and Diane Arbus. As a result, Maloof's selection evoked comparisons that Vivian Maier may not have made herself. Maier had chosen to print from other negatives than those that Maloof selected, and although she saw the images as square in the Rolleiflex viewfinder, her prints were invariably tightly cropped to highlight what she saw as the pictures' subjects. The photographs on Maloof's website were not cropped at all. Maloof's website did not reference Ron Slattery's postings of Maier's color slides, and he had not seen Slattery's dozens of Maier enlargements or his other materials that could potentially complicate—or perhaps simplify and elucidate—the story of the "mystery woman" and her photography.

But soon Maloof would no longer be the only arbiter of Maier's oeuvre. Randy Prow had won many boxes of Maier's work at the original storage locker auctions. That portion of Vivian

Maier's archive was about to be acquired by Jeffrey Goldstein, a Chicago artist and collector. Goldstein's version later evoked the drama of his entry to Maier's story: "Flea market rumors indicated that someone with a significantly larger portion of Vivian's work [than Maloof] had disappeared from Chicago along with his part of the Vivian Maier collection. Mystery and intrigue soon followed."[52]

The Vivian Maier collectors knew one another from Chicago's flea market circuit, and in early 2010—prior to Goldstein's contact with Prow—Ron Slattery had sold fifty-seven small—mostly four-by-five-inch—Maier prints to Goldstein. Slattery then also connected Goldstein and Prow soon afterward.

On May 2, 2010, Randy Prow e-mailed Jeffrey Goldstein pictures of his two-year-old auction winnings, spread out on a concrete floor. Mounds of snapshot-sized prints filled cardboard cartons, and glassine sleeves of negatives packed narrow shoeboxes. A small open storage case revealed rows of 35 mm slides. In one photo, some of Maier's prints were scattered next to a box loaded with rolls of her undeveloped film. Eight pictures showed fourteen boxes from different angles, highlighting various details. Prow promised Goldstein that there were thousands of prints and negatives.

In the pictures, Vivian Maier's earliest known work lay among the cluster of open boxes.[53] Many of the visible prints were the products of the thousands of negatives she shot during her year abroad, and two postcard-sized gray boxes presented stacks of Maier's landscapes of the Champsaur Valley. Nelly Richebois emerged waist deep in tall grass, one of the Les Allards "women in black" stood smiling in dappled sunlight, and the children posing with a cartload of dead lambs sun-saluted the camera. These were the prints that she had carried across the ocean sixty years earlier and then kept with her as she moved from one employer's house to another's.

Much of Prow's collection predated the Rolleiflex work with which John Maloof had introduced Maier. Maloof's negatives commenced in the summer of 1952. It was possible that more of Maier's work would yet surface. In the meantime, the conceit

that Maier led a mysterious life was heightened by the idea that missing pieces existed.

Goldstein jumped at the opportunity to acquire the work; within a day he had gathered the needed cash and prepared for the long drive to southern Indiana to meet Prow. Goldstein and Prow had arranged to meet at a vacant warehouse; the impending exchange seemed like a scene out of a Hollywood gangster drama. The scene was later narrated for a short television piece about the Vivian Maier story: "While John Maloof may have paid just $400 for his first box, Jeff was prepared to pay big money. He won't say how much, but he brought along his biggest, strongest friend, just in case. When they got to the warehouse, it was clear that the seller was also concerned." Goldstein picked up the story: "And his fellow was enormous. And my guy looked at me without saying a word and I knew what he was saying, which was, this guy's bigger than me, and there's not too much I can do here."[54] A later interviewer asked Goldstein, "You carried the money with you?" Goldstein's eyes lit up as he evoked cinematic tropes of kidnapping ransom and hostage exchange: "Yeah. It looked like I had a vest with bricks attached to it."[55] And yet, with all this drama, the men were not acting illegally.

For all the cash and peril of the warehouse transaction, Jeffrey Goldstein may have thought he was acquiring Randy Prow's entire Vivian Maier collection. But a short while later, Prow offered up more auctioned items, and this time, the material was more expensive. Photographs showed two more shoeboxes filled with black-and-white negatives, a stack of around one hundred snapshot-sized prints, fifty-three more rolls of undeveloped film, and many 35 mm slides, loose and in yellow Kodak boxes. This offering also featured more than a dozen of Maier's three-minute movie reels, and eight larger metal canisters of spliced-together footage.

And even this offering was not his last. There was more material available for purchase at yet a steeper price. Goldstein ultimately needed John Maloof's financial collaboration to acquire what he understood was the remainder of the Prow collection; and the final transaction apparently required even more muscle-

men, who this time brought guns. Goldstein and Maloof did not trust that Prow was offering the entire remainder of his cache, so they wrote an agreement listing an approximation of the materials, and specified "restitution" if additional work was withheld from the sale: "The value of the restitution will be based on fair market value based at the time of discovery of works withheld from this sale, including attorney fees."[56] The loose inventory of Maier's photography—each quantity preceded by "+/- or more"—included movies, small prints, undeveloped rolls of 120, 127, and 35 mm film, 35 mm negatives, "negatives, singles and cut strips of 120 format," and in the only reference to work in a separate format, "18+/- large transparencies, and 25+/- or more large individual negatives." No large-format photography has yet emerged from Vivian Maier's archives.

As part of the contract, Prow could keep two samples of "ephemera" and choose fifteen digital or darkroom prints "with certificates of authenticity from Goldstein's or Maloof's Collection." A clause stated that Prow could recover triple the amount of the transaction's sale price if checks were canceled or not honored by banks. The document stated that "the agreed selling price is $50,000.00 . . . ," but that figure was crossed out and a new handwritten amount added: $140,000.00.

Jeffrey Goldstein later wrote, "I have made four purchases with each purchase being progressively higher in cost than the previous."[57] He restaged the dramatic scene: "This transaction was not for the feign [*sic*] of heart as it was consummated far away from Chicago in a randomly selected hotel conference room, with a total of seven people including two off-duty law enforcement agents . . . to make sure all went 'as agreed to.'"[58] He later said, "I went down with John [Maloof] and his friend Tony; I had my friend Rick, who was an off-duty Chicago cop. Rick comes armed, and Randy brought his brother, who came armed. There was a great deal of intensity in that room, because you just don't know what may or may not happen. I was sweating some bullets in there. No pun intended."[59]

Altogether, Jeffrey Goldstein paid Randy Prow $100,000 for his portion of Vivian Maier's archive.[60] Prow cashed out at

more than one hundred times his initial auction expense. Vivian Maier's work would never have warranted lucrative sums during her productive years, when masters of the medium sold prints for less than the price of Maier's Star-D tripod, displayed in her 1955 self-portraits. And although she likely spent thousands of dollars on camera equipment and photo-related materials, her process did not include making prints for sale.

A year after the Hardcore Street Photography group first encountered Vivian Maier, her legacy entered the realm of high finance, high drama, and high art—primarily through its underbelly of speculative investment. But Jeffrey Goldstein's assemblage was heavily weighted in unrealized work—more than twenty thousand negatives and slides and nearly three hundred rolls of undeveloped film.[61] Goldstein's expensive purchase of this raw material implied confidence in its potential to reap even higher gains.

And yet, Randy Prow had not sold any rights to reproduction, and the subject did not come up in his agreement with Goldstein and Maloof.

The collection that was now Jeffrey Goldstein's encompassed Vivian Maier's earliest known work, including thousands of prints and negatives from her year abroad and documentation of her first stints as a nanny and their attendant families and environments. The collection also encompassed work through the summer of 1952, the Riverside Drive family, and her transition to the square-format Rolleiflex. The chronology picked up again with many negatives of 1955 Los Angeles and the blond toddler and with some intermittent color prints and slides. It also evidenced Vivian Maier's arrival in Chicago, where she was to photograph and live for the rest of her life.

1956: CHICAGOLAND AND THE NORTH SHORE

Vivian Maier moved to the Chicago area during the early winter months of 1956. Maybe California disappointed her fantasies. But speculation is a trap; mapping Maier's movements through her trail of negatives merely locates her in the Midwest by her

thirtieth birthday, when she began living among a tight community in suburban Highland Park. We don't know why she moved there.

Located within an elite enclave collectively known as the North Shore, Highland Park was comparable to one of the wealthy towns in Westchester County outside of Manhattan: removed from the clamoring city, yet connected by an efficient commuter railroad. The suburban lots were not as vast as the New York estates where Maier had worked in Brookville and Southampton, and the children's recreational spaces were markedly different from the playgrounds of Riverside Drive, Central Park, and Stuyvesant Town. Highland Park, with its immaculate streets and manicured lawns, fit in more with the 1950s' idealized television neighborhoods of *Leave It to Beaver* and *My Three Sons*. But, unlike those white Anglo-Saxon protestant TV worlds, Highland Park was predominantly Jewish.[62] Either way, Vivian Maier had little in common with its residents.

Among the "household help wanted" advertisements in the *Chicago Tribune* during early 1956, Highland Park's live-in offerings enticed with televisions in private rooms and paid vacation time. Very few ads specifically requested live-in nannies; the majority sought housekeepers who could also cook and watch children. Gone were the days of households like those Maier's grandmother worked for in which an array of individuals performed specific tasks. Here, cooks, chambermaids, parlor maids, and governesses were all rolled into one. A January 16, 1956, *Tribune* listing stands out for its unusual pitch and tone:

General housework and light cooking
—Only angels and living-dolls who would
love 2 small children in Highland Park
need answer this ad; own room with TV;
stay for life.

In early February, Vivian Maier responded to a more nononsense newspaper ad placed by Avron and Nancy Gensburg. Their hands were full with two young children: a boy about

to turn two, and his a two-month-old baby brother. They were not specifically seeking a nanny, but children were part of the package:

GENERAL HOUSEKEEPER
Light hswk.—other help—plain
cooking—must like children—own rm;
bath; TV—5 ½ day week—$45 start—refs.
Nr. Transp. Call collect Highland Park 2-. . . .[63]

The pay was good, and every other detail suited Maier's needs: a private room to maintain her independence, a bathroom that could double as a darkroom, convenient transportation, and days off to spend downtown. She arrived with a camera around her neck.[64]

Twenty-five miles south of Highland Park, Chicago resembled Manhattan in striking, albeit scaled-down, ways: Michigan Avenue—Chicago's "magnificent mile"—paralleled Fifth Avenue; Lake Michigan and Lincoln Park replaced New York's rivers and Central Park; and Madison Street's skid row served as Chicago's Bowery. Chicago skyscrapers didn't compare to Manhattan's; nevertheless, shortly after her arrival, Vivian Maier ascended and photographed from the thirty-fifth-floor observation deck of one of Chicago's highest structures.[65] Accessible by a spiral staircase, the Tribune Tower's observatory boasted clear-day views of Michigan City, Indiana, forty miles across the lake. Maier also shot vast panoramas and dizzying views down the LaSalle Street canyon from the city's tallest building, which housed Chicago's Board of Trade.[66]

At sidewalk level, Chicago's gridded Loop streets resembled Midtown Manhattan, and Maier continued her walking tours in search of eye-catching subjects, acclimating herself to the downtown sights. State Street's flickering theater lights replaced Times Square, and she monitored and shadowed pedestrians, hovering at crosswalks and tucking in along storefronts. The urban and suburban settings complimented each other: she was able to spend solitary days in the city, return to develop her film

in a private bathroom, and devote working days to a family that welcomed her into their home.

In September, Maier made a quick trip to New York and slipped back into her earlier routines, scoping out action and returning to old haunts. The ubiquitous Third Avenue El was gone, and Maier explored the now-bright street, stopping blocks from her old East Sixty-Fourth Street neighborhood to photograph a man cleaning off the bottom of his son's shoe while the boy hung on to him and glared toward the camera.[67] Just west of Third, she could ride the Lexington Avenue subway that paralleled the old elevated train route.

When Maier arrived at Eighty-Sixth Street and Third Avenue, she found a police officer in a confrontation with a stout, unhappy, older woman.[68] Camera ready, she approached as the officer clasped the woman by both wrists, and they stood with elbows bent, face-to-face in a standoff. With eyes closed in defiance, the woman pulled back against the policeman's grip. He appeared to be speaking calmly, as if trying to persuade her to release something from her clenched fist. Then she apparently pulled loose, bolted across Eighty-Sixth Street, and headed north on Third Avenue before the officer was able to apprehend her again. Vivian Maier ran with the action like an experienced photojournalist; a subsequent frame shows the officer grasping the woman by the wrist as she struggled against a parked car.[69] The woman, who had been wearing a knit cap, was now bareheaded, and the contents of her purse lay scattered around her feet. Of the photos that Maier took of the street struggle, she chose to print a tightly cropped version of the initial face-to-face encounter, emphasizing tension by eliminating the surrounding space from her mid-distance vantage point.[70] For this picture, as in most of her other prints, the subjects trumped her in-camera composition.

During her visit, Vivian Maier covered familiar territory though Midtown and Times Square, but for one poignant photograph that would later emerge in a different context, she wandered toward the west side's Chelsea Piers and ended up along the Hudson River. At Pier 64, where Twenty-Third Street met the river, a woman with a baby carriage stood near the water's

edge and a mountainous ocean liner loomed behind her. As the woman leaned over the baby carriage, she turned toward the camera. The resulting photograph, stunning in how its elements parallel Vivian Maier's own biography—a woman like herself, who tended to babies; the massive vessel with its romantic associations of world travel; and the dark river, which she had photographed from the Riverside Drive apartment—remains ambiguous and enigmatic.[71] Perhaps the woman was a friend of Maier's and they strolled together to the pier. Read differently, her activity seems ominous as she reaches into the pram while standing at the foot of the dock. The timing and framing invite alternative interpretations.

Maier also photographed in color during her New York visit and during the spring months in Chicago. She switched from positive transparencies to negative film and had snapshot-sized prints made from her favorite pictures. She had begun using Kodak's new negative film, which was color balanced between daylight and incandescent bulbs and which for the first time could be processed outside Kodak's own plants. Kodacolor was the first film designed expressly for color prints, and Maier made weekly trips to drugstores or labs to collect snapshot-sized photos from her negatives.[72]

Vivian Maier also became more integrated in the photo process by making black-and-white prints in her home darkroom. One night, she recorded her progress in a spiral-bound steno pad:

Dec 6, 1956 (thurs)
enfin, at last!
(normal negative)
9 P.M.
First attempt, counted to 14 print too dark no f2
Kodak paper (normal
negative) lense opening f8
2) counted to 7 lense opening
(8) better print
still not perfect
3) counted to 4 lense

opening 4.5 not good
4) print 5/6 opening
counted 2 not bad
print paper F1[73]

In her struggle to get a satisfying print, Maier adjusted the enlarger lens opening and changed the amount of time that light projected through the negative onto the printing paper. She also lowered the print's contrast by changing the paper from F2 to F1.[74] From one trial to the next—especially from the second to the third print—her adjustments indicate difficulty in comprehending the effect of changing the lens opening together with the duration of light on the paper. Altering one factor at a time would have given Maier better control of the process. Instead, she reduced the exposure time while also more than doubling light with a wider aperture setting, resulting in a "not good" darker print. The final print of the group received her lukewarm assessment of "not bad."

Printing was not yet Maier's forte, but during that winter night, she struggled on, grading the results: a mannequin photo from a thin negative produced a "fair" print; "Johnnie & grandfather," an overexposed negative, resulted in a "good" print; "clown, weak negative" was rated "poor"; and "second attempt" at "NY from Empire State building" yielded the maximum, "good print" appraisal. One "fair" print was crossed out and downgraded to "so so," and a "poor" print was elevated to "fair." Maier produced more than eighteen photographs in just over three hours, which is a frantic pace for the range of adjustments she made. Following her last print, "Lois and baby, also terribly overexposed same as above, doctor print in developer—good results," she penciled in and then firmly underlined, "finished printing at 1/4 past 12."

In this time, Vivian Maier experimented and printed with at least eight different types of paper that had a variety of tones and surface textures and were dominated by warm blacks and fine grain surfaces.[75] As in her repeated instructions to professional printers, she rejected glossy photos.

The Gensburgs' bathrooms also became photo studios, where Maier practiced her flash techniques and created mirror self-portraits in black-and-white and in color. While holding the camera-tethered flash attachment, she bounced light off the ceiling for an effect that highlighted her reflection, which was sometimes repeated in confusing configurations with multiple mirrors. Maier posed in private, sometimes gazing directly at herself in the mirror and, in other instances, peering in the direction where she pointed the light. In one set of pictures she used the camera's self-timer function and posed for portraits in her bathroom's mirror and in her adjacent bedroom, where she kneeled on a backwards-facing chair, looking mysterious in the low light.[76]

Maier got to travel with the Gensburgs to Florida during the winter or spring months. She used the opportunity to explore alone, and one night, on spotting a woman in a party dress with a white shoulder wrap, she followed until she was able to get close enough to frame and capture her under a streetlamp. The resulting photograph of the slightly blurred ghostly figure also revealed Maier's nighttime prowling movements as the distant streetlights' inverted V-shapes imprinted the camera's bumpy exposure.[77]

The Gensburgs' third son was due in early 1958, leading to a bustling household of three boys under the age of four. But during the autumn of 1957, Maier was working with Virginia Hobson of Chicago's Ask Mr. Foster Travel Service to devise an elaborate three-month-long excursion for herself around South America. Throughout 1957, newspaper articles mentioned the rise in South American tourism, and colorful magazine advertisements offered bundled excursions; costs were low for jet-setters and the dollar was strong. Maier conducted research, studying Argentine currency exchange rates and making a list of hotels in Buenos Aires with rooms averaging two hundred pesos per night. She contacted the Argentine consulate and received information regarding an "Institute about aborigines" in Buenos Aires.[78] But Argentina would comprise only four days of the trip.

On November 4, Virginia Hobson mailed the extraordinarily detailed itinerary for the trip that was scheduled to launch in mid-February. Maier had made her own tour package, which left through Miami, and she booked ten days in Mexico City prior to traveling to the Yucatan, and then Guatemala and Panama. The sixth flight leg, which would arrive in Colombia more than three weeks into the trip, initiated a big loop around South America that ended with an eleven-day jaunt through the Amazon. The entire itinerary included sixteen countries and ended with stopovers in Trinidad, Martinique, Puerto Rico, and Haiti. Maier was scheduled to arrive back in Chicago around the twentieth of May.

But Vivian Maier never made the trip.[79] In April, Maier was photographing Highland Park's budding trees and blooming crocuses and was experimenting with her new close-up attachment. In the coming months she'd start over, planning a new trip for herself, to the far reaches of northern Canada.

In 1957, Maier expanded her photographic repertoire to include 35 mm photography. Her new camera, the recently introduced Contaflex IV, was the newest of the German Carl Zeiss line; it was small and sturdy—made of solid brass and steel—had a built-in light meter, and could accommodate different lenses. It was expensive, retailing at $199, but it could shoot three times as many pictures per roll of film as the Rolleiflex. Additionally, Maier could now use Kodachrome transparency film to produce vibrant color slides, which she did at Highland Park's playgrounds and flower gardens. Also during this year, she began shooting motion picture photography, a shift in her vision toward what would seem to be a more efficient means of capturing the world around her.[80]

In the meantime, Maier continued to document the Gensburg family's activities, which she sometimes detailed on her negatives' glassine envelopes. One note highlights her ongoing regard for cinematic events: "Johnny's third movie 'Snow White and the seven dwarfs' at Highland Park movie house 14th of June 1958."[81] Maier seemed fully integrated into the Gensburg household and activities, and yet the arm's-length nature of her

photographic practice—and her role as the hired help—kept her an outsider.

Keeping with her ongoing experimentation with color photography, close-up attachments, flash techniques, and different film formats, in 1958 Maier purchased a unique new still camera. She'd alternated shooting color slides and black-and-white film with the Contaflex and still used both of her Rolleiflexes; but she now acquired a fourth camera, the Robot, a 35 mm camera valued for its sturdiness and automatic features. German fighter pilots had used an earlier version during the Second World War, and its miniature size also led to its reputation as a spy camera. The Robot was best known for its spring-loaded winding knob that automatically advanced the film and allowed for continuous shooting. Maier's model had the special feature of a double-size winding knob that supplied enough power to shoot a burst of six to eight frames per second. The camera also shot in a square format, fitting four times as many pictures on a film cartridge as the Rolleiflex. At forty-eight exposures per roll, Maier could take more pictures, spend less time reloading film, and have fewer rolls to process.[82]

In mid-August, Vivian Maier packed at least three of her cameras and made her way to Winnipeg, where she joined an annual subarctic train excursion. The previous year, the *Chicago Tribune* ran an ad that featured a tourist photographing a fur-clad indigenous Canadian over the copy, "If the pulse of adventure throbs in your veins, this is the trip for you! Six thrilling days north of 54°—the land of the Eskimo and the northern lights."[83] Other features suited Maier's interests and also eliminated the need for further planning: "The train will be used as a hotel at all stops and will be equipped to give movie shows at night. An open observation car will provide working space for camera fans."[84]

The tour's first stop at the old trading post town of Dauphin featured a chamber of commerce–sponsored event on the lawn alongside the railroad tracks. Maier shot 35 mm slides of the affair; Union Jacks and scarlet-coated Royal Canadian Mounted Police provided brilliant reds contrasting with the sapphire sky.

Another stop featured a Scottish pipe band, and she made color portraits of kilted bagpipers and leopard-vested drummers. Maier saw differently with each camera, and reserved color for the Contaflex outfitted with vibrant Kodachrome film. In the small mining town of Flin Flon and also while at Cranberry Portage, Maier wandered off the tourist path wielding her Rolleiflex and found clapboard houses, where she engaged with children and adults who warily posed for her.[85]

The train made its way along the old trade route north toward the Hudson Bay and the Arctic Ocean seaport, Churchill. There, Vivian Maier found Cree women in headscarves standing around the depot, smoking hand-rolled cigarettes. Others were prepared to present their swaddled babies laced into cradleboards for photo opportunities. Maier also found her way into the trading post; armed with her flash attachment, she lit up a weatherworn Cree elder as she turned toward the camera. That same woman also posed for a seated outdoor portrait.[86]

At some point, Vivian Maier handed off her Rolleiflex—loaded with color negative film—for someone to make her portrait. She gazed toward the horizon while clutching her Robot camera as if poised to take a picture; it was outfitted with a yellow filter for heightened black-and-white contrast. With the Contaflex—in its elegant silver-trimmed brown leather case—slung over her shoulder, and in her smartly tailored gray flannel coat, Maier looked like an editorial photographer on a magazine assignment.[87]

Vivian Maier's excursion was dense with new experiences and colorful subjects, but the subarctic adventure would be only a blink compared to the extensive voyage she organized for next spring that would take her entirely around the world.

2011: THE CULT OF VIVIAN MAIER

By January 2011, publications were tallying Vivian Maier's photographic materials: *Chicago* magazine wrote that John Maloof estimated he owned more than a half dozen of her cameras, at least one hundred 8 mm movies, three thousand prints, two

thousand rolls of unexposed film, and a hundred thousand nega-tives.[88] The *New York Times* reported that Jeffrey Goldstein's collection included twelve thousand negatives and seventy homemade movies.[89] Maloof had also acquired some of Maier's personal belongings: "Negatives, cameras, clothes, shoes, tape recordings, documents—Maloof's attic is now a cluttered reposi-tory."[90]

The Gensburg brothers had kept up payments for two storage lockers packed with Maier's possessions, which were in a dif-ferent warehouse than the lockers auctioned off in 2007. After John Maloof contacted them, they proposed meeting him at the warehouse, offering, "If you see anything that you like that we're going to throw out, you can have it."[91] Maloof later said that there were many binders filled with newspaper clippings in the lockers, and he described the rest of the stored items as "a giant collection of various found objects such as crushed paint cans, railroad spikes and other tchotchkes," but he also did receive some of Maier's clothing, other personal articles—"A coupon. A note. A flyer. Bus passes. Train cards. Her hats. Shoes. Her coats. Her blouses . . . un-cashed income tax checks from the government amounting to thousands of dollars"—and a taped-shut leather case that contained hundreds of rolls of undeveloped color film.[92]

Throughout the winter of 2011, a flurry of activity sur-rounded Maier's legacy. While John Maloof was preparing her first major exhibition, which he called *Finding Vivian Maier,* he welcomed a local television reporter into his attic space, which also served as a film-scanning workshop; a TV crew from a national network news program would arrive within weeks. Maloof gestured toward tubs filled with sleeved negatives and binders stuffed with newspaper clippings, and he picked through a silver trunk containing Maier's coats and hats. She was simultaneously absent and present as Maloof and the inter-viewer handled and then tossed Maier's hats back into the chest.

Maloof was also preparing to make his documentary film, also called *Finding Vivian Maier.* He had returned to the Inter-net, seeking $20,000 toward preproduction costs through a

three-month Kickstarter campaign. It seemed that everyone wanted to have a hand in pushing the search along: the campaign reached its goal in two weeks.[93]

On January 7, spectators jammed the opening reception of the *Finding Vivian Maier* exhibition at the Chicago Cultural Center. John Maloof's film crew further charged the atmosphere as they fixed their camera on him within a crush of onlookers. Ron Slattery was there; the Gensburg brothers also came, as did some of Maier's employers and others who had crossed her path.[94] As at other congested opening parties, the framed artwork was nearly impossible to view. Eighty inkjet prints prepared by Maloof from Maier's scanned negatives hung in two galleries that also displayed her possessions as artifacts. Museum cases presented several cameras, a mass of film spools, and a note from a photofinisher. Four broad-brimmed hats were lined up inside a glass-covered table. Personal letters and a scrap of rubber-banded newspaper lay like findings from an archaeological dig. Guests gaped at Maier's belongings like fans peering into a celebrity's closet, the door flung open and the lights switched on. Rather than complete the picture of Maier, this treatment added to her mysterious aura.

But the pictures on the wall told a different story, one that was perhaps more revealing of the woman who was simultaneously present and absent within the exhibition space. And that story was of a conscientious photographer who was engaged with the world. Maloof, who had become the arbiter of the spectacle, had not known Maier, but she emerged through his efforts, his selections from her estate, and his analyses of the particulars in his possession. John Maloof effectively became the voice of Vivian Maier, and he introduced her and her work in a multitude of outlets, with more authority than was warranted. In a January 2011 interview he stated: "I have good reason to believe she began taking pictures in about 1949. Negatives from this year and even a year later have a beginner look to them. They are either over or under-exposed, out of focus, clumsy compositions, etc."[95] But Maloof had not seen any photographs from 1949—Maier's earliest known work is from her trip to France in 1950—and in

the same interview he'd stated that his collection started with work from 1951. Maloof's assessment of Maier's accomplished camera techniques as having a "beginner look" was naive and uninformed. He also hadn't seen the thousands of early Maier photographs that Jeffrey Goldstein had acquired. After Goldstein and Maloof bought the last of the Randy Prow trove, they divvied up the negatives. They studied a portion of the work, and then met with a list of favorites and alternate choices, to negotiate.[96] The transactions occurred in waves over the next two years. By January 2011, Maloof had had only a rudimentary look at a fraction of her early production.

In this same period, Jeffrey Goldstein went to work putting a team together, incorporating his collection, cataloging Maier's photography, and arranging to process her undeveloped film. In late December 2010, he gave Frank Jackowiak, an instructor at a Chicago area junior college, "218 rolls of unprocessed film with cryptic writing on the outside paper sometimes in French" to develop.[97] On New Year's Eve, Jackowiak decided to begin processing the negatives, choosing two rolls of 35 mm Kodak Plus-X film.

Both rolls' metal cartridges had illegible scratches on their surfaces, but amid other markings, one of them clearly read, "Tues 23rd 69." A newspaper stand that appeared in one of the negative frames revealed a *Chicago Sun-Times* headline— "Chicago Jet Crashes in Mexico—40 Die"—confirming that the film was shot on September 23, 1969. Trees were the subject of twenty-six of the thirty-nine frames; nearly all views pointed directly upward, showing branches flattened against the sky. Other images, including one of a girl climbing on a log, were interspersed throughout the roll. The second roll also contained a frame of a newsstand that indicated it was shot the following day and jolted back to a specific turbulent time: "'Chicago 8' Go on Trial Here Today in Riot Case." Maier also recorded her train journey to downtown Chicago that day. A sequence of images shows the train passing through an industrial area alongside the Chicago River, where she framed a layered shot that included cars ordered in a parking lot, a stopped train, and

distant buildings shrouded in fog. Maier made one picture inside the train station and then photographed another stack of newspapers before coming across a group of construction workers walking a picket line. After a few shots from different angles, she continued on in the pouring rain and found a separate mass of protesters with Black Liberation signs and others announcing their efforts against "war and fascism." The last frame portrayed a multiracial couple. The images were casual, mostly blurred, and seemed perfunctory.[98]

By mid-January 2011, a group of volunteers had processed fifty black-and-white rolls from Jeffrey Goldstein's collection. And then, as Maier's story snowballed and Goldstein began exhibiting prints from her negatives, even Jackowiak was recognized as part of the phenomenon. A *New York Times* piece began, "Frank Jackowiak proudly sported a badge when he arrived at the opening for Jeff Goldstein's Vivian Maier exhibition at Russell Bowman Art Advisory in Chicago last April. 'I saw what Vivian never did,' the badge proudly read. 'I processed her film.'"[99] The cult of Vivian Maier was growing.

John Maloof's Kickstarter campaign ultimately raised $105,000, more than five times its initial goal, with fifteen hundred backers. Those who pledged the smallest amount received a Maloof-authenticated empty spool from Vivian Maier's undeveloped film: for ten dollars, backers could own an object that Vivian Maier touched and that once contained film that traveled through her camera; a true devotional relic (plate 30). (Apparently some pledgers thought they were getting an actual roll of Maier's undeveloped film.)[100] Twenty-one supporters committed more than five hundred dollars, but nobody opted for the $5,000 package that comprised all the incentives—a copy of the movie's DVD, the soon-to-be-published book, a thank you in the film's credits, and tickets to the movie's premiere—plus a bonus dinner with Maloof and his production partner.[101]

For all the publicity, Vivian Maier's story was missing an authority that could talk about her work within the genre of street photography, and as Maloof continued generating Maier's web presences—in addition to the Facebook page in her

name, he set up another specifically for his upcoming book of her photographs—he had renewed his correspondence with Allan Sekula. Sekula had also been contacted by an Associated Press reporter who was putting together a piece about Maloof's discovery, and in an honest answer to his opinion of Maier's photography in historical context, he responded: "Sorry to be reticent about ranking her work in a more precise way. I need to see more, and especially to see what she selected for printing. She is certainly a very good photographer, all the more remarkable for working in total obscurity, and worthy of wide international re-discovery."[102]

Sekula agreed to write an essay about Maier for Maloof's book. The early April deadline was tighter than he thought he could manage, and he was unable to get to Chicago immediately, so he asked Maloof to send him a DVD with four hundred images that he could study. Sekula planned to be in Chicago for three days in March; he'd see the exhibition, visit Maloof's attic repository, and sit for an interview for the documentary film. But, on the day that he was supposed to arrive in Chicago, Sekula canceled the trip because "a serious crisis has come up with another project."[103] He still thought that he could write the essay, but he asked Maloof for scans of Maier's vintage prints, her proof sheets, and a list of the books in her library; he also asked to be put in touch with a couple of people that she may have cared for as children.

Allan Sekula did not end up submitting his Vivian Maier essay. In April, he became ill with cancer; he never published any extensive thoughts related to Maier's photography. What he did write about her in e-mails is clear and direct and applies to how he saw Maier working vis-à-vis street photography:

Street photographers try to capture telling images from the unpredictable flow of pedestrian life on city streets. They look for fleeting interactions, for moments of anonymous drama, for style in gestures and clothing. The work is done unobtrusively, usually from within the crowd, with a small hand-held camera. Timing and good reflexes are crucial.

A street photographer has to be willing to walk for hours on end, and

also to loiter in promising spots without being obvious. Good shoes are as important as a good camera.

Typically, the spirit of the street photographer is one of broad democratic acceptance of human diversity and idiosyncrasy.[104]

Sekula's specific observations and interpretation of a subgenre within Maier's work—men sleeping in public places—stop short of psychologizing, a tendency others would not heed with such care:

Everyone is more or less equal before her camera. It's not so much her broad choice of subjects, from down-and-out men in front of temporary labor agencies to the well-to-do parading on Michigan Avenue, but the fact that she takes the same distance and cool observational attitude toward all. You see a picture of a homeless man sleeping on a bench, then a man in a suit sleeping in a car, and then a sleeping sunbather and you realize that she is interested in the male body in it's [sic] unconscious and vulnerable state of rest, all seen from a point of view close to the top of the head. She has nowhere to find that proximity but in public. There is something very poignant about that.[105]

Allan Sekula was aware that Vivian Maier was not known to have had any intimate personal relationships, which contributed to his reading; however, Maier approached sleeping women from the same close distances. Perhaps since women are less likely to nap in public, fewer such images exist. More generally, though, Maier's expansive oeuvre does indeed demonstrate Sekula's notion of a "broad democratic acceptance of human diversity and idiosyncrasy."[106]

1959: WORLD TOUR

Vivian Maier lived among the wealthy in a homogenous North Shore community, but she also spent her days traveling to more diverse neighborhoods and planning exotic trips, including a five-month trip to Southeast Asia and around the world. During this period when photographers like Robert Frank were embark-

ing on American road trips, Maier's interests were becoming intercontinental. But while Frank's project was supported by a Guggenheim Fellowship and would lead to a picture book, and his gritty aesthetic challenged traditional techniques, Vivian Maier financed her own journey, had no support for publication, and followed a more traditional portrait and landscape practice. Henri Cartier-Bresson had presented photographs of China in 1952, but his "decisive moment" approach and trademark Leica 35 mm camera set his work apart from Maier's all-encompassing documentation of her surroundings and her use of the bulky Rolleiflex. At the same time, Cartier-Bresson's recent return to China may have influenced Maier's own ambitious travel plans: on January 5, 1959, a *Life* cover story illustrated his four-month, seven thousand–mile tour.

Vivian Maier was not frugal in her photographic acquisitions; her weekly income seems to have gone directly toward equipment and supplies. But she would need additional funds for her extravagant vacation. Four years earlier, Maier had left more than a thousand dollars in a Los Angeles bank. Now, she directed the manager there to liquidate the account except for a token balance: "Kindly make two checks, one for seven hundred and thirty-five dollars and sixty cents ($735.60) and the other for eight hundred and nineteen dollars and ninety one cents, ($819.91) Please leave my account open with the remaining thirteen dollars."[107] At the outset of her trip, she carried $650 in traveler's checks.[108]

Although she was integrated into the Gensburg family's routines, Maier kept her personal and financial concerns private. She sometimes received mail at the Highland Park house, such as a refund check for overpayment of a cooking pan, but she conducted her confidential business downtown. Vivian Maier's official mailing address—P.O. Box 854, Chicago 90, Illinois— brought her regularly to the city's main post office, an hour-long train ride from Highland Park. An art deco behemoth that was the world's largest such facility upon its completion in 1932, the building straddled a new eight-lane highway. Inside, gleaming brass and marble halls created an environment akin to a well-

appointed bank or an elegant train station. Her two environ-
ments, urban sophistication and suburban comfort, provided
sustenance unlike any in her past. Chicago was not New York,
which was incomparable as a cultural center and the backdrop
to Maier's creative development, but these were halcyon days.

As Vivian Maier prepared for her trip, she kept uniquely
meticulous records by using her camera as a copy machine,
archiving all sorts of notes and documents. When she applied
for a new passport, which required sending back her expired
booklet, she laid the book open on a sunny patch of rug and
photographed each page, evoking all the places that established
her as an independent force and an accomplished photographer.
Now thirty-three, Maier hardly resembled the girl in the pasted-
in photo on that passport.

Maier neatly filled in the boxes of the passport application:
she was never a member of the Communist Party; she was five-
foot-eight with brown hair and hazel eyes; and she was born
in New York on February 1, 1926.[109] The list of her intended
destinations barely fit into the passport form's box: "Philippines;
Hong Kong; Indochina; Siam; East Indies; Malay Peninsula;
Port Swettenham; Penang; Aden; Egypt; Greece; Lebanon;
Syria; Turkey; Italy; France; and Switzerland."[110] But as her
mother and grandmother had on official documents, she falsi-
fied facts. She accurately provided her parents' birthdates and
noted that her father arrived in the United States in 1904, but
she said he died in 1932, the year six-year-old Vivian had left for
France. Similarly, she said her mother had died in 1943, when
seventeen-year-old Vivian lived with Berthe Lindenberger.[111]
The dates may correspond to Maier's final contact with her par-
ents, even though they both still resided in New York.

By the time Maier left Chicago in the early spring of 1959,
she had purchased her third Rolleiflex, a 2.8E, which could
shoot faster under low-light conditions and had an internal light
meter. Armed with the best equipment and having the look of a
seasoned professional, Maier stepped out of the suburban nanny
role, albeit with the knowledge that she would later step back
into it.[112] Unlike Cartier-Bresson's stealth use of his miniature

camera, which he covered in black tape to be less conspicuous, Maier dangled several devices, bringing attention to her activity.

The Santa Fe Railroad's Chief left daily from Chicago for Los Angeles, where Maier would continue by ship. On the train, she made a self-portrait in the mirror of the "Big Dome" lounge car.[113] Looking smart in a tailored gray suit, Maier peered down into her new fancy Rolleiflex and documented herself standing alongside a mirror applique of a Hopi kachina figure. The chrome-barreled Contaflex, outfitted with a telephoto lens, hung from her neck to her hip, and both cameras' swanky leather cases dangled open, revealing crimson velvet interiors. None of the other lounge passengers seems to notice her as they take in the surroundings.

In Los Angeles, Maier returned to familiar downtown sidewalks and retraced her steps from four years earlier. She stopped at the UCLA Medical Center, where she visited a smiling young woman who languished outdoors in a hospital bed under a leafy trellis. Maier kept in touch with select people who she met through her work and travels—though this woman's identity isn't known.

Vivian Maier's photography made her sightseeing purposeful. As she encountered strangers and unfamiliar surroundings, her equipment both shielded and drew her into the unknown. She assumed command in a world in which few women would have felt safe or comfortable. Her camera gave Maier focus through what her pictures demonstrate as fearless adventures. She was adopting an identity of her own creation; on her passport application, she had stated her occupation was "child nurse."

The M/S *Pleasantville* left the port of Los Angeles on April 28. While at sea, Vivian Maier seems to have recorded things she wanted to remember, scenes where light and form caught her eye, and events where her camera enhanced her presence: entire rolls of film show clouds, crashing waves, and parts of the ship; she took more than three dozen photos of two men getting their hair cut; and she documented the ship's variety show from the audience. She also laid out and photographed both sides of her Philippines customs declaration form, having

set it on a *Paris Match* magazine, next to an eight-by-ten-inch yellow Kodak box.[114]

In the Philippines, the first stop was the American Clark Air Base, and she took off for a nearby village where indigenous villagers stood around their Nipa huts adjacent to rice paddy fields. The thatched-roof stilt houses lined up close to railroad tracks, and after a distant shot that showed a breastfeeding mother, Maier crossed the tracks and made a close-up portrait.[115]

Along the journey, signs in various ports change from the Latin alphabet to Chinese characters, followed by Brahmic, and then Arabic script. Villages and streets peopled with Asians transition to dark-skinned Indians and then Middle Easterners in flowing robes. Maier photographed a smiling Sikh with a glistening topknot; toothless peasants in straw coolie hats; turbaned men at street markets; monks in saffron robes; Muslim men bowing in prayer; and, connecting all cultures, she recorded countless women with babies, as well as groups of children. She sat in the front row at a kickboxing match; attended a traditional dance theater; visited ruins, temples, and mosques; and made many photographs in cemeteries, once taking more than fifty color and black-and-white pictures of a Malaysian family at a hillside gravesite. Sometimes, beggars approached Maier's camera beseechingly, and occasionally a few waved her away or covered their faces to avoid the camera's scrutiny; but mostly, people smiled and allowed her close approach.[116]

Traveling with three cameras gave Maier opportunities for a variety of strategies, and she used each device differently. She shot most frequently and quickly in black-and-white with the 35 mm Robot camera that could generate more than fifty square negatives per film roll. Many of these pictures serve more as a collection of souvenirs of places or costumed characters than as composed frames or studied photographs. Of the hundreds of these negatives she shot during the summer months, many look like tourist snapshots and hasty pictures of people who caught her eye. Quick—and often blurred—shots of landscapes from train windows, views down village streets, and docked boats at piers appear alongside rapidly posed street photographs of dis-

tinctive individuals. Those with protruding teeth, sagging skin, or eye-catching headwear drew a quick and sometimes furtive portrait; they also provoked a new Maier strategy that would continue over the years. Like in a game of I Spy, she'd spot and track physical abnormalities: people with missing or shrunken limbs, humpbacks, and misshapen legs all drew Maier's camera in a way that stood out from her other street work.

When shooting with the Rolleiflex—which she did in both black-and-white and color—Vivian Maier worked more deliberately, and the pictures show a rapport with her subjects, who stand singly or in groups, focused on the lens held at chest height. These pictures show sharp planes of focus and consistently balanced framing. Maier used her third camera to shoot color slides or to bring her subjects closer via its telephoto attachment. With every conceivable combination of format and film type—and sometimes shooting with a flash attachment—she typically had two or more devices in continuous action. By mid-July—when Maier left Egypt following a visit to the Pyramids of Giza for Venice and Turin and a return to the Champsaur Valley—she had already shot more than three thousand photographs on at least four different types of film. And there were two more months of travel ahead.

One of Vivian Maier's first stops in the Champsaur Valley was at Saint-Bonnet's camera shop, where she popped in on Amédée Simon. Maier experienced the first moments of her visit through the viewfinder of her Robot camera: as someone opened the door behind the counter and Simon approached, she shot two quick blurred angled shots that showed his surprise in seeing her. She continued photographing as he handled a roll of film.[117]

Maier checked into the Hotel Moderne, across the river from Saint-Bonnet. Before she leaned out an upper window and photographed up and down the narrow road, she filled out the required document to register her visit. In her travels, Maier had never given a house address that could trace her to a specific location, but—unlike all the other papers where she gave her Chicago post office box—here she wrote the information she had used nine years earlier: "P.O. Box 576, New York, NY." When

Maier stayed in nearby Gap within the next month, she again provided that post office box.[118]

Photographs from Vivian Maier's return to the Champsaur Valley, while celebratory in their easy rapport with villagers and in the reappearance of picture postcard landscapes, also carry heavier associations. Maier returned to the École Saint-Bonnet of her youth; the school seemed abandoned, and Maier strayed through, photographing the dusky classrooms. Outside the windows, bright leafy trees contrasted with drab peeling paint and hanging bare light bulbs, and open doors revealed empty closets and murky corridors.[119] These once-vibrant rooms carried the weight of Vivian Maier's childhood. She arrived at this school as an outsider and she was an outsider still. Maier stood apart from typical women of her time. At one end of a dark hallway, she found a mirror and an opportunity to see and portray herself within this fraught place. Looking tan, lean, and masculine in the low light that accented her short hair and her white shirt's rolled-up sleeves, Maier holds her Rolleiflex chest-high and gazes directly at her reflection, half in deep shadow; her two other cameras hang side by side at her waist. She looks like an explorer from a child's imagined story.[120]

Throughout her weeks in France, Vivian Maier revisited places and people she had photographed in 1950, sometimes posing them as she had earlier, like the family members who gamely held iris stalks from their garden. And in an echo from a deeper past, a visit to a villager's home elicited deckled-edge snapshots from 1933. Spread out on a kitchen table alongside an unfinished plate of food, the photos show seven-year-old Vivian upstaged by a baby boy: someone dangles him in one picture to view her wilted leafy bouquet, and in another, she stands, mournfully regarding the camera while her mother sits behind her holding the baby.[121]

Maier also called on her eighty-year-old grandfather, Nicolas Baille, who had aged alarmingly since her last visit and looked like a street person she'd have gravitated to for a portrait: gaunt and sallow, his teeth and eyes appeared blackened by illness and age. In another tribute to her few scattered family members,

Maier visited the gravesite of her great-aunt, Maria Florentine Jaussaud, which was marked with a new white marble upright slab that was perhaps arranged for by Vivian Maier. In the middle of August, in a transaction that may have finalized a land sale—or perhaps she had left money in a regional bank eight years earlier—Maier signed and photographed both sides of a notarized check for 58,220 francs, worth around $9,000 today.[122]

The roving world traveler would never again return to the Champsaur Valley.

2011: THE MYSTERY WOMAN MEETS THE ART WORLD

In January 2011, John Maloof applied to trademark the words "Vivian Maier," and in April he launched his new "official" Vivian Maier website.[123] In addition to elegantly presenting more than two hundred photographs on a clean white background, he included a section that highlighted his story of discovery, and another that provided Maier's biographical details. But some of those details stemmed from little more than speculation based on select items he had acquired from her scattered estate; like other intriguing particulars, they embellished the photographer's mystery.

John Maloof made no pretense of knowing anything about photography when he acquired Vivian Maier's negatives, but since he held the majority of her remaining possessions, his assertions could hardly be disputed. With Maloof's as Vivian Maier's voice, newspaper and magazine writers who sampled from his website perpetuated confounding notions of her progress as a photographer. But without the thousands of early negatives—at this time mostly held by Jeffrey Goldstein—the full scope of her photography was far from resolved.

The negatives in Goldstein's possession contained an abundance of imagery of the Gensburg family and North Shore communities of the 1960s. As Goldstein released those images, a new representation of Vivian Maier emerged, changing her in the public mind from photographer savant to suburban nanny

photographer. And then, heightening the confusion, Goldstein launched his own official-seeming website, highlighting his collection.[124] The header and logo of that site included a digital scan of Maier's signature, projecting authenticity and giving an impression of her tacit approval. In addition, the new site's background color and font choice duplicated John Maloof's original blog, creating further confusion. Jeffrey Goldstein named his website Vivian Maier Prints, hired a technician to make darkroom silver gelatin prints from Maier's negatives, and prepared for the first traditional exhibition and sale of her photography. John Maloof–sponsored showcases of Maier's works had featured digital inkjet prints, not darkroom prints.

In mid-March 2011, a month before the opening of Goldstein's show, a gallery presale offering of new and vintage prints from the Goldstein collection got under way.[125] Twelve-inch-square photos in an edition of fifteen were priced at $1,800, and vintage prints from Maier's storage lockers were offered at $5,000 each. A local reporter—in an article titled "Get Your Hands on Some Black & White Gold"—compared Vivian Maier to Chicago's posthumously discovered "outsider artist," Henry Darger, whose drawings had been embraced by the art world, and the reporter hawked the prints as an investment opportunity: "Just like the prices for Darger's work rapidly skyrocketed, Maier's are on their way up, and now you have a chance at a piece of the pie."[126]

The $5,000 vintage prints were no larger than 4½ × 3½ inches, and some were 2¼-inch-square drugstore photos, the same size as Maier's negatives. Interest in snapshot photography had been on the rise, but these prices surpassed those of all but the most rare prints and sought-after artists of the mid-twentieth century. These weren't anonymous snapshots or large exhibition-quality photographs; these were the works of the "mysterious nanny photographer," who was becoming known throughout the world and whose market was being created at the standard of the greats. In Norway, the Apartment Gallery had sold more than fifty digital inkjet prints from Maier's scanned negatives, and in a post-exhibition offering, the remaining pic-

tures were priced around $800.[127] A limited-edition darkroom print is understandably more costly than a digital reproduction from a scanned negative; but the Norway prints were conceivably derived from the same files as those from which John Maloof had been offering digital prints on eBay for $7.99 and $8.99 less than two years earlier.[128]

All of the gallery's vintage prints were from Maier's New York years. They included a shot of the Riverside Drive dark-haired girl sitting by the side of a pool; a view of buildings surrounding Bryant Park; two boys in a window at the Stuyvesant Town apartments; and a view from the trolley deck of the Queensboro Bridge. Although separated from thousands of her other photos from this era, the pictures represented her exploratory and creative period between 1952 and 1954.[129]

The Chicago exhibition traveled to New York's Hearst Gallery, where a catalog accompanied the show. This was Vivian Maier's first American publication and first exhibition in New York, the city where many of the photographs were taken; in contrast to her unassuming practice and humble roots, the exclusive showing was available for viewing by appointment only. Images from Maloof's collection had also arrived in New York, as he was negotiating with a publisher for Maier's first major photo book. And, separately, two galleries with earlier experience in presenting an eccentric and mysterious photographer's work were about to enter Vivian Maier's realm.

The story of that photographer has parallels to Vivian Maier's emergence: someone acquired a photographer's estate for a trifling sum—in this case, five dollars—and fifteen years later sold negatives to someone else who recognized the work as special. This photographer, Mike Disfarmer of Arkansas, died in 1959, leaving behind more than three thousand studio portrait negatives of local townspeople. After the material changed hands in the mid-1970s, word of these portraits traveled to a New York photo editor who published some of them in *Modern Photography* magazine. Disfarmer and his photographs were subsequently claimed by the art world: a picture book was published, prints from the negatives were exhibited at New York's

International Center for Photography, and the photo journal *Aperture* featured pictures along with the tale of the discovery.

Like Vivian Maier in her later years, Mike Disfarmer was seen as peculiar. (*Aperture* called him "strange and almost friendless.")[130] Like Maier, Disfarmer broke away from his family; and like Maier's photography, Disfarmer's was posthumously handled in ways that were not consistent with his own treatment of his works.

In the late 1970s, New York's photography world was less commercial than it would become over the next decade. Mike Disfarmer's cachet as a "lost genius" of the medium didn't attract a growing base of collectors for nearly two more decades. The Staley-Wise Gallery began selling prints from Disfarmer's negatives in the mid-1990s through 2000, when the Howard Greenberg Gallery became the exclusive representative of the photographer's archive, offering prints through its own Disfarmer website.[131] The swell of interest in vernacular photography renewed Disfarmer's popularity. In 2005, a month before the Howard Greenberg Gallery mounted an exhibition of Disfarmer prints from the original glass negatives, the *New York Times* reported on the discovery of vintage Disfarmer studio prints: "In a hush-hush entrepreneurial race to the finish, two photography collectors from New York have separately bought up about 3,400 vintage prints stashed away in the attics and basements of relatives of Disfarmer's subjects."[132] One of the collectors was Steven Kasher, who had worked for Howard Greenberg and who was about to open his own venue in the Chelsea art district.

The Steven Kasher Gallery's inaugural exhibition featured Disfarmer's vintage prints; simultaneously, midtown's Edwynn Houk Gallery presented Disfarmer prints acquired from the second collector, Michael Mattis. The *New York Times* reported: "Mr. Kasher is pricing his Disfarmer prints from $10,000 to $30,000. Mr. Houk's will range from $7,500 to $24,000. . . . Mr. Kasher said he had bought 400 prints over all, and Mr. Mattis said he had acquired 3,000, selling about 1,000 of those to Mr. Houk. . . . Mr. Kasher would not say what he had paid

over all for his photographs. Mr. Mattis would only say that he had invested a seven-figure sum in the process of acquiring his vintage prints."[133] Kasher and Houk each published handsome picture books of Disfarmer's works from their collections.[134] A documentary film and a puppet show brought Disfarmer's life and works to a broader audience.[135]

The Greenberg and Kasher galleries were also instrumental in launching Vivian Maier's lucrative exhibitions six years later. In 2011, John Maloof was in discussion with the Howard Greenberg Gallery. Separately, Steven Kasher reached out to Maloof, as described here:

I was contacted by marvelous puppet theater director/writer Dan Hurlin. I had assisted Dan on his play "Disfarmer," which was initially inspired by a show I had mounted in my gallery. On learning of Maier, Dan was impressed by certain congruencies between her and Mike Disfarmer. I viewed the website Dan suggested to me and was moved by the Maier photographs I saw there. I immediately reached out to John Maloof and offered to mount a show. He said he would think about it.

Some months went by without me giving this much of a second thought. Then one day I received a call from Jeffrey Goldstein who identified himself as a second holder of Maier negatives. He told me that he and Maloof would both be making limited edition prints, but exhibiting and selling them separately. He said Maloof would be working with Howard Greenberg and that he wanted to work with me, on the recommendation of John Bennette and others. I suggested that both parties should work through one gallery. Jeffrey said that would not be happening. I told him I would consider his offer. I did some research and some pondering, and decided to go forward representing Jeffrey's prints.[136]

On the evening of December 15, 2011, Howard Greenberg Gallery and Steven Kasher Gallery premiered exhibitions of prints from Vivian Maier's negatives. Just four weeks earlier, powerHouse Books had released the first of John Maloof's books of Maier photos, *Vivian Maier: Street Photographer.* On December 9, a blogger reported that the book's first edition was already out of stock.[137] The second printing sold out by January 2, 2012.[138]

RETURN OF THE WORLD TRAVELER

Vivian Maier left the Champsaur Valley and headed to Paris, the capital of French photography and the last stop on her 1959 five-month journey. On September 6, she composed and photographed three letters: one to a friend in California, and the others to Nancy Gensburg and the Gensburg boys, in an affectionate note that began, "Dear little rascals."[139] The boys were now five, three, and not quite two years old, and she asked about the youngest brother's progress in learning to walk. In her letter to Mrs. Gensburg, Maier was straightforward, stating that she'd be returning by the first of October. She signed off, "Vivian Maier."

That same week, Maier meandered through the streets of Paris, stopping at tourist sights. She lingered along the Left Bank by the Sorbonne, made her way through the open market at Les Halles, and visited Napoleon's tomb at Les Invalides. At the Louvre, Maier photographed paintings and sculptures in black-and-white and in color, sometimes including tourists in juxtaposition to the art works. Inevitably, she found her way to the city's most famous graveyard, the Père Lachaise Cemetery.[140]

Maier documented the gravesites of some who may provide insight into her interests and alliances. In addition to popular tourist stops—including the sculptural monuments to composers George Bizet and Frédéric Chopin and the flamboyant playwright, novelist, and poet Oscar Wilde—she found her way to the more subdued memorials of the novelist Colette, and the actress Sarah Bernhardt. The remaining documentation is a catalog of markers of obscure nineteenth-century figures, including the widow of Honoré de Balzac; Dora d'Istria, an Albanian proto-feminist writer who was known as the first woman to climb to one of the highest peaks of the Swiss Alps; and, in a five-picture sequence, former Catholic priest Hyacinthe Loyson's memorial, on which inscriptions embraced all world religions.[141]

While in Paris, Vivian Maier followed a daylong event that filled the streets with hundreds of thousands who waved and shouted, "Vive Ike!" and "Vive de Gaulle!" as the American

and French presidents paraded through the city.[142] Maier waited among the throngs at the Place de la Madeleine for their morning arrival that would lead to a 101-gun salute at the Quai d'Orsay. The parade must have sped by because she shot two frames with her Robot camera that missed their mark, catching the back and then the front half of two decorated horses, followed by a frame that showed only the front of the official convertible. She then ran ahead along the crowded sidewalk and was able to snap a frame that showed the back of the presidents' heads as they turned toward the throngs waving from the opposite sidewalk and upper windows.[143]

Maier continued along the parade route. She traced the Rue Royale to the Place de la Concorde before striding up the Champs-Élysées to the Arc de Triomphe, where the entourage would arrive in the late afternoon. Back at the Hôtel de Ville, plumed guards lined the opulent facade that also featured bright white raised platforms. Narrow French and American flag-themed banners fronted the building, and barricades held back thousands of onlookers who anticipated the dignitaries' arrival. By the time the fleet of mounted guards and motorcycle brigades made its way there, she had scoped out the apartments at the opposite side of the plaza and figured out a way to access an optimal viewing position. A television camera poked out an upper window, but a bit higher, along the adjacent building's mansard roof, an open-hinged attic window became her target.[144]

Maier found her way to the attic room where a small group had gathered to witness the event. From this vantage point, the Hôtel de Ville appeared like a toy house as masses of people swarmed in miniature. A wide red carpet led to stairs and throne-like seating arranged on a dais. During the dignitaries' arrival and in intervals throughout the program, Maier shot with the Robot, changing sometimes to a telephoto lens, while also using her Rolleiflex to photograph in color. Maier managed to occupy the window long enough to shoot a couple dozen photos. At one point, she backed into the darkened space and made a group portrait of five of the people she had joined; in a slightly out-of-focus picture, they flank the window in the murky light.

Once back at ground level, and as the crowds dissipated, Maier took an upward shot toward her attic spot.[145]

Before she returned to Chicago, Vivian Maier stopped in New York. During the last five months, Maier had been a full-time photographer, absorbing and recording thousands of images. She had now carried a Rolleiflex for seven years, and while she steadily enhanced her equipment arsenal, she was most in command of the waist-level lens that she had mastered on the New York streets.

Maier now played Manhattan like a country of its own, traversing the narrow island from Union Square to Washington Heights, photographing people on stoops, in shop windows, from behind, and in bold confrontations. She covered Spanish Harlem, Central Park, and Broadway up to Ninety-Fifth Street, where the Thalia art-house cinema marquee featured Émile Zola's Paris-based *Pot-Bouille* and a movie with the attention-grabbing title *I Am a Camera*. Sixty blocks south, at Penn Station, while the film production of *Who Was That Lady?* was on a shooting break, Maier stepped in and captured a sequence of images of actor Tony Curtis giving an autograph and then aiming his own small camera out of the frame toward an unknown subject.[146]

By the time Vivian Maier arrived back in Chicago, she had shot around ten thousand photographs on three cameras loaded with various film types, including color negatives and slides. But unlike the several thousand negatives with corresponding snapshots from her 1950–51 European trip, the frames within these spools and 35 mm cartridges arrived home with her without matching prints. Other than her color work, which was handled by professional labs, since Maier left New York in 1955, her prints comprised selected enlargements, representing less than 1 percent of her output. The act of photographing had begun taking precedence over collecting stacks of silent moments.

By December, Maier was back to photographing the Gensburgs' birthday parties—she had documented nearly every one since her arrival—as the middle brother turned four with a Mickey Mouse cake and fireman-themed party favors. Weeks later another party celebrated the youngest brother's second

birthday. Vivian Maier, the seasoned traveler, returned to her nanny and housekeeper routines, but she never stopped photographing.[147]

In the spring of 1960, the Gensburgs brought Maier along on one of their frequent excursions to Miami Beach. As always, Maier found a way to independently explore some of her favorite subjects. In between accompanying the family to the Parrot Jungle attraction and the beach, she escaped to the Seminole tribe's environs and mingled with indigenous children.[148] And as she had the knack to do, Maier sighted a Hollywood celebrity.

After hanging around the Lincoln Road cinema during the day—even shooting a self-portrait in the concave mirror of a klieg light—Maier attended the premiere of the Paris-themed movie *Can-Can*, starring Frank Sinatra and Shirley MacLaine. Sinatra was at the theater, and as he stood under the marquee surrounded by statuesque plumed women and official-looking men in suits, Maier stepped up and popped off a flash picture from within four feet of them. At a cinematic event in Chicago a couple of years earlier, she'd achieved even closer proximity to Hollywood stars when she poked her camera nearly against a car window where Cary Grant, Eva Marie Saint, and James Mason sat as they were about to be whisked away during the filming of Alfred Hitchcock's *North by Northwest* (plate 18). Maier would also push her way to the front of the crowd as Kirk Douglas and his wife approached the brightly lit McVickers Theater for the 1960 Chicago premiere of *Spartacus*, where she was able to shoot-and-crank a lightning-speed seven Rolleiflex frames while also following up with her 35 mm camera.[149]

Vivian Maier was never shy when she was intent on getting a photograph, nor was she afraid to scale precarious heights to view an event. During 1960, a presidential election year, she attended numerous events in which she found prime—and what today would be off-limits—sniper-like perches. On July 27, a day after more than a million Chicagoans lined the streets to welcome President Eisenhower to town for the Republican National Convention, Maier positioned herself on a rooftop with clear views of his approach to an 8:30 A.M. breakfast at down-

town's Morrison Hotel. A street clock provides time code as her 35 mm negatives demonstrate minute-by-minute strategies: at curbside, standing nearly under the hotel's canopy, she shot into the sun toward the approach of cars, creating a brilliant effect of long-shadowed silhouettes, but backlight obliterated detail; in the next frame, she's a half block away on the other side of the street facing the hotel, but too far away for a good entrance shot—the corner clock reads 8:20. By 8:25, Maier is leaning over the parapet on the roof of a movie theater, across from the Morrison's entrance. After shooting a dozen frames peering downward, left, and right, at 8:29 she captured seconds-apart pictures of Eisenhower's approach, and then photographed him standing with both arms raised, waving to the crowds. Once the entourage disappeared into the hotel, Maier documented her perch—a ladder leaned against the flat roof's parapet—and returned to the street to mingle with the crowd. Later in the day, Maier prepared for Eisenhower's departure from South Michigan Avenue's Blackstone Hotel by accessing a room on the third floor of the Conrad Hilton Hotel across the street. Leaning out a window, she shot color slides of the president's exit, followed by more frames of the parade of cars heading toward Lake Michigan where, at Meigs Field, a helicopter was waiting.[150]

Vivian Maier shot public events as if she was on assignment, but there's no evidence that she was working for anyone other than herself. Her confidence and handling of several cameras simultaneously suggested that she had journalist credentials, and she often photographed from within sidewalk barricades. Among other photo ops during the days of the Republican convention, Maier worked a parade that featured a Native American drum and bugle corps and the famous sad clown, Emmett Kelly, who participated in a trampoline act.[151]

In September, Vivian Maier was back at her rooftop perch across from the Morrison Hotel photographing Richard Nixon's approach amid throngs of gatherers with Nixon for President signs and banners. And while he was in the hotel, Maier found her way inside the Morrison's lobby. She had cut through the barriers and made it past the police; Nixon had to pass by Maier

to get out of the hotel, and she photographed him from front and back as he crossed within a couple feet of her camera.[152]

On the Democrats' side, Maier attended and photographed a Kennedy-focused torch-lit parade, and when vice presidential candidate Lyndon Johnson paraded along State Street in November, days before the election, she stood curbside in front of the crowd and photographed him as he greeted crowds from the convertible that he and his wife shared with Mayor Richard J. Daley. Sometime later, she succeeded in accessing a luncheon in honor of Eleanor Roosevelt and snapped three frames of her at the head table, inching closer with each shot.[153]

In between political processions and movie premieres, Vivian Maier stayed busy documenting the activities of the Gensburg family and the children of Highland Park. As she had on an earlier Father's Day morning, Maier accompanied Nancy Gensburg and the boys into their father's bedroom, recording the event. Avron Gensburg smiles down at a framed eleven-by-fourteen-inch Maier photograph of three generations of Gensburg men and boys—he, his father, and his sons. Subsequent negatives show the family passing around other large framed pictures.[154]

In 1960, Vivian Maier began assembling eleven-by-fourteen-inch prints, eventually placing them into spiral-bound portfolio books. Maier was editing and enlarging work from tens of thousands of negatives, and her selections included photos dating back to 1950, during her yearlong stay in France. The pictures included New York street photographs, shots from her 1959 world travels, tightly cropped images of children, and an assortment of candid and posed portraits, including several from 1960 of the Gensburg boys.[155] It's impossible to know Maier's intentions in putting together at least four albums, but typically these types of books would be shown to prospective employers, presented as part of a school application, or submitted for exhibition opportunities.

High Art / Downward Spiral

"There's an inherent incorrectness, a legitimate stigma, against printing photographs by an artist when he or she isn't the one interpreting the work," Howard Greenberg explained to a reporter; but, after citing a couple other rare circumstances, he continued with the results of his first showing of Vivian Maier's photographs, "Not only was there an audience for it, but I've never seen so many people walk through this gallery. They came in droves."[1]

Vivian Maier's biggest champions were people who had little knowledge or previous interest in the history of photography. Maier's story and photographs captured people's imaginations, and many first-time collectors paid $1,800, and up to $3,000, for a limited-edition print from a selection of Maier's negatives. In separate enterprises, Jeffrey Goldstein and John Maloof had teams of workers producing and exhibiting photographs from the negatives they owned.[2] Authenticated by rubberstamp, the backs of all the Vivian Maier prints were signed by either Maloof or Goldstein.[3]

In online photography forums people debated the quality of the prints at each gallery, while also weighing in on the choices of imagery. One person who visited the Howard Greenberg Gallery exhibition offered, "I saw it last weekend. Meh . . . There were a few I liked, but the selection on show, at least, didn't strike me as a basis for canonization." He added, "One of the gallery attendants at Howard Greenberg had the courtesy to badmouth the Kasher show to another visitor who asked about it, insisting the pictures there were inferior and not Maloof-approved."[4] Jeffrey Goldstein joined the conversation to defend his collection—"A Vivian Maier is a Vivian Maier is a Vivian

Maier"—and responded to a question about the differences between the galleries' prints: "We are having our prints done by a master printer here in Chicago and the character of our prints has a different feel then [sic] that at Howard Greenberg's show. Perhaps it's the difference between Chicago sensibilities, ours, and a New Yorker's printing sensibility. I will put out there that Vivian Maier spent the better part of her life shooting in Chicago, so dibs."[5] There was no overall consensus, and only those who saw the actual prints could comment on their quality or matters of authenticity.

Within weeks of the New York gallery openings, another Vivian Maier exhibition premiered in Los Angeles. British movie actor Tim Roth had seen an article about Maier in a London newspaper and decided to curate an exhibition of her work. He chose the Merry Karnowsky Gallery and, with Karnowsky, picked photographs from Maloof's collection.[6] The gallery's press release announced that Roth would be hosting the exhibition, mentioned that a movie "about Maier and Maloof's discovery of her work" was in production, and said that the opening reception would be filmed for inclusion in the movie.[7]

Lines snaked along the sidewalk as hundreds of the curious gathered "to appreciate one of the last discoveries of contemporary photography."[8] Prints from Maier's negatives were offered starting at $2,000, and exhibition posters signed by Roth were available for $100 each.

The following month, under the headline "Vivian Maier: Better and Better," the *New York Times Lens* blog reported on Jeffrey Goldstein's crew of technicians.[9] In demonstrating their collaborative effort in promoting Maier's work, the blog published a contact sheet peppered with colored dots that represented "votes" for individual negative frames. This was "Vivian Maier" by committee. And then, further removing Maier herself from the enterprise, that Sunday's *New York Times Magazine* presented "Through the Nanny's Eyes," a slideshow comprising posthumously developed negative frames from Jeffrey Goldstein's collection.[10] The eerie presentation conjured Vivian

Maier through images she never saw except through her Rol-leiflex viewfinder.

During this time, Goldstein's and Maloof's Maier prints also hung in galleries in Atlanta and Santa Fe.[11] The owner of the Monroe Gallery boasted, "This is such a huge international story, and it speaks to Vivian's significance in the art world now. Our goal from day one was to bring in top-flight exhibitions. It speaks to Santa Fe and it being a world-class destination for art and photography."[12]

By the middle of 2012, scores of Maier's photographs had appeared in newspapers and magazines in America and Europe, and Maloof's and Goldstein's Vivian Maier websites cumula-tively presented more than three hundred images that also cir-culated through social media. Although the Goldstein Collec-tion had established a Vivian Maier Twitter feed in February 2011, two months later John Maloof did the same, proclaiming, "Welcome to the official Vivian Maier Twitter page!"[13]

Nearly a year after Vivian Maier's social media and public relations explosion, Howard Greenberg marveled at the crowds visiting his gallery. Later, John Maloof filmed Greenberg in his back room, giving a peek into the workings of a blue-chip gallery: "I think there are about twenty-five or thirty thousand photographs in here. I mean, it's more than most museums have. Vivian Maier; we have more interest in this work than perhaps any other photographer I've ever worked with."[14] In the movie, imagery of boxes labeled "Henri Cartier-Bresson" and "Man Ray" fills the screen as Greenberg speaks, and then someone inserts the "Vivian Maier" box in the slot above one labeled "Lisette Model."[15] Downtown, Steven Kasher had paired Maier's pictures with those by, perhaps, today's most well-known New York photographer of all: Weegee. On the final day of that exhi-bition, visitors packed so tightly into the gallery that the work was nearly impossible to view.[16] Maier's bestselling photographs were her self-portraits. Her enigmatic presence in mirrors and in silhouette stood out among the other pictures, and those prints provided a double cachet of owning Maier and "a Maier," which had become nearly indistinguishable.

In the summer of 2012, Chicago's public television station revisited the Vivian Maier story. The 2010 interview that Jay Shefsky had conducted with John Maloof in his attic had been one of its most-viewed programs, and it was still garnering attention as an online video. The two-part follow-up programs, "The Meteoric Rise of Vivian Maier" and "Searching for Vivian Maier," also profiled Ron Slattery and Jeffrey Goldstein. An exhibition of vintage Maier prints from Slattery's holdings was about to open at a local gallery, giving a glimpse of the third major collection.[17] Slattery also owned some of Vivian Maier's negatives, which he showed within their glassine envelope on the program, but he was not producing prints from those.

John Maloof was reticent in this follow-up interview because his documentary film was in production. Shefsky explained, "He's reluctant to share much of what he's found, but he's happy to tease us," to which Maloof offered, "I found things that show that she may have even had the intention to show her work."[18] That statement didn't really change a reading of Vivian Maier's objectives, but it kept the interested audience on the hook. Jeffrey Goldstein, for his part, shared the story of how he acquired his collections from Randy Prow. Shefsky summed up Goldstein's successful year in the Vivian Maier business: "Goldstein has sold several hundred prints, and the project is mostly paying for itself."[19]

VIVIAN MAIER AND THE EARLY 1960S

The early 1960s seemed a world of adventure, prosperity, and accelerating change. In 1961, the first American was launched into space, and a young president and his glamorous wife moved into the White House. John F. Kennedy had won the election, in part on account of his telegenic appearance and movie star–like ease. But a steady foreboding undercurrent was also rumbling. The Cold War, the failed Bay of Pigs invasion, and the Cuban missile crisis permeated the culture, including Hollywood depictions such as the first James Bond movie, *Dr. No*, which featured Secret Agent 007, the CIA, and a sinister plot to destroy the U.S. space program.

The era also saw a relaxing of social mores and looser attitudes surrounding sexuality as evident through the half-clad women in *Dr. No*, Helen Gurley Brown's book, *Sex and the Single Girl*, and the contraceptive pill, all of which were introduced in 1962. That year also marked the drug overdose death of Marilyn Monroe, the Beatles' first recordings of a new kind of popular music, and Andy Warhol's paintings of Campbell's Soup cans. Pop culture blended high and low.

The world of fine art photography was also evolving. In 1960, when Vivian Maier was assembling her portfolio books of eleven-by-fourteen-inch prints, Chicago's Institute of Design was producing a new breed of photographer. Founded in the late 1930s as the New Bauhaus, with a design-oriented approach to the medium, by the mid-1950s the school offered a master's degree in photography under the guidance of Harry Callahan and Aaron Siskind. Callahan practiced a highly personal approach to photography, and Siskind, who had been a member of the New York Photo League, worked in the social documentary style before segueing to more abstract photographs. Together, they encouraged experimentation with an emphasis on personal vision. Graduate study culminated in a thesis project of a cohesive series of photographs.

The Art Institute of Chicago embraced what became known as the "Chicago school" of photography and, beginning in 1956 with a show of Siskind's photographs, presented exhibitions of their work. From 1960 through 1963, five Institute of Design alumni had solo exhibitions, all but one derived from thesis projects.[20] The museum also acquired more than seventy photographs by nine students, including the ten-print portfolio, "Institute of Design Student Independent 3."[21] The portfolio prints—each cropped differently to depict a highly formal composition on eight-by-ten-inch paper—flattened space through abstractions. Even the two photographs that incorporated people portrayed them as elements of the composition. One of those pictures, a high-contrast print by Ray K. Metzker, from his series "My Camera and I in the Loop," framed pedestrians from the waist down as they walked into a sunny patch of

sidewalk, their forms intersecting with other figures' shadows.

In New York, the social documentary style had also evolved through influential teachers, including Alexey Brodovitch and Lisette Model, who similarly pushed for more personal and innovative approaches in their classes at the New School for Social Research. Brodovitch, the longtime art director for *Harper's Bazaar* magazine, was at the vanguard of design and a new kind of fashion photography that included surreal juxtapositions like Richard Avedon's 1955 shot of an elegant model standing between two circus elephants. With the directive, "Astonish me" Brodovitch also led a popular ten-session course known as the Design Laboratory, described as "an experimental workshop inspired by the ever changing tempo of life—new directions, new ideas, new techniques, new fields of operation."[22]

Photographer Garry Winogrand had studied with Brodovitch. Winogrand would go on to develop a casual approach that became known as the "snapshot aesthetic." Influenced also by Robert Frank's gritty on-the-road pictures, Winogrand's street photographs incorporated visually chaotic scenes and ironic juxtapositions. Disregarding formal composition strategies, his quick shooting techniques and wide-angle lens often produced cacophonous and tilted pictures. In 1963, thirty Winogrand photographs were included in an exhibition at the Museum of Modern Art, some of which were described as "a harrowing series of pedestrians on streets in New York City."[23]

The New School remained a destination for serious photographers into the 1960s. Diane Arbus began studying with Lisette Model, whose course description stated in part, "Photography is an art which is the more difficult because it appears so simple."[24] Arbus had already established a photo studio with her husband, and their collaborative fashion photographs had appeared in numerous magazines. But Arbus was now breaking out solo, and Model encouraged her ongoing exploration of unconventional portrait subjects.

Like Model's early works, Arbus's portraits surveyed people who were "different." After assembling lists of locations and types of subjects she was interested in photographing, Arbus

set out to compile pictures for magazine story pitches. In 1960, *Esquire* published six Arbus photographs titled, "Vertical Journey: Six Movements of a Moment within the Heart of the City." The three double-page spreads opened with the wild-eyed toothless "Jungle Creep" from Times Square's Hubert Museum, facing a picture of an elegant couple at the Grand Opera Ball; the series continued with a photo of a midget actor placed alongside a member of the Daughters of the American Revolution; and the third set paired a one-eyed man with an image of a cadaver on a gurney in a morgue. The jarring juxtapositions of high, low, and taboo highlighted Arbus's range and also presented her subjects as equals.

Like Garry Winogrand, Diane Arbus shot with a 35 mm camera, but in 1962, she transitioned to a Rolleiflex that produced larger and sharper negatives and allowed face-to-face encounters with her subjects. She preferred the newly released Rolleiflex with a wide-angle lens that sometimes distorted her subjects. By this time, smaller faster cameras—that also didn't require reloading film after every twelve shots—had largely replaced the photojournalist's Rolleiflex; but Arbus was printing larger and she was also developing a unique aesthetic that included presenting the entire square negative.

Diane Arbus's square photographs of posed people resemble Vivian Maier's negatives from the mid-1950s, in which Maier sometimes organized her subjects to stand facing the camera. But Maier's prints were framed to match the shape of the photo paper or were tightly cropped to eliminate everything but her portrait subjects. When Arbus began using a flash with her Rolleiflex, her interior shots look similar to Maier's East Sixty-Fourth Street photos of more than a decade earlier. In particular, Maier's portrait of a chubby boy with a parakeet sitting on his chest is nearly interchangeable with Arbus's subjects and aesthetic.[25] But, by 1963, as Arbus homed in on her chosen subject matter and crystallized her style, Vivian Maier's repertoire had expanded along with her equipment choices; around this time, she acquired her first Leica camera, and she also began shooting urban motion-picture studies.

Maier continued her photography jaunts to downtown Chicago, while also accompanying the Gensburgs on family excursions. She trailed the brothers and their grandmother into the Glencoe movie theater, photographed the screen, and then lit up the darkened space with her flash to snap a picture of Matthew, enthralled by a cartoon. The resulting image of the boy and the surrounding audience members rivals Weegee's dark cinema shots from the mid-1940s, although Weegee was more discreet in shooting with infrared film that didn't easily betray his presence. Maier's photo exposed a sleeping woman, squirming kids, and an unself-conscious teenage boy with his mouth ajar, all of whom likely jolted out of their solitude at that instant.[26]

Maier also photographed in various parts of Chicago. She returned several times to the far North Side's Uptown neighborhood, which had a large Appalachian migrant community and an abundance of taverns and rooming houses. Maier also ventured by bus to Chicago's South Side, passed through the near West Side's rundown Maxwell Street flea market area, and toured the near North Side's bohemian Old Town and the glittery nightclub mecca of Rush Street.[27]

In January 1963, Vivian Maier found her way into an abandoned building within a zone that had already been largely bulldozed for slum clearance in anticipation of the new University of Illinois city campus. From the vacant apartment's second story, Maier had a clear view of the north side of Jane Addams's Hull House, and she poignantly framed some shots through several windows' broken panes. Turning her camera toward the interior space, she found a bureau with a mirror and made two self-portraits. Maier's nose appears reddened, and she looks chilled in her trench coat and beret as she expressionlessly regards her reflection. She had removed a bulky work glove to press the Rolleiflex's shutter button. Back outside on the snow-packed sidewalk, and as she walked toward the settlement complex, Maier spotted a woman with a toddler bundled in her arms and hurried a half block to get in front of them to shoot a close-up picture of the child. By the last frame on the roll, she had gone a block farther to document the far side of the site.[28]

During one weekend in September 1963, Vivian Maier split her time between downtown's Michigan Avenue and a far North Side baseball stadium.[29] The French destroyer *Guepratte* had docked at the Chicago River, and three hundred sailors scattered along the Magnificent Mile. Department store Carson Pirie Scott had declared a three-week "salute to the history, culture, and products of France."[30] On the other side of town, seven hundred Native Americans from seventy tribes held their tenth annual Chicago Pow-Wow. The event was a fundraiser for the American Indian Center, which supported Chicago's eight thousand Native American residents; the center's executive director stated that there were "more Indians living in the Chicago area than there are on most of the Indian reservations of the United States."[31]

As migrants and various minorities made Chicago their home, social and economic issues became more volatile. And as in other parts of America, neighborhoods became more diverse, leading to increased tensions. Racial disputes intensified in places like Chicago but especially in the southern states. In July, black activist Medgar Evers was killed by a white supremacist. President John F. Kennedy's assassination in November, while not racially motivated, tore the country apart.

Vivian Maier sat in a darkened bedroom in the Gensburg home and photographed Kennedy's televised funeral. In a short series of photographs—variously framed to include a delicate plant on the corner windowsill—the coffin lowers into an open grave surrounded by members of the armed forces. The final shot shows a wider view of cemetery headstones.[32]

From her earliest known work, Maier had repeatedly photographed graveyards. She mingled with gravediggers, documented headstones with familiar family names, and sometimes recorded funeral processions and burial rites. She had already photographed at least three funerals in 1963, once while hiding behind a tall gravestone that obscured part of the frame as it shielded her from view. We can only speculate what motivated Maier to photograph these events, but watching people who are unaware of being watched—spying—elicits a kind of power.

And Maier would sometimes take things a bit further. A night-time sequence of images from 1964 shows her positioned on a train platform as she aims her camera into the window of an enclosed waiting room. Invisible from the lit interior, Maier circled the small structure and recorded several people interacting; one frame shows a woman sitting on a man's lap, whispering into the ear of another woman who bends toward her. A film noirish effect competes with the voyeuristic frankness of Maier's activity.[33]

Vivian Maier had also been long engaged with the news. A photograph of the bathroom where she developed her film during this period shows stacks of newspapers—a collecting habit that would later intensify and become troubling to her employers—along with books, her steel film-developing tanks, and lengths of dangling negative strips.[34] Maier seems to have pored over the newspapers to gather information regarding Chicago's neighborhoods, visitors, and events. She sometimes took the Gensburg boys on great adventures away from the backyards of Highland Park; they later spoke of trips with Maier to Chicago's Graceland Cemetery and to Chinatown for the New Year's parade. She taught them French and French songs, and she organized play productions in the neighborhood. To one of the brothers, Vivian Maier seemed like Mary Poppins, the magical British nanny.[35] Indeed, Maier must have seemed mythical in comparison to the women of Chicago's North Shore.

While Vivian Maier settled into her Chicago routines, Diane Arbus and Garry Winogrand accelerated their photographic ambitions, and they were both awarded Guggenheim Fellowships to freely pursue their photography. The funding for Arbus's 1963 project, "American Rites, Manners and Customs," allowed her to continue her ongoing portrait studies; and Winogrand's 1964 support paid for a cross-country trip, in which he documented America in the aftermath of the Kennedy assassination. Outdoing Maier with his freedom and excessive picture taking, Winogrand is said to have shot 550 rolls of film—twenty thousand images—during his four-month trip.[36] Winogrand would one day remark that he photographed to see what things

looked like as a photograph, and Arbus once exclaimed that she wanted to photograph "everyone"; but these photographers were also motivated by publication opportunities and the likelihood of sharing their efforts.

In contrast, Vivian Maier's life was slowly beginning to contract. Her remaining slides and negatives suggest that, after 1965, she did not leave the Midwest on her own. In a couple more years, at the age of forty-one, Maier would begin to move away from the Gensburgs—as close a relationship as she ever had to a traditional family.[37] She had already packed nearly all of today's known prints from her negatives into shoeboxes and cardboard cartons.

VIVIAN MAIER: INDUSTRIAL COMPLEX

The Vivian Maier photography exhibitions of early 2012 were hugely successful in attendance and sales. The shows received enviable press, and conversations on social media cheered the work. Although some commenters suggested that Maier would not have wanted her photography shared or handled by others, they were a minority.

At this time when there was still little known about Vivian Maier's photography practice, and when the collectors of her materials might have cooperated in scholarship, the photographic prints found among her possessions—which assert her voice in their selection—became further scattered. In addition to the new prints offered from John Maloof's collection of negatives, Howard Greenberg's gallery in New York and Merry Karnowsky's in Los Angeles offered an assortment of Maier's vintage photos. But, unlike Jeffrey Goldstein's mostly snapshot-sized Maier prints found stacked and scattered in boxes, Maloof's prints represented more ambitious intentions.

Both galleries presented Maier's prints of various sizes, as large as eleven-by-fourteen inches. Many of these photographs were likely part of the group that was won by a businesswoman at the RPN Sales auction in 2007. Merry Karnowsky Gallery labeled each photograph as a "rare vintage print" and priced

the enlargements at between $4,000 and $7,000 each. Approximately fifty such photographs were displayed in Los Angeles and twenty-five more in New York—nearly all derived from negatives from 1960 or earlier.[38]

The prints included early New York street portraits, several shots from 1955 Los Angeles and San Francisco, half a dozen pictures from her 1958 subarctic tour, an equivalent amount from her 1959 trip around the world, and five self-portraits. The rest comprised a smattering of portraits and tightly framed subjects, most not betraying specific dates or locations. All of the black-and-white prints were cropped from the square negative to fit the printing paper or to eliminate surroundings beyond her portrait subjects. In their cropping, many pictures appear as character studies. There is no cohesive vision to the group. The Karnowsky Gallery's selection also included thirteen color photographs from the 1970s. Of these, some stand out as if Maier were on a scavenger hunt—three pedestrians emerge in matching yellow outfits; racy graffiti appears on a newspaper box; an obese woman with grossly misshapen legs is framed from her skirt's hem to the ground; a quick-grab shot of a curly-haired man with a perfectly round bald spot appears like a prize find.[39]

The vintage prints complicated Vivian Maier's story. They did not seem nostalgic like her early New York street photography or as formally strong as the new prints from the square negatives. Crafted by expert darkroom technicians and enhanced by vibrant paper stock, the new prints elevated Maier's work. Full-frame reproductions of Maier's posthumously edited negatives conjure comparisons to other photographers from their era; but none of the images that Maier had selected matched those that were now being chosen for her.[40] The press praised the posthumously chosen photographs; no articles addressed Maier's own choices or the ways that the vintage prints differed from those derived from the exhibition curators' editing of her negatives.

In the summer of 2012, a Chicago gallery presented a show of small vintage photos from Ron Slattery's collection, largely of Maier's New York work. Printed in the early 1950s, the selection included many early themes, including candid shots of children,

a view from the top of the Chatham and Phenix Bank Building, and people sleeping in public. The gallery's co-owner, Jim Dempsey, had known Vivian Maier while he ran the Film Center at the Art Institute of Chicago during the 1980s and 1990s, when she regularly attended screenings. But it wasn't until Dempsey saw her photographs and heard her physical description that he learned that she was the woman with whom he often conversed; she never told him her name. In the exhibition brochure, Dempsey wrote that his earliest memory of her was from a series of Andy Warhol's experimental films in the 1960s. Other than from the countermen at Central Camera, these were the first public recollections of someone who knew Maier outside of her role as a nanny or caregiver.

The remainder of the summer of 2012 was quiet, but then three exhibitions from the Jeffrey Goldstein Collection inaugurated the fall gallery season, all opening during the first week of September. These were coordinated with the launch of a new book, *Vivian Maier: Out of the Shadows*, which introduced biographical details and gave information about Maier that came from recollections of those whose paths she crossed from the late 1960s on. Notably, this book, though derived from Goldstein's substantially smaller collection, presented three times as many images as Maloof's book. And unlike Maloof's *Vivian Maier: Street Photographer*, it listed dates and geographic information.

The photographs in *Out of the Shadows* represented a different Maier than Maloof's 1950s' New York street photographer who encouraged comparisons to familiar names of that era and genre. In more than three hundred images that spanned the Goldstein collection, Maier's New York Rolleiflex work is largely missing. And although the first chapter, "Snapshots," includes more than sixty of her earliest known photographs, from 1950 through the summer of 1952, they are mischaracterized by information derived from John Maloof's website.

Jeffrey Goldstein also offered a "Deluxe Clamshell Edition" of the book, printed in an edition of fifty-five. It included one of three nine-by-nine-inch prints of self-portraits. Through a special website set up for the purpose by Goldstein, buyers could

purchase the $850 package, which included "a custom, cloth clamshell box handcrafted with a silver-embossed impression of Vivian Maier's signature"; shipping and handling was $25 extra.[41]

Two of the Goldstein collection's exhibitions opened in Chicago where locals, mostly oblivious to who owned which part of Maier's legacy, were thrilled to see more of Maier's photography.[42] Nearly two years had passed since John Maloof introduced her photography at the Chicago Cultural Center, and Maier's work had since been featured in nearly twenty international venues. Now, claiming Maier as part of the city's heritage, the Chicago History Museum presented images from Goldstein's negatives as *Vivian Maier's Chicago*, an extravagantly immersive and theatrical experience.

Like at a circus sideshow tent, large lettering at the exhibit's entrance provocatively announced, "few of these photographs have been seen by the public before." Museumgoers entered the darkened gallery—its walls were painted black—and walked through a mazelike configuration of gigantic blowups of Maier's photographs. A horizontal strip of more than two hundred images, representing eighteen rolls of Maier's film, wrapped around the room, conjuring her Rolleiflex days. The museum's website invited viewers to "see Chicago through the eyes of Vivian Maier and witness the life work of a photographer who wowed the world with breathtaking images of everyday life in urban America."[43] Hidden speakers piped in sounds that included car horns and street activity, and a nostalgic jazz overlay enhanced the room's ambience. These forced effects overpowered and put viewers into a contrived space that ironically eliminated Vivian Maier, who had explicitly chosen not to share these photographs.

Covering the new rash of Maier showings, a *Chicago Tribune* reporter exclaimed, "The Vivian Maier Industrial Complex rolls on!" and referred to Maier as a "burgeoning legend."[44] Having interviewed the collectors, the reporter relayed: "As Jeffrey Goldstein, one of the two Chicagoans who own her photos, told me, the human interest story has threatened to drown out seri-

ous appreciation for her work. Or, as John Maloof, the other Chicagoan who controls her artistic legacy, put it: '(Expletive) overkill.'"[45]

By the end of August, Maloof had established a Facebook page for his upcoming film, and by the end of the year, his "official" Vivian Maier Facebook page had surpassed twenty thousand followers.[46] Also by the end of the year, four more Maier exhibitions were launched, with the Goldstein enterprise traveling to Portland, Oregon, and Chiasso, Switzerland, while Maloof-sponsored shows opened in Budapest, Hungary, and Brescia, Italy.[47] A second printing of Goldstein's *Vivian Maier: Out of the Shadows* was expected by mid-December; nearly eight thousand copies of the book had sold in less than two months.[48] Maloof's book was in its fifth printing.

MID-1960S: YEARS OF TRANSITION

Vivian Maier stopped developing some of her film as early as 1964, a year in which she left more than a dozen rolls unprocessed.[49] Perhaps she couldn't keep up with her inexhaustible practice, or perhaps she still intended to develop them; but in the last few years, the act of framing and recording had begun to take precedence over any subsequent photographic steps.

News of racial unrest dominated the first months of 1965. On March 7, outside Selma, Alabama, state troopers assaulted hundreds of marchers protesting racially discriminatory voting laws. Photographers recorded the unprovoked attacks, and the widely circulated pictures caused national outcry. On March 8, in a separate perilous development, thirty-five hundred Marines were deployed to Vietnam, the first U.S. ground troops to arrive there. Student groups protested the Vietnam War and advocated free speech, while a rising counterculture that supported civil rights and social justice spread from campuses into communities. Picketing became commonplace, covered by television and other media outlets, which effectively publicized groups' messages and efforts.

On April 13, Vivian Maier covered a number of events that

had political and cultural resonance. She photographed School of the Art Institute students picketing to bring back a dean who had resigned as a result of administrative concern about his relative inexperience. Students marched in a circle at the museum's Michigan Avenue entrance, carrying artfully lettered signs. That same morning, the *Chicago Tribune* blared, "TWISTER TOLL PUT AT 248: Dazed Crystal Lake Residents Sift Rubble for Possessions."[50] Later in the week, Maier journeyed forty-five miles by train to witness and record Crystal Lake's battered landscape; but on April 13, she was one of several thousand attending the funeral of Albert Cardinal Meyer at Holy Name Cathedral.[51]

Vivian Maier walked a mile and a half from the Art Institute to the church; and then, after photographing priests and parishioners milling around at the street corner, she made her way inside and onto the rear balcony, where she framed the cathedral's vast interior. At the foot of the altar, flanked by six-foot-tall candlesticks, the recently closed casket was set for the two o'clock Mass. It is unknown how Maier managed her way into this event, where throngs had queued outside and dignitaries—including the mayor and the governor—were in attendance, but at its conclusion, she was inside the police-lined barricades at the church's entrance, getting a shot of the hearse, its door open, awaiting the cardinal's coffin.[52]

Three weeks later, Maier was at a memorial service two hundred miles away at the state capital. It was the hundredth anniversary of President Lincoln's burial, which, in 1865, had concluded perhaps the most prolonged funeral in history, as the train carrying his casket stopped in thirteen cities between Washington, DC, and Springfield, Illinois. Maier photographed the political speeches at the anniversary event from her seat, several rows back. Her other 1965 jaunts included a summer trip to New York, where in one twelve-exposure roll of film she covered Times Square to Grand Central Terminal, and then the United Nations Plaza down to Thirty-Third Street and the East Village. Maier also toured Puerto Rico that August, passing through Old San Juan, Maunabo, Guayama, Ponce, San

German, and the American military base in Guaynabo, where she photographed another funeral. Nearly circumnavigating the entire island, Maier's indefatigable spirit comes through her in photographs; but she was now almost forty, and her rapport with her subjects was changing.[53]

While Maier was away, extreme clashes pushed the growing political movements into dangerous new territory. The day after race riots began in Los Angeles, a racially charged incident in Chicago sparked greater violence than the city had seen in more than a decade. Rising political movements brought the disenfranchised together with mostly white college students who also promoted the growing antiwar and freedom of speech movements. The concept of free speech also percolated through cultural outlets. Since 1930, Hollywood's Motion Picture Production Code had dictated permissible depictions of relationships, actions, and language. Now, the movie industry began to rebel. Hollywood studios had lost their stronghold on movie houses, foreign cinema didn't operate on the same strict rules, and soon European art films, including New Wave French and neorealist Italian movies, found American audiences.

Vivian Maier had always gravitated toward the cinema and its movie stars, and her visits to movie houses overwhelmingly outdid her attendance at art venues. In May, Maier visited the Institute of Design, where a student exhibition was presenting pictures of the Selma civil rights march. But Maier was there to catch actress Gloria Swanson, who was hosting an experimental film festival.[54] Sponsored by the new Hull House Film Center, and poised to answer the *Tribune*'s recent query, "Is there an audience in Chicago for the experimental and the independent documentary film?" the festival also included movies by European directors, including Jean-Luc Godard and Luis Buñuel.[55] After documenting her walk from the Chicago "L" train stop, Vivian Maier stood curbside as a dapper white-haired man in a tuxedo helped Swanson out of a vintage Rolls-Royce. Hollywood's veneer could still appear unscathed by the prevailing social climate.[56]

By 1965, the original Hull House mansion was all that

remained of Jane Addams's legendary Chicago settlement; an entire neighborhood had been cleared and replaced by one hundred acres of Brutalist-style architecture. Moved just yards from its original location, the nineteenth-century mansion became a focal point at the Halsted Street entrance to the new University of Illinois city campus. A couple years earlier, Vivian Maier had toured this area's blighted landscape; now she returned to walk through the pristine new campus, stopping to photograph the spruced-up mansion amid its futuristic concrete surroundings. A two-roll sequence illustrated a two-and-a-half-mile walk from the Maxwell Street area to the Loop.

Because of the way that Maier used her camera, her pictures sometimes reveal stories about her. It is easy to assume that Maier is alone because her photographs rarely show an ongoing interaction with others as she traverses city sidewalks. And indeed, part of the legend of the nanny photographer is that she had no social life outside of her work. But just as photographs can deceive in the way they remove scenes from their context, so do they also sometimes mislead by the photographer's framing and editing choices.

Pictures from Vivian Maier's hike from Maxwell Street to the Loop reveal that on that sunny day she had a companion. These photos include typical views of street corners and people who caught Maier's eye, including a man in a fedora, children at a storefront, a short man walking hand in hand with a tall woman, and a junkman pulling a towering load of cardboard boxes—but they also show a young blond woman at both ends of the journey. Fashionable in her headscarf, coat, and boots, the woman carries an umbrella and a folded newspaper under her arm. In one photo she leans on a car, smiling as she faces out of the frame. In another picture, she turns back toward the camera from nearly a half block away; Maier had stopped to photograph some curbside garbage.[57]

Vivian Maier and her companion crossed through the university campus, stopping in the bookstore before continuing across a highway bridge toward the Loop. At the corner of Congress Parkway and State Street, the Follies Burlesque's marquee

announced stage performances by "Ineda Mann," along with the movie *Naked Canvas*. This portion of State Street was losing its luster, while increasingly relaxed views on the depiction of sexuality paved the way for adult movie houses that would soon dominate this area. Surrounded by photos of nearly nude women and signs proclaiming GIRLS GIRLS, Maier's friend gamely posed at the theater entrance as a gruff-looking man scowled at her from the other side of the glass door; farther inside the dark lobby another patron stared confrontationally at the camera. A few storefronts down, Maier held the woman's umbrella and purse as she photographed her trying to soothe a screaming baby in its mother's arms. A young boy in a *Man from U.N.C.L.E.* sweatshirt cast a sideways glance toward the camera. Even as photographs silence moments, this scene transcends the medium's stillness.

As Vivian Maier continued on her jaunts through the city, covering the same areas and the same subjects, others' use of photography shifted with the changing times; and as museums dictate history, exhibitions influenced subsequent photographers. In 1962, Edward Steichen stepped down as the director of the department of photography at the Museum of Modern Art and was replaced by thirty-six-year-old photographer John Szarkowski, who, in shifting authority from the museum to the artist, stated, "The future photography program of the Museum of Modern Art is as unpredictable as the outcome of the searches and experiments of a thousand serious photographers."[58]

Szarkowski initiated new ways of looking at photographs. In 1964, he launched the exhibition *The Photographer's Eye*, which defined the medium as a visual language divided into five categories: "The Thing Itself," "The Detail," "The Frame," "Time Exposure," and "Vantage Point." In demonstrating these principles, photographs by well-known masters were placed alongside anonymous works. Unlike *The Family of Man*'s picture arrangements, monumental scale, and selective cropping, *The Photographer's Eye* focused on the unique language of the image, allowing individual photographs to speak without further context.

In 1967, Szarkowski curated *New Documents*, a show that gathered work by three photographers whose style and attitude were to revolutionize documentary photography. Corresponding to the chaotic and changing times, Diane Arbus, Lee Friedlander, and Garry Winogrand represented editorial photography's counterculture. Yet while Vivian Maier's photographs have been compared to theirs, Maier's strategies stayed aligned with her earliest work, even as her repertoire broadened. Like Arbus and Winogrand, Lee Friedlander started out as a magazine photographer and transitioned to making personal work with the support of Guggenheim Fellowships. Like Winogrand, Friedlander shot street photography with a 35 mm Leica camera, but his images were more self-reflexive; sometimes he even incorporated his own image or shadow into his sharply focused, messy compositions. Winogrand and Friedlander broke formal rules that students of photography had practiced since the advent of modernism. Their framing was casual, like an amateur snapshot, but they had honed their style until the pictures formed their own language.

John Szarkowski described traditional documentary photography as working within an agenda for promoting social change and submitted that the photographs in *New Documents* represented a more personal quest: "In the past decade this new generation of photographers has redirected the technique and aesthetic of documentary photography to more personal ends. Their aim has been not to reform life but to know it, not to persuade but to understand. The world, in spite of its terrors, is approached as the ultimate source of wonder and fascination, no less precious for being irrational and incoherent."[59] Szarkowski could have well been describing Vivian Maier's photography, a solitary practice that she had by then sustained for nearly two decades.

Maier may have been able to take more photo-journeys in the mid-1960s because her role as a nanny to the Gensburg boys was quickly waning. By 1967, the eldest brother was a teenager and the boys didn't require Maier's constant companionship. In March, Maier began watching Inger Raymond, the five-year-old daughter of her new employer, in the nearby town of Wilmette.

During a transition period, Maier worked for both families.[60]

The summer of 1967 saw San Francisco's Human Be-In and Central Park's Be-In—the so-called Summer of Love. Hippies emerged in 1967 as an antiestablishment youth movement, and *Time*'s Man of the Year was awarded to all young men and women.

In contrast, forty-one-year-old Vivian Maier spent June 1967 touring South Dakota and the upper Midwest from the back seat of the Raymond family automobile. Maier brought gear to shoot 8 mm movies, 35 mm color slides, and black-and-white negatives. Sometimes she used all her recording devices nearly simultaneously, thoroughly capturing events and landscape panoramas.[61]

The group left Chicago at the end of May and headed north through Wisconsin to Lake Superior, where they spent a day on a ferry. Maier's documentation includes movie sequences of passing freighters and grain silos that monotonously drone on until she cuts to her fellow boat passengers, some of whom have matching still photos showing them facing the water from the ship's rail. The Raymond group then drove through Minnesota and North Dakota, where they passed through Jamestown and Bismarck, as Maier photographed the passing sights. Maier did not develop much of the film she shot with her Rolleiflex through this stretch of the trip.[62]

During the first weekend in June, Maier used all three of her cameras to record the Memorial Day parade in Sturgis, South Dakota. Cowboys and marching bands paraded up Main Street, waving American flags under the vibrant blue sky, while back in gritty Chicago, a World War I veteran complained, "Those people who call themselves nonconformists and peaceniks have sort of put a damper on things."[63] South Dakota seemed worlds away from the nation's turmoil.

Maier devoted several rolls of film and lots of movie footage to the South Dakota Badlands and Black Hills. Shot mostly through her car window and over the front seat through the windshield, the pictures often include the window's frame or the rearview mirror. In some ways, Maier was doing the legend-

ary photo road trip of Walker Evans, Robert Frank, and Garry Winogrand. But even as Winogrand would sometimes include parts of the car from his driver's seat vantage point, the framing was intentional and became part of his vernacular; also, each of those photographers was in control of his journey.

When the Raymond group made a scenic roadside stop, Vivian Maier put all her cameras to use. She shot at Minnesota's Smokey Bear Park, South Dakota's Wall Drug's dinosaur playground, and a cowboy rodeo. She was especially busy at their visit to Mount Rushmore, framing the looming presidents through archways, mirroring them in reflection on a car hood, and juxtaposing them with a travel brochure.[64] At one picturesque overlook, Maier appeared in two photos shot by Inger Raymond's father; in both images, her Rolleiflex dangles around her neck and she's in action taking a picture with another camera that obscures her face. One of these faceless portraits wound up in a scrapbook put together by Inger's mother. On a page titled, "Mementos of Fifth Year," she captioned the photo, "New Friend Vivian Maier who came to take care of Inger in March 1967."[65]

2013: VIVIAN MAIER IN THE MOVIES

On January 21, 2013, a British documentary filmmaker arrived in Chicago to learn about the Vivian Maier story, which was being considered as a subject for the BBC television documentary series *Imagine*. The next day's temperature dipped below zero, the coldest it had been in the city for two years. It was an appropriate introduction to Vivian Maier's Chicago, where for the next several days filmmaker Jill Nicholls and her research assistant, Tracy Drew, learned about rivalries and were frozen out of access to John Maloof's collection, as well as to people who had known Maier.

Nicholls was accustomed to trials as part of the documentary filmmaking process. She had taken the Hostile Environment Awareness Training course for filming in conflict zones—Iraq, specifically—and her skills in diplomacy and persuasion had often been put to the test. Nicholls had directed and produced

more than twenty movies, and armed bodyguards had accompanied the subject of her most recent project. That film, *The Fatwa: Salman's Story*, also for *Imagine*, presented Salman Rushdie's first personal accounting of what it felt like to be issued a death sentence after he published his novel *The Satanic Verses*. Surely, the Vivian Maier story would be easier to tell since it simply involved a woman and her photographic legacy, which had already been shared in newspapers and magazines, on countless websites, in two books, and in more than two dozen exhibitions.

John Maloof refused to cooperate on account of his own documentary film, which he would be narrating while also leading the project as the director of photography, cowriter, codirector, and coproducer. The $105,000 Maloof had raised on Kickstarter was long gone, used on preproduction costs, and he had since changed collaborators, now partnering with veteran film producer Charlie Siskel.[66] Siskel was the nephew of famous Chicago film critic Gene Siskel, and coincidentally, he had grown up in Highland Park. With access to the vast majority of Maier's materials, their movie had the potential of elucidating Maier's photography practice while also shedding light on her life.

John Maloof had created a new Facebook page for his film, and for the previous five months, he had been gaining followers and giving updates while also keeping his growing audience in suspense. The page presented production stills showing Maloof filming his interview subjects; Maloof filming a darkroom technician developing rolls of Maier's negatives; and Maloof seated at his computer, working on the movie's audio. In October, the page showed a photograph of an open safe loaded with hard drives alongside the caption, "Stories about Vivian by people who knew her and my adventures are in these drives."[67] Three weeks later, an image of motion picture reels appeared: "We have 150 movies that Maier made. All are digitized and will tell us more about her."[68]

The Facebook page also presented stacks of Maier's paper ephemera, including envelopes and receipts: "We were able to find where she was every year of her life, who she was working for, and all of her friends. There are some major breakthroughs

that we can't wait to unveil!"[69] Earlier, the page posted a photo of a mountain range—"While in France, we discovered some amazing information about Vivian's past"—to which people replied, "What did you discover?" and "Oh you tease!!"[70] Maloof also announced that he would be publishing another book, *Vivian Maier: Self-Portraits*, in fall 2013.

Jill Nicholls was slightly dismayed by Maloof's noncooperation, but Jeffrey Goldstein was happy to work with her. In addition, Ron Slattery, who had largely remained out of the limelight, agreed to show his Vivian Maier vintage prints and to tell the story of how Maier's materials spread after the storage locker auctions. Slattery had been advised by his attorney that he did not have the authority to publish any work. He had never made prints or commercialized reproductions from the negatives and slides that he owned, and he did not license image reproductions to the BBC.

John Maloof had asked people whom he interviewed for his film not to talk with the British filmmakers, but the Goldstein team knew other people who agreed to appear. Nicholls also had ideas about other people and ways to fill in the story. The arrival of the BBC crew may have sped up Maloof's efforts to get his film picked up for distribution. On February 15, just as Ron Slattery finished his on-camera interview with BBC presenter Alan Yentob, the *Finding Vivian Maier* movie trailer appeared on YouTube. Earlier that morning, *Variety* reported that Maloof's film had deals with television stations in Sweden, Holland, and Switzerland, and film rights were being negotiated in Canada and Italy. The news spread through industry and social media channels, and within days the trailer had been viewed more than three hundred thousand times.[71]

While Vivian Maier fans waited for the movies to be completed, more shows of her photography were put on in the United States and Europe. During the next six months, exhibitions from the Goldstein collection appeared in Washington, Oregon, California, and Florida, while shows derived from the Maloof collection went up in London and Antwerp. Each venue received local press, and Vivian Maier's fan base grew still further.

In their four days in Chicago, Nicholls and her crew interviewed more than a dozen people, from the North Shore to Maxwell Street to the South Side. Nicholls and her team met with some men who had crossed paths with Maier the photographer—not the nanny—even though they did not know the quality or quantity of her pictures. These included Albert "Don" Flesch, the proprietor of Central Camera; Pat Velasco, another camera shop worker; and film house manager Jim Dempsey.[72]

The BBC team continued on to New York to illustrate some of Vivian Maier's early picture-taking strategies and to show places where she or members of her family had stayed. They also traveled to locations where Maier photographed, from Fifth Avenue to the Bowery, across the Queensboro Bridge and along the East River, Riverside Drive, and East Sixty-Fourth Street.[73] These places were where and when Maier developed her vision and used her camera the most creatively, making abstractions, exploring reflections, approaching strangers, catching moments, working like a photojournalist, and looking back at herself as a photographer in mirrors and windows.

The crew then flew to France, where they toured the villages where Vivian Maier and her mother had stayed. By this time, the locals were well aware of Maier, her photography, and the men who owned her materials. And unfortunately, as in Chicago, their allegiance was divided. The Association les Amis de Vivian Maier, although initiated through Maloof's 2011 visit, was now aligned with the Goldstein team, while the newer Association Vivian Maier et le Champsaur was backed by Maloof. Also as in Chicago, some villagers were off-limits to the filmmakers, while others were willing to share their recollections. Some accused others of not really knowing Maier but "remembering" her only once she became famous.[74]

Jill Nicholls's filming was finished within weeks. Over the next few months, Nicholls and her editor cut together the film for the season premiere of *Imagine*. On June 25, *Vivian Maier: Who Took Nanny's Pictures?* aired on BBC One, viewable only in the United Kingdom. The title's awkward pun played with the notion of Maier as a nanny-cum-photographer, while also

hinting at questions of appropriation. A shorter version of the movie would later be released to international audiences as *The Vivian Maier Mystery.*

Only two individuals would appear in both Vivian Maier movies: photographer Joel Meyerowitz and Inger Raymond, whom Maier had tended as a young girl. Meyerowitz, familiar to the British audience through *The Genius of Photography*, talked about the travails of being a street photographer. Additionally, he suggested that Maier's was not one-shot amateur work by showing a sequence of 1950 images, where she had circled a seated beggar at the Saint-Bonnet market. Meyerowitz also addressed the problems that the collectors' editing of her life's work had created for understanding Maier's photography and intentions.[75]

Inger Raymond remembered Vivian Maier from 1967 through 1974. In 2011, Raymond had stumbled onto a blog illustrating the Vivian Maier timeline and had typed into the comments section, "Miss Maier was my governess from when I was 5 years old until age 11. I remember going with her around Chicago she always had her box camera with her. This is quite a shock. I am glad her pictures are getting recognition. I still have the picture she took of my grandmother. I would be willing to talk about her. She worked and had a room with us from 1966–1972."[76] Raymond's mistaken recollection of the years is indicative of the fluidity of memory—in contrast to the documentary aspects of photography.

1968: A VOLATILE YEAR IN WORDS AND PICTURES

From the excessive documentation of the 1967 Raymond family's summer vacation, it seemed that Vivian Maier spent more time behind her cameras than she did watching Inger. In some of her photographs and films, young Inger would blur by, inadvertently ruining a shot; those frames suggest that she was under Maier's distracted care.

Just as Vivian Maier had graded her 1956 darkroom prints "good," "so-so," "fair," and "poor," she penciled "comme si

comme sa" (a phonetic spelling) on a box of slides from that summer's travels.[77] To her, the slides were neither good nor bad; conversely, Maier didn't even bother to develop some of her other film from that summer. She became notably lax about film development in April, just after relocating to Wilmette.

Maier may have seemed cosmopolitan to her new employers—in early 1968, she photographed a giggling Inger trading her winter stocking cap for a French beret—and she sustained her varied cultural interests, documenting stage and screen events on the street or from the audience. In 1967, Maier photographed Dan Dailey again, one of her earliest movie star sightings, from her balcony seat during his appearance in the play *The Odd Couple*; and she staked out Lee Radziwill on the sidewalk by a North Side dinner theater, where she likewise captured Zsa Zsa Gabor. Maier also found and photographed French-themed performances, including Maurice Chevalier's concert at Orchestra Hall, and a production of *Waiting for Godot*, staged in French by students at Northwestern University.[78]

But there was more going on in Chicago at this time than was revealed by stage lights and glittering cinema marquees. And Vivian Maier captured it, too. The train Maier boarded in the northern suburbs terminated downtown at the Chicago and North Western Station, also known as Madison Street Station, from which she would sometimes head west into the stretch known as skid row. Populated by variously disheveled and inebriated men hanging out on sidewalks in front of taverns and transient hotels, West Madison Street was also part of one route that Maier walked to the Maxwell Street Market. Although her pictures never show hostile approaches, the locals regard her with expressions that range from caution and bemusement to open smiles. With her cameras, trench coat, beret, and foreign affect, she was likely seen as a harmless oddity or perhaps a European journalist.

While the nation's antiwar protests went on and racial unrest simmered with each news story, Chicago had largely maintained a precarious calm. Then, on Friday, April 5, 1968, pent-up anger erupted with unprecedented fury; the day before, Martin Luther

King Jr. had been assassinated in Memphis. Black residents took to the streets, throwing bricks and bottles through windows, and then ransacking, looting, and setting businesses on fire. President Johnson sent in thousands of National Guard soldiers as rioting spread.[79] One hundred city buses and other trucks had their windows broken, bloodying drivers. In some areas, snipers shot at firefighters and National Guardsmen. By Saturday night, seven looters were dead and hundreds were in jail. Smoke billowed from more than thirty fires set along a two-mile stretch of Madison Street. By Sunday, Mayor Daley had imposed a curfew, banned the sales of guns and flammable liquids, and ordered all area taverns and liquor stores closed. Public transportation had ceased through the torn neighborhoods, which had also lost electricity and telephone access, leaving residents stranded and helpless.

Newspapers published many photographs of looting, fires, and decimated streets. On Monday, April 8, the *Chicago Defender* ran a picture of soldiers with bayonet-mounted rifles standing by battered vehicles on Madison Street.[80] The *Tribune* followed up, conveying the waning of hostilities, "Riot Task Force of 16,000 Restores Order"; "Madison St. a Blackened Scar in Heart of Chicago."[81]

On Wednesday, April 10, Vivian Maier boarded a Madison Street bus and rolled directly into the aftermath. She brought along at least two cameras, including her Rolleiflex for black-and-white work and a 35 mm camera for color slides. Maier bounced back and forth, photographing from windows on both sides of the bus: first, she got the skid row men as they loitered about; and then, at Ashland Avenue, near the end of her first spool of film, two workers stood at a gutted clothing store, its displays and plate glass windows gone. Maier's next roll picked up with a long line of African Americans queuing into the Lutheran Salvage Center, and then her bus detoured onto a parallel street. Window views of peripheral damage and broken glass complete the second roll as Maier's picture taking slowed down to every few blocks until she reached the end of the line, six miles out. The bus's detour had skirted the epicenter of the

rioting; so, on her return trip, Vivian Maier disembarked at Homan Avenue and went right into the smoldering wreckage of Madison Street.[82]

Smoke and dust filled the air, but bulldozers had already cleared most of the ruins and debris. Maier photographed some piles of rubble, and then she came across six white men wearing yellow hardhats who, incongruously, smiled for group portraits in black-and-white and color. Farther along, Maier framed a sidewalk still life that included a garbage can, a ladder, a chair, and the bottom half of a female mannequin leaning on an incinerated storefront. She passed National Guardsmen posted at intersections and teenage girls walking by the smoking wreckage alongside a clothing store named Gaytime; and she stopped to photograph a couple of hardhat workers having sandwiches in front of a charred Western Union office. Maier pressed her camera into the open front of a department store and then a beauty parlor, and as she made her way out of the most devastated part of the strip, she photographed a cardboard sign behind the storefront glass of a tailor shop: "I am a soul brother don't fite me." Maier walked more than a mile east on Madison Street, photographing her way back toward skid row. Since first boarding the bus, she had rewound and reloaded her Rolleiflex more than seven times.[83]

The uncertain times led to more killing and continued political unrest. Two months after the assassination of Martin Luther King Jr., Senator Robert F. Kennedy was shot and killed in California. Maier posed Inger Raymond in profile on a Wilmette sidewalk with the *Chicago Tribune* propped in her arms: "BOBBY SHOT IN HEAD." She set the next day's newspaper under a desk lamp by a window with drawn shades and tried shots with and without the lamp on: "Bobby Dies." On the following day, a picture of a loaded newspaper stand filled in the story: "Thousands Pay Tribute to Bobby," "RFK Lies in State," "Crowds Mourn Bobby." On the fourth day after the shooting, another newsstand simultaneously announced, "A Nation's Farewell to RFK" and "SEIZE KING DEATH SUSPECT."[84]

Vivian Maier had long taken pictures of newspapers; some-

times they were crumpled in the garbage or on the ground, and she often photographed people reading newspapers, carrying them folded under their arms, or using them as headrests during public naps. Visible news items would sometimes connect people and their surroundings to a specific time or event. But, recently, she had begun using their words and messages as surrogates in her photographs. And Maier continued to retain and accumulate newspapers.

Inger Raymond's father had installed a brace underneath Vivian Maier's room on account of the sagging ceiling. Maier had filled the room with "boxes, newspapers, lots of clothes, lots of different items." Said Inger, "You had to almost narrow your way in on the occasions that she'd let you in, because she was very, very private."[85]

Over the summer, the city mended and Maier spent extended periods with six-year-old Inger. She recorded their days together around the house, at parks, on the suburban sidewalks, and frequently, at the Wilmette beach, including from inside the beach house concession stand. William Eaton, then a young lifeguard, saw Vivian Maier often in the summer of 1968. Eaton had just graduated from nearby New Trier High School, where he had studied photography.

He recalled that she had "a Rollei grafted to her chest," and when she was in the mood, they would have conversations about a range of topics including photography. They both liked Walker Evans, Henri Cartier-Bresson, and Edward Weston. Weston, best known for his images of organic forms, seemed a surprising choice, but Eaton said that Maier was a "visual omnivore"; they talked about Weston's famous green pepper photograph. He remembered Maier as "a very big woman" who "took no shit at all," and "demanded respect." Maier sometimes got annoyed with him. "She could be a bit haughty and dismissive . . . that French accent. It went with the hat, and the attitude. She really did not suffer fools . . . and I . . . was a bit of an idiot and got singed a bit as she was rather sharp witted. There was a bit [of] Ingrid Bergman in her presence. She could be a bit dryly coquettish on a good day. Not flirtatious, but the product of being

a bit charged up that day."[86] The nineteen-year-old lifeguard, who was shooting color slides that summer, likely had more in common with forty-two-year old Vivian Maier than any other acquaintance in Wilmette.

During the last days of August, Chicago hosted the Democratic National Convention, which was wracked by antiwar protests in downtown parks. The demonstrators included "an assortment of peace radicals, Yippies, street fighters and assorted fuzzophobes."[87]

An August 28 rally in Grant Park, across Michigan Avenue from the Democratic headquarters at the Conrad Hilton Hotel, drew tens of thousands. Tension built all day, and crested that afternoon when someone lowered the American flag. Police with clubs moved in and somebody threw a tear gas bomb. The foggy raucous scene, backlit by sunlight, made dramatic newspaper photographs. Filmmaker Haskell Wexler was shooting *Medium Cool*, a movie about a news reporter that included actual street scenes and thus blurred fact and fiction; as a cloud of tear gas moved toward the camera, someone shouted, "Look out Haskell, it's real!"—heightening awareness of a camera operator's state of detachment.

By nightfall, a large group had gathered again in Grant Park, and police struggled to keep them at bay. Television news crews and photojournalists were on hand, and when hostilities escalated they recorded the police officers' brutal assaults. Police then turned on photographers and TV news crews themselves, arresting them and pushing them into paddy wagons. That night, the police harassed and injured six news reporters, bringing the total of journalist casualties during the convention to around thirty.[88]

Vivian Maier may have missed the action on August 28, but the next morning she was downtown, photographing along Madison Street—dipping into the Eugene McCarthy headquarters in the lobby of the LaSalle Hotel—on her way to Michigan Avenue, and then recording her walk through Grant Park to the Hilton. She found newspapers in mesh garbage cans that cast vivid shadows onto headlines; newsstands showing mul-

tiple front-page stories; a boy in a straw hat on a street corner, hawking newspapers from each hand; and a man with a *Tribune* folded and stuffed into his back pocket, talking to police officers in riot gear. Along her way, she passed an elderly man reading the paper on a stone bench, a crumpled newspaper remnant at the foot of a tree, and another trash can displaying the previous day's discarded news. At the scene of the past night's battle, a bearded hippie glanced up at Maier while reading the *New York Times,* while others occupied benches, poring over the *Tribune* and the *Chicago Daily News.*[89]

A row of National Guardsmen stood at ease, facing the park to keep people out of the Hilton. Some young demonstrators remained in their bedrolls, asleep on the grass. A large Make Love Not War sign leaned against a tree amid a group of lounging youth, and elsewhere, a softball game was in progress. The mood had shifted, and cleanup was under way. The scattered debris hardly compared to the aftermath of the riots on West Madison Street, but Chicago was now marked for its rough expressiveness on both sides of the law—and Vivian Maier had documented its results.[90]

2013: COMPLICATIONS AND CELEBRATIONS

As Vivian Maier's story grew, people came to believe vast sums of money were being made from her work, and this renewed rumblings about the profits. Since the earliest forum discussions, some had questioned the propriety and legitimacy of the print sales and publishing enterprises. In February 2013, a commenter on *Gapers Block,* a Chicago-based arts and culture website, submitted, "It's quite confounding to me that anyone would claim copyright to Vivian Maier's heavenly work as Mr. Goldstein and others are now doing so publicly. They did not take these photographs, Vivian did. They were not willed to these people, they found or bought them from others that had no legal right to them. They are not theirs to sell and earn a profit from."[91]

Jeffrey Goldstein and John Maloof had never publicly addressed their right to reproduce Vivian Maier's photographs.

When asked, they demurred, explaining that they had a non-disclosure agreement. Both of their websites presented the copyright symbol along with a warning that all rights were reserved, but they did not own the copyrights they were asserting.

In July 2013, after the airing of the BBC documentary, British photographer Ian Murray, active on a stock photography Internet forum, was unhappy about how Maier's legacy was being handled:

Are all the people profiting from her work in breach of copyright and if not why not?

When it is stated that she had no family that surely cannot be absolutely true—there has to be a relative somewhere no matter if very distant and currently unknown. Has there been a truly diligent search done by genealogists for her family?

Is there a danger this could set some sort of precedent that could come back to bite photographers? I have read arguments that because much of her work was not "finished" and because she did not photograph for commercial reasons that copyright should be ignored. I wonder how many other artists such logic could be applied to?[92]

The ensuing discussion, rooted in personal opinions, did acknowledge that copyright law is not always clear and that it varies from country to country. Many members of the group felt that Maloof and Goldstein deserved to continue their production of Maier's materials because they had done a lot of work to establish her standing as a photographer. This mystified Murray: "I must say I have been surprised by the rather cavalier attitude towards photographer copyright displayed by several people here. The argument seems to be that if a guy can make money and not get into any trouble then good on him."[93]

Murray sent his questions to Jeffrey Goldstein, who responded with arguments that emphasized the complexity of producing work from Maier's materials: "I am limited to what I can speak of specifically as I am in an ongoing Non-Disclosure Agreement with John Maloof, but I can state in general terms that there are a series of laws concerning copyright and storage locker

purchases and rights transferred with legal ownership and Orphaned Copyright laws which with a high degree of effort, AKA due diligence, along with professional expertise we have heavily investigated and resolved."[94]

Goldstein followed up with a thirteen hundred–word e-mail that he invited Murray to distribute unedited. After simply stating that copyright was a "non-issue" and referencing his and Maloof's genealogists and attorneys, Goldstein launched into his own history in the art world and his team of workers' efforts to produce impeccable prints from Vivian Maier's negatives. Goldstein acknowledged that he purchased his collection for more than $90,000 and that in the last year the project had brought in $180,000; but after various expenses, he asserted, he had only broken even. He ended his missive by inviting anyone passing through Chicago to stop by "to see what we do" and offered to be available for a chat in Paris, where he'd be in November for a gallery exhibition of his Maier prints.

Within the next few weeks, the article "The Curious Case of Vivian Maier's Copyright" was posted on *Gapers Block*, attempting to understand the story's unique variables and explore what could happen to Maier's photography if copyright were challenged.[95] The reporter interviewed attorneys, as well as the Maier collectors, to get to the bottom of the story of the work that she said "industry observers" had valued at between mid–six figures and tens of millions of dollars. Maloof, who had just returned from France, where he had donated a stack of vintage Maier prints to the village of Saint-Julien-en-Champsaur, scoffed at the high-end value but said that due to the nondisclosure agreement with Goldstein, he couldn't discuss copyright or other business details.[96]

Maloof and Goldstein's mysterious agreements encouraged ongoing speculation. The *Gapers Block* article included a checklist of scenarios and challenges, with counterpoints and contradictions: Maier died without a will, which, absent any heirs, made her property revert to the state—but her storage lockers had been sold while she was still alive, so their items belong to the collectors. And even if her estate did revert to the state,

the estate would technically retain copyright, which is ephemeral and separate from physical property; but without anyone to enforce that, the printing and publishing enterprises might go on indefinitely.

The article also discussed the concepts of orphaned works and storage locker laws: the first applies when no copyright owner can be located; the second is a state law that would defer to federal laws on copyright. Worst of all, the article concluded, "None of the probate, estate or intellectual property attorneys contacted for this story had the same answers with regards to who gets what when a person without a will or heirs dies."[97] In the end, a spokesperson for the Cook County state's attorney acknowledged that the office would get involved only if an heir came forward to initiate proceedings. Goldstein offered that it would be "a very sad day if the state gets a hold of it."

Amid all the talk of copyright, the debut of John Maloof's long-awaited film, *Finding Vivian Maier*, was imminent. At the end of July, Vivian Maier's "official" Facebook page announced that the movie would premiere in September at the Toronto International Film Festival. In the intervening three months, seven exhibitions of Maier's photography were presented worldwide, including in Shanghai and Moscow.

Overlapping Vivian Maier exhibitions from the Goldstein and Maloof collections were on display in Toronto in September. Maloof's gallery was presenting a solo exhibition of Maier's work, and a group show, "Street View," in which Maier's pictures were included with those of other noted photographers, including Berenice Abbott, André Kertész, and Garry Winogrand.[98]

Two months after the Canadian film festival, the movie's American premiere came at a documentary festival in New York, coordinated with the release of the new book and another exhibition, both titled *Vivian Maier: Self-Portraits*. These presented Maier's increasingly familiar face and persona as she recorded them through reflections and shadows. Several portraits depicted Maier, though someone else had handled the cameras— meaning the works were not self-portraits, but underscoring that she and her photographs had become interchangeable.[99]

Finding Vivian Maier was shown at a half-dozen venues and festivals—including in Paris, Berlin, and Rio de Janeiro.[100] At the end of March 2014, the movie's American theatrical release was finally under way, starting in New York and Los Angeles. The buzz culminated in a sensational *New York Post* headline that echoed those that had grabbed Vivian Maier's own attention: "Recluse Nanny Turns Out to Be Photography Genius."[101]

1968–1973: DIRTY STREETS, ADULTS ONLY

Headlines can be misleading and stories one-sided. Because of the isolated perspectives of protestors, policemen, and television and film cameras, it was nearly impossible to reconstruct exactly how the Chicago Democratic Convention's peace demonstrations escalated to extreme police brutality. On September 15, 1968, Mayor Daley—who had referred to the demonstrators as communists—released the city's official version. The one-hour documentary film played on 140 television stations and a fifty-five-minute audio production was broadcast on a thousand radio stations.[102] The mayor's tilted version of events exonerated the police, but those who were aware of the conflicting voices and pictures became more distrustful of authority.

Vivian Maier continued covering Chicago events, but she increasingly eliminated a step in the photography process—a choice that today contributes to multiple readings of her intentions. Maier had already mostly stopped making prints, but she was now also increasingly neglecting to develop her black-and-white film.[103] From the convention through the end of 1969, she had put aside more than eighty—and likely well over one hundred—spools of film that she had wound through her Rolleiflex.[104]

Unlike smaller 35 mm film that pops into a camera, scrolls onto an opposing spool, and then gets cranked back into its protective metal cartridge, the Rolleiflex's wider film format uses two spools. The twelve-frame filmstrip, which is taped onto a longer length of paper, is more delicate to handle, and it can take up to several minutes to unload and reload the camera: first,

crank the rest of the paper strip onto the opposing spool; then, remove the camera from its leather case, open its back, pull out and moisten and seal the paper roll with its adhesive strip; next, replace the take-up reel with the now-empty film spool, tear another film package open, drop in the new roll, and thread the paper leader into the opposing film spool slot; finally, advance the paper roll, close the camera back, crank the advancing lever until it locks at the first frame, and replace the leather case. Vivian Maier's self-portraits from this period and earlier show her with a short-strap handbag that she carried in the crook of her arm, another element in the juggling act of changing film every twelve shots.

If shooting an event, Maier would finish a roll of film within a short period of time, quickly exchanging the film to continue. But by 1969, she would also sometimes take a day or two to complete a roll. In addition to casual and often-blurred street shots and suburban neighborhood photos, unprocessed pictures from this time included a trashed newspaper with the headline, "Nixon Promises No More Wars"; a magazine newsstand that announced the marriage of Jackie Kennedy to Aristotle Onassis; several rolls showing a State Street torchlight parade for Hubert Humphrey; and Richard Nixon's inaugural speech, from the perspective of a television atop a chest of drawers.[105]

But just because Vivian Maier did not develop more than a thousand Rolleiflex images does not mean she wasn't recording as many—or more—other pictures and scenes that she did process and view. Maier often shot thirty-six-exposure rolls of 35 mm slides and motion picture footage along with her twelve-frame black-and-white work, or she alternated between two or more formats. She shot motion-picture street studies simultaneously with her Rolleiflex still images; color slides of events that she also filmed in 8 mm; Rolleiflex and 35 mm simultaneously; and every combination of black-and-white and color in separate cameras, including swapping Rolleiflex color transparencies with 35 mm black-and-white. Additionally, slides from today's separate collections show identical coverage, suggesting that she may have also used two 35 mm cameras simultaneously.

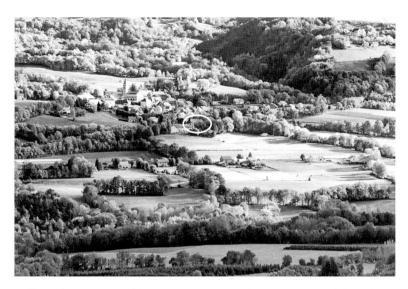

PLATE 1. Saint-Julien-en-Champsaur and the Beauregard estate (*circled*), in the Champsaur Valley in the Hautes-Alpes region of southeast France. Vivian Maier's family came from here, and Maier spent her childhood years in this region. (Photograph by the author.)

PLATE 2. Vivian Maier's great-grandfather, Germain Jaussaud, acquired this house as part of the Beauregard estate. Maier's mother, Marie Jaussaud, was born here in 1897. Maier inherited the estate, along with more than 170 acres of farmland, which she sold in 1950. (Photograph by the author.)

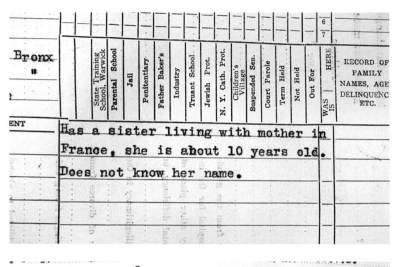

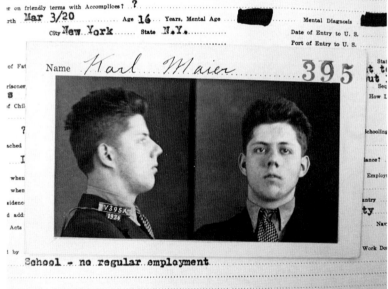

PLATE 3. Above is a sample of Vivian Maier's brother's materials at his entry to the New York State Vocational Institute in 1936. Karl and Vivian were raised separately; Karl had resided with his paternal grandparents. (New York State Vocational Institute Inmate case files, ca. 1930–1965, 14610–88C, Box 13, New York State Archives.)

PLATE 4. Documentation here shows Karl Maier on his incarceration at age sixteen for petit larceny at the New York State Vocational Institute. (New York State Vocational Institute Inmate case files, ca. 1930–1965, 14610–88C, Box 13, New York State Archives.)

PLATE 5.
Vivian Maier and her grandfather, Nicolas Baille, in the Champsaur Valley, 1950. Baille and Maier's grandmother, Eugenie Jaussaud, conceived Maier's mother, Marie Jaussaud, out of wedlock in 1897. (Photograph from the Ron Slattery collection.)

PLATE 6.
Vivian Maier traveled throughout France during 1950–51. In this January 1951 portrait, Maier poses in the cliffside village of Saorge, near the Italian border. (Photograph from the Ron Slattery collection.)

PLATE 7. An early Maier photograph showing a juxtaposition of young and old. Maier shot scores of photos of hay harvesting activities in the Champsaur Valley in the summer of 1950. (Photograph from the Ron Slattery collection. Courtesy of the Estate of Vivian Maier © 2017 The Estate of Vivian Maier. All rights reserved.)

PLATE 8. Three gravediggers pose for Vivian Maier in front of the open grave of
Maier's aunt, Maria Florentine Jaussaud, who died in 1943. Maier arranged for the
disinterment of her aunt from a common grave to a single burial lot. Other prints of
the cemetery taken on this day are annotated, verso, "January 5, 1951, fri." Vivian
Maier continually photographed funerals and cemeteries. (Photograph from the Ron
Slattery collection. Courtesy of the Estate of Vivian Maier © 2017 The Estate of
Vivian Maier. All rights reserved.)

PLATE 9. Twenty-five-year-old Vivian Maier aboard the SS *de Grasse* en route to New York in April 1951. Maier cut her nearly waist-length hair during her year away and returned as a sophisticated world travel. (Photograph from the Ron Slattery collection.)

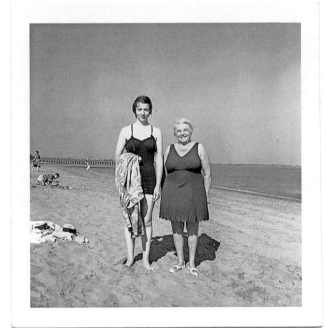

PLATE 11. Vivian Maier with her friend Emilie Haugmard at Staten Island's
South Beach in the summer of 1952. Haugmard lived in the building where
Maier and her mother, Marie Jaussaud, settled in 1938 after six years in
France. Maier gravitated toward women her grandmother's age as photo
subjects and friends. (Photograph from the Ron Slattery collection.)

PLATE 12. A crowd faces Vivian Maier's camera during the filming of Taxi on August 1, 1952. Maier is standing in front of 983 Third Avenue, where a photo studio offered classes and darkroom usage. (Photograph from the Ron Slattery collection. Courtesy of the Estate of Vivian Maier © 2017 The Estate of Vivian Maier. All rights reserved.)

PLATE 13. In an unusual instance of split-second timing, Maier captured an acrobat's legs parallel to the Central Park horizon in New York, 1952. (Photograph from the Ron Slattery collection. Courtesy of the Estate of Vivian Maier © 2017 The Estate of Vivian Maier. All rights reserved.)

PLATE 14. On the rooftop terrace of the Tudor City apartment complex in New York, 1952. Maier's photographs often featured rooftop perspectives and demonstrated an ongoing top-of-the-world theme that dated to her earliest known works shot from above the Champsaur Valley. (Photograph from the Ron Slattery collection. Courtesy of the Estate of Vivian Maier © 2017 The Estate of Vivian Maier. All rights reserved.)

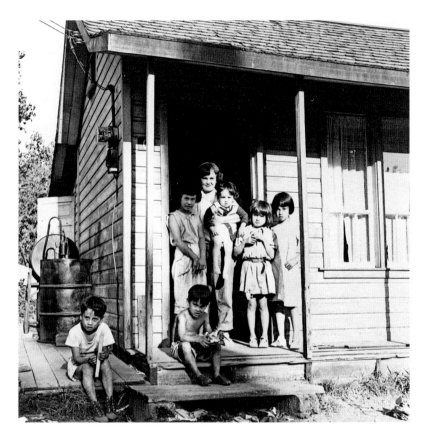

PLATE 15. In late summer of 1953, Maier traveled with her employer's family to Vancouver, British Columbia. This image was among negatives from several rolls of film in an envelope marked, "Canada 1953." (Photograph from the Ron Slattery collection. Courtesy of the Estate of Vivian Maier © 2017 The Estate of Vivian Maier. All rights reserved.)

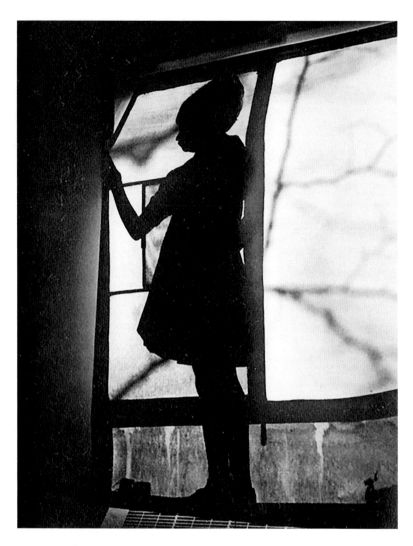

PLATE 16. Stuyvesant Town apartment complex window, New York, circa 1954. Maier continually noticed and experimented with shadows, silhouettes, and reflections. (Photograph from the Ron Slattery collection. Courtesy of the Estate of Vivian Maier © 2017 The Estate of Vivian Maier. All rights reserved.)

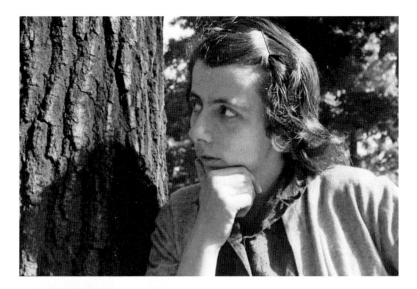

PLATE 17. (*above*) A portrait of thirty-two-year-old Vivian Maier in Highland Park, Illinois, taken in 1958 with her camera. (Image from the Ron Slattery negative collection.)

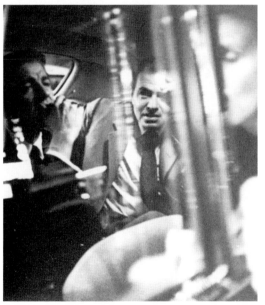

PLATE 18. Cary Grant, James Mason, and Eva Marie Saint in a taxi cab at the time of the 1958 filming of Alfred Hitchcock's North by Northwest. Maier often photographed theatrical and cinematic events, including movie premieres, actors on the street, and the stage and cinema screen from her seat in the audience. (Photograph from the Ron Slattery collection. Courtesy of the Estate of Vivian Maier © 2017 The Estate of Vivian Maier. All rights reserved.)

PLATE 19. Chicago, 1964. The film negatives for the images shown here and in plate 20 were sold on eBay the week that Vivian Maier died in April 2009. The impeccable compositions demonstrate ongoing themes, such as individuals sleeping in public, as shown here. (Image from the Philip Boulton negative collection. Courtesy of the Estate of Vivian Maier © 2017 The Estate of Vivian Maier. All rights reserved.)

PLATE 20. Chicago, 1964. Another ongoing theme of Maier's was partially hidden camera framing. (Image from the Philip Boulton negative collection. Courtesy of the Estate of Vivian Maier © 2017 The Estate of Vivian Maier. All rights reserved.)

PLATE 21. Chicago, circa 1970. These two images side by side show Vivian Maier's rapport with her subject. (Image from the Philip Boulton negative collection. Courtesy of the Estate of Vivian Maier © 2017 The Estate of Vivian Maier. All rights reserved.)

PLATE 22. (*facing, bottom*) Vivian Maier sometimes posed and framed her subjects to include their shadows, as in this portrait from August 1969, which was among film that remained undeveloped for forty years. This black-and-white negative, sold by John Maloof on eBay in 2009, was acquired by Philip Boulton in England. Color slides in Ron Slattery's collection show this same man, who was participating in the annual National Hobo Convention in Britt, Iowa. (Image from the Philip Boulton negative collection. Courtesy of the Estate of Vivian Maier © 2017 The Estate of Vivian Maier. All rights reserved.)

PLATE 23. (*above*) Chicago, circa 1967. Maier frequented various Chicago neighborhoods. She photographed these men outside a Goodwill store in Uptown, well known for its taverns, men's hotels, and Appalachian and Native American communities. (Vivian Maier negative acquired by Allan Sekula [1951–2013], reproduced courtesy the Estate of Allan Sekula. Courtesy of the Estate of Vivian Maier © 2017 The Estate of Vivian Maier. All rights reserved.)

PLATE 24. It seems that Vivian Maier could hardly pass a mirror without recording herself in juxtaposition with her surroundings. (Image from the Ron Slattery 35 mm slide collection, original in color. Courtesy of the Estate of Vivian Maier © 2017 The Estate of Vivian Maier. All rights reserved.)

PLATE 25. This image further illustrates Vivian Maier's attraction to creating self-portraits in mirrors that she encountered. (Image from the Ron Slattery negative collection. Courtesy of the Estate of Vivian Maier © 2017 The Estate of Vivian Maier. All rights reserved.)

PLATE 26. Chicago's Central Camera, still owned by the Flesch family, has been in business since 1899. The countermen here were the first to publicly recall Vivian Maier as a photographer. Maier frequented the shop for many years. (Photograph by the author.)

PLATE 27. Vivian Maier spent many days on this park bench by Lake Michigan near her apartment in Chicago's Rogers Park neighborhood. She sat on this bench so often and for such extended stretches that some of her neighbors thought she was homeless. (Photograph by the author.)

PLATE 28. Vivian Maier photographed newspapers in many variations, including in news-stands, in garbage cans, and, as here, within her living quarters. This contact sheet shows a roll of film that was devoted to articles in the *Chicago Sun-Times*, the *Chicago Daily News*, the *Chicago Tribune*, and the *New York Times*, illustrating stories from early 1974 related to the Watergate scandal, the national oil crisis, and local Chicago politics amid dappled sunlight. Maier did not develop this roll of film; it was purchased at her storage locker auctions and then processed and printed at a photo lab after her death. (Photograph from the Ron Slattery collection. Courtesy of the Estate of Vivian Maier © 2017 The Estate of Vivian Maier. All rights reserved.)

PLATE 29. (*top*) A selection of Vivian Maier's vintage prints of various sizes from the Ron Slattery collection. (Photograph by the author.)

PLATE 30. (*bottom*) "Official film spool used by Vivian Maier." Jenn Fletcher of Atlanta acquired this film spool, one of 326 that were offered as a Kickstarter fundraising incentive to help with the production of the film *Finding Vivian Maier*. The film spools had contained undeveloped film that Maier had left in her storage lockers. Ron Slattery acquired one thousand rolls of undeveloped film, then sold them to John Maloof, who developed them.

In the course of her seven years with the Raymond family, Maier's habits became more extreme. And those years—1967 through 1974—also saw acute societal shifts and a transformation of Chicago's Loop. Sexual mores became even more lax, street violence escalated, and other fears compounded when a recession and energy crisis hit. Television and Hollywood reflected the changing social landscape, leading to cries that they were causing more violence and crimes.

A building boom altered the face of the Loop, and Vivian Maier's photographs document the ongoing transformation. From the time she arrived in Chicago in the mid-1950s, Maier had a habit of snapping a picture from the window seat as her suburban train pulled into the rail yard.[106] Side by side, dozens of photographs show an evolving city skyline. The 1965 demolition of the massive nineteenth-century domed federal building and adjacent post office left an entire square block area in disorder for ten years. In April 1969, thirty buildings were in development or under construction, including the nearly finished hundred-story John Hancock Center. Dozens of businesses were eliminated or displaced during the ongoing disruptions that left pockets of ruins and the Loop in perpetual transition. And as urban crime skyrocketed, racial fears hastened "white flight," and downtown became deserted after dark.

In 1969, Vivian Maier's imagery also took a turn toward monotony. An April film reel carton shows that she took footage of State Street, and "aussi les gosses assez bon" (also pretty good kids).[107] But, later that year, among scores of undeveloped pictures, Maier shot two dozen photos aiming up at a dead tree, portraying its skeletal form in relief against the sky. The pictures were mostly blurry and improperly exposed; she scratched the date onto the 35 mm metal cartridge and set the film aside. The following day, she was downtown foraging for action in the rain: soggy newspapers filled garbage cans, union construction workers picketed, and a downpour soaked demonstrators at the trial for the Democratic convention insurgents.

For more than fifteen years, Maier had gravitated to the Loop's movie premieres, glittering marquee lights, and down-

town stage productions, photographing—and filming—from her seat. Vivian Maier frequented the Clark Theater, which screened art-house films nearly twenty-four hours a day. Its "Little Gal-lery for Gals Only" reserved a section of the mezzanine for women, who were also offered discounted seating on Wednesdays and Fridays. Maier had used the Clark's April 1968 film calendar as part of a still life that included her tax return from that year.[108]

In 1969, twenty-three-year-old Gene Siskel began chronicling the changing landscape of Chicago cinema for the *Tribune*. The number of X-rated movies rose along with the era's crime surge and contributed to the decline of downtown as a nighttime destination. In February 1970, Siskel noted "the number of sex and violence films that play downtown."[109] Weeks later, he referred to the movie he was reviewing as a "yawnful nudie," but he more vehemently objected to the venue: "I was annoyed with 'Female Animal,' but I was sickened that I was watching it in the Michael Todd theater."[110] The eleven hundred–seat playhouse, like other nearby movie palaces, could not sustain business otherwise.

Vivian Maier's 1970 film footage confirms the changing times, and her panning and zooming techniques divulge the subjects that grabbed her attention. After an establishing shot that draws across the Loop Theater's marquee lettering—"Restricted to Adults Only, Without a Stitch, in Color"—Maier stood on the sidewalk under the canopy and filmed men who stepped in to view the promotional photos. She panned with them as they perused the display, zoomed in on the X-rating sign at the cashier's booth, and then panned back to the men. Cutting, panning, and zooming, she ended the minute-long sequence with a close-up shot of the cashier counting dollar bills.[111]

Maier's filmmaking techniques, like her still photography, show hunt-and-snare methods. The Rolleiflex work maintains a consistent aesthetic in the way she tracked her sidewalk portrait subjects; and with that camera, she typically captured the most sharply focused results. Maier looked the most conspicuous with the movie camera shielding her face, but she could zoom

in on her subjects, a feature not available on her still cameras. Her moving pictures are jittery with quick cuts and pans, and the 35 mm slides and black-and-white images are frequently blurred. By the early 1970s, immodest fashions and public displays of intimacy attracted Maier's cameras as she zoomed in or followed those in tight clothes or short skirts or couples walking hand in hand. She still tracked women wearing fancy hats, but those subjects now appeared old-fashioned, as did Maier with her Rolleiflex.

Around this time, Maier mingled with a group of suburban teenage boys who likely asked to pose with her for a group portrait. She gamely handed off her Rolleiflex and stood pleasantly among them in her beret and trench coat. Several of the boys were flipping off the camera, though their hands were hidden from her.[112] She never developed that roll of film to learn of their joke at her expense. Even as she was becoming a figure of fun to some, she continued to take street portraits of people who looked "different." Stooped men and women, those who were exceedingly tall, short, or malformed drew Maier's attention. Most frequently, overweight people and women with distinctive legs initiated sequences of images. Strips of Maier's negatives show her following obese women in two or more frames, sometimes photographing while crossing the street as she drew in for a closer shot of their legs.[113] On the same film reel as the X-rated movie sequence, she zoomed in on a large woman in a yellow dress, and then panned down to her calves.

During the late 1960s and into the 1970s, garbage and graffiti permeated the landscape and populated Maier's pictures. The sentiments of the words and drawings further despoil their surroundings. A batch of negatives comprising nothing but pictures of garbage in the street, at curbside, and along sidewalks reads as an aesthetic inventory of the reasons people fled the inner city. Maier had always aimed her cameras into garbage cans, capturing poignant still lives that included abandoned baby dolls, dead flowers, and gloomy newspaper headlines, but widespread grime and unrestrained littering was a new phenomenon.[114] Similarly, in New York, where street photographers

had developed their vision, parts of the city became filthy and dangerous spaces that were captured by a younger generation of photographers, including Danny Lyon, who published *The Destruction of Lower Manhattan* in 1969; and Bruce Davidson, whose *East 100th Street*, a two-year project on one block in Harlem, was released in 1970.

By 1973, Gene Siskel reported that around two dozen downtown Chicago theaters were showing only sex movies. The Clark Theater succumbed to showing only X-rated movies in 1971, but Maier found other venues to suit her eclectic tastes in cinema. In October of that year, she was on the city's northwest side attending the packed American premier of a Polish movie; she shot the film's closing credits in color with her Rolleiflex.[115] In the summer of 1972, Maier was in another neighborhood photographing lobby cards for foreign movies that were playing on the Northwest Side.[116] Also in 1972, the School of the Art Institute of Chicago opened the Film Center, which screened movies of all sorts.[117]

In reflecting on Vivian Maier's employment with her family, the adult Inger Raymond relayed, "After she got done with supper, she would leave, and she would walk to this train station headed towards the Chicago area. That's all we knew. I never heard where she went. She never told anybody . . . and she would be very angry if we asked."[118]

2014: SIMPLIFYING AND COMPLICATING VIVIAN MAIER

John Maloof and Charlie Siskel's movie about Vivian Maier portrayed her story differently than the BBC production had. *Finding Vivian Maier* was told from Maloof's perspective and focused on his personal journey to learn about her through people she had worked for or crossed paths with. His interview subjects had seen Maier with her cameras, but they had never seen her photographs and could only portray her as a nanny, housekeeper, caregiver, or eccentric. Issues of class, work, and memory skew perspectives. Vivian Maier hid her rich life for reasons of her

own, and she also cultivated an air of inscrutability by evading personal questions, leading to speculation about her background and family. And yet her real family remained unexplored: for example, Maloof's team of genealogists had not found Maier's brother, Karl.

The dominant portrayal of Maier as a mystery woman characterized her desire for privacy as a one-sided nondisclosure agreement. Maier was the perfect subject for Maloof's detective story, which could veer toward fiction, as he explained: "Vivian is one of those people that becomes mythical. Nobody has moving footage with dialogue out there. Nobody knows her that well. There's a lot of room for the imagination to create who she was."[119]

Maloof simplified the tale of Maier's abandoned storage lockers, omitting mention of everyone else who had acquired her work and possessions. He eliminated the year and a half that had passed from the time of the auctions to her death and repeated the story of how he Googled Maier's name and found her obituary. To the uninitiated, Maloof appeared to be the sole owner and arbiter of Maier's legacy; the objects in his possession, including articles of Maier's clothing, confirmed his authority. But more than two tons of earlier auctioned belongings were unaccounted for, and materials from her extensive oeuvre were in other collectors' hands.

The distortions occurred on every scale. In 1957, Vivian Maier did detailed research for a trip to South America, and John Maloof owned her proposed itinerary. He therefore described the trip and showed some photographs that seemed to be from South America. But as we know, Maier never went on that tour. Conversely, Maier *did* travel to the subarctic a few months later, a trip Maloof's film did not represent.

Finding Vivian Maier was produced for a broad audience and was not meant to portray a complex subject with all her subtleties. It functioned well as a travelogue told from the perspective of a young man with a captivating story of an intriguing woman. And in January 2015, it was nominated for an Academy Award, carrying Vivian Maier full circle from a devotee of

motion pictures to the subject of a critically acclaimed movie. But the movie did Vivian Maier a disservice by not portraying her as a photographer above all else. The movie's presentation of its subject as an enigma was easily accomplished through interviews with people with whom Maier chose not to share of herself, and their lack of familiarity with her and her photographic work heightened the confusion. Unlike the BBC documentary, Maloof and Siskel's movie did not introduce anybody who knew Maier through her photography or through her passion for cinema.

The most troubling voice in the movie came from Carole Pohn, who knew Maier as an adult during the 1960s. Pohn and her five children lived in the same neighborhood as the Gensburgs, and Maier had once told her, without explanation, that she was "the only civilized person" in town.[120] Pohn's was one of few voices that suggested Vivian Maier would not have approved of the movie's investigation of her life, reiterating that she had been a very private person. Pohn was stunned by Maier's photography and seemed crushed that Maier had not shared the work with her because she thought they were friends.

Finding Vivian Maier was a box office success by documentary standards. The film grossed one million dollars in three weeks and was playing in ninety venues.[121] The critical consensus was overwhelmingly positive, but among the exceptions were three notable New York publications, all written by women. Madeline Coleman from *Aperture* suggested that Maloof and Siskel could have presented more photography background and said that they "devoted the majority of the film to often-damning first-person testimony from the photographer-nanny's employers." Yet "with a subject who knew it was all about context, the filmmakers owe her that much."[122] In addressing Vivian Maier's nonconformity with female norms of her time, *New Yorker* contributor Rose Lichter-Marck felt that the movie treated Maier unfairly: "*Finding Vivian Maier* shows that stories of difficult women can be unflattering even when they are told in praise. The unconventional choices of women are explained in the language of mental illness, trauma, or sexual repression, as symp-

toms of pathology rather than as an active response to structural challenges or mere preference."[123] Manohla Dargis, of the *New York Times*, wrote, "Vivian Maier is a find but she's also now a business, and the documentary would be stronger if it had dug into the complexities of what it means when one person assumes ownership of another's art."[124]

Jeffrey Goldstein took advantage of the new publicity around Vivian Maier. In the first eight months of 2014, he presented fourteen exhibitions of her work. In January alone, works from his collection were on display in three midwestern galleries. Soon thereafter, the Minneapolis Photography Center opened a permanent gallery, showing forty-five prints that it had purchased from Goldstein.[125] These works were also for sale, at prices between $2,200 and $4,500. The center also sold a poster of Maier's work and a fifty-page catalog of its collection.

That summer, four exhibitions from the Goldstein collection were displayed simultaneously in the Chicago area, including at the school where former students had developed Maier's film, the downtown branch of the Chicago Public Library, and the history museum, which was now into its third year of *Vivian Maier's Chicago*. Goldstein also announced a new book of photographs, *Vivian Maier: Eye to Eye*, featuring photographs of people looking at Maier's camera.[126] The book title is misleading because Maier's lens was held at chest level, but the chosen photographs were indeed portraits made with their subjects' consent.

In July, an article appeared in the UK's *Independent* that described the roles of Ron Slattery and Randy Prow.[127] Since neither man appeared in *Finding Vivian Maier*, the reporter wrote, "This has left Mr. Maloof facing accusations of airbrushing them out of Maier's fascinating story—and, after Mr. Maloof also refused to appear in the BBC programme on Maier last year because it clashed with his own movie, glorifying his own role as sole 'finder.'"[128] John Maloof had so successfully packaged his version of the Vivian Maier story that the idea that more people had been involved with Maier's "discovery" seemed like big news, and the story soon spread to other venues.[129]

Back in Chicago, the *Reader,* a weekly newspaper, ran an article that credited the Maier sensation to her photographs and the story of discovery—but "it has also been fed by the divided ownership of her work, which is largely in the hands of two private collectors who function—sometimes collaboratively, sometimes in competition—as high-voltage publicity machines."[130] The writer, Deanna Isaacs, implied a sullying effect by adding, "Both are issuing posthumous limited edition prints from her virgin negatives."[131] She also parenthetically mentioned that Maloof and Goldstein had acquired copyright from one of Maier's heirs.

A week before Isaacs's article hit the Internet, one of the earliest Vivian Maier bloggers and champions, Blake Andrews, posted a snarky piece about how he broke the law the previous day by putting a Maier photograph on his blog. He had discovered that Maloof had asserted copyright and was prohibiting reproduction of his Maier images: "The photographs may not be reproduced in any form, stored or manipulated without prior written permission from the Maloof Collection."[132] Andrews acknowledged that he had not gotten permission from Maloof but added, "I don't really give a shit and here's why." He then listed three ways of legally sharing images on the Internet: he linked back to Maloof's website, had used the image for secondary purposes, and didn't represent the work as his own.[133] Andrews ended his post, "I think I've taken proper steps to cover myself. After all, it's not as if I just found an old photo in storage, attached my name to it, claimed all rights, and sold limited editions of that photo for thousands of dollars. I could see how that might raise questions. But I'm not doing that so I should be covered."[134]

Once Andrews discovered that Maloof had not simply asserted that he owned copyright—rather, he acknowledged he had acquired copyright from a Vivian Maier heir—Andrews posted another blog piece noting this, as well as that the media had always reported that Maier had no heirs. He ended his piece, "The fact that she died with no heirs feeds into the romantic fable. But as with all romance, the initial blush is beginning to

wear off. What else might there be underneath?"[135]

Deanna Isaacs then published another article, this time about the Ron Slattery collection. In 2012, Slattery's only foray into exhibiting his vintage Maier prints had resulted in damage to the photographs, and he was suing the gallery for compensation. The lawsuit contended that fifty-six prints, which had been priced between $5,000 and $6,000, were incorrectly mounted and stored, leading to severe damage of the entire lot. Isaac reported: "Slattery is seeking $200,000 for damages to the value of the photographs in the show and another $2 million in punitive and indirect damages to the value and marketability of the rest of Slattery's Maier collection."[136]

Conversations, blog pieces, and newspaper articles kept coming.

Some began to discuss judgments of taste and the watering-down effect of all the exhibitions. Would tighter editing represent Maier better? Or was she not really that good? One writer called the saga "The Vivian Mire."[137]

1974: THE END OF ANOTHER ERA

Vivian Maier witnessed the era's changes through the mask and filter of her cameras and lenses. America's involvement in the Vietnam War ended nearly simultaneously with the collapse of a presidency. The televised Watergate hearings brought spying back into vogue. Cataclysmic and nightmarish films, including *Earthquake*, *The Towering Inferno*, and *The Texas Chainsaw Massacre*, became mainstream fare. The *Los Angeles Times* reported the results of a far-reaching mental health study: "The energy crisis is putting Americans under stress that has caused increased fears, frustration, violence, alcoholism, drug abuse, escapism, and sexual promiscuity."[138]

Vivian Maier maintained a degree of detachment through her documentations, but she also appeared purposeful when she showed up with her camera at events, including talks at the Moody Church on the near North Side and various rallies for social causes. Over the years, as society became more casual

and disorder came to dominate, Maier transitioned from a compositionally aware square-format photographer who homed in on the theater of the street, to one who recorded as much as she could of her swirling surroundings. The tens of thousands of undeveloped Rolleiflex images left latent evidence of her routines, even as many color slides faded to oblivion.[139]

Maier was a regular attendee at public lectures at Northwestern University's Africa House, the headquarters of the African studies program. From 1969 through 1972, she photographed more than a dozen sessions from her seat in the middle of the classroom.[140] She also hung out at the university's foreign language lab and attended other campus lectures, movies, and theatrical productions. In December 1973, Maier was among a crowd at DePaul University, where she recorded silent movie footage of a rally hosted by oral historian and radio personality Studs Terkel, who was well known for his books based on tape-recorded on-the-street interviews.

Maier also made audio recordings, questioning strangers in public spaces in the manner of a journalist. During the Watergate hearings, she asked a man she knew named Carl if he "had anything to say about all this political scene." Carl's tepid response, suggesting that things happen for the good of the country, provoked Maier's own stronger opinion: "And maybe this should be a warning for future politicians." Unlike Studs Terkel's gentler, open-ended approach with his subjects, Vivian Maier inserted her own opinions or seemed to expect more than what her interviewees offered. Maier stopped a young woman and asked what she thought of the Nixon impeachment, quickly adding, "Well, come on." The woman inquired whether she was being recorded and replied that she didn't know, which led to Maier's reprimand, "Well, you should have an opinion. Women are supposed to be opinionated, I hope. Come on." The woman laughed out of nervousness, or perhaps at the absurdity of the questioning by the insistent woman with the tape recorder.[141]

Vivian Maier's multimedia documentation of her rich and busy life creates a chronology of her journeys and habits, and culled still images show recurring themes. Maier's photographs

of her personal documents also present evidence of her life's journey: pages from her passport detail an entire year's course of travel; correspondence and bank books depict her finances; tax forms show her income; and a medical prescription reveals her transition into menopause.[142] In addition, Maier showed herself via the kinds of elements that consistently caught her eye: the narrow space between buildings, shadows on walls, the silhouettes of trees, and patterns of fallen leaves. She could hardly resist capturing her own form in shadow and, always, as the serious photographer in mirror and window reflections.

Vivian Maier's world took a radical turn in 1974 as Inger Raymond, then twelve, was no longer in need of a full-time nanny. Moreover, her family was planning to move out of state. Inger had accompanied Vivian Maier on many of her photo safaris ("when we'd go on our walks, she'd take me all over the place"). She sometimes appears in a single frame on a roll of film that shows the city streets, which reveals that she'd been with Maier all along. She later portrayed Maier as a sort of photography teacher: "She told me about the importance of the contrast between dark and light."[143] Sometimes Maier would let Inger take a picture with her Rolleiflex, but she wasn't a very patient teacher: "She wanted that focus of that camera just so. And she'd be frustrated because she didn't think I could get it to the point where she wanted it." The concept of "focus" extended to the act of picture taking, which Raymond pantomimed as she explained, "When she took her photos, she would be completely and utterly focused . . . it was . . . instant . . . concentration . . . then it would be done."[144] As the Raymonds prepared to vacate their house at the beginning of August, forty-eight-year-old Maier went about organizing her own transition by photographing some of the newspapers that she'd collected. Collages laid out on the floor show headlines with no obvious threads but give a sense of Maier's accumulating habits. In different patchwork combinations, the *Chicago Tribune*, *Chicago Sun-Times*, *Chicago Daily News*, and the *New York Times* quilt the floor, with stories redundantly overlapping or arranged in seemingly random juxtapositions. The selected newspapers were from two months

earlier, the previous spring, and each of the five previous years. One *Tribune* dated back to July 23, 1965.[145]

In this same period, Vivian Maier recorded the yard sale of Inger's used toys and games, the removal of furniture, and a view of the Raymond house with its For Sale sign that had been slapped with a Sold banner. Maier also photographed the dock of the Iredale Storage & Moving company warehouse, which held more than two dozen boxes at the foot of the loading platform; a vintage travel trunk covered in stickers stood upright in the open freight elevator.[146]

+ + +

By September, Vivian Maier had moved in with an elderly couple who lived in a high-rise apartment overlooking Lake Michigan in Wilmette. Maier shot color slides of her narrow room, which she had decorated with pictures and a small collection of quartz rocks.[147] On a round table at the corner by a window, a cluster of eight antique box cameras and an 8 mm film projector surrounded a table lamp. Full shopping bags and boxes sat in a mass hidden partially behind a TV set on a rolling stand. Shelves with books lined one side of the room. Scores of books were stacked in the same way that she had placed some in her bathroom darkroom at the Gensburgs' house: on their sides with the spines facing the wall, keeping the titles hidden. On the other side of the room, three 1950s-era suitcases stood next to a bookcase loaded with old magazines. Above the suitcases and bookcase, a framed lithograph of a woman in profile hung alongside one of Maier's enlarged photographs from 1950s' New York depicting two old women in fancy hats talking to a uniformed park attendant.[148]

Eleven large framed pictures—and one painting—lean against one another at the foot of one of the bookshelves. Only the front two pictures are visible: an enlargement of one of Maier's French landscapes and a self-portrait by German artist Käthe Kollwitz. Maier had purchased the reproduction in 1971, when she also photographed the emptied frame package

on a garbage can lid.[149] Käthe Kollwitz made more than one hundred self-portraits during her sixty-year career. They are a fair parallel to Maier's: "Even in youth, the artist looks serious, prematurely old. Thus her outward appearance does not change as much as one might expect. . . . Kollwitz's self-portraits depict a constant, unwavering state of inquiry: a searching, rather than a finding; a questioning, not an answering."[150]

Vivian Maier lasted less than a month at the high-rise apartment, though she made portraits of her male employer reading a newspaper and his wife writing at her desk; she also photographed some of their belongings, including framed family photographs and more than one personal document. The last series of slides from this brief interlude shows a still life arrangement spread out on a lawn: Maier's handbag, some money fanned out and held down by a stick, an envelope, a couple of small notes including a scrap of paper that says "your second week," and a more extensive written message that began and then disappeared into a fold: "Dear Miss Meyer, I am sorry to let you go—but I think you will be happier where you . . ."[151]

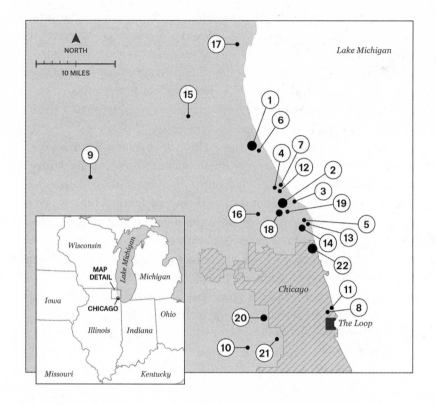

Vivian Maier's
CHICAGO-AREA
RESIDENCES

- • Indicates one year or less at this location
- ● Indicates one to five years at this location
- ⬤ Indicates five years or more at this location

1. Highland Park (1956-1972)
2. Wilmette (1967–1974)
3. Wilmette (1974)
4. Winnetka (1975)
5. Evanston (1976)
6. Highland Park (1977)
7. Winnetka (1978)
8. Chicago - Near North Side (1979)
9. Barrington Hills (1979)
10. Riverside (1980)
11. Chicago - Gold Coast (1980)

12. Winnetka (1980)
13. Evanston (1981)
14. Evanston (1982–1985)
15. Vernon Hills (1986)
16. Glenview (1987)
17. Waukegan (1988)
18. Wilmette (1989-1993)
19. Wilmette (1993)
20. Oak Park (1994–1996)
21. Cicero (1997)
22. Chicago - Rogers Park (1998-2008)

FIGURE 4. Vivian Maier's Chicago-area residences

PART 4

THE AFTERMATH

Chapter Eight

The Missing Picture

VIVIAN MAIER'S LAST THIRTY YEARS

After Vivian Maier left the Wilmette high-rise in late 1974, she soon settled in nearby Winnetka, where she was hired by the television talk-show host Phil Donahue as a live-in housekeeper. Donahue was a newly single parent with four sons; the youngest brother was a preteen. The boys were evidently not charmed by Maier; she stayed with the family for less than a year.[1] By 1976, Maier, then fifty, was residing five miles south in Evanston, where she worked within a household that included a disabled woman and her four children.[2]

On April 6, 1976, Maier tested a new tape recorder by chatting with the woman, asking her mock-seriously to state her name and age and, later, going out of her way to record the date. Maier had recently seen the Rudolph Valentino movie, *Four Horsemen of the Apocalypse* at Northwestern University, and she was heading next door to record a neighbor who claimed to have once met the matinee idol. Maier set the tone by referring to her subject as "this lady"—and the neighbor played along during her story by intoning, "as the speaker just said," as if they were broadcasting to an audience. Again, Maier dominated the conversation.[3]

The two women dished on Valentino's appearance, but Maier interrupted her interviewee's low opinion of Valentino's looks with her impression of Douglas Fairbanks, whom she called "almost ugly." Returning to Valentino, Maier relayed obscure biographical details before she turned back to the woman's story and then interrupted again to share more particulars of Valentino's life, including innuendo about his homosexuality. Maier said that she thought Valentino had "savoir-faire and savoir-

vivre," setting him apart from other men "who were uncouth at that time, and are still uncouth today, in my estimation."

The woman interjected a tidbit about Valentino's movie *The Sheik*, which led Maier to give a history lesson about Northern Africa. The conversation meandered with Maier drifting back to Valentino's early death and funeral: "It was a circus in New York, from what I understand, at the funeral parlor." Maier did not mention that her grandmothers, Marie von Maier and Eugenie Jaussaud, had both been laid out at the same funeral home, but she did discuss how they bury the dead in Italy.

In the course of the fifteen-minute recording, Vivian Maier mentioned that she'd lived in Los Angeles—calling it a hick town, and also stating that it was a "dreadful place" for the poor—said that New York was "a fabulous place," where one could go to Harlem to see a movie in an air-conditioned theater, and declared, "New York is Europe, Asia, America, it's everything." The conversation demonstrated Vivian Maier's worldliness and her love of New York, as well as her knowledge of history, the stage, and cinema. Maier also disclosed an aspect of her photography habit by referencing that day's front-page story about the death of millionaire Howard Hughes: "I wanted to take a still life of that with my camera, but I had just taken my last picture, so I haven't been able to do it yet." The woman laughed as if Maier were joking.

At the end, Maier waxed poetic: "Well I suppose nothing is meant to last forever. We have to make room for other people, it's a wheel: you get on you have to go to the end and then someone else has the same opportunity to go to the end, and so on, and somebody else takes their place. There's nothing new under the sun."

Vivian Maier stayed at the Evanston home for less than a year, while most of her possessions remained in storage at the Iredale warehouse. The next few years included a stint as a nanny for at least two more North Shore families; one employer had to let Maier go because she felt that the volume of newspapers Maier had collected in her room was a fire hazard. She also never saw Maier with a camera, but John Maloof's collection

contains pictures of the woman's children, suggesting she wasn't especially familiar with Maier and her habits.

Vivian Maier's collecting and stockpiling also led to an accumulation of correspondences, receipts, and photofinishing envelopes that show us her whereabouts even as her undeveloped film accumulated. Throughout the late 1960s and 1970s, as Maier moved around the northern Chicago suburbs, various labs developed her film and enlarged some of her color work: Glencoe Camera, Powell's of Highland Park, Wilmette's Lyman Sargent's, Phototronics in Winnetka, and from Evanston, Je-Ron Camera Shop and Hoos Drug and Photo. Their envelopes show Maier's various addresses along with comments and instructions for enlargements. Printing orders clearly demonstrate Maier's preference for matte-surface prints, and variations of the comment "nice work appreciated" seem like a directive from Maier herself. Notes also show that she sent work back for reprinting. She stored some color prints in three-ring binders.[4]

Pat Velasco worked at Hoos Photo Center from 1967, when he was nineteen, through 1977, when he switched to Phototronics in Winnetka. Vivian Maier often shared her photographs with him.[5] She was strictly business, dropping off film and asking technical questions. Velasco saw her pictures of streets and portrait subjects in neighborhoods that he felt were "unsafe," and he was afraid that Maier would get mugged, or worse.

Maier sometimes brought her cameras in for repair. Once Velasco sent both of her Rolleiflex cameras out; one had been dropped in sand at the beach and the other had gotten wet. He said Maier was nearly in tears, and during that time, she used her Baby Rolleiflex, a scaled-down version that took a smaller format film. But she found that camera frustrating and stopped shooting with it after fifteen or sixteen rolls. Velasco suggested that Maier's "big catastrophe in life" occurred in the late 1960s when the lab that Hoos used to develop film stopped cutting the rolls into sections and instead returned the Rolleiflex negatives in a rolled-up strip with eight-by-ten-inch contact sheets. She was upset by the change in the way things had been done. Maier also received small black-and-white prints of these negatives as

part of the processing. No contact sheets or other prints have surfaced from this period of Maier's photography.

Pat Velasco didn't see Vivian Maier with a Leica camera, but she used two separate models for self-portraits from the early 1960s through the 1970s: first, one that was manufactured in 1950 and, later, an early 1930s model. Don Flesch, who saw Maier as far back as the 1960s when he was a teenager working at Central Camera, once gave her a vintage Leica camera as a gift, which he said thrilled her.[6] The black Leica model that he referred to matches the camera that Maier held in her self-portraits from the mid-1970s through at least 1986.[7]

Vivian Maier's last known Rolleiflex photographs date to the mid-1970s, the point at which John Maloof has implied that she switched exclusively to thirty-five millimeter.[8] But people who knew Maier in the 1980s and even into the 1990s remember her with a Rolleiflex slung around her neck. It seems likely that she continued using the camera with which she took to the streets in 1952; and it seems equally likely that those negatives or undeveloped film rolls have disappeared into a landfill or are in the hands of someone who doesn't know what they are.

In late 1978, Maier left the suburban North Shore for a job in a stately walkup in Chicago's elegant Gold Coast neighborhood. During the first week of February 1979, she received a letter there warning her that the contents of her Evanston storage locker would be auctioned off the following month if she didn't pay her outstanding balance.[9] Maier paid up, leaving her possessions there. By the middle of March, she was living forty miles away in the village of Barrington Hills, known for its sprawling horse farms and widely spaced houses. Maier could hardly have been more removed from the streets of Chicago. In 1980, Vivian Maier lived in the western suburb of Riverside. She came back to the Gold Coast to work in a vintage high-rise apartment, but by the end of the year, she had returned to Winnetka. She had moved more than ten times during the previous six years.

Late in the summer of 1982, Curt and Linda Matthews, parents of two young children and a five-month-old baby, responded to an ad that Maier placed in an Evanston newspaper. Maier

arrived at their door looking like a character from an Edward Gorey book, in "black Oxfords and a black skirt, black jacket and wide-brimmed black hat."[10] Maier stayed with them for three years, her longest period of employment since looking after Inger Raymond. The Matthewses soon realized that Maier was more a photographer than a nanny: "She was businesslike and usually competent, but our children knew she was much more interested in taking photographs than she was in them."[11] Maier once wandered off with her camera while out with the children, leaving them to make their way home on their own.

Vivian Maier arrived at the Matthews home with only a few suitcases and boxes, but she proclaimed that she had "12 broken Leicas in storage, valuable to anyone who could afford to fix them."[12] Maier's attic room was a secretive place, and she asked Linda Matthews to install a lock on the door—a common request of hers. Maier again accumulated and stacked so many newspapers in her room that a narrow path through it was all that remained.

In 1985, when the Matthews family no longer required Vivian Maier's services—they later implied that Maier's eccentricities had become unsettling—Maier placed another ad.[13]

EXP. MIDDLE-AGED European
woman looking for live-in situa-
tion w/children or elderly, $220
per week. References. Write:
G-589, Box 10, Wilmette 60091[14]

A woman offered Maier a position living with and caring for her elderly bedridden aunt. Maier did not take the job, but she took notes on prospective employers, listing children by ages, along with comments and impressions.

In 1986, after briefly caring for an elderly man in Evanston, Maier arrived in the northern suburb of Vernon Hills, where she moved in with a family in which the father was French; they lived at the end of a cul-de-sac in the ten-year-old Indian Creek

development. Maier had just turned sixty and was as confident as ever. During her interview, asked why she'd want to work for them, Maier replied, "because I've worked with the old rich and I want to see what it's like to work with the new poor." Aghast but amused, the prospective employer told Maier that she'd hire her because she "didn't think her husband would run off with her."[15] And thus began a friendly working relationship.

The employers were out of town when Maier moved in, and she reportedly "forgot" to tell them about the possessions that she was bringing along. Evidently, Maier hired someone to haul all of her boxes from the Evanston storage warehouse to her employers' home. They returned to find their garage filled, five boxes high and three boxes deep. Maier had also requested a specific kind of bed with a mattress of cotton ticking, but after it arrived Maier informed her employers that they had purchased the wrong kind. Somehow, the new help had taken over the household; the bed was replaced. The mother of the family trusted Maier and always felt that her children were safe with her; she accepted Maier's quirks and eccentricities as part of who she was.

Vivian Maier was soon comfortable and tolerated by her employers. Vernon Hills was not within walking distance of the train or shopping areas, so the mother would drive Maier to the local photofinishing lab, where she'd wait in the car until Maier returned, often furiously suspicious that the workers had looked through her photographs. One time, while Maier was with one of her charges at a ballet lesson, she was mistaken for the girl's grandmother. Maier made a scene, angrily stating that she was "a virtuous woman." As others would also suggest, the mother was certain that Maier was asexual.

Vivian Maier would lock herself into her room, again filled with books and newspapers. The family would sometimes hear "hoots of laughter" as she read her various materials. Maier traveled often to Evanston for Northwestern University theater productions. In July, she told her employers that her absolute favorite play, Moliere's *Tartuffe*, was being performed there, and that they must see this production of it. She went on to such a

degree that they relented and bought tickets, ultimately not feeling the same as Maier.

Some of Maier's habits changed a bit with this family. Maier insisted on watching the public television program *Wall Street Week* with Louis Rukeyser on Friday evenings, and she always read the *Christian Science Monitor.* Curiously, Maier adamantly refused to have her photograph taken, turning or covering her face if a camera seemed to point her way. The family has a snippet of video that shows Maier noticing the camera and then turning away and leaving the frame. By then, Maier had also stopped carrying around her motion picture camera, after more than twenty years of recording on hundreds of reels of film.

Maier's stay in Vernon Hills ended as the family prepared to move out of state. Before she left, she made a self-portrait in the mirror of her bathroom: appearing as the embodiment of a camera or as a spy, Maier's identity is obscured by her pulled-down red felt hat and a black coat she holds closed with one hand; her black Leica camera covers her face. In another photo, she laid the coat and hat out on the veranda as if she were lying flat on her back and recorded her presence as if in a chalked-out crime scene.[16]

Vivian Maier moved on to be a nanny for a family in Glenview, another northern suburb. Upon her hiring, Maier confided to her employers, "I have to tell you that I come with my life, and my life is in boxes."[17] Still, they were taken off guard when she arrived with two hundred boxes, which they stored in their garage. Maier stayed with them for one year, and as at her previous stop, she left the boxes untouched.

In 1988, Maier relocated to the city of Waukegan, forty miles north of Chicago on Lake Michigan, and she transferred her boxes to a $70-per-month storage locker in a warehouse in the nearby village of Gurnee. The boxes remained there through the following year when she moved back to Wilmette, into the home of Federico Baylaender, across the street from a park by the beach where she had spent summers with Inger Raymond twenty years earlier. Maier stayed with the Baylaenders for nearly four years, occupying her days with Federico's develop-

mentally disabled teenage daughter and returning to her city travels during evenings and her time off. While living with the Baylaenders, Maier often left the house on Friday with her Rolleiflex dangling from her neck. She'd be carrying shopping bags filled with clothing and other personal items and sometimes did not return until Sunday. (She had done the same in Vernon Hills.)

Federico's son, Richard, remembers Maier as being very opinionated about every subject and having extended conversations in French with his father over the dinner table.[18] She could also be very abrupt, hanging up the phone without saying good-bye, and was generally dismissive with people. But Baylaender said that Maier was very good with his younger sister; they would draw or paint and play games and take walks. He said that she acted differently with his sister than she did with adults. Maier shopped in second-hand stores, and she would often also buy clothes for the girl. Baylaender said that he would sometimes find his sister looking like a "mini-Vivian," which was disconcerting.

While living with the Baylaenders, Maier moved her possessions from Gurnee's Safe Self Storage to the Hebard Storage warehouse on Chicago's North Side.[19] Maier evidently brought with her or accumulated more boxes that went into her employers' basement, but the hundreds of boxes that reportedly filled the garages of previous employers somehow made it to Hebard Storage, where they would remain until they were dispersed nearly twenty years later.

Vivian Maier left the Baylaenders in 1993 and then worked a short time for another Wilmette family. In January 1994, she arrived at Judith and Charles Swisher's home in the western suburb of Oak Park, where she cared for Judith's elderly mother. Judith thought seventy-year-old Vivian Maier had "a wonderful humor . . . a warmth about her . . . she really did care about people."[20] Maier never discussed photography during her three years with the Swishers, but she did often talk about cinema. At one point, Maier gave them a list she had put together of obscure films that she suggested was a must-see catalog of the best movies ever made.[21]

But Maier also lingered in the house (even after Judith's mother had transitioned to a nursing home), refusing to allow realtors in to show the home to prospective buyers. She stayed in what may have been her last job until the end of 1996. There, Maier continued a practice that she had begun in the mid-1980s, or earlier, of cutting out seemingly random newspaper articles and inserting them into clear sleeves in three-ring binders. The Swishers had been spared the hundreds of boxes, then in multiple lockers at Hebard Storage, but Maier filled the Swishers' screened-in porch with more boxes of items—including the binders—that she'd acquired.

Maier paid her storage locker bills with money orders, the receipts for which she saved along with other miscellaneous paper remnants that she also sometimes photographed. These show her moving transitions, purchases, and income tax payments. As she had in the past, she corresponded with the Internal Revenue Service in late 1989—seemingly because she had overpaid her taxes—sending them copies of her money orders from that year's tax return and photocopying that letter before mailing it. She did receive, but never cashed, subsequent tax refund checks.[22]

Vivian Maier long had been concerned for her privacy. But as Maier aged, she evaded personal questions altogether in some circumstances, refusing to give her full name or using aliases with business owners. At an Evanston antique shop, when Maier put items on layaway—political buttons and costume jewelry— she gave the name "Miss V. Smith."[23]

Her paranoia grew, echoing that of her French grandfather and that of her mother. She once told an Evanston bookstore owner that she thought her employers were going through her belongings and that she had arranged things in her room so that she could tell if they had been moved. He also said that she thought people were using binoculars to look into her room.[24]

During the period when Maier's troubling tendencies deepened and her behavior grew more extreme, she was regularly attending movie screenings at the Film Center at the Art Institute. She escaped to the stage and the cinema, especially when

she could no longer travel the world as she had. It was in this time that Jim Dempsey, the house manager at the Film Center, first encountered Maier. He knew her as an eccentric old woman dressed in old-fashioned clothes, complete with a floppy hat and a vintage camera. Dempsey thought the camera was part of that costume.[25] Dempsey's not sure why Maier was drawn to him, but he is easygoing, is quick to smile, and was a consistent presence at what was likely her favorite regular destination. Dempsey sometimes saw Maier once a week, and they had many conversations over the years. His staff avoided Maier, and they jokingly referred to her as Frau Blücher, the comically bitter old woman in Mel Brooks's *Young Frankenstein*. She never told him her actual name.

Maier devoured films, taking in everything, reminiscent of the way that she hoarded newspapers and also her own images. She had not developed film that comprises one-third of her life's known works.[26] Dempsey saw her walking through downtown Chicago, always carrying two heavy shopping bags filled with newspapers, magazines, and other items. She was carrying a Rolleiflex, and her attire seemed to date from the 1950s, the height of her creativity. Now, however, Maier could seem rootless, with only the weight of her photographs keeping her planted in the world.[27]

Those Who Did Not Know Her

Vivian Maier did not share her life story with her employers or any of those who have represented her, but she did portray herself in ways that provoked others' depictions. Always independent, always moving through the world, she invented herself—and then was reinvented through selective presentations of her photography and representations by people whose paths she crossed. Maier came into the world as part of a family that nearly immediately broke apart. At the end of her life, a similar outward spread of her innumerable possessions landed all over the world.

As Vivian Maier was beginning a downward spiral in the mid-1970s, the members of her family lived out their own isolated lives. By 1977, likely unknown to her, Maier was the sole remaining member of her immediate and extended American family.

Vivian Maier's father, Charles, died at the age of seventy-five in 1968, within weeks of the death of his second wife, Berta. They had been married for thirty-four years and had lived in the same house in the Richmond Hill neighborhood of Queens, New York, for more than two decades. In the summer of 1964, Charles Maier had drawn up a will that left everything to Berta. It also acknowledged his first marriage and his children in a way that reveals their estrangement and makes clear his intention that they not receive any of his assets. He wrote: "I have made no provision for my children, CARL and VIVIAN, for the reason that I have not seen them in many years, and that they have not been close to me." He further stated: "I make this will with

the understanding that my first wife, MARY [*sic*], whom I have not seen in over thirty years divorced me in France, many years ago."[1] An earlier story relayed that he had obtained a divorce from his first wife in Mexico, raising the possibility that they had never legally separated.[2]

Charles Maier's sister, Alma Corsan, living on Park Avenue on Manhattan's Upper East Side, also drew up a last will and testament. In 1958, she made arrangements for her estate, which was worth around $150,000 ($1.1 million today). Alma's will expressly left everything to her husband, Joseph, and specified that if he died first, her assets would go directly to "the United States." She deliberately excluded her birth family, adding intrigue to her directive: "I make no provision for any of my relatives for reasons best known to me and which I have disclosed to a few of my most intimate friends."[3]

After Alma died in 1965, Joseph Corsan and his attorney were the only attendees at her funeral and interment.[4] Joseph had her body placed in a crypt in the Shrine of Memories mausoleum at Ferncliff Cemetery in Westchester County. In the graveyard's main mausoleum, Vivian Maier's paternal grandmother's remains already laid within an elegant columned alcove, behind an engraved white marble panel that read, simply, "Marie Von Maier 1860–1947."

Joseph Corsan died in a residential hotel in Atlantic City in 1970. He had left his Park Avenue apartment and, over the previous few years, had also lived at the Biltmore Hotel in Manhattan. His estate was valued at $250,000. He left $10,000 each to four New York organizations: the Lutheran Church in America Foundation, the Federation of Jewish Philanthropies of New York, the Lenox Hill Hospital, and the Washington Square Home for Friendless Girls, which served unwed mothers. He left the remainder of his estate to friends and members of his family. Joseph and Alma Corsan never had children.[5] They lay side by side in a top vault along a long corridor of crypts stacked seven high; mismatched and missing letters from their names show years of neglect.

Vivian Maier's brother Karl—also known as Carl, Charles,

sometimes Charlie, and under the alias William—died at the age of fifty-seven in 1977, at the Ancora Psychiatric Hospital in New Jersey. He was among the first patients to enter the facility when it opened in April 1955, just as Vivian was preparing to leave Stuyvesant Town on her trek to Los Angeles.[6] In 1967, as part of a deinstitutionalization movement, Karl Maier was released to a nearby boarding house. He applied for Social Security, and the owners of the home used his disability check as his room-and-board payment. Such houses soon became notoriously exploitative "psychiatric ghettoes," and this one was said to misuse patients' funds.[7] Karl Maier returned to the Ancora Psychiatric Hospital in 1975. He is buried in a small cemetery on the densely wooded hospital grounds along with several hundred other patients who died there over the past four decades, forgotten, shunned, or unclaimed by their families. Among the rows of concrete coping, Maier's simple bronze plaque reads, "Carl Maier 1920 to 1977."

Vivian Maier's mother, Marie Jaussaud, remained in Manhattan for the rest of her life, ending up within blocks of where she lived before she married Charles Maier in 1919. She never remarried after their 1926 separation at the birth of their daughter, Vivian. Jaussaud died in 1975 at the age of seventy-eight while she was a resident of the Endicott Hotel at Columbus Avenue and West Eighty-First Street. Once elegant, the Endicott had become a decrepit and infamous welfare hotel, well known for a series of murders in 1972 and 1973 that provoked headlines of the sort that her daughter cultivated: "Two Women Slain in Hotel Stabbing"; "4th Slaying Victim Is Found in a Hotel"; "After 4 Hotel Slayings, Fear Stalks All Rooms"; "Man, 63, is Slain; 5th Murder Victim in Hotel in a Year."[8] The first two murders had been a double homicide on the floor where Marie Jaussaud lived.[9]

In 1975, as crime and filth permeated the streets, and welfare and single room occupancy hotels dotted Manhattan, the four hundred–room Endicott was singled out for its squalor. Two months before Jaussaud's death, a television news reporter presented "Room 550: Diary of an SRO Hotel," the culmination

of his undercover study of the Endicott: "For nearly a month (at a rate of $39 a week), Mr. Gonzalez lived in a smelly, roach-infested room at the Endicott, a once-luxurious, now dilapidated hotel. . . . The hotel was singled out 10 years ago as a haven for drug pushers."[10] Things hadn't changed much but seemed to have become worse.

Marie Jaussaud died on June 28, during the summer that her daughter Vivian was living in the North Shore home of Phil Donahue, and her son Karl was transitioning back to the Ancora psychiatric facility. Because Jaussaud died alone in a New York public hospital, officials searched her room for information about her estate. Nothing was found that connected Jaussaud with any family members.

Marie Jaussaud was buried in a pauper's grave on Harts Island, and her estate was assigned to a public administrator to inventory and distribute. Jaussaud had funds in two banks and received a Social Security death benefit, together totaling $1,491.67, which was mostly used to pay for her funeral, hospital, and court costs; the remaining balance of $291.29 was held for four years until it reverted to the state: "The decedent herein died on June 28, 1975, and to date no proofs of kinship have been submitted to your petitioner nor have any claims of alleged kinship been made."[11]

During the four years Jaussaud's estate remained in probate, her son died and her daughter worked in at least six different households. Jaussaud and her children had likely not communicated for more than twenty years. For Vivian Maier's remaining thirty years, she was her American family's sole survivor. The shame associated with illegitimacy and mental illness permeates the family's legacies.

+ + +

When Vivian Maier arrived in Chicago in 1956, she began a new life. A photographer who also cared for children within households far more privileged than her own, she deleted her family history and selectively, sometimes imaginatively, addressed any

questions about her past. Would families have trusted Maier in their homes if they had known her brother was in a psychiatric hospital? One employer who had young children confessed that had she known, she would likely not have hired Maier, justifying Maier's secrecy.

Less dramatically, Maier told Linda Matthews that she worked in a sweatshop when she had arrived in America from France as a girl.[12] That eliminated her pre-France New York years and explained her lingering accent. But Vivian Maier had arrived back in New York in 1938, when the garment industry had become tightly regulated, and on the 1940 federal census her mother said fourteen-year-old Maier was still attending school—though she might have been lying. Three years later, while living in Queens, Maier filed a Social Security application that revealed she worked in a doll factory on East Twenty-Fourth Street in Manhattan. Maier may have been cutting and sewing, but the fabric would have been for miniature clothing.

Maier's photographs, which divulge her passion and reveal a rich life beyond her domestic jobs, were also largely mysterious to her employers and their children. Maier's camera was ubiquitous, but nobody knew about the scope or content of her photography. In those days before social media, they didn't seem threatened by the possibility that Maier was recording their activities. Vivian Maier came of age during an era of real espionage scares, with Communist threats generating suspicions and leaving people mistrustful of each other. Maier told at least one person that she was a "sort of spy," which every good street photographer should be. Yet she herself resisted having her likeness recorded on film by others, even while she continued making self-portraits.

Vivian Maier was secretive even about her name. She was particular, but unpredictable, in how she chose to be identified. The Gensburg boys and other Highland Park children called her Vivian, but Inger Raymond always called her Miss Maier: "That was what she wanted me to call her, or my parents. Never Vivian, and she would take your head off if you used anything else."[13] Camera shop counterman Pat Velasco called Maier "Viv-

ian" once and was corrected to say, "Miss Maier," and the same was true for Phil Donahue. In the Matthews household, everyone called Maier "Viv," though the use of that diminutive is incomprehensible to every other person who crossed paths with Maier. Maier did tell the very young daughter of a subsequent employer to call her Vivian, though the girl always pronounced it "Bibian."

Vivian Maier's agreements with her employers seem to have gone in only one direction. Said Nancy Gensburg, "She just would not conform—no rules, just her rules."[14] Linda Matthews recalled, "She saw life in black and white, with no room for other points of view."[15] Richard Baylaender more elaborately described the Vivian Maier of the early 1990s: "Opinionated? Of course! Reasoned and erudite? Absolutely. Knowledgeable about local & world events that encircled her life at that moment? Yes, she was a scholar, second to none. Those newspapers and magazines were not just for show or to weigh down the second floor of my dad's house! She read them and could debate with the best, and was quite capable of running circles around those who espoused casual opinions without any backup. . . . That's just how she was. She rubbed many people the wrong way because of it. Her way, or no way."[16]

Maier's distinct personality dominates even contradictory stories about her. Two former employers told stories of Maier grocery shopping and treating herself to better cuts of meat than she served them. But Karen Usiskin, who hired Maier in the same period, described Maier setting aside bruised fruit for herself and eating the fat off a steak "like somebody who was looking for calories to stay alive." Usiskin thought Maier had "a real identity with being a poor person."[17] Usiskin once discussed doctors and insurance with Maier. Maier said, "The poor are too poor to die."[18]

Vivian Maier's physicality changed. People generally perceived Maier as tall and masculine, with clunky shoes and long purposeful strides. Pat Velasco described her as looking just like the very tall and rail-thin Olive Oyl character from the Popeye cartoons; but Linda Matthews said that Maier, ten years

later, "was not lanky or crane-like but big-boned, man-sized, buxom."[19] Richard Baylaender also described Maier as "big-boned" but said that she may have looked larger than she actually was because of the large coats that she favored. Baylaender also saw Maier wear black lace-up combat-style boots in the early 1990s when she was in her late sixties and still riding a bicycle around Wilmette.[20] Nancy Gensburg said, "She dressed masculine, but she was very feminine. But she didn't care what she looked like."[21]

She was memorable to her charges in many ways. During the years Vivian Maier tended to the Gensburg boys they saw her as adventurous, magical, and unlike any other women in their North Shore neighborhood. She was exotic and a world traveler, and she likely made them feel very special. In 1998, Jennifer Levant—whom Maier photographed extensively as a young child in Highland Park—was standing on Michigan Avenue when she saw a city bus approaching with Maier hanging out of a window with her camera, waving enthusiastically. Levant waved back, realizing that she had never before seen Maier smile.[22] Two years later, Levant was with her young children and her mother, Carole Pohn, when they all ran into Maier walking near the Wilmette beach. Maier tried to strike up a conversation. Pohn invited Maier to join them, but Maier resisted, wanting Pohn to stay and talk with her, finally telling her, "I thought you were my friend." It was the last time Carole Pohn saw Maier.[23]

It is not that people did not want to help Vivian Maier. The Gensburg brothers, specifically, had long been concerned for her, but it seemed that Maier sometimes did not want to be found. After falling out of a touch for a while, in the late nineties she found them. The younger two Gensburg brothers were then attorneys, and she stopped in to see Matthew in his Loop office. Nancy Gensburg would later relay the story: "The lady who was—the office manager—came out and says, 'Matthew, there's this lady out here who insists on seeing you.' And Matthew says, OK, let's get her name. And the woman says, 'Oh no, she won't give her name.'" Avron Gensburg interjected, "The

receptionist thought this was some bag lady walking in," and Nancy continued, "So Matthew walked out and said, 'Vivian!' And they hugged each other. And he said to [the office manager]: 'Don't ever not let her into the office. Ever.'"[24]

After leaving the Oak Park home, Maier had moved to her own apartment in neighboring Cicero. It seems that her hoarding habits had led to her eviction, and this is when she visited Matthew Gensburg. He and his brothers stepped in and moved her into an apartment in Rogers Park. Eventually she moved into the first-floor studio apartment by Lake Michigan's shore.

+ + +

Here our story comes full circle, as we come back around to the familiar image: the cranky anonymous lady on the bench by the lake.

Maier was nearing eighty and seemed withdrawn and cantankerous. She avoided conversations with most of her neighbors. Maier ate directly from cans, and although she refused neighbors' food offerings, she took books that they left out for her. People thought Maier was homeless, but she paid $695 in rent and received a Social Security check of $897 each month.[25] She also had a bank account, which had a balance near $4,000 when she died.[26] Maier did not cash earlier income tax and stock dividend checks, and she may not have been aware of $21,000 of unclaimed funds in her name.[27]

During this period Maier apparently stopped paying for the five storage lockers she had accumulated over the past fifteen years. In fall 2007, after she had been sent a letter regarding the disposal of her possessions, her accumulated belongings—books, magazines, undeveloped film rolls, motion picture reels, and prints and negatives dating back more than five decades—were scattered into small lots at the RPN Sales auction house.

The dispersal began. In January 2008, two separate eBay sellers sold a total of sixty-one reels of Maier's 8 mm footage to a collector in Montreal. They also offered items that hint at her life story: an early 1950s slide rule for determining flash

exposures; postcards from Manitoba; her 1959 Santa Fe Chief train ticket and meal stubs; photographer Margaret Bourke-White's 1963 autobiography, *Portrait of Myself*; and *Wilmette Life* newspapers from 1968 through 1974, when she lived with the Raymond family. Subsequent auctions included separate lots of motion picture reels and also descriptions of 35 mm slides: "Lot 35mm Amateur Slides New York City 1965"; "Lot Richard J. Daley Slides St. Pat's Parade Chicago '71"; "Lot Large Transparency Slides Marina Towers Chicago '67"; and "Enormous Lot 35mm Amateur Slides 1960's Family Chicago." And then, in three separate listings: "Huge Lot Vintage Photo Negatives 600+"; "Huge Lot of Vintage Negatives 700 1970's 1960's"; and "Huge Lot 1200 Vintage Negatives Ali, Sharif, Chicago!!!"

On July 22, vernacular photography collector Ron Slattery posted on his website some color images from slides he had acquired, writing, "The last six slides are from a street photographer named Vivian Maier. I don't know much about her. From the images, I can tell she mostly shot in New York and Chicago 1950s and 60s. I bought a ton of her stuff at a small auction. Part of what I got are 1200 rolls of her undeveloped film. They sit in boxes next to my desk. Everyday, I look at those boxes and wonder what kind of goodies are inside."[28]

During the week of Thanksgiving, eighty-two-year-old Vivian Maier got up from her favorite park bench and fell and hit her head by the gate at the sidewalk exit of Rogers Beach Park. She was taken by ambulance to an Evanston hospital. Somehow, the Gensburg family was notified.

On January 1, 2009, John Maloof posted one of Vivian Maier's photographs on his new Flickr account, labeling it: "1950s—Vivian Maier. This is my favorite picture of vintage Chicago. I have tons of vintage negatives from Chicago in the 50s and 60s from Vivian and this one really inspires me as a street photographer."[29]

From the time of her November fall, until her death five months later, Vivian Maier was shuttled back and forth between hospitals and nursing homes. At the end of January, Lane Gensburg applied to be appointed Maier's legal guardian. The peti-

tion stated that Gensburg was a family friend and "Respondent was Petitioner's nanny." In reply to the nature of Maier's disability, he submitted, "traumatic head injury due to a fall and Dementia." The petition also stated, "Respondent has no known relatives in the United States. Respondent was born in France, was never married, never had siblings, and never had children."[30]

Because of Maier's delicate condition, and to stop a uniformed sheriff from serving her official papers, Gensburg put forth an emergency motion to appoint a "special process server," stating in part, "Maier's mental condition is extremely frail as a result of her traumatic head injuries and service by the Cook County Sheriff may aggravate her fragile mental state." A licensed private detective was hired to perform the protocol of summoning Maier to court. In February, two days after Vivian Maier's eighty-third birthday, the detective located her in a Highland Park nursing home and delivered the document with a social worker as a witness. The report described Maier as five-foot-two and weighing 115 pounds.

Following the summons, a court-appointed guardian ad litem visited Maier to ascertain the extent of her disability before approval of Lane Gensburg's petition. He submitted a report of how he found Maier and stated that while he was positioned directly in front of Maier, "her eyes were open but it was clear she was not focusing on me." He tried to get her attention, greeted her by name, and moved his arm up and down. He identified himself, told Maier the reason for his visit, presented and also read her the statement of rights and asked if she had any questions. His report continued, "I asked Vivian whether she consented or objected to the subject Petition. Once again, Vivian did not respond. As I kept speaking, Vivian closed her eyes." The court representative concluded his report: "At no time during my visit with Vivian did she speak to me, look directly at me, or attempt to communicate with me in any way." He recommended that she be "adjudicated a disabled person" and also advised that the court assign a "plenary guardian of her person and estate."

While Vivian Maier's health faltered, John Maloof was developing the film that he had acquired from Ron Slattery. At the end of March, the negatives began appearing on eBay and a group of international admirers began to acquire single frames from negatives that had been left unprocessed for forty years. Allan Sekula began his correspondence with Maloof and tried to track down Maier. The day before Vivian Maier died, Sekula turned down John Maloof's offer to sell him all the negatives he'd already processed along with the remaining undeveloped rolls.

Vivian Maier died on April 21, 2009. Her death certificate states that she was born in France. Just as she had erased her parents from her 1959 passport application, and confirming that the Gensburgs only knew what little Maier revealed, both of her parents' names were given as "Unknown." Maier's ashes were scattered near a wild strawberry patch, by a ravine alongside the Gensburgs' Highland Park home, where she had spent many seasons.

In 2013, after Vivian Maier, the mysterious nanny photographer, had become an international phenomenon—with photographs from her negatives reaping high prices and her own prints selling at upward of $10,000 apiece—Curt Matthews revealed on his blog that he once asked to see Maier's photographs. She showed him some of her pictures that he thought were "terrific," and he asked her why she hadn't pursued photography as a career.

"She told me that if she had not kept her images secret, people would have stolen or misused them."[31]

Chapter Ten

Who Owns Vivian Maier's Photography?

In the summer of 2014, as four Vivian Maier exhibitions were being presented simultaneously in the Chicago area, another heir appeared. This turned everything upside down.

The prime mover of this development was a Virginia attorney, David Deal. After receiving an undergraduate degree in architecture in the mid-1990s, Deal had embarked on a freelance career as a documentary and portrait photographer.[1] It was the dawn of the digital era, which transformed photography. Internet users often appropriated professionals' work and were lax in applying the concept of intellectual property; moreover, copyright laws lagged behind new trends in sharing imagery. Over fifteen years as a photographer, Deal repeatedly found unauthorized reproductions of his images: "I never did anything about it," he said, until the day he saw of one of his photographs on a billboard. That made him want to go to law school.[2]

Deal began his studies in 2010, focusing on intellectual property law. In his third year he wrote a paper titled "Moral Rights, Copyrights, and the Case of Vivian Maier."[3] Deal argued that Maier's case was unique because she left her work unfinished by not developing or printing from negatives; she chose to not share her photography; and she was not a commercial artist. While he also acknowledged that the public would not have learned about Vivian Maier's photography without John Maloof's efforts, he flatly stated that Maloof did not own copyright to Maier's works. Furthermore, because Maier died without a will, Deal asserted that her estate, which included her copyrights, belonged to Cook County, the location of her final address. He further

suggested modifications to American copyright laws—a system that encourages monetary benefits—by suggesting the adaptation of some of the European "moral rights" concepts that focus on individuals vis-à-vis intellectual property.

David Deal completed his law degree in spring 2013, but his interest in Maier's copyright dilemma did not end there; in his next step, he sought to rectify what he perceived to be a violation of federal law. While newspapers, magazines, and blog reporters interviewed Charlie Siskel and John Maloof about their movie, David Deal was on a quest to find Vivian Maier's closest heir.

On June 9, 2014, an attorney on behalf of David Deal filed papers in Cook County probate court, submitting an heir to Maier's estate.[4] Sixty-three-year-old Francis Baille had signed a detailed affidavit demonstrating his genealogical connection to Maier: Vivian Maier's grandfather and Baille's father were brothers. The third and thirteenth among fourteen siblings, respectively—five who died as infants—they were born twenty-one years apart. The challenge over the rights to publish and sell Vivian Maier's photography was silently underway.

Unaware of these developments, Jeffrey Goldstein, in July, expounded in an interview on his role in Maier's story, saying that when he first heard of her, "there was no Vivian Maier at that point, she didn't even exist."[5] It was only through his activity, he said, that a market for Maier's photography took shape and her work's value was established.

Goldstein further said, "Morally the question that has been asked is whether this is the right thing to do, would she have wanted it. And I think that at this point it is totally irrelevant." Goldstein felt that artists should edit their work and, "if it's important to them, they need to make arrangements," for how it should be handled after their deaths. He felt that Vivian Maier thought her work was important, which is why she kept it, and his job was to "maintain that level of importance." Goldstein described himself as the luckiest person he knew and concluded, "If I were struck by a bolt of lightning right now, I'd be fine with it."

In Cook County probate court, unbeknownst to Goldstein,

David Deal's action led to the reopening of Maier's estate, five years after her death. Not accepting Francis Baille's submission outright, the county's public administrator assumed control of Vivian Maier's estate and opened an investigation to determine Maier's closest living heir. As required by law, a representative for the public administrator mailed and published multiple notices related to the estate's activity, and by August official letters began appearing at the addresses of those who had been identified as involved with marketing Vivian Maier's photography.

The letters came from a Chicago law firm and opened with, "We represent the Estate of the Photographer Vivien [sic] Maier." They went on to notify the addressees of the investigation into "potential misuse and infringement of copyrighted works whose rights are held by the Estate." If gallery owners were surprised to receive the missive, they were likely not as shocked as Jeffrey Goldstein, or John Maloof, who said that he felt "blindsided."[6]

The two-page letter informed the recipients of their "obligation to take reasonable steps to preserve and retain" all Maier-related items relevant to the investigation and listed seven types of "documents, things and electronically stored information" related to copying, printing, distributing, publishing, licensing, and selling "works originally created by Vivien Maier." That included "information related to the creation, publication, and distribution of derivative works, compilations, or collective works based on, using, or incorporating the work of Vivien Maier, including any books, periodicals, or motion pictures."[7] That is, everything.

On the same date as the letter, the estate's probate lawyers petitioned the circuit court judge for orders of "citations to discover and/or recover assets" from John Maloof, Jeffrey Goldstein, and their respective corporate entities. The document acknowledged that Vivian Maier was the copyright holder of thousands of photographs of which "the Public Administrator has learned of widespread potentially unauthorized use" and submitted that, "in order to pursue an action for infringement,"

the estate would first need to register copyrights. In other words, the estate was requesting that John Maloof and Jeffrey Goldstein provide copies of images from their collections so the public administrator could sue them for copyright infringement.

The story hit the media in September 2014, reigniting arguments over Vivian Maier's rights and legacy, as well as over the complicated layers of her story. The social media backlash on David Deal was tremendous. One blogger responded, "This is where the Maier saga finally transforms into modern day, capitalist horror story via hostile takeover courtesy of none other than that classic 19th century villain reassuming his rightful position as 21st century scum of the earth."[8] What made this notable was the common theme that *Deal* was the one appropriating Maier's legacy, "stealing" her from the public. One blog commenter, perhaps not entirely joking, posted, "I vote for a Kickstarter campaign called 'Give Vivian Maier Back to the Public.'"[9]

Other reactions focused on the money involved.[10] Jeffrey Goldstein often stated that he was not making money from selling Vivian Maier's photography; in interviews, he had repeatedly listed his costs and the efforts that were needed to keep his "project" going. Howard Greenberg also deflected the issue: "The fact that I and other galleries have helped in creating a market for these prints that we're making—I don't see it as commercialization. I see it as saturating an incredible demand among the widest swath of people I've encountered in my career to own a Vivian Maier photograph."[11]

David Deal reiterated his position: "The possession of someone else's artwork does not give you the right to reproduce it and sell it. . . . And under no circumstances are they the owners of the copyright. They know that."[12] But John Maloof insisted that he did have permission: "I have a copyright agreement with her relative. I have an heir that I'm working with that I got exclusive rights from, and this heir knows Vivian well."[13] Maloof's applications for the copyrights that he had acquired from that heir, however, were said to be still pending.[14]

Jeffrey Goldstein announced that he would be shutting down

his office operations: "The potential legal conflict ahead is of a nature where it is better for us to fold and go into a sleep pattern until this is resolved."[15] Goldstein for the first time acknowledged that he had bought his rights to reproduce Vivian Maier's photography from John Maloof, who had acquired exclusive permission from the French heir.[16]

That heir was Sylvain Jaussaud, identified in *Finding Vivian Maier* as "the last of" Maier's cousins.[17] Maloof and Goldstein's team of genealogists lost track of Vivian Maier's brother "Charles"—who therefore should not have been ruled out as an heir—and identified Sylvain Jaussaud as Maier's closest heir.[18] Jeffrey Goldstein later revealed that Maloof paid Jaussaud $5,000 in exchange for full copyright of all of Vivian Maier's works.[19]

Sylvain Jaussaud had not been legally submitted to Cook County to assume control of Vivian Maier's estate. He also was likely not the closest living family member: Jaussaud's great-grandfather and Vivian Maier's great-grandfather were brothers. Francis Baille seemed to be at least a generation closer, as his father was Maier's grandfather's brother.

Yet Francis Baille, who had no idea that he was a member of her extended family, became identified by the callous legal term "laughing heir." Moreover, had Nicolas Baille not recognized thirty-five-year-old Marie Jaussaud as his daughter in 1932, Vivian Maier may not have been legally connected to the Baille family at all.

All of this wrangling over lineage disregards Maier's own conscious efforts to detach herself from her family. Her separation from her own family as she assumed an outsider's role among others stands out as a poignant reminder of her independence and self-determination. Maier's choices to not share her history or her photography also seem vital to seeing her as a woman who did her best to control the way she was seen, as well as how she viewed and recorded her surroundings. Maier found men to be "uncouth," yet her legacy has been almost entirely in the hands of men—something we cannot ignore when considering how her life and work have been depicted.

While debates raged on, court activity crept along with repeated extensions and private negotiations.[20] The public administrator offered to set up a foundation whereby the estate would control the material, and separately suggested that Maloof's and Goldstein's work could resume, but with Cook County receiving a majority of the profits.[21] But, in the middle of the ongoing discussions and unknown to the estate, Jeffrey Goldstein sold his entire collection of Vivian Maier's negatives.[22] Further complicating the legal case, he sent the material out of the country. The week before Christmas 2014, Canadian gallery owner Stephen Bulger, who had shown Goldstein's Maier prints in two separate exhibitions, purchased Goldstein's collection of black-and-white negatives.

Stephen Bulger broke his exciting news in an interview with a street photography blog. "Jeffrey didn't feel the photographs were quite safe in Illinois," he said. "The border does complicate things quite a bit." Bulger explained that the Vivian Maier Estate's public administrator was suggesting that the court might allow it to seize Goldstein's materials, and "for Cook County to try to extradite material that's in another country, there's definitely a couple more layers of protection there."[23]

Jeffrey Goldstein's anger and frustration spilled out. In January, he told a *Chicago Tribune* reporter, "I'm not going to partner up with Cook County. I'd cut my wrists first," adding that the court didn't know or care what it was doing.[24] And referring to Stephen Bulger Gallery, he stated in another interview, "It's a warm, fuzzy feeling to know that it's in the hands of people who are really going to respect it."[25] Goldstein did keep around two thousand vintage prints and slides, as well as many motion picture reels. And at the time he stopped production, he owned fourteen hundred darkroom photographs from Maier's negatives that his team had printed.[26]

Cook County representatives pursued Jeffrey Goldstein, seeking an accounting of his assets, which he would not provide. The public administrator's attorney got the judge to issue a new citation.[27] In response, Goldstein's attorney filed a counterclaim against the public administrator, charging the Vivian Maier

Estate with "unjust enrichment," arguing that his efforts had created the value of Maier's copyright, and therefore, he was entitled to monies that may be generated by the estate.[28]

In his fifteen-page, forty-eight-item document, Jeffrey Goldstein described Maier as "primarily a hired nanny" who "maintained a lifelong hobby of picture-taking." Moreover, "when she died, Vivian left nothing of any then-measurable financial value." Yet Maier's unpublished works were of great monetary worth: "In four separate purchases taking place over the course of several years, Jeffrey Goldstein acquired vintage prints, negatives, slides, home movies and transparencies taken by Vivian Maier totaling some 20,000 images for a total cost to Goldstein of approximately $100,000.00." Still, Goldstein insisted that he and his team of skilled workers were responsible for creating the photographer Vivian Maier: "What the public now knows of Vivian Maier as a photographer has been through the collective interpretation of Vivian Maier's negatives by Respondent and these talented individuals."

Jeffrey Goldstein's document also acknowledged his "friendly competition" with John Maloof, and he asserted that after Maloof "saw the marked difference in quality between Goldstein's work product and his own, Maloof re-focused his energies to match the quality of the printing of the Goldstein team." The resulting efforts "achieved superior artistic integrity," ultimately creating "artistic work of significant monetary value." The document went on to detail the hiring of genealogists, as well as the work and financial investment involved in presenting "the precious work of this mysterious photographer."

Ultimately, Goldstein's lawsuit was dismissed, and his request for a jury trial was denied. Over the next few months, he posted an eighteen-minute YouTube video, which he explained was a presentation that he was not allowed to present in court.[29] And in response to his perception that the public unjustly regarded him as a profiteer, Goldstein put on his Vivian Maier website the top page of his last five years' of tax returns.

Two years after David Deal presented Francis Baille to the probate court of Cook County, Vivian Maier's closest heir had

still not been identified. In late 2015, another French cousin, related to Maier's grandfather, emerged and was turned away by the court.[30] Karl Maier's death had been confirmed a few months earlier, but it would be impossible to determine if he had any children. Thus, the court could conceivably maintain control of Vivian Maier's estate until her copyright expired in 2079, seventy years after her death. At that time, her work would pass into the public domain.

In May 2016, the public administrator and John Maloof settled their two-year-long negotiation in a sealed confidential agreement. By the end of the year, updated inventories of Vivian Maier's estate showed three deposits labeled "Proceeds from Sale of Maier Works," adding nearly three-quarters of a million dollars to the Estate of Vivian Maier.[31]

But even as one strand in Vivian Maier's story found a kind of closure, others did not. In early 2017, the negatives that Jeffrey Goldstein had sold to Stephen Bulger were acquired by a Swiss consortium of investors, removing them further from their origins and the estate's control.[32] And in April 2017, after several fruitless attempts at cooperation, the Estate of Vivian Maier initiated proceedings in federal court to sue Goldstein for copyright infringement.[33]

Vivian Maier's story continues on without her.

Epilogue

The particular qualities and intentions of photographs tend to be swallowed up in the generalized pathos of time past. Aesthetic distance seems built into the very experience of looking at photographs, if not right away, then with the passage of time. Time eventually positions most photographs, even the very amateurish, at the level of art.

SUSAN SONTAG, "PHOTOGRAPHY"[1]

Among the astonishing coincidences that seem integral to Vivian Maier's story is that in 1973—twenty-one years after Maier began using the Rolleiflex while caring for the dark-haired girl at 340 Riverside Drive—Susan Sontag was living at the same address, in penthouse A, writing essays later collected in her now-classic book *On Photography*. The first published essay appeared during a year that Maier left more than fifty rolls of film undeveloped, all of which were processed in the twenty-first century. Maier's most creative and productive years had ended long before the depiction of her as a mysterious and eccentric nanny captured the public imagination.

"Vivian Maier" is an invention and an inspiration; her story and her work have transcended the world of photography. A Wisconsin-based choreographer presented an interpretive dance program based on women in Maier's photographs; a poet from Saskatchewan is compiling a book of poetry based on Maier's story; a London theater troupe is producing a play about Vivian Maier, focusing on the theme of privacy; a Sioux Falls, Iowa, high school marching band performed among ten-foot-tall reproductions of her photographs. In China, where the main access to Maier's story and photography was through the film *Finding Vivian Maier*, the concept of a nanny photographer con-

founds and stirs questions of class and station. In 2015, a two-day forum presented Chinese scholars' impressions of Maier and her photography. In the Champsaur Valley, a photographer is assembling a series of portraits of villagers who claim to remember Maier. A square in Saint-Julien-en-Champsaur has been dedicated *Place Vivian Maier.* In southern Italy, the Centro per la Fotografia Vivian Maier evokes her as their muse.

In Rogers Park, where Vivian Maier spent her last years, community members are now united through their connections to her, however slight. The son of a former employer stated, "Frankly, it remains altogether bizarre for me that my life briefly crossed that of an eccentric caretaker, who has gained such posthumous notoriety years after our lives intersected. At the same time, it has led to new friendships, greater knowledge of the arts, and new experiences. All good things."[2]

Vivian Maier's photography was introduced via the Internet at a time when venues like Instagram, Tumblr, and Pinterest were in their infancy. Those sites helped launch Maier's photography, which also led to a resurgence in sales of vintage Rolleiflex cameras and in black-and-white photography. Photography students now go on Vivian Maier–premised photography jaunts. A Facebook group compiles Vivian Maier–inspired street photography. Hundreds of negatives were sold on eBay, and those scattered parts of Maier's fractured archive are now part of the greater world—fittingly, in a way, since Maier ultimately was so, too.

Vivian Maier was a fiercely independent woman who lived the life of a photographer while also working as a nanny. She had a difficult personality, she was a hoarder, and she sought anonymity. These qualities may ultimately have little to do with her photography, but together they form a picture of a woman who chose to remain unknown.

Author's Note
and Acknowledgments

I have many people to thank for their assistance during the four years of research and writing that led to this book. During that time, my efforts to elucidate the Vivian Maier phenomenon sometimes merged with the developing story.

My involvement began in 2012 when Lane Relyea, then chair of Northwestern University's Department of Art Theory and Practice, encouraged me to talk about Vivian Maier on Chicago's public television station, WTTW, which was preparing a program on Maier and her work. Reporter Jay Shefsky asked me to respond to the critique that Maier's photographs were "derivative" of the artists' work with which her own had been compared, like Lisette Model and Diane Arbus. In the following weeks, I studied several hundred Vivian Maier photographs then available online, in an attempt to map and track her movements and techniques. That was when I found Maier with Salvador Dalí at the entrance to the Museum of Modern Art while the exhibition *Five French Photographers* was on display. I wound up questioning why we should measure Maier against others, and I took note of the fact that we only knew of her through what we'd been shown by the men who came to own and edit her photography. As a result of these efforts, Shefsky expanded the program, "The Meteoric Rise of Vivian Maier," to also include a segment called "Searching for Vivian Maier," in which I demonstrated my techniques in reading her photographs.

In the days after the programs aired in August 2012, Jeffrey Goldstein contacted me and generously shared his digitized collection of Maier photography, though our interests eventually seemed to diverge. Ron Slattery also contacted me, and over

the next several years, he graciously allowed me access to his Maier materials. All the images made by Vivian Maier that are reproduced in this book come from the collections of Ron Slattery and Philip Boulton, as well as from the Allan Sekula Estate. John Maloof first declined my requests to study his collection and then set conditions that I could not agree to. I would have loved to have had his cooperation on this book.

This project was originally called "Vivian Maier's Fractured Archive," a comment on her legacy's scattered state, as well as an acknowledgment of the impossibility of fully appreciating the scope of her photography and biography. Details from one trove revealed missing and erroneous information originating from another. Discord among the collectors did not encourage scholarship. Before I began writing, I spent two years chronologically and geographically sorting the images that were available to me: nearly twenty thousand pictures from the Goldstein collection, and thousands of prints, slides, and negatives from the Slattery collection. John Maloof has published around one thousand Maier images online, in books, and in his movie. Handwritten dates and other details found in the Slattery collection helped contextualize—and sometimes match—photo material in the other collections. Jeffrey Goldstein's team also scanned the backs of Maier's prints, which revealed her notations.

As I carefully tried to reconstruct Maier's scattered archive, my goal was always to recognize and give Maier agency within her own story. Here, as in my previous work, I sought to locate and reveal "hidden truths," in the process showing how changing stories and masked intentions can obscure history. In an age where truthfulness seems increasingly under attack, this objective seems all the more critical to me.

I inadvertently perpetuated an inaccuracy when I first spoke on WTTW about Vivian Maier. I presented the same primitive box camera that I had learned from John Maloof's website that Maier had used, and I talked about the "steep learning curve" in transitioning to a Rolleiflex. By the time I saw the early photographs in Jeffrey Goldstein's collection that revealed Maier's sophisticated camera techniques, my demonstration had become

part of the record. I was later contacted by a student who was developing a scholarly thesis based on the jump between the two cameras I had demonstrated. He was disappointed to learn what I had since discovered.

My efforts to understand Vivian Maier by exploring her family, and seeking to contextualize and reconstruct her massive photographic legacy, led several individuals to approach me with information that helped put the story together. As my research became recognized, others contacted me.

BBC filmmaker Jill Nicholls and her research assistant, Tracy Drew, indulged me in a two-day seven-hour presentation of my discoveries. I explained how the archive had been fractured, I gave close readings of her photographs, and I detailed the significance of three generations of French working women to Maier's life and work. Part of that presentation is featured in their documentary *Who Took Nanny's Pictures?* on which I was a consultant.

I am grateful to others who gave me the opportunity to share my research in public lectures, including Janine Mileaf at the Arts Club of Chicago; Liz Garibay at the Chicago History Museum; Michele L'Heureux at Brandeis University; Rebecca Salzer at Lawrence University; Jane Hutchison at Teesside University in Middlesbrough, England; Johanna Empson at the Photographers' Gallery in London; and Weike Zhao for a two-day Vivian Maier symposium at Shandong University of Art and Design in Jinan, China.

Many thanks to Roger Gunderson, Ron Slattery, and Kathy Gillespie, who recalled the 2007 reauctioning of Vivian Maier's five storage lockers, and also to the eBayers I tracked down and those who contacted me after realizing they had acquired Maier's materials, particularly Philip Boulton, Hugo Cantin, Charlotte Jones, Kimmo Koistinen, Benjamin Wickerham, and to Sally Stein and Ina Steiner, on behalf of the late Allan Sekula, whose text appears with permission courtesy of the Allan Sekula Studio LLC. I am also grateful for the detailed chronicling of eBay transactions of Vivian Maier's negatives by an individual who declined to be named.

I am indebted to those who helped with genealogical research, including Susan Kay Johnson, who I discovered sitting next to me in a New York Public Library research room, and also Jeanne Marie Olson. Johnson was the first to verify that Vivian Maier was born in New York. Olson identified Karl Maier in 2011 through his baptismal record; this led to my discovery of his burial at the Ancora Psychiatric Hospital in New Jersey. After my confirmation of Karl's death, the Cook County Office of the Public Administrator, which oversees the Estate of Vivian Maier, eliminated Karl as the heir to his sister's copyright. Although it is unknown whether Karl Maier ever married, the Office of the Public Administrator will not rule out that he had children; therefore, county officials retain control of Maier's intellectual property. I appreciated my conversations with Leah Jakubowski, the general counsel in the Office of the Public Administrator, as well as my meetings with her and David Epstein, the supervised public administrator of the Estate of Vivian Maier. I am grateful for permission to reproduce Maier's photographs in this book.

Several people in France provided information related to Maier's family and her visits to the French countryside. Jean-Marie Millon's devotion to Maier's legacy is exceptional, and I am beholden to him for driving me to locations of her photographs throughout the Champsaur Valley. I am also grateful for Salam Nacrour's gift of translating during that trip, and Michel Clement's assistance in retrieving documentation of the Beauregard land transfers. I enjoyed ongoing conversations with Sylvie Bouvier, who cheered me on during the past two years. Bouvier's interest in the French women in Maier's story extended to Jeanne Bertrand, and she graciously put me in touch with Bertrand scholar Gary V. Smith, who was generous with his impeccable research. Lola Scarpitta kindly shared the complicated Cartaino family history.

Many others provided expert assistance, including in multiple research rooms at the New York Public Library; New York Surrogate Courts in Queens, Nassau, and New York counties; Saint Jean Baptiste church; Ferncliff and Gate of Heaven cem-

eteries; Ancora Psychiatric Hospital; New York City Municipal Archives; and most notably, Jim Folts, head of Researcher Services, at the New York State Archives at Albany. Also, Reverend Edward R. Udovic of DePaul University helped me understand particulars related to the Catholic Church.

I am thankful for the generosity of those who crossed paths with Vivian Maier and shared their stories in hours of conversation and correspondence, including Richard Baylaender, Eula Biss, Bindy Bitterman, Cathy Bruni-Norris, Jim Dempsey, William Eaton, Patrick Kennedy, Jennifer Levant, Linda Matthews, Carole Pohn, and the Vernon Hills employer who preferred to not be named. William Ruppert, Robert Loerzel, and others filled in gaps with their recollections of a woman who was undoubtedly Vivian Maier. I'm especially grateful for conversations with Pat Velasco and Don Flesch, who knew Maier as a photographer; and with Jim Dempsey, to whom Maier gravitated as a fellow cinephile. Nora O'Donnell graciously shared her 2010 transcripts of interviews with Nancy, Avron, and Lane Gensburg, whose fond recollections were invaluable. It was illuminating to learn that Maier read innumerable biographies and taught the Gensburg brothers the historical importance of cemeteries.

I appreciate the cooperation and assistance in relaying Vivian Maier's posthumous story, particularly through those who handled Maier's prints and negatives and others who shared interviews from their own writings: Blake Andrews, Jerry Cargill, Kathy Gillespie, Steven Kasher, Heiwon Shin, and Anne Zakaras. Colin Westerbeck was kind to share his candid assessments of Vivian Maier and her published work in relation to the history of photography.

William Conger, Joanna Scott, and Iñigo Manglano-Ovalle were supportive in the earliest stages of this endeavor; and as the project evolved into a book, Leigh Bienen continually championed my efforts and offered sage advice. I am honored by their kindnesses. Eula Biss, Jessie Mott, Elizabeth Taylor, Alison True, Om Ulloa, Lynne Warren, and Nancy Watkins contributed insights and feedback throughout my writing process, helping at different stages with immeasurable encouragement. Cristina

Bragalone provided support and refuge during crucial days. I am most grateful for my agent, Carol Mann, who instantly took me on and promoted my manuscript with characteristic zeal. And I extend my deepest gratitude to my editor, Timothy Mennel, who immediately understood how "mansplaining" Vivian Maier contributed to her mythologizing. He recognized the value of this story, advocated for the book's structure, and guided me through the process of bringing it to fruition. Also, I appreciate Yvonne Zipter's patience and thoroughness in copyediting the manuscript, and Rachel Kelly's assistance with final details.

As always, my friends and family stood by me through another intensive research project, listening patiently to the complexities chronicled in this book; most of all, Jessie Mott, Manuela Hung, Penelope Bannos, Tom Bannos, Kathy Pilat, Michael Ensdorf, Maura Costa, Greg Cameron, Greg Thompson, William Conger, Kate Newman, and Stacey Shintani, who illustrated the maps and Maier's family tree.

After I embarked on this project, I realized that for more than twenty years, on my route to and from Northwestern University, I drove past Vivian Maier's final residence in Rogers Park, also passing the storage warehouse where she lost her legacy. I never met Maier, but as in so many other ways, her presence still looms.

Abbreviations of Sources
Used in Notes

ARCHIVES

CJG: Collection of Jeffrey Goldstein
CJM: Collection of John Maloof
G/M-Undivided: Collection remaining to be split among Jeffrey
 Goldstein and John Maloof (Split in March 2013)
CRS: Collection of Ron Slattery
NYSA: New York State Archives, Albany
U.S. NARA: U.S. National Archives and Records Administration,
 College Park, MD

Notations to CJG, CJM, and G/M-Undivided refer to the collections' file
numbers, when available.

MOVIES

FVM: *Finding Vivian Maier*, produced by John Maloof and Charlie
 Siskel, Ravine Pictures, LLC, 2014.
VM:WTNP: *Vivian Maier: Who Took Nanny's Pictures?* Part of the
 Imagine series, BBC1, first aired June 25, 2013.

BOOKS

VM:APF: John Maloof, *Vivian Maier: A Photographer Found.* New
 York: Harper Design, 2014.
VM:ETE: Richard Cahan and Michael Williams, *Eye to Eye: Photo-
 graphs by Vivian Maier.* Chicago: CityFiles Press, 2014.
VM:OOTS: Richard Cahan and Michael Williams, *Vivian Maier: Out
 of the Shadows.* Chicago: CityFiles Press, 2012.
VM:Self: John Maloof, ed., *Vivian Maier: Self-Portrait.* New York: power-
 House Books, 2013.
VM:SP: John Maloof, ed., *Vivian Maier: Street Photographer.* New York:
 powerHouse Books, 2011.

Notes

INTRODUCTION

1. *VM:SP* (Maloof); *VM:OOTS* (Goldstein); *VM:Self* (Maloof); *VM:ETE* (Goldstein); and *VM:APF* (Maloof).
2. Karl Edwards, "Interview: Jeffrey Goldstein on Why He's Suing Vivian Maier's Estate," *PetaPixel*, May 17, 2015, http://petapixel. com/2015/05/17/interview-jeffrey-goldstein-on-why-hes-suing-vivian-maiers-estate/; *The Numbers*, http://www.the-numbers.com/ movie/Finding-Vivian-Maier#tab=summary.
3. Deanna Isaacs, "Vivian Maier, the Lawsuit," *Chicago Reader,* May 13, 2014.
4. Deanna Isaacs, "Vivian Maier: Cottage Industry," *Chicago Reader,* April 29, 2014.
5. Dmitry Samarov, "The Vivian Mire," *Spolia*, no. 9 (July 2014), 12–20.

CHAPTER ONE

1. Point 2 Homes, "6331 N. Broadway St, Chicago, Cook County, IL 60660," http://www.point2homes.com/US/Commercial-Property/ IL/Chicago/Edgewater/6331-N-Broadway-St/78756320.html; Open-DataChicago, "6331 N Broadway, Chicago, IL," opendatachicago. com/building-permit.php?id=1803509.
2. In 2016, the monthly fees totaled $385.
3. Google Streetview, August 2007, https://www.google.com/ maps/@41.9974731,-87.6605112,3a,75y,124.84h,107.06t/data=!3m7!1e 1!3m5!1sZiR82Hx88bA9v00UZvGKqQ!2e0!5s20070801T000000!7i3 328!8i1664!6m1!1e1.
4. The Hebard Storage building has changed hands at least twice more. It was first sold and renamed Extra Space Storage; by early 2013, it was known as Uncle Bob's Self Storage, run by a real estate investment trust out of Buffalo, NY; in late 2016, it was rebranded as Life Storage.
5. Roger Gunderson, phone conversation with the author, December 27, 2012.
6. All of Maier's earliest known negatives (mid-April 1950 through mid-July 1952) measure 2¼ × 3¼ inches. Maier's penciled notations

on the back of her prints reveal the transition: among the final early rectangular prints, an image of a boy on a park bench is marked "End of June 1952" (CJG, c51-55_VP-043-Kodak.Velox_507-verso) and an image from a square negative of a boy giving a horse carriage driver a shoe shine is marked "Le 12 Julliet [*sic*] 1952 East 59th S.t. [*sic*] N.Y.C." (CJG, 51-55_VP_RS47_996-verso).

7. Roger Gunderson, phone conversation with the author, December 27, 2012.

8. RPN Sales ad, *Daily Herald*, October 11, 2007, sec. 6, p. 3.

9. Unpublished portion of Nora O'Donnell's "The Life and Work of Street Photographer Vivian Maier," *Chicago*, January 2011. Quoted from interview with Lane Gensburg, December 2010, courtesy of O'Donnell.

10. Ron Slattery, phone conversation with the author, September 2012.

11. "What Do I Do with This Stuff (Other Than Give It to You)?" Flickr thread in the Hardcore Street Photography group, end of December 2010, https://www.flickr.com/groups/94761711@N00/discuss/72157622552378986/.

12. Ibid.

13. *VM:WTNP*, time code 00:14:46.

14. John Maloof in *FVM*, time code 00:02:15.

15. Jennifer Wehunt, ed., "Who Makes What—Salaries List," in "Money in Chicago 2007," *Chicago*, April 2007. John Maloof's eBay store, Pardon My Pigeon, is located at http://stores.ebay.com/pardonmypigeon/. Accessed February 1, 2017.

16 John Maloof, *The Real Estate Agent's Guide to FSBOs: Make Big Money Prospecting For-Sale-by-Owner Properties* (New York: AMACOM, 2007); Daniel Pogorzelski and John Maloof, *Portage Park* (Charleston, SC: Arcadia, 2008).

CHAPTER TWO

1. Hautes-Alpes, France, departmental archives: listing references 2 E 154/3/3 and 154/8/2, Saint-Laurent-du-Cros, 1896 census, https://www.archives05.fr/n/vos-archives/n:1.

2. Hautes-Alpes, France, departmental archives: listing reference 2E 153/18, Saint-Julien-en-Champsaur civil register of births, 1897, https://www.archives05.fr/n/vos-archives/n:1.

3. As described by Marie Daumark in *VM:WTNP*, time code 00:45:40.

4. Hautes-Alpes, France, departmental archives: listing reference 2 E 21/6, Bénévent-et-Charbillac civil register of marriages, 1878, www.archives05.fr/n/vos-archives/n:1.

5. Joseph Albert Jaussaud died at age four in 1889, and an unnamed baby boy died after one day in 1891. Hautes-Alpes, France, departmental archives: listing reference 2 E 154/10/2 and 2 E 154/12, Saint-Laurent-du-Cros civil register of births, 1889 and 1891, respectively (www.archives05.fr/n/vos-archives/n:1).

6. SS *La Gascogne*, ship manifest, May 11, 1901, New York, Passenger Lists, 1820–1957, microfilm T715, roll 0197, line 22, p. 92, Records of the Immigration and Naturalization Service; National Archives at Washington, DC.

7. SS *La Bretagne*, ship manifest, June 15, 1901, New York, Passenger Lists, 1820–1957, microfilm T715, roll 0208, line 1, p. 129, Records of the Immigration and Naturalization Service; National Archives at Washington, DC.

8. Hautes-Alpes, France, departmental archives: listing reference 2 E 153/7, Saint-Julien-en-Champsaur civil register of births, 1852, www.archives05.fr/n/vos-archives/n:1.

9. U.S. NARA, *The 1910 Federal Population Census.*

10. Marriages solemnized in New Marlborough, County of Berkshire, Massachusetts in the year 1873. Massachusetts, Town and Vital Records, 1620–1888.

11. U.S. NARA, *The 1910 Federal Population Census.*

12. SS *La Bourgogne*, ship manifest, February 13, 1893, New York, Passenger Lists, 1820–1957, microfilm M237, roll 603, line 38, Records of the Immigration and Naturalization Service; National Archives at Washington, DC.

13. U.S. NARA, *The 1900 Federal Population Census.*

14. "From Factory to High Place as Artist. Jeanne J. Bertrand, a Girl of 21, Has Become One of the Eminent Photographers of Connecticut." *Boston Globe*, August 23, 1902.

15. A Beauregard real estate transaction 4 Q 2932, dated October 20, 1904, shows Eugenie Jaussaud's address as Box 244 Norfolk, Litchfield County, Connecticut. Tribunal de grande instance, Gap.

16. SS *Kronprinz Wilhelm*, ship manifest, October 17, 1905, New York, Passenger Lists, 1897–1957, microfilm T715, roll 632, line 6, Records of the Immigration and Naturalization Service; National Archives at Washington, DC. The town is now known as Modra, Slovenia.

17. Primary Declaration of Intention for Naturalization of Wilmos Maier, September 12, 1906, Queens County Circuit Court, New York. Wilmos is the Hungarian derivative for Wilhelm.

18. SS *Brandenburg*, ship manifest, November 3, 1906, New York, Passenger Lists, 1897–1957, microfilm T715, roll 791, line 12, Records of the Immigration and Naturalization Service; National Archives at Washington, DC; Slovakia Church and Synagogue Books, 1592–

1910, parents Rudolph Mayer and Carolina neé Mayer. https://familysearch.org/; Marie von Maier's death certificate lists her parents as Ferdinand Hauser and Elisabeth Maier (July 20, 1947, certificate number 16105, New York Municipal Archives, New York).

19. U.S. NARA, *The 1910 Federal Population Census.*

20. SS *France*, ship manifest, June 20, 1914, New York, Passenger Lists, 1897–1957, microfilm roll 2336, line 26, p. 154, Records of the Immigration and Naturalization Service; National Archives at Washington, DC.

21. Parole Officer Carroll, from an interview with Vivian Maier's paternal grandmother in Karl Maier's chronological history, May 18, 1936, Inmate Case Files, 1930–1965, Box 13, New York State Vocational Institution, NYSA. (All documents related to Karl Maier's incarceration are from these files and will be cited henceforth only by description and date.)

22. Louise Heckler's 1921 U.S. passport application; the *France*'s registrar.

23. "Officer Carroll," interview with Vivian Maier's paternal grandmother, May 18, 1936.

24. In 1927, Fred Lavanburg died, leaving Louise Heckler $250,000. Lavanburg created a $3 million foundation in his own name that established low-income housing on the Lower East Side. He also left $500,000 to establish the Hannah Lavanburg Home for Immigrant Girls.

25. NYSA, *New York State Census*, 1915.

26. Ibid.

27. Wilmos Maier, petition for naturalization, November 12, 1912, U.S. District Court for the Southern District of New York.

28. Chas Maier [*sic*], World War I Draft Registration Card, June 5, 1917, New York Draft Board 137, Roll 1766400, Irma and Paul Milstein Division of United States History, Local History and Genealogy, New York Public Library.

29. Men obviously used Kodak cameras, too, so Eastman's ads effectively opened up a new market with its images of liberation and free-spiritedness, notably during the decade of the women's suffrage movement.

30. The marriage certificate shows that Jaussaud lived at 33 West Seventy-Fourth Street, the Seligmans' address, and Charles Maier lived at 162 East Fifty-Sixth Street, where the whole family is recorded together in the January 1920 U.S. census. U.S. NARA, *The 1920 Federal Population Census.*

31. New York Marriage certificate 13505, New York City Department of Records/Municipal Archives; *VM:WTNP*, time code 00:42:47.

32. Although "filius naturalis" can be interpreted as a child born out of wedlock, in e-mail correspondence with the author, Reverend Edward R. Udovic relayed: "Since they had been married in a Lutheran Church she would have been in trouble for not getting married in the Catholic Church with a dispensation for a "mixed marriage.""

33. Hautes-Alpes, France, departmental archives: listing reference 4 Q 4282—Formal Reports: Vol. 138, cases 422/423, Vol. 911, Art. 24, recorded February 21, 1921, Bureau de conservation des hypothéques de Gap. This documented transaction included a transcription of the letter from Eugenie Jaussaud to her sister Maria Florentine. Eugenie's address was noted as 930 Park Avenue, New York, New York.

34. U.S. NARA, *The 1920 Federal Population Census.*

35. NYSA, New York State Census, 1925.

36. A 1936 document in Karl Maier's case files at the New York State Archives in Albany, shows the Maier family interactions with New York agencies and includes the notation, "State Charities Aid Assn-Mason 5-28-25." Additionally, in an undated handwritten note by Karl Maier during his 1936–38 stay at the Coxsackie Vocational School, he stated in part, "I was born in 1920. My father & mother took care of me until 1926. My mother left him. (I'm stating facts as they really are) Previous to this they placed me in the Hecksher Foundations [*sic*] care. Obviously they didn't want me."

37. Parole Officer Carroll, from an interview with Vivian Maier's paternal grandmother as part of Karl Maier's chronological history, New York State Vocational Institution, May 18, 1936, NYSA.

CHAPTER THREE

1. NYSA, *New York State Census*, 1925 New York State Census.

2. A 1936 document in Karl Maier's case files at the New York State Archives in Albany shows the Maier family interactions with New York agencies and includes the notations, "N.Y. Catholic Charities #7949 10-25-26" and "National Desertion Bureau #M80450 11-8-29." Also, in an undated handwritten note by Karl Maier during his 1936–38 stay at the Coxsackie Vocational School, he stated in part, "My father didn't pay a cent towards my support until 1929. He contributed for a period 8 months then the payments fell off again."

3. The 1930 federal census identifies Jeanne Bertrand as the head of the household, with Marie Maier noted as a boarder and Vivian Maier as a lodger. U.S. NARA, *The 1930 Federal Population Census.* The building was built in 1929 (per, e.g., listing at apartable.com for "720 St. Mary's Street, Bronx," http://apartable.com/buildings/720-st-marys-street-bronx).

4. "Local Briefs," *Torrington Register*, September 4, 1903.

5. "In Retreat," July 1, 1909; "Goes Insane Here," June 13, 1917; and "In Sanitarium," June 14, 1917—all in *Torrington Register*.

6. "Tries to Kill Two Nieces," *Lowell Sun*, June 14, 1917, 5.

7. In 1912, Jeanne Bertrand became romantically involved with sculptor Pietro Cartaino, known professionally as C. S. Pietro. Bertrand moved to New York during this period and traveled in art circles that included Gertrude Vanderbilt Whitney, who worked with Cartaino to form the group Society of Friends of Young Artists. Jeanne Bertrand named their son Pierre, and he was raised as part of the Cartaino family, though she maintained a relationship with them. In 1930, Bertrand was again working as a studio portrait photographer, in Union City, New Jersey, which she did until at least 1948. Jeanne Bertrand died in 1957. There is no evidence of any further connection between her and Vivian Maier.

8. U.S. NARA, *The 1930 Federal Population Census*.

9. "BOY NOW HAS $4,969,789," *New York Times*, February 2, 1915.

10. Among Eugenie Jaussaud's 1931 naturalization papers, on her petition for citizenship dated September 30, she gave her daughter's address as 103 W. Eightieth Street. John Nelson Steele is the only listed occupant at that address from 1930 through 1933, and in the 1930 federal census his household includes a governess, a chambermaid, a cook, and a waitress. U.S. NARA, *The 1930 Federal Population Census*.

11. Marie Daumark, in *VM:WTNP*, time code 00:48:28.

12. Hautes-Alpes, France, departmental archives: listing reference 4 Q 4282—listings by names (cases) of real estate holdings: Vol. 138, cases 422/423/424. www.archives05.fr/n/vos-archives/n:1.

13. The Napoleonic Code's emphasis on family and property resulted in now-public records that meticulously detail land transfers. Germain Jaussaud's will left his widow the right to live on the land that was legally handed down to his children. Emilie Jaussaud died in 1917, just weeks after her son Joseph Marcellin. Each real estate transaction detailed the history of the ownership of the family land.

14. Inheritance rights at that time were allowed only for illegitimate children of parents who could have legally married; birth by incestuous or adulterous relations were not recognized. In 1972 another amendment allowed for recognition of adulterous illegitimate children.

15. Some villagers now dispute that the woman in the photograph is Vivian Maier's mother. There is no definitive proof one way or another. A second photograph, shot by Maier in 1951 on the beach in Southampton, Long Island, has been said to be her mother by virtue of the likeness to the woman in the 1933 snapshot.

16. Photo of Vivian Maier and her mother, Association Vivian Maier et le Champsaur, http://www.association-vivian-maier-et-le-champsaur.fr/medias/images/jaussaud-maier-corrige-1bis-copie.jpg.

17. Photo of Vivian Maier, age seven, Association Vivian Maier et le Champsaur, http://www.association-vivian-maier-et-le-champsaur.fr/medias/images/jaussaud-maier-corrige-2bis-copie.jpg.

18. Photo of Vivian Maier and unknown woman, Association Vivian Maier et le Champsaur, http://www.association-vivian-maier-et-le-champsaur.fr/medias/images/jaussaud-maier-corrige-3bis-copie.jpg

19. CJG, 59_8_20-21_00327-051.

20. CJG, 59_8_20-21_00327-057.

21. The mini museum display, presented by one of two rivaling French Vivian Maier associations, accompanied a showing of Maier's photographs from the second largest collection of her negatives, CJG. Selling for upwards of $2,000 each, the photographs of New York and Chicago were printed after Maier's death. Simultaneously, another Parisian gallery showed works derived from CJM, the major stakeholder in Maier's legacy.

22. Katharine Grant Sterne, "The Camera: Five Exhibitions of Photography," *New York Times*, December 6, 1931, XX214. The "shingle" was a contemporary haircut, and the other exchanges replaced the old with the new.

23. In *Berenice Abbott & Eugène Atget* (Santa Fe, NM: Arena Editions, 2002), Clark Worswick writes of the distribution of Atget's estate: "With the conundrum of what to do with his friend's life's work, Andre Calmette divided it into two categories. Half the work comprised pictures and negatives of historical Paris, which Calmette placed in the collections of the Monuments Historiques. The other half of Atget's life's work numbered approximately 1,400 negative plates and 8,000 prints. After a protracted negotiation that continued into the next year, Berenice Abbott, who was thirty years old in 1928, bought this second group of pictures" (24).

24. "Fame Comes to Photographer after His Death," *Escanaba Daily Press*, January 15, 1929, 2.

25. Testimony from Marie von Maier to the parole officer in 1936. "The mother is being supported by her mother, Mme. Eugenie Joussard [*sic*] who is employed by Jacob Strauss at 720 Park Ave. she sends MJ $50 each month."

26. Quote about Marie von Maier from parole officer Carroll on April 14, 1937, NYSA; Eugenie Jaussaud, declaration of intention to become an American citizen, May 27, 1925.

27. Parole Officer Carroll, April 14, 1937, NYSA. An endowment policy can be paid out upon its maturity.

28. From a 1936 interview with Marie von Maier, her grandson's parole officer reported, "In 1933, the father secured a Mexican divorce from the boy's mother. A few days later he remarried." In Charles Maier's August 4, 1964, last will and testament, he stated that his first wife had "divorced him in France." Berta Maier's 1947 petition for naturalization states that she and Charles Maier married in Jersey City, New Jersey, on May 17, 1934.

29. SS *Bremen*, ship manifest, August 30, 1934, New York, Passenger Lists, 1897–1957, microfilm roll 5538, line 11, p. 48, Records of the Immigration and Naturalization Service; National Archives at Washington, DC; "Chronological History of No. 395," Parole Department, New York State Vocational Institution, May 18, 1936, NYSA.

30. Parole Officer Carroll, interview with Marie von Maier, May 8, 1936, NYSA.

31. Official Record, Legal History, Analysis of Offense, Sentenced April 17, 1936, NYSA.

32. "History and guide for investigating case of No. 395," Parole Department, New York State Vocational Institution, April 20, 1936, NYSA.

33. Notation on the Saint Jean Baptiste Catholic Church ledger that recorded her 1926 baptism.

34. Letter from Inspector in Charge, J. J. Doran, Post Office Department, New York, NY, August 3, 1936, NYSA.

35. Letter dated March 29, 1937, Inmate Case Files, 1930–1965, Box 13, New York State Vocational Institution, NYSA.

36. Excerpt from summary document upon Karl Maier's ultimate release from Coxsackie, dated September 27, 1938, New York State Vocational Institution Case Files, NYSA.

37. "Chronological History of No. 395," Parole Department, New York State Vocational Institution, September 18, 1937, NYSA.

38. Postcard from Eugenie Jaussaud to Karl Maier, April 1937. Transcribed from the original with errors intact. Jaussaud also sent her grandson snapshot-sized photos of Emerson's Florida estate with notes about her surroundings. The files in the New York State Archives contain multiple instances of confiscated correspondence to and from Karl Maier. It is sometimes difficult to discern why the communication was intercepted.

39. Eugenie Jaussaud, confiscated letter, postmarked September 23, 1937, NYSA.

40. Another Vivian Maier researcher, Ann Marks, has also studied Karl Maier's files at the New York State Archives at Albany, but she has interpreted the documents differently. Kerri MacDonald, "A Peek

into Vivian Maier's Family Album," *Lens* (blog), *New York Times*, January 13, 2016, https://lens.blogs.nytimes.com/2016/01/13/a-peek-into-vivian-maiers-family-album/.

41. SS *Normandie* ship manifest, August 1, 1938, New York, Passenger Lists, 1820–1957, microfilm T715, roll 6190, line 21, Records of the Immigration and Naturalization Service, National Archives at Washington, DC.

42. "Professor Jumps Off Normandie after Attempt to Choke His Wife," *Montreal Gazette*, August 2, 1938; "Believed Drowned: Missing Professor Beats and Chokes Wife, Disappears at Sea," *Abilene Reporter-News*, August 2, 1938; "Chokes Wife, Leaps Off the Normandie: Duncan, Colgate Professor, Vanishes after Quarrel as Ship Nears New York," *New York Times*, August 2, 1938.

43. The photographer Arthur Fellig was nicknamed Weegee as the phonetic spelling for the Ouija board. As the first photographer granted a police radio, he would sometimes arrive on the scene of a crime before the officials.

44. Ad for Saint Paul Hotel, *New York Times*, October 23, 1938.

45. Parole Officer Joseph Pinto, "Chronological History of No. 395," Parole Department, New York State Vocational Institution, September 24, 1938, NYSA.

46. Marie Maier, confiscated letter, October 1, 1938, NYSA.

47. Karl Maier, intercepted letter, August 3, 1938, NYSA.

48. Unsigned document recommending Karl Maier's parole, September 27, 1938, NYSA.

49. Marie Maier, letter to the New York State Vocational Institution, November 13, 1938, NYSA.

50. Parole officer Joseph Pinto, "New York State Vocational Institution Parole Department Chronological History of No. 395," November 30, 1938, NYSA.

51. Ibid., December 14, 1938.

52. Ibid., January 11, 1939.

53. Marie Maier, letter to the New York State Vocational Institution, March 22, 1939, NYSA.

54. Ibid.

55. U.S. NARA, *The 1940 Federal Population Census.*

56. Beaumont Newhall, *The History of Photography from 1839 to the Present* (New York: Museum of Modern Art, 1937).

57. Jacob Deschin, "New York's Streets: Making Picture Stories of the City's Avenues," *New York Times*, April 6, 1947, X13.

58. The 1940 federal census showed that the Lindenbergers were foster parents for two young boys. U.S. NARA, *The 1940 Federal Population Census.*

59. Death certificate no. 734, January 22, 1943, New York City Munici-
 pal Archives.
60. Vivian Maier, Social Security application, February 22, 1943, Social
 Security Administration, Baltimore, MD.
61. Marie Maier, Social Security application, November 25, 1943, Social
 Security Administration, Baltimore, MD.
62. Eugenie Jaussaud's death certificate, filed on October 21, 1948, New
 York City Municipal Archives.
63. Death notice for Eugenie Jaussaud, *New York Times*, October 22,
 1948. After Marie von Maier died on July 20, 1947, Alma Corsan
 had similarly arranged a Frank E. Campbell funeral for her mother.
 Unlike her husband, von Maier's death was not registered in the Lu-
 theran Church.
64. In 1959, Vivian Maier photographed every page of her 1950 U.S.
 passport (CJG, 59_00365-4-006).
65. SS *de Grasse*, outgoing manifest from New York, March 29, 1950,
 Records of the Immigration and Naturalization Service, 1787–2004,
 Record Group No. 85, Series No. A4169, NARA Roll No. 69, National
 Archives, Washington, DC.
66. Randy Prow acquired the bulk of these negatives along with more
 than one thousand of the prints at the 2007 auctions. CRS currently
 holds at least one thousand prints from Maier's April 1950–April
 1951 European trip.

CHAPTER FOUR

1. "The Meteoric Rise of Vivian Maier," *Chicago Tonight*, August 1,
 2012.
2. *VM:WTNP*, time code 00:15:21.
3. Kathy Gillespie, interview by the author, November 21, 2013.
4. Kathy Gillespie, e-mail correspondence with the author, October 31,
 2013.
5. Ibid.
6. *VM:OOTS*, 283.
7. "John starts making prints from Vivian's negatives and selling them
 on eBay" (Ron Slattery in *VM:WTNP*, 00:16:38).
8. eBay user wistafke123, feedback, accessed February 1, 2017, http://
 feedback.ebay.com/ws/eBayISAPI.dll?ViewFeedback2&ftab=AllFe
 edback&userid=wistafke123&iid=-1&de=off&items=200&interva
 l=0&searchInterval=30&mPg=102&page=88; originally accessed
 on July 11, 2014. eBay stopped showing user names on their feed-
 back pages in October 2013, and in August 2014, the website stopped
 showing dates of purchase.

9. eBay user gleeper6, feedback, http://feedback.ebay.com/ws/eBay-ISAPI.dll?ViewFeedback2&ftab=FeedbackAsSeller&userid=gleeper6&iid=-1&de=off&items=200&interval=0&searchInterval=30&mPg=18&page=6.

10. Hugo Cantin, e-mail correspondence with the author, July 15, 2014. To date, more than two hundred reels of Vivian Maier's motion picture footage are accounted for: CJM is said to have more than a hundred reels; Hugo Cantin, sixty reels; CJG, thirty reels; and CRS, around a dozen reels.

11. CJG: 50_VP_hw8_456D, and 50_VP_hw8_456D-verso.

12. *VM:WTNP*, time code 00:52:16.

13. CJG: 49-50_00030-006.

14. CJG: 50-49-50_00159-003, 49-50_00001-006, 49-50_00153-001, 49-50_00156-006, 49-50_00097-006, and 49-50_00153-001.

15. *VM:WTNP*, time code 00:48:20.

16. From 1922 through 1935—as Mlle. Joubert—Marguerite Joubert published nearly three thousand postcards.

17. G/M-Undivided: 2842 and 2843; CJG: 49-50_00133-001, 49-50_00135-006, and 49-50_00129-001.

18. *VM:OOTS*, 32.

19. *VM:WTNP*, time code 00:49:07.

20. Susan Sontag, *On Photography* (New York: Farrar, Straus & Giroux, 1977), 6–7.

21. "About Vivian Maier," accessed February 1, 2017, http://www.vivianmaier.com/about-vivian-maier/.

22. In an August 2012 e-mail exchange with the author, John Maloof insisted that it was her first camera because it produced the same size frames as Maier's 1950–52 negatives and also because he had found film inside it.

23. *VM:OOTS*, 24.

24. For more than four years, John Maloof has been aware of the challenge to his assertion, but he has chosen to maintain his unsubstantiated interpretation of Maier's earliest known work.

25. CJG: 51_4_5_VP_hw4_181-verso.

26. CJG was digitally scanned and both sides of prints with verso notations were available for study. Penciled notations on 1950–51 prints in CRS, which I was able to handle and inspect, filled in missing places and periods. None of this early material was sorted.

27. CJG: 49-50_00023-006.

28. *VM:WTNP*, time code 00:51:38. Maier made a five-by-seven-inch print of one of the Simon portraits (CRS).

29. CJG: 49-50_00146-002.

30. *VM:WTNP*, time code 00:50:29.

31. CJG: 49-50_00046-001, and 49-50_00049-001.

32. *VM:WTNP*, time code 00:50:03.

33. Jill Nicholls, "Vivian Maier: Lost Art of an Urban Photographer," article with "web-exclusive" clip from *VM:WTNP*, BBC Arts, June 25, 2013, http://www.bbc.co.uk/arts/0/23007897.

34. CJG: 49-50_00001-007, and ND_1178_002.

35. CJG: 49-50_00021-003, 49-50_00021-008, and 49-50_00160-006.

36. *VM:OOTS*, 32, photo captioned, "Benevent cemetery with Maier's ancestors"; also *VM:WTNP*, time code 00:00:27.

37. One of the pictured men, now in his nineties, remembers the occasion not least because it was unusual to photograph such an activity.

38. CJG: 49-50_00058-002.

39. G/M-Undivided: 3125 and 3126; CJG: 49-50_00059-006, and 49-50_00010-001.

40. CJG: 49-50_00087-006, and 51_3_16_VP_hw4_090-verso.

41. Jean-Marie Millon, e-mail correspondence with the author, January 28, 2015.

42. One of the boys in this photograph, Jean-Marie Millon, was very helpful with filling in details about photographs of the Gap region. He lived in the building across from where Maier stayed with the Lafonts and has been dedicated to Maier's legacy since her posthumous emergence.

43. Jean-Marie Millon found this window view and made his own photograph from it.

44. CJG: 49-50_00180-008, and 49-50_00155-004.

45. CRS prints; CJG: 49-50_00053-008.

46. CJG: 49-50_00071-007, and 49-50_00111-006: G/M-Undivided: 2504 and 2566.

47. CJG: 49-50_00169-007, 49-50_00145-006, 49-50_00067-006, and 49-50_00013-003; CRS prints.

48. CJG: 49-50_00211-008, and 50_VP_hw_451. The back of the print is annotated, "Aout 1950 Domaine" (August 1950 Estate).

49. SS *de Grasse*, outgoing manifest from New York, March 29, 1950, *Records of the Immigration and Naturalization Service, 1787–2004*, Record Group No. 85, Series No. A4169, NARA Roll No. 69, National Archives, Washington, DC.

50. CJG: 49-50_00103-002.

51. G/M-Undivided 2181 and 2606; CJG: 49-50_00167-003, 49-50_00032-008, and 49-50_00178-008.

52. CRS prints.

53. *VM:OOTS*, 29.

54. CJG: 50_09_10_VP_hw_096, and 49-50_00069-008.

55. Maier's 1950 U.S. passport, p. 9: CJG: 59_00365-6-007.

56. CRS: print annotated, "October 1, 1950 Sun Neuchatel Suisse"; also CJG: 49-50_00102-003, 49-50_00052-005, and 49-50_00173-008.

57. CRS prints, including one with the penciled notation: "Le Mont Blanc October 4, 1950 wed."

58. CRS print.

59. The "before and after" negatives were nearly separated in the dividing of John Maloof and Jeffrey Goldstein's combined acquisition of Maier's works more than a year after her death. (See chapter 6.)

60. It is unclear how the income derived from the Beauregard house and farmland was handled from the time of Florentine's 1943 death.

61. Beyond the farmhouse, the remaining land comprised farmable and less useful ground. Nearly half of the acreage was wooded, and one parcel was all trees and moors, useless as income-producing properties.

62. CJG: 49-50_00060-004, ND_1171_007, 49-50_00169-001, and 49-50_00012-004.

63. CJG: 49-50_00211-002, and 49-50_00175-008; CRS enlarged print.

64. *VM:WTNP*, time code 00:49:12; CRS enlarged print.

65. CJG: 49-50_00205-008, 49-50_00152-006, 49-50_00022-003, and 49-50_00008-005.

66. CJG: 49-50_00017-001, 49-50_00083-006, 49-50_00200-005, and 51_01_22_VP_hw-014_016-verso, annotated, "Basses Alpes, Lundi 22 Janvier 1951."

67. CJG: 49-50_00083-006, 49-50_00085-008, 49-50_00070-004, and 49-50_00106-006.

68. CJG: 49-50_00014-004.

69. CJG: 49-50_00115-008 (CRS print annotated "January 25th 1951 thurs"), 49-50_00119-002, and 49-50_00128-008 (CRS print annotated "January 25th 1951 thurs"). CRS prints are often annotated in Vivian Maier's handwriting and they helped with the chronological sorting of CJG negatives.

70. CJG: ND_1177_004; also CRS print.

71. CJG: 49-50_00180-002.

72. Stamps in her passport show Maier entering and leaving Italy through Ponte S. Luigi on January 28, 1951 (CJG: 59_00365-9-001).

73. CJG: 49-50_00058-007, and 49-50_00197-001.

74. CJG: 49-50_00018-001.

75. CJG: 49-50_00001-003, and 49-50_00144-003.

76. *VM:WTNP*, time code 00:00:13; CRS: Marseille prints; CJG: 51_1_30_VP_hw-789A-Velox_083-verso, annotated, "January 30th, 1951 tues. Nice, A.M."

77. CJG: 49-50_00179-004, and 49-50_00171-005; CRS: verso, "Marseille, A.M. February 4th 1951"; CJG: 49-50_00194-003,

49-50_00194-003, and 49-50_00166-006. The several other negatives that portray the aftermath of this pickpocket affair were separated by scores of other negatives in one of the collections of Maier's works, obscuring an understanding of her strategies as a developing street photographer.

78. Maier's U.S. passport, p. 10: CJG: 59_00365-7-003.

79. G/M-Undivided: 3168.

80. CJG: 49-50_00054-005, 49-50_00053-001, and 49-50_00167-008.

81. CJG: 49-50_00045-005, 49-50_00078-006, 49-50_00045-001 (CRS print, annotated, "Cordoba Spain"), and 49-50_00044-004.

82. G/M-Undivided: 2733 and 2734; CJG: 49-50_00045-006; CRS prints, annotated "Madrid, Spain February 13, 1951 tues"—same notation as print on boulevard.

83. Maier's 1950 U.S. passport, p. 12: CJG: 59_00365-8-002.

84. CRS prints.

85. CJG: 49-50_00078-001, and 49-50_00078-004.

86. CJG and CRS: prints with verso notation, "End of February 1951 Gap H.A."

87. CJG: 49-50_00022-006; also CRS print.

88. CJG negatives with many CRS matching prints.

89. CJG: 49-50_00139-007, and 49-50_00021-006.

90. *VM:WTNP*, time codes 00:49:25, 00:49:25, 00:49:28, and 00:49:30; a CJG print from the series is annotated, "Le 27 Mars 1951 Mardi."

91. CJG print: 51_03_20_VP_hw05_241-verso (notation "March 20th 1951 tues").

92. Eula Biss, correspondence with the author, September 1, 2014.

93. Unidentified woman in *FVM*, 01:12:17

94. Sally Reed, "Vivian Maier's Last Days," *CityFiles Press Blog*, August 16, 2012. This blog entry is no longer accessible on the CityFiles Press website.

95. Patrick Kennedy, conversation with the author, March 15, 2015.

96. The company, established as AuctionWeb in 1995, changed its name to eBay in 1997.

97. A portion of W. M. Hunt's collection was published as *The Unseen Eye: Photographs from the Unconscious* (New York: Aperture, 2011).

98. Jennifer 8. Lee, "A Mundane Shot? If It's on a Photoblog, Someone's Interested," *New York Times*, June 8, 2005, 9.

99. A selection of snapshots from John Foster's collection, including many that were enlarged for display, toured regional galleries and museums for four years beginning in 2005, titled *Accidental Mysteries: Extraordinary Vernacular Photographs from the Collection of John and Teenuh Foster.*

100. In 1944, the Museum of Modern Art presented *The American Snap-*

shot. But that show consisted of photographs that were considered accomplished by their makers and had been submitted to Kodak-sponsored contests. They were cropped and enlarged for exhibition.

101. John Maloof, eBay store description, accessed August 12, 2016, http://stores.ebay.com/pardonmypigeon/. The quoted description is no longer available online.

102. *VM:SP*, 19 (also *VM:APF*, 104, "New York, November, 1953") and 57; CRS: multiple prints; *VM:SP*, 25; CJG: multiple negatives; and CRS: multiple prints. (Dates as captioned are presumed to be correct unless specific information indicates otherwise, in which case it is noted.)

103. eBay user heebiejeebies! accessed February 1, 2017, http://www.ebay.com/usr/heebiejeebies%21. "All Feedback" listing at two hundred items per page shows item listings describing Maier photographs scattered from pages 27 to 57.

104. CJM: 56-738, "September 30, 1956, New York, NY," Internet Archive: Wayback Machine, February 10, 2012, web.archive.org/web/20120210153811/http://www.vivianmaier.com/portfolios/new-york-1/?show=thumbnails&pid=209.

105. Charlotte Jones, e-mail correspondence with the author, March 7, 2015.

106. SS *de Grasse*, ship manifest, April 26, 1951, New York, Passenger Lists, 1897–1957, microfilm roll 7973, line 9, p. 200.

107. CJG: 49-50_00003-008; also *VM:WTNP*, time code 00:52:25; and G/M-Undivided: 2728.

108. CJG: 49-50_00109-002, 49-50_00112-003, and 49-50_00112-005.

109. CJG: 55_00290-008, and 55_00301-006.

110. CJG: 49-50_00152-007, 55_00288-005, 55_00291-002, and 55_00292-007.

111. CJG: 55_00291-007, 55_00291-003, and 49-50_00150-005. Lisette Model's negatives in the archive at the National Gallery of Art in Ottawa, Canada, reveal that Model's prints of those seated at the Promenade des Anglais were cropped to have them appear closer to the camera than they appear in the full frame negatives.

112. "2 Stowaways Back, Wiser—Visited France via Porthole," *Brooklyn Eagle*, April 27, 1951, 13.

113. CJG: ND_1177_009; CRS prints.

114. CJG: 49-50_00003-006, 49-50_00045-004, and 49-50_00182-008.

115. CJG: 49-50_00144-006; also *VM:WTNP*, time code 00:47:52.

116. Press release, "George Eastman House Acquires Kodak's Colorama Archive," June 11, 2010, George Eastman House: International Museum of Photography and Film, Rochester, NY. The "Coloramas," which changed nearly every month, were essentially Kodak adver-

tisements and largely featured families with cameras. Coloramas also showed images of sporting events, seasonal landscapes, tourist destinations, etc. A total of 565 Coloramas dominated Grand Central Terminal from May 1950 through March 1990.

117. "What Is Modern Photography?" panel discussion led by Edward Steichen, October 20, 1950, Museum of Modern Art, New York, featuring Margaret Bourke-White, Walker Evans, Gjon Mili, Lisette Model, Wright Morris, Homer Page, Irving Penn, Ben Shahn, Charles Sheeler, and Aaron Siskind.

118. "News and Notes along Camera Row: Museum Symposium," *New York Times*, November 5, 1950, 16X

119. "Camera Notes: Box Cameras Lead," *New York Times*, September 24, 1950, X15.

120. "Photographers Unlimited," *New York Times Magazine*, April 29, 1951, 24–25.

121. CJG: 49-50_00134-006.

122. The adult Pamela and Laura Walker appeared in *FVM*, though they did not remember Vivian Maier from the summer of 1951.

123. CJG: 49-50_00108-005, 49-50_00210-006, 49-50_00208-005, and 49-50_00210-003.

124. CJG: 55_00308-003, 49-50_00146-005, 55_00312-002, and ND_1174B_003. A woman within this series has been identified as Marie Jaussaud, though this is highly unlikely. There is no evidence that Maier and her mother were in contact after 1942. On Maier's 1959 U.S. passport application, she noted that her mother had died in 1943, though in fact she lived until 1975.

125. CJG: 51_3_16_VP_hw44_135-verso.

126. On the back of one of the prints, Maier wrote, "Aout 1951 Indian Reservation Southampton L.I." (CJG: c51-55_VP-32_495-verso).

127. G/M-Undivided: 3094.

128. CJG: ND_1177_005; G/M-Undivided: 3339.

129. Camp Red Fox was in New Hampshire, but a 1950s' advertisement indicated that the camp's director lived in Oyster Bay, Long Island.

130. G/M-Undivided: 3094

131. Antoine de Saint-Exupéry. *The Little Prince* (1943; repr., Boston: Houghton Mifflin Harcourt, 2010), 64.

132. Ron Slattery, "Story," Big Happy Funhouse, July 22, 2008, www.big-happyfunhouse.com/archives/08/07/22/12-30-34.html. Though the buyers at the RPN auction did not know her name when they were bidding, Slattery found her name written on her materials.

133. Days later, Slattery followed up by introducing another photographer who also made black-and-white photographs of Chicago that dated to the 1950s. But in that case Slattery had obtained the de-

ceased photographer's full archive and was working with the family to secure copyright so he could reproduce the work.

134. The April 22, 2008, invoice shows ten rolls of 120 film developed at a steep $12 each, and their contact sheets printed at $8 each.

135. On John Maloof's website, he states, "In 2008 Vivian fell on a patch of ice and hit her head in downtown Chicago," accessed February 1, 2017, http://www.vivianmaier.com/about-vivian-maier/; and Jeffrey Goldstein relayed that Maier fell more than a half mile away from her home, at the foot of a train platform: "She fell, and actually hit her head right by those tracks," *VM:WTNP*, time code 00:19:26. But Patrick Kennedy witnessed the aftermath of Vivian Maier's fall, in the park.

136. johnmaloof, "1950s—Vivian Maier," https://www.flickr.com/photos/ragstamp/3155991381/.

137. johnmaloof, "Dark Alley Original 1950s—Vivian Maier," https://www.flickr.com/photos/ragstamp/3170168459/in/photostream/, and "Dark Alley 2009—Homage to Vivian Maier," https://www.flickr.com/photos/ragstamp/3166390731/in/photostream/.

138. "Little Miss Big Shot: Fifties America Exposed—by a French Nanny," *Independent*, November 1, 2009.

139. Blake Andrews, "Q & A with John Maloof," *B: Rumblings from the Photographic Hinterlands* (blog), January 12, 2011, http://blakeandrews.blogspot.com/2011/01/q-with-john-maloof.html.

140. First posted feedback on receipt of shipped negatives, March 30, 2009, eBay user photographybinge, as of January 17, 2017, known as artaround, http://www.ebay.com/usr/artaround. (In October 2013, eBay removed purchase details from its feedback pages). First posted feedback, accessed February 1, 2017, feedback.ebay.com/ws/eBay-ISAPI.dll?ViewFeedback2&ftab=AllFeedback&userid=artaround&iid=-1&de=off&items=200&interval=0&searchInterval=30&mPg=3&page=3.

141. CJG: c51-55_VP_033_497, 55_00312-007, c51-55_VP_451_652, and c51-55_VP_535_733.

142. CJG: ND_1174B_004, and ND_1174B_006.

143. CJG: c51-55_VP_535_732 (annotated in pencil, "Sun. 23rd of Sept. 1951 River, New York"), and 55_00312-001.

144. A print shows the sisters also with an older woman, and a print of the woman alone is annotated in pencil, "Dimanche le 14 Octobre 1951 Madame Randazzo" (CJG: c51-55_VP_452_690-hw452_690). The sisters' father's naturalization papers show his address as 324 E. Sixty-Third St. and list his daughters' names and birthdates. Details of the surrounding area show that the portraits were made from the roof of this building.

145. CJG: 55_00283-006.

146. CJG: 55_00285a-001, and ND_1179_001.

147. "Long Island City," *New York Neon Blog*, September 27, 2012, http://nyneon.blogspot.com/2012/09/long-island-city.html.

148. Ibid.

149. *Manhattan Address Telephone Directory*, April 28, 1950 (New York: New York Telephone Company, 1950), microform, New York Public Library.

150. CRS: multiple prints, annotated "End of October 1951 Taken from Queens Plaza"; and *VM:APF*, 44: "New York, February 9, 1953."

151. CRS annotated print, "Samedi le 3 Novembre 1951 Francisco, Camaguey Cuba Mr. & Mrs. Mc. Nulty's daughter"; G/M-Undivided: 2725 (CRS print annotated, "Dimanche le 4 November Francisco, Camaguey Cuba [Sugar Mill]"); CJG: 55_00309-003 (CRS print).

152. CJG: 55_00309-004 (CRS print).

153. CJG: 55_00309-005 (CRS print, annotated, "Dimanche le 4 Novembre 1951 Francisco, Camaguey Cuba").

154. G/M-Undivided: 2964 (CRS print), 2906 (CRS print).

155. *VM:WTNP*, time codes 00:53:51 and 00:53:46.

156. CJG: 55_00287-002.

157. "LIFE Announces the Winners of the Young Photographers Contest," *Life*, November 26, 1951, 15.

158. Ibid.

159. The names of the other contest winners are Esther Bubley, Alfred Gescheidt, John Goeller, Regina Fisher, Carroll Seghers, Louis Stettner, and Dennis Stock (ibid.).

160. Fendall Yerxa, "Photography: Prints Sold at Museum of Modern Art. Sale Coupled with Exhibition Tests Public Interest in Photo Collecting," *New York Times*, December 2, 1951, D16.

CHAPTER FIVE

1. Estate of Vivian Maier No. 09 P 00587, "Report of the Guardian Ad Litem," filed February 26, 2009, Circuit Court of Cook County.

2. Philip Boulton, e-mail correspondence with the author, January 8, 2014.

3. Kimmo Koistinen, e-mail correspondence with the author, January 16, 2014.

4. Allan Sekula, e-mail correspondence with Maloof, April 16, 2009; anonymous potential buyer, phone conversations, April 11, 2013; Benjamin Wickerham, e-mail correspondence, January 17, 2014.

5. Wickerham, e-mail correspondence with the author, January 17, 2014.

6. Anonymous sources, phone conversations, April 11, 2013, November 2013.

7. Anonymous source, e-mail correspondence, July 24, 2013; anonymous source, phone conversations, November 2013.

8. For more than two years, beginning in January 2011, postings on a photography forum refer to the Canadian woman's collection. May 28, 2012: "One of my friends bought 40 negatives of Vivians [sic] work when they first started going on Ebay. Her goal is to make silver gelatin fibre prints of this body of work" (http://www.largeformatphotography.info/forum/showthread.php?84744-Vivian-Maier-in-NYC-until-Jan-28th-2012&p=892354&viewfull=1#post892354).

9. Allan Sekula, "On the Invention of Photographic Meaning," *Artforum*, 13, no. 5 (January 1975): 36–45, and "The Body and the Archive," *October*, no. 39 (Winter 1986): 3–64.

10. Sekula, e-mail to John Maloof, April 20, 2009. Sekula was preparing for an exhibition at the University of Chicago's Renaissance Society: *Polonia and Other Fables*, September 20–December 13, 2009. Sekula quoted by permission, courtesy of the Allan Sekula Studio LLC.

11. Ibid.

12. Sekula, e-mail to Ron Slattery, April 23, 2009.

13. Slattery, e-mail to Sekula, April 27, 2009.

14. Sekula, e-mail to Slattery, April 28, 2009,

15. Sekula, e-mail to Sally Stein, May 3, 2009.

16. Ibid.

17. CJG: 52_01_VP_hw-146-Kodak.Velox_551-verso ("Early January 1952 Brookville, L.I."), c51-55_VP_074_513-verso ("Mercredi le 16 Janvier Central Park"), c51-55_VP_hw866_811-verso ("Dimanche le 20 Janvier 1952 Brookville, L.I."), c51-55_VP_hw965_839-verso ("Jeudi le 24 Janvier 1952 Queensborough [sic] bridge N.Y."), c51-55_VP_561-hw561_755-verso ("Mercredi le 30 Janvier 1952 Brookville, L.I."), and 52_02_13_VP_hw-179-Kodak.Velox_564-verso ("Mercredi le 13 Fevrier 1952 west 42nd St. N.Y."); CRS: "End of February 1952 Brookville, L.I. Home of John Aiken"

18. Jacob Deschin, "M. Atget's Paris. 200-Print Show at New School Presents His Record of the City's Beauty," *New York Times*, December 2, 1951, 138.

19. "Pictures as Art: Instructor Defines Creative Photography as Scientific Eye That Captures Life, by Lisette Model, Photographer and Teacher," *New York Times*, December 9, 1951, 143.

20. CJG: 1952_1-24c51-55_VP_hw965_839-verso ("Jeudi le 24 Janvier 1952 Queensborough [sic] bridge N.Y.").

21. CJG: 55_00251-001, and 55_00251-007.

22. CJG: 55_00251-003 (*VM:WTNP*, time code 00:54:21), print an-

notated, "jeudi le 24 janvier 1952 Salvadore [*sic*] Dali taken shortly before 12 o'clock."

23. *VM:WTNP*, time code 00:54:23.

24. *VM:OOTS*, p. 37, photo captioned "Artist Salvador Dali."

25. Jacob Deschin, "The Work of French Photographers. Museum Show Points up Their Ability to Use the Commonplace," *New York Times*, December 23, 1951, X14.

26. Soichi Sunami, installation view of *Five French Photographers*, Exhibition Installation Photograph Collection (Photographic Archive, Museum of Modern Art, New York).

27. CJG: 52_02_13_VP_hw-179-Kodak.Velox_564.

28. It's unclear where Maier was residing during this period. Although some photographs show her in Queens, it is possible that she was living in the same East Sixty-Fourth Street building from her youth. Other images show the inside of a kitchen in which a window reveals a fire escape and narrow courtyard that closely resembles that building's features.

29. CJG: c51-55_VP_861_807; G/M-Undivided: 3368.

30. CJG: c51-55_VP_hw884_822-verso ("Dimanche le 30 Mars 1952 Gentleman from Holland N.Y.C.").

31. CJM: VM1953W03397-12-MC, "1953. New York, NY," accessed February 1, 2017, http://www.vivianmaier.com/gallery/street-2/#slide-33.

32. CJG: c51-55_VP_hw404_617-verso ("Beatrice Lilly english comedienne").

33. CJG: ND_1173_005 (*VM:OOTS*, 35, photo captioned "Central Park, New York").

34. CJG: 55_00278-007.

35. CJG: 55_00300-003, 55_00277-002, and 55_00270-001; *VM:OOTS*, 34.

36. CJG: 55_00258-005, and 55_00258-008 (CRS prints).

37. CJG: 55_00307-002.

38. *VM:OOTS*, 39 (CRS print) This image has repeatedly been misattributed as depicting Coney Island, including in the 2012 *New York Times Lens* blog by Richard Cahan and Michael Williams, "An Outsider's Life in Pictures and Boxes," November 7, 2012, http://lens.blogs.nytimes.com/2012/11/07/a-outsiders-life-in-pictures-and-boxes/?module=Search&mabReward=relbias:w&_r=0; and in *VM:OOTS*, both photos captioned, "On the beach at Coney Island during the early 1950s. Vivian Maier learned to photograph using a box camera, which lends an impressionistic look to her early work."

39. CJG: 55_00280-005, and 55_00280-010.

40. Maloof's blog is titled *Vivian Maier—Her Discovered Work* (http://

vivianmaier.blogspot.com). Slattery says he helped Maloof establish Maier's web presence during this period.

41. Allan Sekula, e-mail to John Maloof, June 6, 2009, first of two.

42. Ibid.

43. Sekula, e-mail to Maloof, June 6, 2009, second of two.

44. Sekula, e-mail to Maloof, June 10, 2009.

45. "The first batch of rolls came out a bit thin but mainly usable. It was only after developing about 100 rolls that I realized I should be pushing these. Since then, they have been fine" (Hardcore Street Photography, October 9, 2009, https://www.flickr.com/groups/94761711@N00/discuss/72157622552378986/page1).

46. Maloof also acquired the URL http://www.vivianmaier.com, which redirected to the Blogspot page.

47. The web addresses for the two sites are http://www.vivianmaier.blogspot.com and http://www.johnmaloof.blogspot.com, respectively.

48. The website John Maloof, Chicago Street Photography no longer exists in its original incarnation.

49. Gene M. Brown, "Business Streets of New York: Third Ave. Is City's Curio Shop," *New York Times*, July 16, 1951, 21.

50. "Pawnshop Goes to Movie. Owner Rents It to Film Unit: Suits Stay in Pawn for Week," *New York Herald Tribune*, August 2, 1952, 4.

51. CRS prints.

52. This is likely the negative from which John Maloof sold digital prints labeled, "VINTAGE 50'S OLD NEW YORK PHOTO OF L-TRAIN/MOVIE"; it is also featured as the back cover of his first book of Maier's work, *VM:SP*. Maloof inexplicably indicates the picture was taken in 1953.

53. CRS prints.

54. "Darkroom Rental Space. Robert Cottrol's Studio 983 at 983 Third Avenue offers equipped darkroom, studio and club or group meeting space on a rental basis by the hour, day, week or month. Studio 983 is open from 9 A.M. to midnight seven days a week" (*New York Times*, April 13, 1952, X13).

55. "Courses," *New York Times*, April 6, 1952, X16. Cottrol went on to a long illustrious career that included editing *Photo Arts* magazine in addition to doing his own camera work. Obituary, *New York Amsterdam News*, November 26, 2009.

56. Until Maier's negatives changed to a square format, stamped and penciled marks on the prints' reverse sides indicated that the establishment that developed the film had also printed them. But during the summer of 1952, many of Maier's small, snapshot-sized contact prints show the images crookedly placed on not-quite-square cut pieces of photo paper.

57. CJG: ND_1174_006 (CRS print).

58. G/M-Undivided: 2634, 2635, and 2655 (CRS prints).

59. Negatives from that day's activity were also part of Randy Prow's cache. John Maloof and Jeffrey Goldstein would separate the negative frames when they divided Prow's collection. CRS contains vintage prints that match the negatives.

60. *VM:WTNP*, time code 00:55:42.

61. *VM:WTNP*, time codes 00:55:33, 00:56:43, and 00:57:00; *VM:OOTS*, 60, 61.

62. *VM:WTNP*, 00:55:29.

63. CJG: 55-00215a-001 (CRS print).

64. CJG: 55_00212-004, and 55_00212-008; *VM:WTNP*, time codes 00:57:28 and 00:57:18; CRS prints.

65. *VM:WTNP*, time code 00:56:11; *VM:OOTS*, 69.

66. "GOVERNESS—French, experienced nursery governess, very trustworthy, with Christian family going to California or South; best reference Write E. Haugmard, 254 East 48th," *New York Herald Tribune* ad, October 23, 1928.

67. Haugmard is listed as living at 419 East Sixty-Fourth Street from 1940 through 1959. *New York City Telephone Directories: Manhattan—Address Telephone Directory* (New York: New York Telephone Company, 1940–59), microform, New York Public Library.

68. *VM:OOTS*, 65 (CRS print).

69. CRS prints.

70. CJG: 55_00224a-005.

71. CJM: CHI-874 (vivianmaier.blogspot.com/2009/07/blog-post_28.html); CJG: 1952_10-c51-55_VP_xx_850, and c51-55_VP_xx_852; CRS prints.

72. CRS prints.

73. Blake Andrews, "Q & A with John Maloof," *B: Rumblings from the Photographic Hinterlands* (blog), January 12, 2011, http://blakeandrews.blogspot.com/2011/01/q-with-john-maloof.html

74. Jeffrey Fraenkel, interview in "1800–1914: Fixing the Shadows," episode 1 of 6, in *The Genius of Photography*, October 25, 2007, series director and producer, Tim Kirby, BBC4.

75. Series narrator Denis Lawson, in ibid. Lartigue's biographer, Kevin Moore, acknowledged that the child prodigy was "essentially a gifted amateur," words that would echo through Vivian Maier's story.

76. Joel Meyerowitz, interview in "1918–1945: Document for Artists," episode 2 of 6, in *The Genius of Photography*, November 1, 2007, series director and producer, Tim Kirby, BBC4.

77. François Reynaud, chief curator of the Musée Carnavalet in Paris,

which owns the Lartigue photo albums (interview in "1918–1945: Document for Artists," episode 2 of 6, in *The Genius of Photography*, November 1, 2007, series director and producer, Tim Kirby, BBC4).

78. Jack Kerouac, "Introduction," in Robert Frank, *The Americans* (Paris: Robert Delpire, 1958; New York: Grove Press, 1959).

79. Colin Westerbeck and Joel Meyerowitz, interviews in "Paper Movies," episode 4 of 6, in *The Genius of Photography*, November 15, 2007, series director and producer, Tim Kirby, BBC4.

80. Emmanuel Pierrat, interview in "Snap Judgments," episode 6 of 6, in *The Genius of Photography*, November 29, 2007, series director and producer, Tim Kirby, BBC4.

81. Revisions to the Copyright Act include: 1831, protection extended from fourteen to twenty-eight years; 1909, published works marked as copyrighted are protected; 1976, extension of protection to life plus fifty years, the introduction of "fair use," and protection to unpublished works; 1988, United States added to countries of the 1886 Berne Convention, which unified rules and protection; 1992, protection of works made between 1964 and 1977 automatically renewed, even if not registered; 1998, life plus seventy years, protection of works published before 1978 extended to ninety-five years after publication date. Also in 1998, the Digital Millennium Copyright Act codified the 1996 World Intellectual Property Organization copyright treaty, which was in agreement with an amendment in the Berne Convention dealing with protection of works utilizing digital technologies.

82. CRS prints; also CJM: https://www.facebook.com /photographervivianmaier/photos/a.10150753556990720 .718487.444225420719/10150763476020720/.

83. CRS print, featured in Andrew Huff, "Opening: Vivian Maier: Vintage Prints," *Gapers Block*, June 29, 2012, http://gapersblock.com/ ac/2012/06/29/opening-vivian-maier-vintage-prints/; *VM:APF*, 44, photo captioned "New York, February 9, 1953."

84. CJM: VM1953W03396, "Fall 1953, New York, NY," accessed February 1, 2017, http://www.vivianmaier.com/gallery/contact-sheets/#slide-2.

85. *VM:SP*, 100; and *VM:APF*, 88 ("New York, 1953"); CJG: c51-55_ VP_xx_945.

86. "France's Pinay: Sécurité, stabilité, tranquillité." *Time*, December 22, 1952; *VM:Self*, 39, photo captioned "Undated—New York."

87. *VM:SP*, cover; *VM:APF*, 57, photo captioned "Self-portrait, New York, October 18, 1953."

88. Vivian Maier Facebook page, "1950ies," October 10, 2011, https://www.facebook.com/photographervivianmaier/photos

/a.10150753556990720.718487.444225420719/10150860884450720/;
VM:Self, 19.

89. CJM: 53-473, "End of April, 1953, New York, NY," Internet Archive: Wayback Machine, August 19, 2011, web.archive.org/web/20110819032759/www.vivianmaier.com/portfolios/new-york-2/?pid=231.

90. Ruth Orkin, photographer, *Judy Holliday at Columbus Circle for "It Should Happen to You"* / *Ruth Orkin*, 1953 [printed, ca. 1975], https://www.loc.gov/item/2016646150/.

91. CJM: 53-187, "Untitled, 1953," Internet Archive: Wayback Machine, August 19, 2011, web.archive.org/web/20110819031940/www.vivian-maier.com/portfolios/new-york-2/?pid=226.

92. *VM:APF*, 60, photo captioned "New York, March 27, 1953"; CJM: VM1953W00564-04-MC, "1953, New York, NY," accessed February 1, 2017, http://www.vivianmaier.com/gallery/street-1/#slide-26.

93. CJM: VM1953W03404-09-MC, "May 10, 1953, New York, NY," accessed February 1, 2017, http://www.vivianmaier.com/gallery/street-2/#slide-26; *VM:APF*, 61, photo captioned "New York, May 10, 1953."

94. *VM:Self*, 69, photo captioned "1953—New York"; *VM:AFP*, 53, photo captioned "New York, September 1953."

95. CRS negatives and prints; *VM:APF*, 155, photo captioned "Canada, date unknown."

96. CRS negatives and prints.

97. Jacob Deschin, "Mankind in Pictures: Steichen Planning Exhibit on International Theme," *New York Times*, September 21, 1952, X17.

98. "The Taxing Task of Rounding up Pictures," *Life*, February 14, 1955, 29.

99. "What Do I Do with This Stuff (Other Than Give It to You)?" Flickr thread in the Hardcore Street Photography group, end of December 2010, www.flickr.com/groups/94761711@N00/discuss/72157622552378986/.

100. Hardcore Street Photography, https://www.flickr.com/groups/onthestreet/.

101. "Vivian Maier Follow Up," December 26, 2010, Metafilter, http://www.metafilter.com/98950/Vivian-Maier-follow-up#3438490.

102. Paid death notice, *Chicago Tribune*, April 23, 2009. The Gensburgs acknowledged Maier's interest in Native Americans and chose this charity via an Internet search. Unpublished portion of Nora O'Donnell's "The Life and Work of Street Photographer Vivian Maier," *Chicago*, January 2011. From interview with Lane Gensburg, December 2010, courtesy of O'Donnell.

103. Blake Andrews, "Lost, and Found," *B: Rumblings from the Photo-*

graphic Hinterlands (blog), October 12, 2009, http://blakeandrews. blogspot.com/2009/10/lost-and-found.html.

104. Jacob Deschin, "Pictures Wanted: Museum Calls for 'Family of Man' Contributions," *New York Times*, January 31, 1954, X12.

105. Ibid.

106. The first photo, captioned "Christmas Eve 1953, East 78th Street & 3rd Avenue, New York, NY," can be found at *VM:SP*, 111, and http://www.vivianmaier.com/gallery/street-1/#slide-20 (accessed February 1, 2017); CJM: VM1953W03399-01-MC; second photo, accessed January 20, 2014, http://alafoto.com/listing/albums/Vivian%20Maier/Vivian_Maier_018.jpg (no longer available online). An eleven-by-fourteen-inch print of the first image was within a portfolio acquired by Kathy Gillespie at the November 7, 2007, RPN auction.

107. CJG: c51-55_VP_xx_939.

108. CJG: 51-55_VP_RS25_974-verso.

109. CRS prints, seated woman annotated verso, "January 1953." John Maloof has identified the strip of negatives as from his collection. The *New York Times Lens* blog reproduced the picture of the woman holding the negative strip in an article in which independent researcher Ann Marks asserted the woman was Jeanne Bertrand and, further, speculated that Maier had an ongoing relationship with Bertrand. There is no known evidence that Maier and Bertrand had contact beyond 1930, when four-year-old Vivian lived with her mother in Bertrand's Bronx apartment. Jeanne Bertrand's granddaughter confirmed that the woman in the photograph is not her grandmother. Kerri MacDonald, "A Peek into Vivian Maier's Family Album," *Lens* (blog), *New York Times*, January 13, 2016, https://lens.blogs. nytimes.com/2016/01/13/a-peek-into-vivian-maiers-family-album/.

110. The letter (translation from phonetic French) is in CJM.

111. The roll of film with the restaurant interior is in CJG.

112. CRS prints.

113. CJG: c51-55_VP_xx_914.

114. CRS prints.

115. CRS prints.

116. CJG: 45-1954_51-55_VP_RS45_994, and c51-55_VP_rs34_983 (both enlarged as four-by-five-inch prints); *VM:APF*, 116, photo captioned "New York, 1954."

117. *Vivian Maier—Her Discovered Work* (blog), June 2, 2009, vivianmaier.blogspot.com/2009/06/blog-post_8714.html. Maier later made an eleven-by-fourteen-inch print of this shot (CRS).

118. CRS prints, many four-by-five-inch enlargements.

119. CRS prints; this image was presented in *VM:APF*, 17, with the

misleading caption, "An acquaintance of Maier's making photo-graphic prints. New York, 1954."

120. CRS prints; *VM:APF*, 77, photo captioned "Self-portrait, New York, 1954."

121. Joe Hyams, "Anne Baxter Cast by U-I as Star of 'Tacey Cromwell,'" *New York Herald Tribune*, September 30, 1954, 17.

122. *VM:APF*, 31, photo captioned "Actress Ava Gardner signing auto-graphs. Location unknown, 1954."

123. *VM:APF*, 97, photo captioned "Lena Horne, New York, September 30, 1954." Maier also made an eight-by-ten-inch enlargement of this image (CJM).

124. Allen Ginsberg, *Howl and Other Poems*, Pocket Poets Series, no. 4 (San Francisco: City Lights Pocket Bookshop, 1956).

125. CJM: 54-60, "Undated, New York, NY," Internet Archive: Wayback Machine, February 12, 2012, https://web.archive.org/web/20120212020618/www.vivianmaier.com/portfo-lios/new-york-2; CJM: 54-56, "1954, New York, NY," Inter-net Archive: Wayback Machine, May 7, 2011, web.archive.org/web/20110507235710/http://www.vivianmaier.com/portfolios/new-york-2/?show=thumbnails&pid=237; *VM:SP*, 52.

126. CRS four-by-five-inch prints.

CHAPTER SIX

1. Blake Andrews, "The Flame of Recognition," *B: Rumblings from the Photographic Hinterlands* (blog), October 19, 2009, http://blakean-drews.blogspot.com/2009/10/flame-of-recognition_19.html.

2. John Maloof, "Unfolding the Vivian Maier Mystery . . . ," October 22, 2009, http://vivianmaier.blogspot.com/2009/10/unfolding-vivian-maier-mystery.html.

3. *VM:Self*, back cover; CJM: VM1955W02770-06-MC, "Self-Portrait, 1955," accessed on February 1, 2017, http://www.vivianmaier.com/gallery/self-portraits/#slide-5.

4. johnloofy, "When Do I Own the Rights to Reproduce Photo-graphs[?]," ExpertLaw, October 21, 2009, http://www.expertlaw.com/forums/showthread.php?t=87719.

5. *Vivian Maier—Her Discovered Work* (blog), October 31, 2009, vivi-anmaier.blogspot.com/2009/10/blog-post_31.html.

6. johnloofy, "When Do I Own the Rights to Reproduce Photo-graphs[?]," ExpertLaw, November 1, 2009, http://www.expertlaw.com/forums/showthread.php?t=87719.

7. "Little Miss Big Shot: Fifties America Exposed—by a French Nan-ny," *Independent*, November 1, 2009.

8. Felix, "[Fotógrafos anónimos] Vivian Maier," *Carborian,* October 23, 2009, http://www.caborian.com/fotografos-anonimos-vivian-maier/.

9. Kathy Gillespie acquired this mounted print at the November 7, 2007, RPN auction, amid approximately 150 eleven-by-fourteen-inch Vivian Maier prints.

10. She was using 8 ISO film until July or September, then when 35 mm format was released in July it was discontinued and replaced with 32 ISO film, exceedingly slow by today's standards. Jacob Deschin, "A Faster Color Film," *New York Times,* January 2, 1955, X11.

11. CRS transparencies.

12. Maier may have meant to say she was shooting with "key light," which is the main light source in studio photography.

13. CRS transparencies and prints; CJG: c51-55_VP_xx_925.

14. CJG: c51-55_VP_xx_909.

15. *VM:Self,* 63, photo captioned "1955—New York."

16. CRS transparencies.

17. CRS transparencies,

18. *VM:WTNP,* time code 00:57:52.

19. John Maloof, blogger profile, Internet Archive: Wayback Machine, October 16, 2009, https://web.archive.org/web/20091016225138/http://www.blogger.com/profile/13276966317587795374.

20. Gillespie and her son kept the portfolios until November 2011. They initially listed the portfolios as a lot on eBay for $9.99, but the work didn't receive any bids. They then put all but a half-dozen prints up for sale at another small Chicago auction house. Gillespie learned about Vivian Maier long after the prints were sold.

21. *Viva Vivian,* Bruun's Galleri, March 19, 2010, for 3 weeks, Aarhus, Denmark. John Maloof: "19th of March for about 3 weeks," March 6, 2010, Internet Archive: Wayback Machine, October 15, 2010, web.archive.org/web/20101015220433/http://vivianmaier.blogspot.com/2010/03/19th-of-march-and-for-about-3-weeks.html.

22. Bruun's Galleri—i hjertet af Århus, Med afsæt i den tidløse elegance i Vivian Maiers billeder præsenterer vi forårsmoden 2010 i Bruun's Galleri. På de følgende sider ser du snapshots af de nyeste trends. Når du besøger os, folder vores 90 butikker hele modebilledet ud. Velkommen. April 12, 2010, http://bruunsgalleri.dk/ (no longer available online; archived).

23. Michelle Hauser, "Finding Vivian Maier," interview with John Maloof, March 31, 2010, Design Observer Group, http://designobserver.com/feature/finding-vivian-maier/13118.

24. Ibid.

25. Ibid.

26. Mir Appraisal Services: A Research-Based Fine Art & Personal

Property Appraisal Company, http://mirappraisal.com/about/our-company/: "We regard research and analysis to be the most important aspects of the appraisal process. Our researchers and appraisers place an overall value on items by taking into account their provenance, examining their historical significance, and analyzing the current state of the market for comparable items."

27. Jessica Savitz, "Vivian Maier Tribute, Part I," May 7, 2010, MIR Appraisal Service: A Research-Based Fine Art & Personal Property Appraisal Company, http://art-appraisals-and-research.com/blog/?p=439.

28. Jessica Savitz, "Vivian Maier Tribute, Part II," May 14, 2010, Appraisal Service: A Research-Based Fine Art & Personal Property Appraisal Company, http://art-appraisals-and-research.com/blog/?p=474.

29. Jessica Savitz, "Vivian Maier Tribute, Part IV: The Interview," interview with John Maloof, May 28, 2010, Appraisal Service: A Research-Based Fine Art & Personal Property Appraisal Company, http://art-appraisals-and-research.com/blog/?p=506.

30. Bilerico Project: Daily Experiments in LGBTQ, "About Us," Internet Archive: Wayback Machine, June 28, 2010, http://web.archive.org/web/20100628124324/http://www.bilerico.com/about.

31. Gloria Brame, "Undiscovered Lives: Vivian Maier," Bilerico Project, July 2, 2010, http://www.bilerico.com/2010/07/undiscovered_lives_vivian_maier.php. The Wikipedia entry cited by Brame has since been edited and no longer references her men's jacket.

32. The obituary, of course, called Maier a "photographer extraordinaire." Kitchen Sisters, "The Lost and Found Photographs of Vivian Maier," March 24, 2010, http://www.kitchensisters.org/girlstories/the-lost-found-photographs-of-vivian-maier/; and Lacy Roberts, "Vivian Maier's Hidden World," audio piece presented on January 8, 2011, http://www.kitchensisters.org/girlstories/vivian-maiers-hidden-world/.

33. Blake Andrews, "Q & A with John Maloof," *B: Rumblings from the Photographic Hinterlands* (blog), January 12, 2011, http://blakeandrews.blogspot.com/2011/01/q-with-john-maloof.html.

34. John Maloof, "Update," *Vivian Maier—Her Discovered Work* (blog), November 11, 2010, vivianmaier.blogspot.com/2010/11/update.html.

35. Ibid.

36. Maier photographed her passbook in March 1959 before sending it to the Los Angeles bank to withdraw money for her East Asian travel excursion. (See note 47, below, which refers to the photo of her passbook).

37. CJG: 55c_00242-004; *VM:OOTS*, 49, photo captioned "Grauman's

Chinese Theater"; CJG: 55c_00242-001.

38. CJG: 55c_00242-004-000243-010; "International Film Fete to Be Held at Sunset," *Los Angeles Times*, May 22, 1955, E2. Vivian Maier's photograph shows the advertisement for *Children of Paradise*.

39. *VM:OOTS*, 47, photo captioned "Richard Widmark at Farmer's Market."

40. "Henry's Camera Bargains Sells at New York Prices," advertisement, *Los Angeles Times*, September 11, 1955. Vivian Maier banked at the Seventh and Grand branch of the Security-First National Bank of Los Angeles. The Southland Hotel was located at 605 S. Flower Street at Sixth Street. Envelope from Tricolor Laboratories with this address from the Ron Slattery Collection.

41. CJG: 1955_6-55c_00242-007, 55_7_00234-002, ND_1158_005, and 55c_00244-003.

42. CRS transparencies; CJG: 55_00240-002, 1955_8-22-55_8_00231-002, and 55_8_00229-012.

43. *VM:OOTS*, 55, photo captioned "Self Portrait."

44. *VM:Self*, 15, photo captioned "September 10, 1955—Anaheim, California." This was the first portrait that Maloof posted of Vivian Maier.

45. CJG: 55c_00243-001, ND_1122_002, ND_1122_007, and ND_1122_001.

46. CRS five-by-seven-inch print.

47. CJG: 59_00832ab-020.

48. CRS prints.

49. CRS print.

50. *VM:SP*, 51; CRS print: "Adventure," October 25, 2008, http://www.bighappyfunhouse.com/archives/08/10/25/19-36-56.html; CJM: VM1955W03422-06-MC, "November 8, 1955," accessed February 1, 2017, http://www.vivianmaier.com/gallery/street-4/#slide-45; Vivian Maier Facebook page, "1955, San Francisco," https://www.facebook.com/photographervivianmaier/photos/a.10150753556990720.718487.444225420719/10153814140765720/.

51. CRS prints.

52. Jeffrey Goldstein, "Vivian Maier Prints: The Story," Internet Archive: Wayback Machine, April 16, 2011, web.archive.org/web/20110314193103/http://vivianmaierprints.com/the-story.

53. *VM:WTNP*, time codes 00:16:08 and 00:16:12.

54. "The Meteoric Rise of Vivian Maier," *Chicago Tonight*, August 1, 2012, transcript.

55. *VM:WTNP*, time code 00:20:57.

56. Agreement signed by Randy Prow, Jeffrey Goldstein, and John Maloof, January 21, 2011. Presented as "Motion to Clarify Issue

Arising during Oral Argument," to the Circuit Court of Cook County, Illinois, filed June 30, 2016. The first two agreements between Goldstein and Prow were submitted, as well: "Sold old vintage negs and prints for [$]16,000"; and "June 2, 2010 Paid Cash [$]5,000.00 Vivian Maier photos negs., movies & slides."

57. Jeffrey Goldstein, "Art, Money and Vivian Maier," Vivian Maier Prints website, February 14, 2011, Internet Archive: Wayback Machine, April 15, 2012, web.archive.org/web/20120415130024/ http://vivianmaierprints.com/vivian-maier-prints-inc-blog. php?id=7820129143727252813.

58. Ibid.

59. *VM:WTNP*, time code 00:21:54.

60. "Counterclaim for the Imposition of a Constructive Trust and an Equitable Lien on the Basis of Unjust Enrichment," issued by Jeffrey Goldstein and his attorneys, May 12, 2015, Circuit Court of Cook County.

61. Karl Edwards, "Interview: Jeffrey Goldstein on Why He's Suing Vivian Maier's Estate," PetaPixel, May 17, 2015, http://petapixel. com/2015/05/17/interview-jeffrey-goldstein-on-why-hes-suing-vivian-maiers-estate/.

62. Frances Brent, "Vivian Maier's Jewish Chicago: A Reminiscence, as a New Doc Tries to Revive Her Story," *Tablet*, October 10, 2012, http://www.tabletmag.com/jewish-arts-and-culture/113385/vivian-maier-jewish-chicago. "In Highland Park, where she worked for our friends the Gensburgs, living in their house from 1956 until 1972, Vivian was one of the outsiders—housekeepers, maids, nannies who came into our tight, predominantly Jewish community and ensured it wasn't hermetically sealed."

63. "Help Wanted Women: Household Help," *Chicago Tribune*, February 2, 1956, C18. A slightly altered version ran three days later. The phone number in the ads belonged to the Gensburgs.

64. Unpublished portion of Nora O'Donnell's "The Life and Work of Street Photographer Vivian Maier," *Chicago*, January 2011. Quoted from interview with Avron and Nancy Gensburg, December 2010, courtesy of O'Donnell.

65. CJM: 56-610, http://www.vivianmaier.com/media/2011/04/56-610_298px.jpg.

66. *VM:WTNP*, time code 00:16:28.

67. CJM: VM1956W03425-04-MC, "September 1956. New York, NY," accessed February 1, 2017, http://www.vivianmaier.com/gallery/street-1/#slide-47.

68. For more than two years, John Maloof's website captioned this photograph, "Armenian woman fighting, September, 1956, Lower

East Side, NY," despite the storefront awning in the distance that clearly reads "218 East 86th." Vivian Maier website, February 10, 2012, Internet Archive: Wayback Machine, http://web.archive.org/web/20120210153805/www.vivianmaier.com/portfolios/new-york-1/?show=thumbnails&pid=208.

69. CJM: 56-139, *Vivian Maier—Her Discovered Work* (blog), February 14, 2011, vivianmaier.blogspot.com/2011/02/blog-post_14.html.

70. Jill Nicholls, "Vivian Maier: Lost Art of an Urban Photographer," BBC Arts, June 25, 2013, http://www.bbc.co.uk/arts/0/23007897.

71. CJM: 56-738, "September 30, 1956, New York, NY," Internet Archive: Wayback Machine, February 10, 2012, web.archive.org/web/20120210153811/www.vivianmaier.com/portfolios/new-york-1/?show=thumbnails&pid=209.

72. The backs of Maier's remaining photos from this time show processing details. For example, a now-faded nearly monochrome magenta photograph of a woman in cat's-eye glasses and green shorts, and carrying a sun parasol, is marked on the verso, "This is a Kodacolor print made by Eastman Kodak Company, T.M. Regis. U.S. Pat. Off. Week Ending Aug. 25, 1956." CJG: c50s-70s_VP_56_08_1038.

73. CRS. Misspellings and strikethroughs are as in the original.

74. Paper emulsions were "graded" to counterbalance high- or low-contrast negatives. *F* was a code for Kodak's glossy surface paper (the *F* may have stood for "ferrotyping," the process by which paper was treated to give a high shine). While she usually eschewed glossy prints, Vivian Maier experimented with a variety of surfaces, as evidenced by photographic paper boxes and envelopes in CJM and CRS.

75. CRS includes six empty envelopes of five-by-seven-inch paper and three empty envelopes of eight-by-ten-inch paper. Several show expiration dates of 1957 and 1959, and all are of the same vintage. Kodak's Opal G is represented by an eight-by-ten as well as a five-by-seven envelope. Opal G paper was described as having a brown-black tone with a fine-grain luster surface, which matches vintage Maier prints in CRS.

76. *VM:APF*, 288 ("Self-portrait, Chicagoland, 1956"); *VM:Self*, 28 ("Early July 1956—Chicago area"), and 21 ("1956—Chicago area").

77. *VM:APF*, 171, photo captioned "Florida, January 9, 1957."

78. CRS notebook with Maier's travel notations, including hotel names, exchange rates, and embassy phone numbers.

79. Vivian Maier's passport had expired in 1952; she did not renew it until 1959. John Maloof's collection includes the South America itinerary; CRS includes notes for hotels and consulates for numerous countries, as well as correspondence with the travel agent.

80. CRS includes still-vibrant prints, one made during the week of May 13, 1957. Summer 1957 film footage from CJM was presented as part of *FVM*, and CRS includes a 16 mm Kodachrome movie from January 1958.

81. Annotated glassine envelope, CRS.

82. CJG negatives showed that Maier routinely fit as many as fifty-three exposures on a forty-eight-exposure roll of 35 mm film. Similarly, Maier got up to thirty-nine frames from the standard thirty-six-exposure format.

83. "6 Adventure-Packed Days in the Sub-Arctic . . . $141.50 from Winnipeg, Canada," Canadian National Railways advertisement, *Chicago Tribune*, July 7, 1957, D7.

84. Ward Allan Howe, "Plenty of Trains," *New York Times*, June 8, 1958, XX26.

85. CJG: 8-58_9_SL_PG9-010, nd_SL_PG77-001, and 58_9_SL_PG9-002; Internet Archive: Wayback Machine, January 15, 2013, web. archive.org/web/20160618020041/http://www.vivianmaier.com/ media/gallery/unknown/2398.jpg; "August, 1958, Cranberry Portage, Manitoba, Canada," Internet Archive: Wayback Machine, January 10, 2012, web.archive.org/web/20120110225340/http://www. vivianmaier.com/portfolios/travels/?show=thumbnails&pid=137. In 2012, three eight-by-ten-inch prints and one five-by-seven-inch of locals from this trip were offered for sale at Los Angeles's Merry Karnowsky Gallery via CJM.

86. "August, 1958, Churchill Manitoba, Canada," Internet Archive: Wayback Machine, January 10, 2012, web.archive.org/ web/20120110225436/http://www.vivianmaier.com/portfolios/tra vels/?show=thumbnails&pid=136; *Vivian Maier—Her Discovered Work* (blog), October 18, 2009, vivianmaier.blogspot.com/2009/10/ blog-post_1714.html; CJM prints.

87. *VM:Self*, 4, photo captioned "Fall 1958." CJM file number: VM1958Z06868-12-MC. John Maloof's file numbers indicate the year the image was taken (if shown on Maier's materials); number strings that refer to contact sheets and their image sequence; and the film type: "K, Color original positive; P, Black & White original positive; W, Black and White original negative; Z, Color original negative." Accessed June 9, 2013, archive.vivianmaier.com/about (no longer available online).

88. Nora O'Donnell, "The Life and Work of Street Photographer Vivian Maier," *Chicago*, January 2011, www.chicagomag.com/Chicago-Magazine/January-2011/Vivian-Maier-Street-Photographer/index. php?cparticle=2&siarticle=1%23artanc.

89. David W. Dunlap. "New Street Photography, 60 Years Old," *Lens* (blog), *New York Times*, January 7, 2011. Goldstein's website stated that he owned only twenty reels of 8 mm footage.

90. O'Donnell, "The Life and Work of Street Photographer Vivian Maier."

91. John Maloof in *FVM*, time code 00:06:57.

92. John Maloof, "History," Vivian Maier website, accessed February 1, 2017, www.vivianmaier.com/about-vivian-maier/history/; *FVM*, time code 00:07:57. This film remained undeveloped until late 2016 or early 2017. On January 23, 2017, Maloof told me that the film had been processed and the most recent annotated cartridge was from 1999.

93. John Maloof, "Funded!" Kickstarter campaign: "Finding Vivian Maier"—A Feature Length Documentary Film, December 31, 2010, https://www.kickstarter.com/projects/800508197/finding-vivian-maier-a-feature-length-documentary/posts?page=6. The Kickstarter blog had featured the "Finding Vivian Maier" project the day after its launch, bringing it wider attention. Crowdsourcing was still in its infancy; at the time, two weeks was an extraordinarily short amount of time to achieve funding goals for the three-month-long fundraising model.

94. Photographs of the Cultural Center opening reception appeared on Flickr, footage was posted to YouTube, and Ron Slattery reported his impressions on Hardcore Street Photography.

95. Blake Andrews, "Q & A with John Maloof," *B: Rumblings from the Photographic Hinterlands* (blog), January 12, 2011, http://blakeandrews.blogspot.com/2011/01/q-with-john-maloof.html.

96. Conversations with Jeffrey Goldstein, whose digitized material was cataloged by the date of the "box split," the first of which was labeled in March 2011. Also, in February 2013, he showed me the last undivided batch to me.

97. Frank Jackowiak, "Chance Meeting Brings Obscure Photographer Vivian Maier into the Light and to the College of DuPage," *Silicone and Silver* (blog), College of DuPage Photo Program, January 14, 2011, https://codphoto.wordpress.com/?s=vivian+maier.

98. Ibid.; CJG: nd-01_01081_cod-001 through nd-01_01081_cod-39, and nd_37_01080_01081_cod-001 through nd_37_01080_01081_cod-039.

99. Kerri MacDonald, "Vivian Maier: Better and Better," *Lens* (blog), *New York Times*, February 16, 2012, http://lens.blogs.nytimes.com/2012/02/16/vivian-maier/.

100. Cassie Marketos, "Creator Q&A: The Museum of Non-Visible Art," interview with Brainard and Delia Carey, *Kickstarter Blog*, June 15,

2011, https://www.kickstarter.com/blog/creator-q-a-the-museum-of-non-visible-art.

101. Throughout the early phases of the documentary film production, Maloof's friend Anthony Rydzon was involved; the production company name combined their names: Toneloof Productions. Tony Rydzon soon disappeared from the production and was never mentioned again.

102. Allan Sekula, e-mail to Sharon Cohen, Associated Press reporter, January 5, 2011.

103. Allan Sekula, e-mail to John Maloof, March 11, 2011.

104. Allan Sekula, e-mail to Sharon Cohen, February 1, 2011.

105. Allan Sekula, e-mail to Sharon Cohen, February 9, 2011.

106. Allan Sekula died in August 2013.

107. CJG: 59_00832ab-010, photographed letter dated March 11, 1959. The total amount, $1,555.51, has a modern equivalent of approximately $15,000. Maier ended her missive: "Thank you for your help. Sincerely yours, Vivian Maier P.S. Kindly send me back my bankbook."

108. Maier photographed the document where she declared this sum as she was en route to the Philippines; $650 is worth approximately $6,000 today.

109. *VM:WTNP*, time code 00:57:57.

110. Some of these places are now known by different names: Indochina is Mainland Southeast Asia; East Indies now describes South and Southeast Asian countries, including India, Thailand (Siam), and Singapore, countries that Maier visited; and Port Swettenham is now Port Klang, the main gateway to Malaysia. Maier's listings of Penang and Aden are cities in Malaysia and Yemen, respectively.

111. *VM:WTNP*, time code 00:58:05. For whatever reason, two eight-by-ten enlargements of pages from Berthe Lindenberger's savings passbook are part of CRS.

112. The family would hire a replacement for Maier when she went on her excursions (O'Donnell, "The Life and Work of Street Photographer Vivian Maier").

113. *VM:Self*, 45, photo captioned "April 1959."

114. CJG: 156 negatives from the Robot camera.

115. *VM:ETE*, 88, photo captioned "Asia, 1959."

116. The part of CJG representing Southeast Asia (more than fifteen hundred images) was largely made up of Robot camera black-and-white negatives (there were also some color prints from the Rolleiflex, and color slides from the Contaflex); John Maloof's published images have been black-and-white ones from the Rolleiflex. Overlapping subject matter shows Maier sometimes shooting with more

than one camera nearly simultaneously. CRS includes an album of square color snapshots from the journey.

117. CJG: 59_7_23_00322-001, 59_7_23_00322-002, and 59_7_23_00322-003.

118. CJG: 59_00357-001, and 59_00315-006.

119. CJG: 59_7_23_00322-055; *VM:WTNP*, time codes 00:45:48 and 00:45:55.

120. CJM: 59-1528, "Self-Portrait, 1959," Internet Archive: Wayback Machine, July 8, 2011, web.archive.org/web/20110708032637/www.vivianmaier.com/portfolios/self-portraits/?show=thumbnails&p id=287.

121. Vivian Maier Facebook page, "France, 1959," May 7, 2013, www.facebook.com/photographervivianmaier/photos/a.1015195595625072 0.882732.444225420719/10152791638415720/?type=3&theater; CJG: 59_8_20-21_00327-057; CJG: 59_8_20-21_00327-051.

122. CRS eleven-by-fourteen-inch print; CJG: 59_7_00323-055, 59_8_14_00339-044, and 59_8_14_00339-045.

123. Maloof was granted trademark registration of "Vivian Maier" in November 2011 ("Mark: Vivian Maier," U.S. Patent and Trademark Office, U.S. Serial Number: 85227162, http://tsdr.uspto.gov /#caseNumber=85227162&caseType=SERIAL_NO&searchType =statusSearch). In August 2016, the trademark was reassigned to the Vivian Maier Estate (http://tsdr.uspto.gov/caseviewer/assignme nts?caseId=85227162&docIndex=0&searchprefix=sn#docIndex=0).

124. Goldstein's website is Vivian Maier Photography, vivianmaierprints. com.

125. Kelly Reaves, "Get Your Hands on Some Black & White Gold," *Gaper's Block*, March 15, 2011, http://gapersblock.com/ac/2011/03/15/ get-your-hands-on-some-black-white-gold/.

126. Ibid.

127. Although the exhibition closed in November 2010, on October 24, 2011, a Facebook post offered the remaining inventory of Maier digital prints at 5,000 Kronen (The Apartment Art Gallery, Oslo Norway, Facebook page, https://www.facebook.com/163527170348786/ photos/a.163843760317127.36726.163527170348786/277965525571616 /?type=3&theater).

128. Some of the prints matched eBay descriptions from 2008–9 sales.

129. "Vivian Maier works available" Internet Archive: Wayback Machine, September 12, 2011, web.archive.org/web/20110912103008/ http://www.bowmanart.com/bowman_info/archive/2011_vivian_ maier_photographs.html.

130. Julia Scully. "Mike Disfarmer, Heber Springs, Arkansas," *Aperture* 78 (Spring 1977): 6.

131. "Disfarmer prints featured in this Website are available exclusively from the Staley-Wise Gallery," http://www.disfarmer.com/order. htm (no longer available online; archived from February 21, 1997). "Disfarmer prints featured in this Website are available exclusively from the Gallery 292" (no longer available online; archived from August 15, 2001). Gallery 292 was a subsidiary of the Howard Greenberg Gallery.

132. Philip Gefter, "From a Studio in Arkansas, a Portrait of America: A Maverick Photographer Set up Shop on Main Street." *New York Times*, August 22, 2005, E1.

133. Ibid.

134. Edwynn Houk and Gerd Sander, *Disfarmer: The Vintage Prints* (New York: powerHouse Books, 2005). Mike Disfarmer, *Original Disfarmer Photographs*, ed. Steven Kasher (Göttingen: Steidl; New York: Steven Kasher Gallery, 2006).

135. *Disfarmer: A Portrait of America*, directed by Martin Lavut, Canada Media Fund (CMF), 2010. And puppet show: *Disfarmer*, by Dan Hurlin, originally performed at St. Ann's Warehouse, New York, January 27–February 8, 2009.

136. E-mail between the author and Steven Kasher, September 17, 2015. John Bennette curated the Hearst Gallery exhibition of vintage and prints made following Maier's death from CJG.

137. DH Haritou, December 9, 2011, comment on a review of *VM:SP*: "This first edition is sold out at the publisher. They are planning a reprint" (3G1B, review of *VM:SP*, 3G1B: Three Guys One Book, December 8, 2011, http://threeguysonebook.com/vivian-maier-street-photographer/).

138. "PRINTING UPDATE: The 2nd printing of Vivian Maier has sold out more quickly than expected, but a 3rd printing is on the way! Due to arrive mid/late Feb" (*VM:SP* Facebook page, January 2, 2012, https://www.facebook.com/vivianmaier/posts/272693446119011).

139. CJG: 59_9-6_00337-053.

140. CJG: 59_9_00318-007, 59_9_00318-019, 59_9_14_00335-041, 59_9_00317-042, and 60_08_C-VP_stamp_1085 (later print). Several color photos from throughout Paris in CJG (printed in September 1960) suggest Maier was shooting color negatives with the Rolleiflex and black-and-white with the Robot camera.

141. CJG: 59_9_00326-008, 59_9_00326-039, 59_9_00326-013, 59_9_00326-016, 59_9_00326-029, and 59_9_00326-043.

142. Robert J. Donovan, "Eisenhower Takes Paris," *New York Herald Tribune*, September 3, 1959, 1.

143. CJG: 59_00315-057, and 59_00315-058; *VM:WTNP*, time code 00:01:16.

144. CJG: 00315-002, 59_00315-010, and 59_9_00317-010.

145. CJG: 59_00315-037-647, 59_00315-039, 59_00315-041, 60-08_VP_stamp_1066-939-628 (printed later), and 59_9_00317-011.

146. CJM: VM1959W03439-02-MC, "September 29, 1959, New York, NY," accessed February 1, 2017, http://www.vivianmaier.com/gallery/street-4/#slide-44; CRS eleven-by-fourteen print; *VM:APF*, 45 ("East 108th Street, New York, September 28, 1959"), and 27 ("Maier often made photographs that referenced image making. New York, 1959"); CJG: 59?_00372-009, and 59?_00372-003.

147. CJG: 59-60_12_00388-008, and 59-60_12_00388-016.

148. CJG: XX_SL_PG40-004, XX_SL_PG40-012, and 60_4_SL_PG73-003.

149. *VM:Self*, p. 24: "1960"; CJM: VM1960W00211-12-MC, "Frank Sinatra, 1960," accessed February 1, 2017, http://www.vivianmaier.com/gallery/street-2/#slide-25; CRS: several five-by-seven prints of the actors from *North by Northwest*; CJM: VM1960W02526, "Kirk Douglas at the premiere of the movie Spartacus in Chicago, IL. October 13, 1960," accessed February 1, 2017, http://www.vivianmaier.com/gallery/contact-sheets/#slide-4; CJG: 60_10_00397-008.

150. CJG: nd_00838a-012, nd_00838a-020, 1960_nd_00838a-018, nd_00838a-001, nd_00838b-007, 60_8_SL_PG18-006, and 1960_7-27zz-60_8_SL_PG18-014; Robert Wiedrich, "CROWDS CHEER IKE AND MAMIE AS THEY LEAVE," *Chicago Tribune*, July 28, 1960, W5.

151. "YOUNG G.O.P.S GIVE THE LOOP A REAL CIRCUS," *Chicago Tribune*, July 28, 1960, S9; CJM: VM19XXW03098, "Undated," accessed February 1, 2017, http://www.vivianmaier.com/gallery/contact-sheets/#slide-7.

152. CJG: 60_9_00391-019; CJG: 60_9_00392-005; *VM:WTNP*, time code 00:01:19. Nixon was in Chicago for the first televised presidential debate, that night.

153. CJG: 60_00390-00; http://vivianmaierfirstlook.tumblr.com/post/44543661632/vivian-maier-chicago-state-street-lyndon-b-and; CJG: 61_00404-007, 61_00404-008, and 61_00404-009.

154. CJG: ND_1170_027, ND_1170_026, and ND_1170_012.

155. Kathy Gillespie's descriptions of Maier's eleven-by-fourteen-inch prints in the portfolios she acquired at the RPN auction, including the statement that "there was one portfolio that was all foreign countries, Middle East, France, Italy, Asia, and some that looked like the Southwest" (Gillespie, e-mail correspondence with the author, November 15, 2013). CRS prints; CJM prints.

CHAPTER SEVEN

1. Claire Sykes, "Vivian Maier. Private Life. Public Eye," *Photographer's Forum* 34, no. 3 (Summer 2012): 19–20.

2. The galleries had matching price structures, which incrementally increased as prints sold from an edition of fifteen.

3. The CJG's stamp consisted of a facsimile of Vivian Maier's signature and the words, "Vivian Maier Prints Inc." Those prints were signed in pencil by the darkroom printers Ron Gordon and Sandy Steinbrecher, as well as Jeffrey Goldstein. The CJM's stamp presents a square containing the words "Vivian Maier"; the date of photograph; the date of the print; the edition number; John Maloof's name with a line for his signature; and the words "© Maloof Collection." Maloof signed the back of a print in *FVM* (time code 00:50:28). Additionally, Maloof rubberstamped the back of Maier's vintage prints and validated them by signing them in ink.

4. Oran Grad, December 21, 2011, comment on the thread "Vivian Maier in NYC until Jan 28th 2012," Large Format Photography Forum, http://www.largeformatphotography.info/forum/showthread.php?84744-Vivian-Maier-in-NYC-until-Jan-28th-2012.

5. Jeffrey Goldstein, December 26 and 27, 2011, respectively, comments on the thread "Vivian Maier in NYC until Jan 28th 2012," Large Format Photography Forum, http://www.largeformatphotography.info/forum/showthread.php?84744-Vivian-Maier-in-NYC-until-Jan-28th-2012.

6. Christina Grasso, "Actor Tim Roth Talks 'Vivian Maier: A Life Discovered,'" *BULLETT*, January 5, 2012, http://bullettmedia.com/article/actor-tim-roth-talks-vivian-maier-a-life-discovered/.

7. Merry Karnowsky Gallery press release, "Vivian Maier—a Life Discovered: Photographs from the Maloof Collection," January 7–28, 2012.

8. Mark Westall, "Vivian Maier 'A Life Discovered: Photographs from the John Maloof Collection,'" *FAD*, January 9, 2012, http://fadmagazine.com/2012/01/09/vivian-maier-'a-life-discovered-photographs-from-the-maloof-collection'/.

9. Kerri MacDonald, "Vivian Maier: Better and Better," *Lens* (blog), *New York Times*, February 16, 2012, http://lens.blogs.nytimes.com/2012/02/16/vivian-maier/.

10. Julie Bosman, "Through the Nanny's Eyes," *New York Times Magazine*, February 16, 2012, http://www.nytimes.com/interactive/2012/02/19/magazine/vivian-maier.html.

11. *Vivian Maier*, Jackson Fine Arts, Atlanta, January 28–April 7, 2012; *Street Talk*, Lumiere Gallery, Atlanta, January 21–March 31, 2012;

Vivian Maier: Discovered, Monroe Gallery, Santa Fe, NM, February 3–April 22, 2012.

12. Sidney S. Monroe, quoted in Adrian Gomez, "Everyday People," *Albuquerque Journal*, January 29, 2012.

13. CJG, "@vivianmaiernews" first tweet: "Check out the new Vivian Maier web site: http://www.vivianmaierprints.com," https://twitter.com/vivianmaiernews/status/41281356147200000 (Although on February 1, 2017, this link still points to "vivianmaiernews" and all CJG tweets through September 18, 2015, are intact, in November 2016, the Twitter account appears to have been taken over by a sex chat worker.) John Maloof's first tweet appeared on April 13, 2011, https://twitter.com/Vivian_Maier/status/58305128935067649.

14. *FVM*, time code 00:48:25.

15. *FVM*, time code 00:48:38.

16. I was among the gallery-goers on that Saturday, February 25, 2012.

17. Corbett vs. Dempsey [Gallery], June 29–July 21, 2012.

18. "Searching for Vivian Maier," *Chicago Tonight*, August 2, 2012.

19. "The Meteoric Rise of Vivian Maier," *Chicago Tonight*, August 1, 2012.

20. Institute of Design alumni who had solo exhibitions: 1960, Ray Metzker; 1961, Yasuhiro Ishimoto and Joseph Jachna; and 1963, Charles Swedlund and Art Sinsabaugh.

21. The portfolio comprised ten prints by six students: Joseph Jachna, Ray K. Metzker, Dan Seiden, Joseph Sterling, Charles Swedlund, Robert Tanner, and Paul Zakoian.

22. Design Laboratory course description, *New School Bulletin*, Art, 1954–55, vol. 12, no. 2, September 13, 1954, unpaginated.

23 Museum of Modern Art press release, "Five Unrelated Photographers: Heyman, Krause, Liebling, White, and Winogrand," May 28, 1963.

24. Lisette Model, course description for "Basic Photography," *New School Bulletin*, vol. 17, no. 1, September 7, 1959, p. 128. Model also offered private classes from her Greenwich Village home and studio.

25. CJM: 53-210, "Sept, 1953, New York, NY," February 10, 2012, Internet Archive: Wayback Machine: web.archive.org/web/20120210153902/http://www.vivianmaier.com/portfolios/new-york-1/?show=thumbnails&pid=186.

26. CJG: 61_00410-007.

27. Allan Sekula purchased negatives of men loitering on the sidewalk in Uptown from John Maloof on eBay in 2009; Vivian Maier Facebook page, "1961, Chicago," https://www.facebook.com/photographervivianmaier/photos/a.10150753556990720.718487.444225420719/10153005692675720/;

CJM: VM1962W01099, "Maxwell Street, Chicago, IL. 1962," accessed February 1, 2017, http://www.vivianmaier.com/gallery/contact-sheets/#slide-6; Vivian Maier Facebook page, "1963, Chicago," https://www.facebook.com/photographervivianmaier/photos/a.10150753556990720.718487.444225420719/10152401584140720/; Vivian Maier Facebook page, "A new week, another new find from the Vivian Maier archive," https://www.facebook.com/photographervivianmaier/photos/a.10150753556990720.718487.444225420719/10152195467115720/ (details in the photograph indicate it was shot in 1963).

28. CJM: VM1963W00684, "January 31, 1963, Hull House, Chicago, IL," accessed February 1, 2017, http://www.vivianmaier.com/gallery/contact-sheets/#slide-12.

29. CJG: 63_9_00423-001, 9_00423-009, 63_9_00419-002, 63_9_00419-008.

30. "Paris Coming to Chicago at Carson's," *Chicago Tribune*, September 22, 1963, sec. 4, p. 1.

31. Jean Kotulak, "Drums to Echo Needs of Urban Indians," *Chicago Tribune*, September 20, 1962, sec. S, p. 6.

32. CJG: 63_11-29_00418-001, 63_11-29_00418-002, 63_11-29_00418-003, 63_11-29_00418-004, 63_11-29_00418-006.

33. CJG: 63_4_SL_PG75-002 (one of several color slides shot from behind a funerary monument), 61-65_00678-002, 61-65_00678-006, 61-65_00678-004, and 61-65_00678-003.

34. *VM:APF*, 10. This photo is misdated "c. 1950." Maier did not arrive in Chicago until 1956. Several other images in *VM:APF* are also captioned inaccurately: e.g., "Chicago, c. 1952" (132) shows a cinema marquee displaying *Congo Crossing*, which wasn't released until 1956, and "Chicago, 1954" (134), showing a movie poster for *Giant*, also released in 1956.

35. Nora O'Donnell, "The Life and Work of Street Photographer Vivian Maier," *Chicago*, January 2011, www.chicagomag.com/Chicago-Magazine/January-2011/Vivian-Maier-Street-Photographer/index.php?cparticle=2&siarticle=1%23artanc. An unpublished portion of the interview referenced Maier's French influence and play productions.

36. Trudy Wilner Stack, *Garry Winogrand 1964* (Santa Fe, NM: Arena Editions, 2002). When Winogrand died, he left behind around twenty-five hundred rolls of undeveloped film, which amounts to ninety thousand images.

37. The Gensburg family commented on their relationship with Vivian Maier for only one magazine article. They have been silent since December 2010, extremely protective of Maier, and even though John

Maloof recorded interviews with them for *FVM*, they later refused to allow those interviews to be included.

38. Howard Greenberg Gallery presented two shows simultaneously, December 15, 2011–January 28, 2012: *Vivian Maier: Photographs from the Maloof Collection* and *Vivian Maier: Lifetime Prints from the Maloof Collection.* Merry Karnowsky Gallery, *Vivian Maier—a Life Discovered: Photographs from the Maloof Collection*, January 7–28, 2012.

39. Images of vintage prints from the Howard Greenberg exhibition *Vivian Maier: Lifetime Prints from the Maloof Collection*, accessed February 1, 2017, http://www.howardgreenberg.com/exhibitions/vivian-maier-lifetime-prints-from-the-maloof-collection/selected-works; the Merry Karnowsky Gallery website displayed forty-eight prints, along with their dimensions; *VM:APF*, 250, photo captioned "Location unknown, 1976," and 254–55, photo captioned "Chicago, 1975."

40. Eventually, some of the earlier Vivian Maier vintage print images emerged as full-frame posthumous prints.

41. "Vivian Maier Out of the Shadows Deluxe Clamshell Edition with Print," December 9, 2012, http://web.archive.org/web/20121209035127/http://www.vivianmaierclamshellbook.com/.

42. The third Goldstein-sponsored Maier exhibition was held at the Catherine Couturier Gallery in Houston.

43. The exhibition opened on September 7, 2012. Its run had been extended three times; the show has since become a permanent exhibition. *Vivian Maier's Chicago*, Chicago History Museum, https://www.chicagohistory.org/exhibition/vivian-maiers-chicago/.

44. Christopher Borrelli, "Vivian Maier's Photos Worth 1000 Instagrams," *Chicago Tribune*, September 21, 2012.

45. Ibid.

46. As of this writing, there are over 359,000 followers.

47. Hungarian House of Photography in Mai Mano House André Kertész Hall, Budapest, Hungary, September 20–January 6, 2013; Galleria dell'Incisione, Brescia, Italy, October 1–November 30, 2012; Bi8 Biennale Dell'Immagine, Chiasso, Switzerland, November 24, 2012–January 20, 2013; Basil Hallward Gallery, Powell's City of Books, Portland, Oregon, December 6–31, 2012.

48. "100 Copies Left of Vivian Maier: Out of the Shadows—Get One While You Can!" *Vivian Maier Photography Newsletter*, November 30, 2012.

49. John Maloof, Jeffrey Goldstein, and Ron Slattery all acquired undeveloped rolls of black-and-white film from 1964. Some of Maloof's subsequently processed 1964 negatives were sold on eBay, including to Allan Sekula and Philip Boulton.

50. "Twister Toll Put at 248," *Chicago Tribune*, April 13, 1965, 1.
51. CJG: 65_4-16_00441-005, 65_4-16_00440-005, and 65_4-16_00438-008.
52. CJG: 65_4_13_00433-006, 65_4_13_00433-012, and 65_4-13_00446-011.
53. CJG: 65_5_4_00460ab-006, and nd_00774-001 through 00774-012; *FVM*, time code 00:47:20; *VM:APF*, 199, photo captioned "San Juan, Puerto Rico, 1965,"; CRS color slides of Puerto Rico; CJG: thirty-five black-and-white negatives depicting the five Puerto Rican cities.
54. Maier's negative sleeve notation shows that she photographed the display board at Illinois Institute of Technology's Hermann Hall, which announced the film festival on the day that it launched, May 12, 1965 (CJG: 65_5_12_00458-002).
55. Mae Tinee, "Hull House's Film Festival This Week," *Chicago Tribune*, May 9, 1965, H11.
56. CJG: 65_5_12_00458-004, 65_5_12_00458-009, and 65_5_12_00463-002; Vivian Maier, "Untitled, 1965," posted by lievbengever, July 9, 2013, http://calumet412.com/post/55002383408/untitled-1965-chicago-vivian-maier-a-rare.
57. CJG: 61-65_00670-001 through 00670-001-012, and 61-65_00732-001 through 00732-012.
58. John Szarkowski, quoted in the Museum of Modern Art press release that announced his appointment, March 4, 1962.
59. "New Documents" press release, Museum of Modern Art, February 28, 1967.
60. Nora O'Donnell, "The Life and Work of Street Photographer Vivian Maier," *Chicago*, January 2011, http://www.chicagomag.com/Chicago-Magazine/January-2011/Vivian-Maier-Street-Photographer/index.php?cparticle=2&siarticle=1%23artanc.
61. CJG: reels of 8 mm motion picture footage, black-and-white negatives, and color slides; CRS: color slides; Allan Sekula acquired black-and-white negatives from this excursion on eBay, as did Philip Boulton.
62. John Maloof sold individual negative frames from these places to at least two eBay bidders. They were included among the thousand rolls of unprocessed film he had acquired from Ron Slattery. Separately, Allan Sekula purchased a negative frame showing Inger Raymond sitting with some other children at the prow of the ferry.
63. "Memorial Day Tributes Set thruout Area," *Chicago Tribune*, May 28, 1967, sec.1, p. 7.
64. CRS: color slides.

65. Inger Raymond presented these photographs and the scrapbook in *FVM*, time code 00:51:24.

66. Toneloof, September 11, 2014, comment on Kickstarter for *Finding Vivian Maier*: "We put that Kickstarter money 'on the screen'— meaning we used it to pay our crew and pay genealogists and pay for travel to Maier's childhood home in France" (https://www. kickstarter.com/projects/800508197/finding-vivian-maier-a-feature-length-documentary/comments).

67. *FVM* Facebook post, October 11, 2012, https://www.facebook.com/ FindingVivianMaier/photos/a.279556652144214.47767.278987812201 098/292403507526195/?type=3&theater.

68. *FVM* Facebook post, November 1, 2012, https://www.facebook. com/FindingVivianMaier/photos/a.279556652144214.47767.2789878 12201098/298669610232918/?type=3&theater.

69. *FVM* Facebook post, January 16, 2013, https://www.facebook.com/ FindingVivianMaier/photos/a.279556652144214.47767.278987812201 098/324840587615820/?type=3&theater.

70. *FVM* Facebook post, January 3, 2013, https://www.facebook.com/. FindingVivianMaier/photos/a.279556652144214.47767.278987812201 098/320045281428684/?type=3&theater.

71. "Our film trailer received 300,000 views in only 3 days!" *FVM* Facebook post, February 18, 2013, https://www.facebook.com/Find-ingVivianMaier.

72. Despite other anecdotes of Vivian Maier's secrecy with her employers, Nancy Gensburg commented that Maier "knew many interesting people who were in the photography business. They were her friends." When asked about Maier's mysterious aura, Gensburg offered, "Well, [she was] different, I don't know if mysterious, but [she was] different." Unpublished portion of O'Donnell's "The Life and Work of Street Photographer Vivian Maier," quoted from interview with Avron and Nancy Gensburg, December 2010, courtesy of O'Donnell.

73. I was a consultant on this film.

74. Anonymous sources in e-mail correspondence and conversation with the author, August 14, 2012, and October 18, 2016.

75. *VM:WTNP*, time codes 00:49:16 and 00:17:11.

76. Miserere, "Vivian Maier, Chicago's Mysterious Photographer—A Timeline," Enticing the Light: A Quest for Photographic Enlightenment, http://enticingthelight.com/2011/01/13/vivian-maier-chicagos-mysterious-photographer-a-timeline.

77. CRS color slide box.

78. CJG: 68_00595-010, 68_00595-011, and 67_1106_005; *VM:ETE*,

162, photo captioned "Chicago, Illinois, 1967"; CJG: nd_00760-009, and nd_00757-011.

79. Donald Janson, "7 Die as Fires and Looting Spread in Chicago Rioting," *New York Times*, April 6, 1968, 1.

80. Donald Mosby, "Despite Guard, Cops, Federal Troops, More Looting Hits Ghetto," *Chicago Defender*, April 8, 1968, 1.

81. Robert Weidrich, "Madison St. a Blackened Scar in Heart of Chicago," and "Halt Disorders in Areas Near Jackson Park," *Chicago Tribune*, April 8, 1968, 1.

82. CJG: 67-68_00572-007-600, and 67-68_00572-010-1548; Richard Cahan and Michael Williams, "An Outsider's Life in Pictures and Boxes," *Lens* (blog), *New York Times*, November 7, 2012, lens.blogs.nytimes.com/2012/11/07/a-outsiders-life-in-pictures-and-boxes/; CJG: 67-68_00571-005.

83. *VM: OOTS*, 182–87, photo captioned "West Madison Street, Chicago"; CJG: color slides, including, 68_4_SL_PG40-008.

84. *FVM*, time code 1:02:19; *VM: OOTS*, 189–91.

85. *VM: WTNP*, time code 00:28:12.

86. William Eaton, correspondence with the author, December 3, 2013.

87. Robert C. Maynard, "Police, Protesters Clash in an Atmosphere of Hatred," *Washington Post*, August 27, 1968, A6.

88. "Police Injure 6 More Newsmen," *Chicago Tribune*, August 29, 1968, 7.

89. CJG: 68_00742-010, 68_00742-006, and 68_00742-008; *VM: OOTS*, 196, 204 photo captioned "Chicago Loop", 199, 203 photo captioned "Grant Park"; CJG: nd_00776-001.

90. CJG: 68_00743-008; *VM: OOTS*, 192, 193 photo captioned "Grant Park".

91. S. Simon, February 24, 2013, comment on Kelly Reaves, "Getting the Right Angle on Vivian Maier," *Gaper's Block*, January 6, 2011, http://gapersblock.com/ac/2011/01/06/getting-the-right-angle-on-vivian-maier/.

92. Ian Murray, "Vivian Maiers Work," The Stock Photo Network, July 2, 2013, https://groups.yahoo.com/neo/groups/STOCKPHOTO/conversations/messages/47631.

93. Ibid., July 3, 2013.

94. Ibid., July 4, 2013.

95. Julia Gray, "The Curious Case of Vivian Maier's Copyright," *Gaper's Block*, August 13, 2013, http://gapersblock.com/ac/2013/08/13/the-curious-case-of-vivian-maiers-copyright/#.V1kBqVf0DdQ.

96. On July 5, 2014, the Vivian Maier Facebook page presented an album of Maier's vintage prints: "John Maloof currently is in France for yet another visit to the roughly 300 people village of

Saint-Julien-en-Champsaur . . . with around 55 vintage prints of the village, it's [*sic*] people and surroundings to donate them for exhibition purposes. These are some of the vintage prints he donated" (https://www.facebook.com/pg/photographervivianmaier/photos/?tab=album&album_id=10152972410010720).

97. Gray, "The Curious Case of Vivian Maier's Copyright."

98. The Goldstein exhibit was at the Stephen Bulger Gallery, July 25–September 14, 2013. The Maloof exhibits were at the Isa Spalding Gallery, September 5–October 15, 2013.

99. The Steven Kasher Gallery had a print of Vivian Maier for sale that was shot by six-year-old Inger Raymond. *VM:WTNP*, time code 00:30:15. Kasher Gallery e-mail, June 28, 2016, "Say Hello to Summer with these special selections from Steven Kasher Gallery," "Chicago, North Suburbs (Partial View, Vivian Maier), 1968, Gelatin silver, printed 2014, 20x16 inches, Edition 11/15."

100. Despite the release of *Finding Vivian Maier* at festivals throughout the world, the film did not play at Chicago's international film festival, and it wouldn't open in Chicago until April 4, 2014, a week after the national premiers in New York and Los Angeles. At each announcement of screening venues, *FVM*'s Facebook page received comments saying that Chicago was being passed over, e.g., Chad Jahnel, "I find it interesting~her film has been promoted on the west coast ~east coast:~ but within her profile she seems to resonant from CHICAGO, and some of her best work. . . . why ? wasn't Chicago the first place this film would be presented, or is it just about the $$$$$$$$$$$$$$$$$$$$$$$$$. . . . which I guess I understand.but, she never was~" (April 3, 2014, https://www.facebook.com/FindingVivianMaier/posts/478314892268388).

101. Frank Scheck, "Recluse Nanny Turns Out to Be Photography Genius," *New York Post*, March 22, 2014, http://nypost.com/2014/03/22/recluse-nanny-turns-out-to-be-photography-genius.

102. Associated Press, "140 TV Stations Show Daley Film," *Boston Globe*, September 16, 1968, 1.

103. A neighbor, Carole Pohn, relayed to me (May 25, 2016) that Maier continued printing in the Gensburgs' darkroom after she left their employment.

104. Of the several hundred rolls of undeveloped black-and-white film that Jeffrey Goldstein acquired from Randy Prow, more than seventy were from this period. Also, Ron Slattery processed film from the years 1968 and 1969, and countless other rolls were included in the thousand that he sold to John Maloof, of which several have been accounted for through eBay sales. Additionally, photoless gaps

of several weeks duration within periods during which Maier was otherwise shooting large numbers of photos could indicate a dozen or more missing rolls.

105. CJG negatives, processed by Frank Jackowiak, colleagues, and former students at the College of DuPage.

106. The same view of Maier's approach to the Madison Street Station appears in color slides and on 35 mm and 120 black-and-white film in CJG; it was also represented on a frame in the ten rolls Ron Slattery had processed before selling his undeveloped rolls to John Maloof. One of the earliest Maloof Blogspot postings shows the view: *Vivian Maier—Her Discovered Work* (blog), October 26, 2009, vivianmaier. blogspot.com/2009/10/blog-post_26.html.

107. CRS: 8 mm Kodachrome, image posted January 8, 2010, https:// www.flickr.com/photos/57819210@N07/5336714204/in/dateposted/.

108. CJG: 68_4_14-15_00502-009

109. Gene Siskel, "The Minx," *Chicago Tribune*, February 24, 1970, B5.

110. Gene Siskel, "Female Animal," *Chicago Tribune*, March 3, 1970, B4.

111. CJM: "Vivian Maier 8mm Home Movie," YouTube video, 12:21, posted by VivianMaierFilm, May 23, 2014, https://www.youtube. com/watch?v=nXASDjCwxsE.

112. CJG: nd_00979_8062-007.

113. CJG: 69_00885_8039-004, 69_00885_8039-005, and 69_00885_8039-006.

114. CJM: VM1953W02859-05-MC, "June 1953, New York, NY," accessed February 1, 2017, http://www.vivianmaier.com/gallery/ street-5/#slide-15; CJM: VM1955W02714-03-MC, "April 9, 1955, New York, NY," accessed February 1, 2017, http://www.vivianmaier. com/gallery/street-4/#slide-48; *VM:OOTS*, 258 ("1971"), and 259 ("1974").

115. G/M-Undivided: 4057.

116. CJG: 72_6_16_00631-003.

117. In 2000, the Film Center was renamed in honor of Gene Siskel.

118. *VM:WTNP*, time code 00:31:13.

119. Bryce J. Renninger, "John Maloof and Charlie Siskel Talk Researching the Life of the Nanny Street Photographer Vivian Maier," *IndieWire*, September 15, 2013, http://www.indiewire.com/article/ john-maloof-and-charlie-siskel-talk-researching-the-life-of-the-nanny-street-photographer-vivian-maier.

120. David Zax, "Vivian Maier: The Unheralded Street Photographer," *Smithsonian Magazine*, December 2011.

121. "Finding Vivian Maier," Box Office Mojo, http://www.boxofficemo-jo.com/movies/?id=findingvivianmaier.htm.

122. Madeline Coleman, "The Myth of Vivian Maier," review of *Finding*

Vivian Maier, Aperture, March 31, 2014, http://aperture.org/blog/myth-vivian-maier/.

123. Rose Lichter-Marck, "Vivian Maier and the Problem of Difficult Women," *New Yorker*, May 9, 2014, http://www.newyorker.com/culture/culture-desk/vivian-maier-and-the-problem-of-difficult-women.

124. Manohla Dargis, "The Nanny as Sphinx, Weaving Enigmatic Magic on the Sly," movie review, *New York Times*, March 27, 2014, http://www.nytimes.com/2014/03/28/movies/finding-vivian-maier-explores-a-mysterious-photographer.html.

125. Jahna Peloquin, "Permanent Vivian Maier Gallery Coming to Mpls Photo Center," *Vita.min: The Twin Cities Going-Out Guide*, March 12, 2014, Internet Archive: Wayback Machine, September 30, 2015, web.archive.org/web/20150930193701/http://www.vita.mn/crawl/249955231.html.

126. "New Book—Eye to Eye: Photographs by Vivian Maier," *Vivian Maier Photography News*, June 3, 2014.

127. Paul Gallagher and Rob Hastings, "Row between Collectors over Discovery of Works by American Photographer Vivian Maier as New Documentary Is Released," *Independent*, July 18, 2014, http://www.independent.co.uk/arts-entertainment/art/news/row-between-collectors-over-discovery-of-works-by-american-photographer-vivian-maier-as-new-9615697.html.

128. Ibid.

129. Jillian Steinhauer, "The Vivian Maier 'Discovery' Is More Complicated Than We Thought," *Hyperallergic*, July 21, 2014, http://hyperallergic.com/138816/the-vivian-maier-discovery-is-more-complicated-than-we-thought/.

130. Deanna Isaacs, "Vivian Maier, Cottage Industry," *Chicago Reader*, April 29, 2014, http://www.chicagoreader.com/chicago/nanny-genius-photographer-vivian-maier-is-everywhere/Content?oid=13298357.

131. Ibid.

132. "What is the Maloof Collection's Copyright Policy?" accessed February 1, 2017, http://www.vivianmaier.com/frequently-asked-questions/.

133. Blake Andrews, "Dis Claimer," *B: Rumblings from the Photographic Hinterlands* (blog), April 17, 2014, http://blakeandrews.blogspot.com/2014/04/the-unclaiming.html.

134. Ibid.

135. Blake Andrews, "Heir Apparent," *B: Rumblings from the Photographic Hinterlands* (blog), April 29, 2014, http://blakeandrews.blogspot.com/2014/04/heir-apparent.html.

136. Deanna Isaacs, "Vivian Maier, the Lawsuit," *Chicago Reader*, May 13, 2014, http://www.chicagoreader.com/chicago/slattery-vivian-maier-prints-lawsuit-corbett-dempsey/Content?oid=13506031.

137. Dmitry Samarov, "The Vivian Mire," *Spolia*, no. 9 (July 2014), 12–20.

138. United Press International, "Fears, Sex, Violence Tied to Energy Crisis," *Los Angeles Times*, March 3, 1974, 18.

139. Jerry Cargill, who helped develop Jeffrey Goldstein's collection of Maier black-and-white negatives and printed nearly all of those proof sheets, suggested that as a result of unstable dyes, all of Goldstein's undeveloped color film was destroyed in processing (e-mail correspondence with the author, August 11, 2012). John Maloof reportedly had four hundred frozen unprocessed rolls of color film, representing more than fourteen thousand images. On January 23, 2017, Maloof told me that this film had recently been developed. The most recently annotated film cartridge was dated 1999.

140. The Goldstein collection of negatives contained twelve rolls of film showing views of the Africa House classroom, and one of the rolls of film from 1971 that Slattery had processed also showed the classroom.

141. Excerpts from Vivian Maier's 1974 audiotapes, in *FVM*, time codes 00:27:58 and 00:28:17.

142. CJG: black-and-white negatives of each of these items.

143. Inger Raymond, in *VM:WTNP*, time code 00:30:31.

144. Ibid., time code 00:06:00.

145. CJG: 74_00861_8012-009.

146. CJG: 74_00910_6589-008.

147. CJG: 74_9_SL_PG56-004, 74_9_SL_PG56-005, and 74_9_SL_PG56-009.

148. Maier made at least three eight-by-ten prints of this negative, two are in CJG, and John Maloof acquired the mounted picture from this scene.

149. CJG: 71_01029_8143-004.

150. Galerie St. Etienne, "Kathe Kollwitz: A Portrait of the Artist," http://www.gseart.com/Artists-Gallery/Kollwitz-Kathe/Kollwitz-Kathe-Essays.php?essay=2.

151. CJG: 74_10_SL_PG69-006.

CHAPTER EIGHT

1. Nora O'Donnell, "The Life and Work of Street Photographer Vivian Maier," *Chicago*, January 2011, www.chicagomag.com/Chicago-Magazine/January-2011/Vivian-Maier-Street-Photographer/index.php?cparticle=2&siarticle=1%23artanc: "She was the eccentric French woman who dragged them to obscure monuments, served

them yucky peanut butter sandwiches with apricots, and made the girls a present of a paper bag full of green army men."

2. *VM:OOTS*, 243.

3. This recording was presented as a bonus feature as part of the DVD release of *FVM*.

4. *FVM* displays her various collections, including one that shows more than two hundred photofinishing envelopes. Similar envelopes also appeared in the Randy Prow's collection and CRS. Maloof flipped through one binder in WTTW's "Vivian Maier, Street Photographer and Nanny," which showed a print of men in yellow hardhats amid 1968's West Madison Street's aftermath of the riots. *Chicago Tonight*, December 22, 2010.

5. Pat Velasco, phone conversation with the author, May 18, 2016.

6. Flesch's grandfather founded Central Camera, and Flesch now owns it; interview with the author at Central Camera, July 16, 2013.

7. The Randy Prow collection abruptly ended at the end of 1974.

8. "She switches to color in the mid 70's, uses a 35 mm camera (mostly a Leica), and I get the feeling that she is seeing the world differently at that time" (Blake Andrews, "Q & A with John Maloof," *B: Rumblings from the Photographic Hinterlands* [blog], January 12, 2011, http://blakeandrews.blogspot.com/2011/01/q-with-john-maloof. html).

9. Document from CJM from Iredale Storage & Moving Co., Evanston, February 3, 1979.

10. Linda Matthews, "Diary," *London Review of Books*, October 22, 2015, 38.

11. Curt Matthews, "Vivian Maier & Independent Publishing," *Gone Publishing* (blog), Independent Publishing, January 15, 2013, https://gonepublishing.wordpress.com/2013/01/15/vivian-maier-independent-publishing/.

12. Matthews, "Diary."

13. After an incident over Maier's newspaper hoarding, Linda Matthews wrote, "I thought we could work through it, find a way to keep going. My husband said no, she was getting too nutty."

14. Help-wanted ad, *Evanston Review*, October 3 and 10, 1985. A letter in CJM shows a response to this ad.

15. Anonymous employer, interview with the author, May 27, 2016.

16. *VM:Self*, 113 ("September 1986—Chicago area"), and 118 ("Undated"). They are the latest of her photographs to be released to date.

17. O'Donnell, "The Life and Work of Street Photographer Vivian Maier."

18. Richard Baylaender, e-mail correspondence with the author, May and June 2016.

19. CJM has post office money-order receipts that show Maier's payments to a Gurnee storage facility and then Hebard Storage from the Baylaender's Wilmette address. *FVM*, time code 00:13:20.

20. Heiwon Shin, "Block Cinema Screens Documentary on Photographer Vivian Maier," *Daily Northwestern*, October 28, 2013, http://dailynorthwestern.com/2013/10/28/campus/block-cinema-screens-documentary-on-photographer-vivian-maier-2/.

21. Charles Swisher, at a Northwestern University Block Cinema public screening of *VM:WTNP* hosted by me, October 26, 2013.

22. John Maloof relayed this story at a question-and-answer session after the Chicago premiere of the movie, April 5, 2014 ("Finding Vivian Maier Q&A," YouTube video, 23:01, posted by "Matt R," April 5, 2014, https://www.youtube.com/watch?v=zvA4jGOGX94).

23. Bindy Bitterman, conversation with the author, November 21, 2013.

24. Roger Carlson, proprietor of Bookman's Alley, *FVM*, time code 01:03:31.

25. As late as 1996, Cathy Bruni-Norris, whose sister had employed Maier, saw Maier rushing through the mall at Water Tower Place with the Rolleiflex dangling from her neck (phone conversation with the author, May 27, 2016).

26. CJM undeveloped 35 mm slides, 21,000 (600 rolls); CJG undeveloped 35 mm slides, 2,700 (approx. 75 rolls); CJM other undeveloped film, 12,000 (1,000 rolls); CJG other undeveloped film, approx. 3,000 (218 rolls of 35 mm and 120 format).

27. Chicago-based detective fiction novelist Sara Paretsky made a similar point in *VM:WTNP* time code 00:35:08.

CHAPTER NINE

1. Charles Maier probate records, Queens County Surrogate Court, Queens, NY, file no. 1798-1968.

2. Parole Officer Carroll, interview with Marie von Maier, May 18, 1936. NYSA.

3. Alma Corsan probate records, New York County Surrogate Court, NY, file no. 497-1965

4. Attorney Richard Heller testimony, in Joseph Corsan's probate papers, New York County Surrogate Court, New York.

5. Joseph Corsan probate records, New York County Surrogate Court, NY, file no. 4010-1970.

6. Karl Maier was likely one of the original transferees from the psychiatric hospital in Trenton, suggesting that he had been part of state institutional systems for well over twenty years. "Mental Patients Transferred to Ancora Hospital," *Philadelphia Inquirer*,

April 7, 1955; and an anonymous source, in communication with the author, June 2015.

7. Alfonso A. Narvaez, "Hot Line Set Up on Boarding Homes," *New York Times*, June 30, 1978, NJ15; Edward A. Gargan, "As 'Psychiatric Ghettos,' Boarding Homes Get More Dangerous," *New York Times*, February 8, 1981, E6.

8. "Two Women Slain in Hotel Stabbing," October 6, 1972; "4th Slaying Victim Is Found in a Hotel," November 19, 1972; "After 4 Hotel Slayings, Fear Stalks All Rooms," November 20, 1972; and "Man, 63, Is Slain; 5th Murder Victim in Hotel in a Year," September 8, 1973—all in *New York Times*.

9. The Office of the New York State Comptroller, Office of Unclaimed Funds, shows three unclaimed items for "Marie Jaussaud C/O Endicott Hotel Room 369, 440 Columbus Avenue, New York, NY, 10024."

10. John J. O'Connor, "TV: 3 Worthy Projects," *New York Times*, April 28, 1975, 46.

11. "Accounting of the Public Administrator of the County of New York, as Administrator of the Estate of Marie Jaussaud, also known as Marie Jaussaud Maier, Deceased," July 10, 1979, Surrogate's Court, New York County, New York, NY.

12. Linda Matthews, "Diary," *London Review of Books*, October 22, 2015, 38.

13. *VM:WTNP*, time code 00:29:53.

14. Marie Doezema, "Vivian Maier: Amateur with a Sharp Eye," *Christian Science Monitor*, April 12, 2011, http://www.csmonitor.com/The-Culture/Arts/2011/0412/Vivian-Maier-Amateur-with-a-Sharp-Eye.

15. Linda Matthews, "Diary."

16. Richard Baylaender, e-mail exchange with the author, June 2, 2016.

17. Nora O'Donnell, "The Life and Work of Street Photographer Vivian Maier," *Chicago*, January 2011, www.chicagomag.com/Chicago-Magazine/January-2011/Vivian-Maier-Street-Photographer/index.php?cparticle=2&siarticle=1%23artanc.

18. Karen Usiskin, in *FVM*, time code 00:35:12.

19. Linda Matthews, letter to the editor, *Harper's*, March 2015.

20. Frances Brent, in *VM:WTNP*, time code 00:23:47. Also, Frances Brent, from "Vivian Maier's Jewish Chicago: A Reminiscence, as a New Doc Tries to Revive Her Story," *Tablet*, October 10, 2012, http://www.tabletmag.com/jewish-arts-and-culture/113385/vivian-maier-jewish-chicago. Years earlier, when Maier switched from a motorized bike to a traditional pedal model, she already stood out in Highland Park simply for being an adult on a bicycle.

21. Unpublished portion of O'Donnell's "The Life and Work of Street

Photographer Vivian Maier." Quoted from interview with Avron and Nancy Gensburg, December 2010, courtesy of O'Donnell.

22. Jennifer Levant, conversation with the author, May 25, 2016.

23. Carole Pohn, conversation with the author, May 25, 2016.

24. Unpublished portion of O'Donnell's "The Life and Work of Street Photographer Vivian Maier." Quoted from interview with Avron and Nancy Gensburg, December 2010, courtesy of O'Donnell.

25. There has been speculation that Maier was homeless at some point, but the Gensburgs dispute this. Lane Gensburg said that he was not aware of any time that Maier didn't have a place to stay, adding, "I would never have permitted that if I had known about it" (ibid.).

26. "Beginning Inventory February 26, 2009," Estate of Vivian Maier, 2009P 000587, Circuit Court of Cook County, IL, filed July 24, 2009.

27. "Inventory," Estate of Vivian Maier, 2014P 3434, Circuit Court of Cook County, IL, filed December 16, 2014.

28. Ron Slattery, "Story," July 22, 2008, Big Happy Funhouse, http://www.bighappyfunhouse.com/archives/08/07/22/12-30-34.html.

29. "1950s—Vivian Maier," John Maloof Flickr page, January 1, 2009, https://www.flickr.com/photos/ragstamp/3155991381/.

30. "Petition for Appointment of Guardian for Disabled Person," Estate of Vivian Maier, Circuit Court of Cook County, January 26, 2009.

31. Curt Matthews, "Vivian Maier & Independent Publishing," *IPG Blog*, Independent Publishing, January 15, 2013, http://www.ipg-book.com/blog/vivian-maier-independent-publishing/.

CHAPTER TEN

1. David C. Deal, "Attorney Profile," The Law Office of David C. Deal, http://www.daviddeal.com/attorneyprofile.html.

2. "New in Town: Deal Hangs His Shingle in Crozet," *Crozet Gazette*, February 4, 2016, http://www.crozetgazette.com/2016/02/new-in-town-deal-hangs-his-shingle-in-crozet/.

3. David Deal, "Moral Rights, Copyrights, and the Case of Vivian Maier," Villanova Law School, February 2013, accessed June 27, 2013, http://works.bepress.com/david_deal/1 (no longer available online).

4. "Petition for Letters of Administration," filed in the Circuit Court of Cook County, Illinois, June 9, 2014.

5. Eliana Vagalau, "'I'm still falling'—Jeffrey Goldstein on Vivian Maier," *BAR: The Buenos Aires Review*, July 23, 2014, http://www.buenosairesreview.org/2014/07/im-still-falling-jeffrey-goldstein-on-vivian-maier/.

6. Jason Meisner, "Court Case Clouds Legacy of Photographer Vivian Maier," *Chicago Tribune*, September 8, 2014.

7. Letter from James E. Griffith, of Marshall Gerstein Borun LLP, to the director of Jackson Fine Art, Atlanta, August 19, 2014, introduced as evidence by Jeffrey Goldstein on September 8, 2015, Circuit Court of Cook County, Chicago.

8. Stan B, September 8, 2014, comment on Mike Johnston, "Vivian Maier Battle Royale," *Online Photographer*, September 8, 2014, http://theonlinephotographer.typepad.com/the_online_photographer/2014/09/vivian-maier-battle-royale.html.

9. MM, September 8, 2014, comment on Johnston, "Vivian Maier Battle Royale."

10. See, e.g., tweets from Twitter users, September 6, 2014, between 8:00 A.M. and 11:00 A.M. CDT. Tracey Capes (@TraceyCapes, twitter.com/TraceyCapes/status/508230537714991104; Josh Spero @joshspero, twitter.com/joshspero/status/508271998548840449; Jörg M. Colberg (@jmcolberg, twitter.com/jmcolberg/status/508280170990796800.

11. Jillian Steinhauer, "The Key Players in the Ever-More-Complicated Vivian Maier Case," *Hyperallergic*, September 22, 2014, http://hyperallergic.com/150288/the-key-players-in-the-ever-more-complicated-vivian-maier-case/.

12. Meisner, "Court Clouds Legacy of Photographer Vivian Maier."

13. Steinhauer, "The Key Players in the Ever-More-Complicated Vivian Maier Case."

14. Randy Kennedy, "The Heir's Not Apparent: A Legal Battle over Vivian Maier's Work," *New York Times*, September 5, 2014, http://www.nytimes.com/2014/09/06/arts/design/a-legal-battle-over-vivian-maiers-work.html.

15. Mike Johnston, of *Online Photographer*, and Jillian Steinhauer, of *Hyperallergic*, both quoted this passage from an e-mail message Jeffrey Goldstein sent them.

16. Steinhauer, "The Key Players in the Ever-More-Complicated Vivian Maier Case."

17. *FVM*, time code 00:43:37.

18. There had also not been a thorough investigation of Vivian Maier's father's Austro-Hungarian ancestors.

19. "Counterclaim for the Imposition of a Constructive Trust and an Equitable Lien on the Basis of Unjust Enrichment," filed in the Circuit Court of Cook County, May 12, 2015.

20. The October 21, 2014, court hearing following the September 4 citations to discover John Maloof and Jeffrey Goldstein's assets related to Vivian Maier's estate was continued to December 9, and then continued again to February 10, 2015, during which off-the-record negotiations occurred.

21. Jason Meisner, "Behind-Scenes Struggle Plays Out over Vivian Maier's Photos," *Chicago Tribune*, January 23, 2015, http://www.chicagotribune.com/news/ct-vivian-maier-photos-court-met-20150123-story.html.

22. Goldstein reportedly sold his negatives because his and Maloof's genealogists lost track of Maier's brother "Charles" in the mid-1950s, and the estate declared that it would be in control until 2020 when Maier's brother would be one hundred years old and considered deceased. Stephen Bulger: "[The Estate] say[s] Charles Maier is the one true heir and the law provides him 6 years to make a claim. . . . [Goldstein] can't afford any sort of legal fees if anything does get drawn out. In the end Jeffrey sort of thought that these negatives are a liability" (Karl Edwards, "Toronto Gallery Buys Jeffrey Goldstein's Entire Collection of Vivian Maier Negatives," *StreetShootr* (blog), December 20, 2014, http://www.streetshootr.com/toronto-gallery-buys-jeffrey-goldsteins-entire-collection-vivian-maier-negatives/).

23. Amy Luo, "Vivian Maier Negatives Come to Canada," *Canadian Art*, January 21, 2015, http://canadianart.ca/news/vivian-maier-stephen-bulger/.

24. Meisner, "Behind-Scenes Struggle Plays Out over Vivian Maier's Photos." In my January 20, 2017 meeting with David Epstein, the supervised public administrator (PA) of the Vivian Maier Estate, he clarified some of the complexities of his and the court's role. Vivian Maier died intestate (without a will) in Cook County, and her estate is adjudicated by the Probate Division of the Circuit Court of Cook County. The state's attorney, who represents "unknown heirs," oversees the interests of the estate. Epstein is a state official who was appointed by the governor as Cook County's public administrator. The PA's responsibility includes an investigation to identify the decedent's closest heir, to whom the estate (and Maier's copyright) would be turned over. If an heir is not identified within seven years, the unclaimed inheritances may be deposited with the Cook County treasurer. Income derived from sales of Maier's works stay within the estate, overseen by the state's attorney. Epstein further explained that they could sell Vivian Maier's copyright, and a future judge could declare that the estate be closed.

25. Jillian Steinhauer, "Major Vivian Maier Collector Sells Holdings to Toronto Gallery," *Hyperallergic*, December 23, 2014, http://hyperallergic.com/170540/major-vivian-maier-collector-sells-holdings-to-toronto-gallery/.

26. Estate of Vivian Maier, "The Public Administrator's Motion to Compel Response to Citation and Turnover of Estate Assets," filed in the Circuit Court of Cook County, February 21, 2017. A November

18, 2016, letter from one of Goldstein's attorneys states: "Our clients remain in the possession of the following items: 1. Black and White Film Negatives: None; 2. Posthumous Prints: 1,400 silver gelatin; 3. Vintage Prints created prior to death: 2000; 4. Other, including color negatives, slides, and transparencies: 1,700."

27. Estate of Vivian Maier, "Motion to Re-Set Return Date for Citation to Discover/Citation to Recover Assets," submitted January 6, 2015, Circuit Court of Cook County, Chicago. A county sheriff's failed attempt to serve Jeffrey Goldstein led to a second summons and then to the enlistment of a private detective who served the document on February 4.

28. "Counterclaim for the Imposition of a Constructive Trust and an Equitable Lien on the Basis of Unjust Enrichment," filed in the Circuit Court of Cook County, Chicago, IL, May 12, 2015.

29. "The Heart of the Vivian Maier Project," YouTube video, 18:02, posted by Mirko Popadic, May 1, 2015, https://www.youtube.com/watch?v=kvPrhe4tfrk.

30. "Motion for Leave to Appear in Proceedings," filed in the Circuit Court of Cook County, Illinois, November 19, 2015; "Order: This matter coming to be heard on Yves Mangin's Motion for Leave to Appear, the Motion is denied," December 1, 2015. Mangin is a grandson to one of Nicolas Baille's siblings.

31. "Third supplemental inventory of the Estate of Vivian Maier," filed in the Circuit Court of Cook County, Illinois, January 13, 2017. First deposit, $170,000; second deposit, $350,000; third deposit, $200,000.

32. Jason Meisner, "Suit Alleges Artist Illegally Profited off Vivian Maier's World-Famous Photos," *Chicago Tribune*, April 26, 2017, http://www.chicagotribune.com/news/local/breaking/ct-vivian-maier-photographs-court-fight-met-20170426-story.html.

33. The Estate of Vivian Maier v. Goldstein et al., Illinois Northern District Court Case No. 1:17-cv-02951, https://www.plainsite.org/dockets/34yrfcwat/illinois-northern-district-court/the-estate-of-vivian-maier-v-goldstein-et-al/.

EPILOGUE

1. Susan Sontag, "Photography," *New York Review of Books*, October 18, 1973, 59–63.

2. Richard Baylaender, e-mail correspondence with the author, December 19, 2013.

Index